CONSTABLE

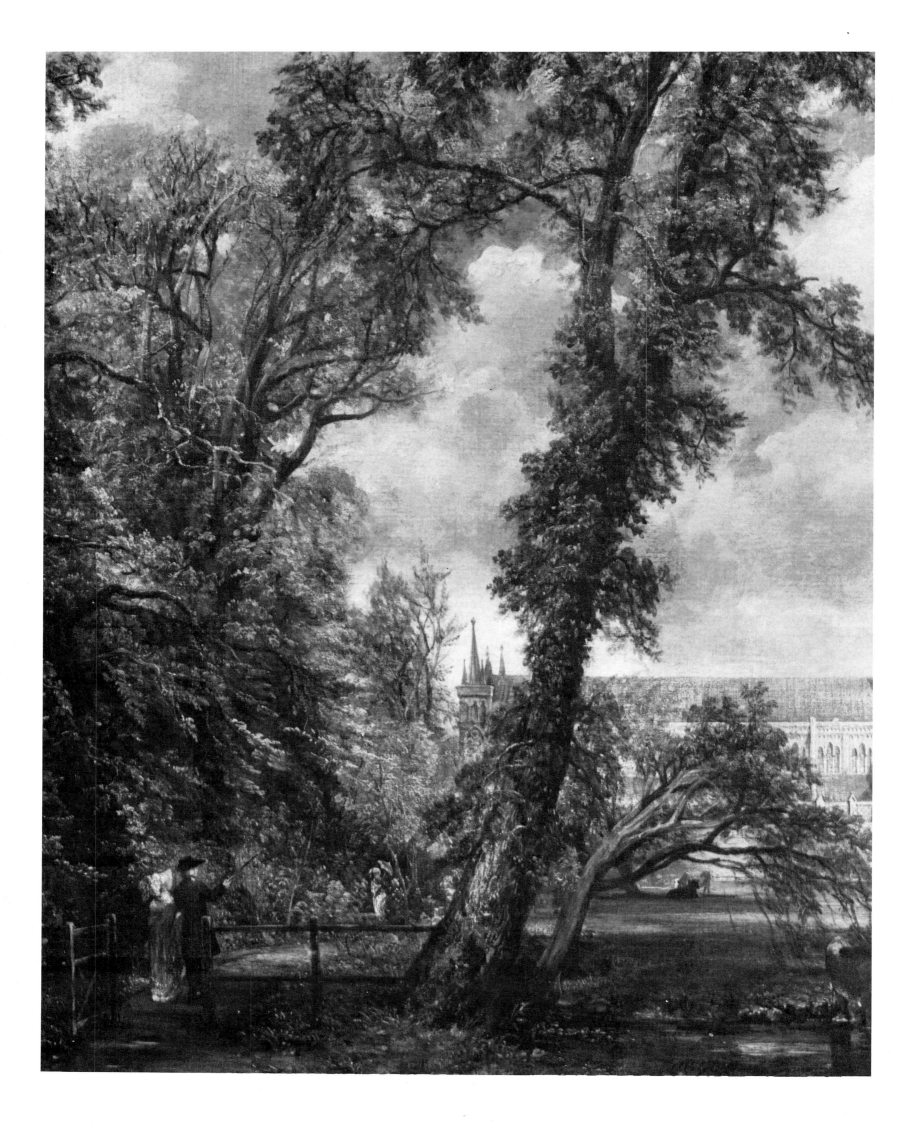

CONSTABLE

Malcolm Cormack

PHAIDON · OXFORD

To Lynn

Acknowledgements

140, Copyright reserved to H.M. Queen Elizabeth II; 43, 82, 131, By permission of C. A. Brooks of Dedham; 80, Photo: West Park Studios, Leeds; 203, By Courtesy of Thos. Agnew & Sons Ltd., London; 144, 191, Bridgeman Art Library, London; 38, 64, 161, 162, 197, 211, 221, Reproduced by courtesy of the Trustees of the British Museum, London; 25, 113, Photo: Courtauld Institute of Art, London; 189, By Courtesy of Oscar and Peter Johnson Ltd., London, (Ekta, Christie's); 14, 20, 23, 29, 31, 32, 36, 37, 42, 45, 57, 59, 61, 63, 68, 69, 70, 72, 73, 74, 76, 81, 83, 85, 86, 99, 101, 108, 109, 116, 119, 128, 129, 130, 141, 149, 156, 164, 166, 175, 177, 184, 185, 194, 198, 199, 204, 207, 208, 214, 215, 216, 218, 219, 220, 222, 224, 225, 226, By Courtesy of the Board of Trustees of the Victoria and Albert Museum, London; 192, Reproduced by permission of the Trustees of the Wallace Collection, London; 107, Copyright The Frick Collection, New York.

Phaidon Press Limited, Littlegate House, St Ebbe's Street, Oxford, OX1 1SQ

First published 1986
© Phaidon Press Limited 1986

British Library Cataloguing in Publication Data

Cormack, Malcolm
 Constable.
 1. Constable, John, *1776–1837*
 I. Title. II. Constable, John, *1776–1837*
 759.2 ND497.C7

 ISBN 0–7148–2350–3

Filmset in 11 pt. Garamond by Clark Constable, Edinburgh and London
Printed in Spain by Heraclio Fournier SA, Vitoria

Frontispiece. Detail from *Salisbury Cathedral from the Bishop's Grounds* (Plate 119).

Contents

Acknowledgements

All who work on Constable are indebted to the late R.B. Beckett's edition of the correspondence. I am also particularly grateful to Graham Reynolds, Charles Rhyne, Reg Gadney, Louis Hawes, Michael Rosenthal, Lt. Col. Attfield Brooks, Ian Fleming-Williams, and Leslie Parris, for help concerning Constable. Duncan Robinson has been kind over the writing of the book, and Joy Pepe has worked industriously to prepare the manuscript.

Introduction

Constable is one of England's greatest artists and his most famous pictures, such as *The Haywain* and *The Cornfield*, have become known through constant reproduction the world over. They seem to embody an ideal of naturalistic landscape that is immediately accessible and to which we know he devoted himself singlemindedly. He is also acknowledged to be a fundamental member of the Romantic Movement, although his position within it is not easily defined, and since in his own day landscape painting was not considered of the highest importance contemporary criticism of his work was by no means unanimous about his merits. He attained professional success slowly, in contrast to his precocious contemporary, Turner. Nevertheless, our ideas of realism and what constitutes naturalism have been subject to change ever since he painted, and his contribution to this development of perception cannot be ignored.

The time is now ripe for a synthesis that can give a wide view of Constable's endeavours, one which reveals his art to be a deeply thoughtful and individual commentary, not only on the art of landscape in general, but also on the social and intellectual history of his times. There is enough evidence for this without recourse to inexact historical speculation or the invention of false sentiment. Constable was not the helpless victim of his own times, without motivation and independent aims.

Much can be made, for example, of his original attempts to be scientific, whether in his reaction to the transitory effects of nature, in particular of the weather, or in his approach to the optical problems of colour. In these aspects of his art he can be compared to other Romantic artists, notably Turner, but it must be emphasized that it was from Constable that Delacroix learned and transmitted so much to the next generation in France.

In his methodical approach Constable frequently used drawings, and a careful study of them, which has occurred only recently, tells us much about his working methods. He did not entirely abandon a due deference to the artists of the past, who drew for the careful creation of a finished masterpiece. He was a Romantic, however, in the way he made use of his drawings. They were brought together over a period of time. They were both exact and vague. They dealt with the minutiae of natural

fact and unfashionable lowly subject matter, in itself a Romantic trait, but they also embodied draughts for grander designs. They were used as the occasion demanded, so that Constable showed not only an eighteenth-century virtuosity but also a nineteenth-century richness of personal imagination.

His scientific attitude to facts; his use of preparatory drawings; his belief in the power of the individual imagination; and, especially, his choice of subject matter were all part of the Romantic Movement, and the present study sees them as essential to the understanding of his art. When towards the end of his life, he attempted to sum up his artistic aims in the form of a carefully selected series of mezzotint prints after his pictures, known as the *English Landscape Scenery*, he noted as his immediate aim, 'to increase the interest for, and promote the study of, the Rural Scenery of England with all its endearing associations, its amenities, and even its most simple localities; abounding as it does in grandeur, and every description of Pastoral Beauty'. In this he was exploring new territory for artists and writers, but he was not alone during the Romantic Period. John Clare, the rural poet, thought that the finest achievements of Peter De Wint's art were his sketches from nature, done without 'touches of fancies and vagaries'. Nature to him appeared best 'in every day dessabille — in fact she is a Lady that never needed Sunday or holiday Cloaths' (Letter to De Wint of 1829).

Constable's life's work, particularly 'to make something out of nothing', as he described it, can be compared with masterpieces from other arts of the period. His object was, as Coleridge described Wordsworth's poetry of the *Lyrical Ballads*, 'to give the charm of novelty to things of everyday' and to direct the mind 'to the loveliness and the wonders of the world before us'. As with Wordsworth, Constable deliberately chose humble subjects but like Wordsworth's *Prelude*, Constable's works are immediate and yet transcend their own particular background. They say something equally personal to each generation but remain timeless and of fresh inspiration. In his *Landscape Scenery* he stressed that

In some of these subjects of Landscape an attempt has been made to arrest the more abrupt and transient appearances of

the CHIAR'OSCURO IN NATURE; to show its effect in the most striking manner, to give 'to one brief moment caught from fleeting time', a lasting and sober existence, and to render permanent many of those splendid but evanescent Exhibitions, which are ever occurring in the endless varieties of Nature, in her external changes.

This book shows how he went about this difficult task.

Chapter I

'I associate my "careless boyhood" to all that lies on the banks of the Stour'

Towards the end of his life, Constable selected a view of the house where he was born at East Bergholt, in Suffolk, as a frontispiece for *English Landscape Scenery*, a series of prints after his paintings, that would introduce his life's work to the public. Accompanying the plate was a significant Latin inscription, which emphasized that the place had brought him his greatest happiness, had first imbued him with a sense of art and was the origin of his fame (Plate 1).[1] To these elegant pieties he added the quotation, 'Fond Recollections round thy memory twine'. His home, his surroundings in East Bergholt and his relationship to the countryside of the Stour valley in Suffolk and Essex obviously meant much to him in the development of his art.

'I should paint my own places best,' he wrote in 1821, to his friend Fisher.[2] 'I associate my "careless boyhood" to all that lies on the banks of the Stour. They made me a painter (and I am grateful!) that is I had often thought of pictures of them before I had ever touched a pencil.' Both Constable's attachment to the places he knew best and the direct and constant interaction between the circumstances of his life and the creation of his art are the strongest of all artists, save, perhaps Cézanne. There is thus a great justification for intermingling a description of his art with the details of his life, rather than for carefully separating them — a procedure that criticism has generally demanded for other artists.

Even during his lifetime the connection between his homeland and his art was noticed. In 1832 he wrote to his engraver, David Lucas: 'In the coach yesterday coming from Suffolk were two gentlemen and myself, all strangers to each other. In passing through the valley about Dedham, one of them remarked to me — on my saying it was beautifull — "Yes Sir — this is *Constable's* country!" I then told him who I was lest he should spoil it.'[3] (Plate 2)

His first biographer, C.R. Leslie, followed Constable's example in the opening paragraphs of his classic *Life*, when he deliberately emphasized Constable's background by quoting Constable's text that accompanied the frontispiece for the *English Landscape Scenery*.[4]

East Bergholt, or as its Saxon derivation implies, 'Wooded Hill', is thus mentioned in 'The Beauties of England and Wales':– 'south of the church is "Old Hall", the Manor House, the seat of Peter Godfrey, Esq., which, with the residences of the rector, the Reverend Dr. Rhudde, Mrs. Roberts, and Golding Constable, Esq., give this place an appearance far superior to that of most villages.

Constable was setting the scene (Plate 3) and resurrecting the names of people — all dead, except the squire, by 1832 — who had had an important influence on the principal events of his life. He proudly went on to describe the place, the source of his art:

It is pleasantly situated in the most cultivated part of Suffolk, on a spot which overlooks the fertile valley of the Stour, which river divides that country on the South from Essex. The beauty of the surrounding scenery, the gentle declivities, the luxuriant meadow flats sprinkled with flocks and herds, and well cultivated uplands, the woods and rivers, the numerous scattered villages and churches, with farms and picturesque cottages, all impart to this particular spot an amenity and elegance hardly anywhere else to be found; and which has always caused it to be admired by all persons of taste, who have been lovers of Painting, and who can feel a pleasure in its pursuit when united with the contemplation of Nature.

His discussion reads as if it was taken from a guidebook. Constable drew a diagram of the valley's character (Plate 4), with the river meandering gently among the low hills towards the estuary and the sea, for his engraver David Lucas in 1830. His awareness of the obsessive attachment that all Suffolk dwellers were supposed to have to their birthplace can be recognized from his story, which Lucas inscribed on the *verso* of the sheet, 'of a farm laborer who was in quest of work who after crossing the valley on to the Essex side being about to descend the rising ground looking back said, "Goodbye Old England perhaps I may never see you any more." '[5]

Lest his readers should not agree that the Stour valley was a suitable place to paint, Constable, admitting he was guilty of 'an over-weening affection for these scenes', was keen to point out in his Preface that such well known patrons of painting as

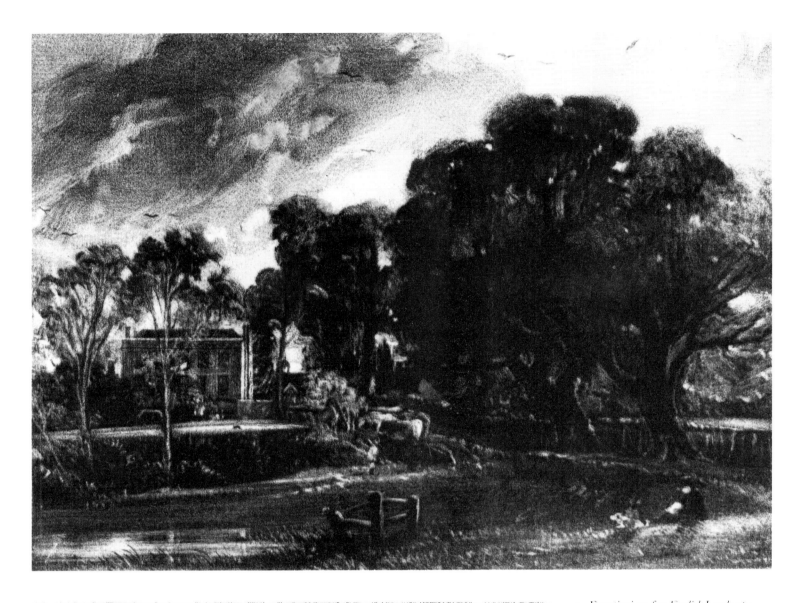

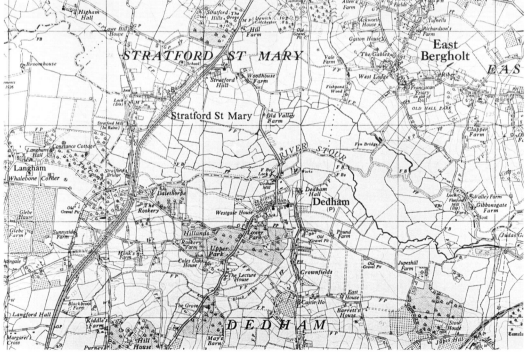

1. Frontispiece for *English Landscape Scenery*. 1832. Mezzotint, engraved by David Lucas. New Haven, Yale Center for British Art, Paul Mellon Collection

2. Map of the Stour Valley around East Bergholt. Sheet TM03 of the Ordnance Survey 1:25000 First Series

3. Enclosure Map of East Bergholt.
1817. Suffolk Record Office

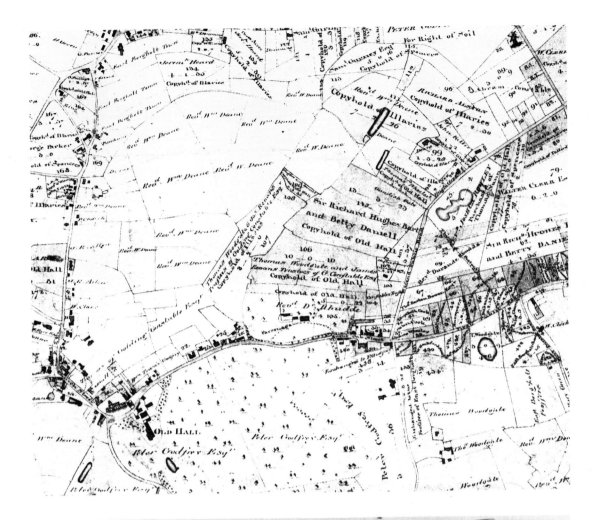

4. *A Diagram of the Stour Valley.*
1830. Pen, brown ink and wash,
11.2 × 18.4 cm. Cambridge,
Fitzwilliam Museum

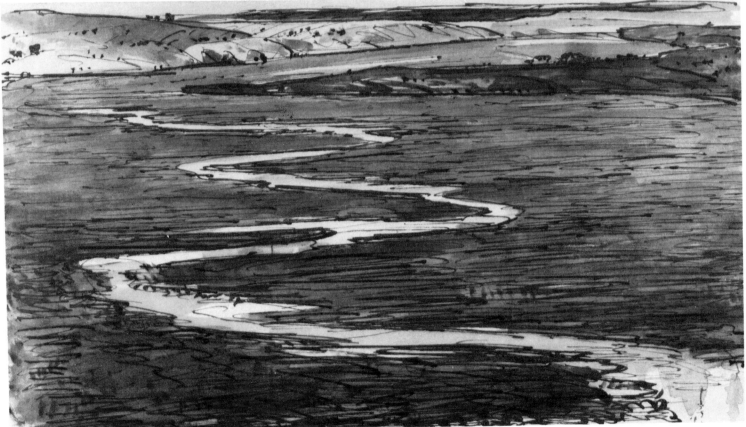

the late Dr John Fisher, the Bishop of Salisbury, and the late Sir George Beaumont, had close attachments to Dedham. When Joseph Farington, RA, the diarist, who was so helpful to Constable, visited the area in 1794 he described it equally favourably: 'The country about Dedham presents a rich English landscape, the distance towards Harwich particularly beautiful.'[6] It was also, as Constable and others remarked, an extremely fertile and prosperous farming area.[7] Its neat and tidy air still proves an attraction.

Yet, apart from Gainsborough, no outstanding artist had painted in these parts. It was, perhaps, too well cared for to be suitable for excursions in search of the Picturesque, which had become fashionable by 1800.[8] Wales, the Peak District, the Lake District and Scotland were more popular, where artists were caricatured travelling with considerable hardship through the mountains in the rain.[9] The Reverend Dr Gilpin hardly mentioned Suffolk in his indefatigable tours.[10] Constable, in fact, visited the Peak District and the Lake District but never returned to them. While he admitted that they were suitable for grand and solemn effects, he complained that 'the solitude of mountains oppressed his spirits.' He 'could not feel satisfied', Leslie thought, 'with scenery, however grand in itself, that did not abound in human associations.'[11] Constable, unlike his great contemporary, Turner, was not a constant traveller in search of views. He never went abroad, even when he had been awarded a gold medal at the Paris Salon of 1824.

The locality, with very little waste land, had none of the craggy awfulness of the sublime — the highest point is only 150 feet above sea level — and it had too much of the lowly 'rural picturesque' for artistic respectability. It was, perhaps, the well tended nature of its views that satisfied Constable and into which his family fitted so well. From it and his comfortable family circumstances he gained early encouragement and patronage, in the form of local commissions, and these practical circumstances formed a secure base for the development of his art. Details of his local background, however, are of more than passing interest. He was proud of his upbringing as a country man and dismissive of those whom he felt were ignorant of the true realities of the countryside and nature. He thought the French artists, for example, 'know about as much of *nature* as a *"hackney coach horse does of pasture"*'.[12] He was praised several times for the accuracy of his local detail. His younger brother, Abram, told C.R. Leslie that 'When I look at a mill painted by John, I see that it will *go round*, which is not always the case with those by other artists.'[13] Leslie also relates the anecdote of Samuel Strowger, a Suffolk man, who was Porter and occasional model at the Royal Academy, telling Constable that 'Our gentlemen are all great artists, Sir, but they none of them know anything about the lord.' The *lord* was a Suffolk term for the chief reaper in a cornfield, who had appeared in one of Constable's pictures.

Because recent criticism has argued that Constable's later pictures of local scenes are expressions of a romantic and backward-looking view — 'a complacent vision' it has been called — of a countryside that it has been claimed was by the 1820s beset by change and disorder, his social background needs to be examined in great detail. Similarly, because his states of mind and his relationship to the countryside have

been cited as evidence for a psychological interpretation of his art we need to examine what his relationship to the landscape was to see whether these judgements have any basis (or whether they are purely speculative and reveal more about the critic). Psychoanalysing an artist after an interval of 150 years, even with considerable evidence, is a brave undertaking, and we should be cautious not to read too much into the bumps of the Stour and the hollows of Hampstead Heath. In examining the complexities of Constable's landscape we should be aware that he was a deeply sophisticated observer of real and painted nature, of which his home background was but one important part.

He was born on 11 June 1776 at East Bergholt in Suffolk and was apparently lucky to survive. An old friend of his father's, the Reverend Walter Wren Driffield, who lived in East Bergholt (although his living was actually at Southchurch in Essex, near Hadleigh Castle) had to be summoned hastily, 'to go in the night over the Heath to make a Christian of me at a cottage where I was dying when I was an infant'.[14] Many years later, when Constable came to paint his large emotional work of Hadleigh Castle, perhaps some memory of Driffield's dramatic start to his life and the christening, which gave him the faith to withstand the death of his wife, helped to choose that particular subject, taken from his original drawing of 1814.

In spite of family legends to the contrary, Constable's ancestors were from Suffolk and Essex, his great grandfather Hugh Constable died at Bures St Mary.[15] It is to one of Hugh's sons, Abram, that the Constable family owed its position. Constable's father, Golding (1739–1816; Plate 5), inherited from his uncle Abram (d. 1764) a thriving business as a corn factor in the City of London, as well as cash and property in and around East Bergholt, such as the tenancy and the corn milling business of Flatford Mill on the Stour.[16] The Constable family first lived in the houses attached to the water mill until Golding, becoming more and more prosperous, built the three-storeyed brick mansion known as East Bergholt House (Plate 59), already mentioned as the frontispiece to Constable's series of prints. This was the family home from around the time of Constable's birth to the time it was sold in 1816. Golding had previously acquired a partnership in the larger corn mill at Dedham and a windmill at East Bergholt. As well as other land, he also had two yards on the quay side at Mistley at the estuary of the Stour, river barges, and a boat to move his grain to London. He was made a member of the Stour Navigation Commission, the river on which his barges plied, in 1781.

By 1785 he was described by another miller from East Maldon, Essex, 'as a man of fortune' who 'lives in the style of a country squire'.[17] His business had expanded enough by 1797 to mark the launching of his new corn ship, *The Telegraph*, by 'a handsome entertainment at the Crown Inn' for 'an immense concourse of people', as the local paper described it, 'where many loyal, constitutional and commercial toasts ... were drank'.[18] By 1800 he employed a liveried servant, gardeners, millers, a cook and other domestics, as well as a loyal manager for his business affairs, James Revans, who was buried next to him in the East Bergholt churchyard. There were also

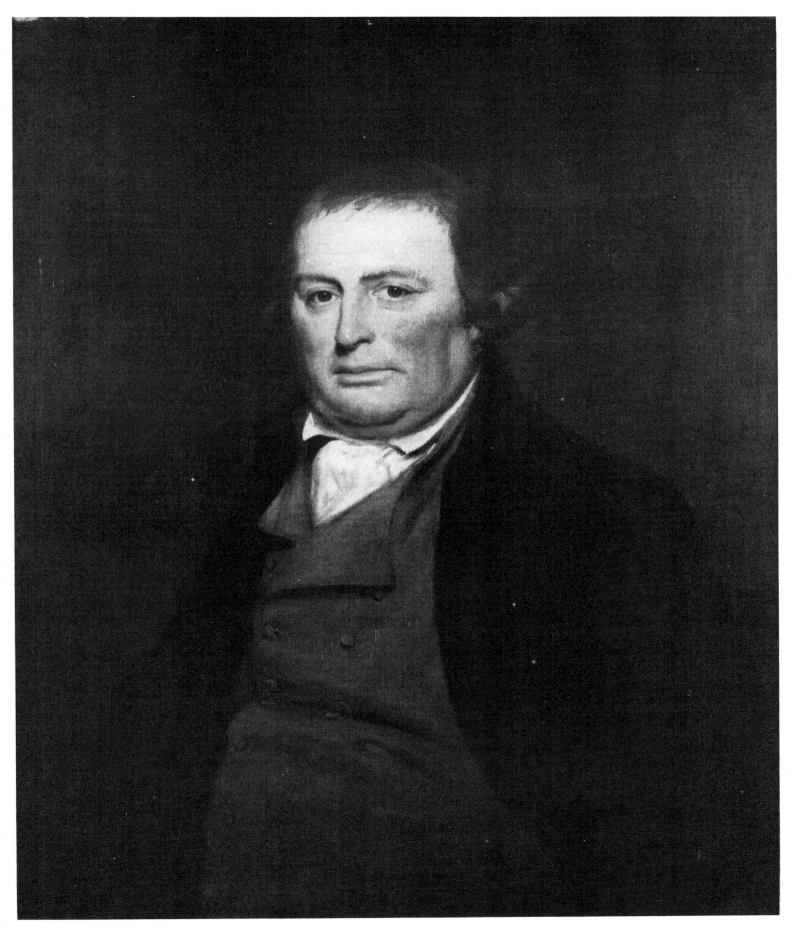

5. *Golding Constable, the Painter's Father*. 1815. Oil on canvas, 75.6 × 62.9 cm. Family collection, Mrs E. Constable

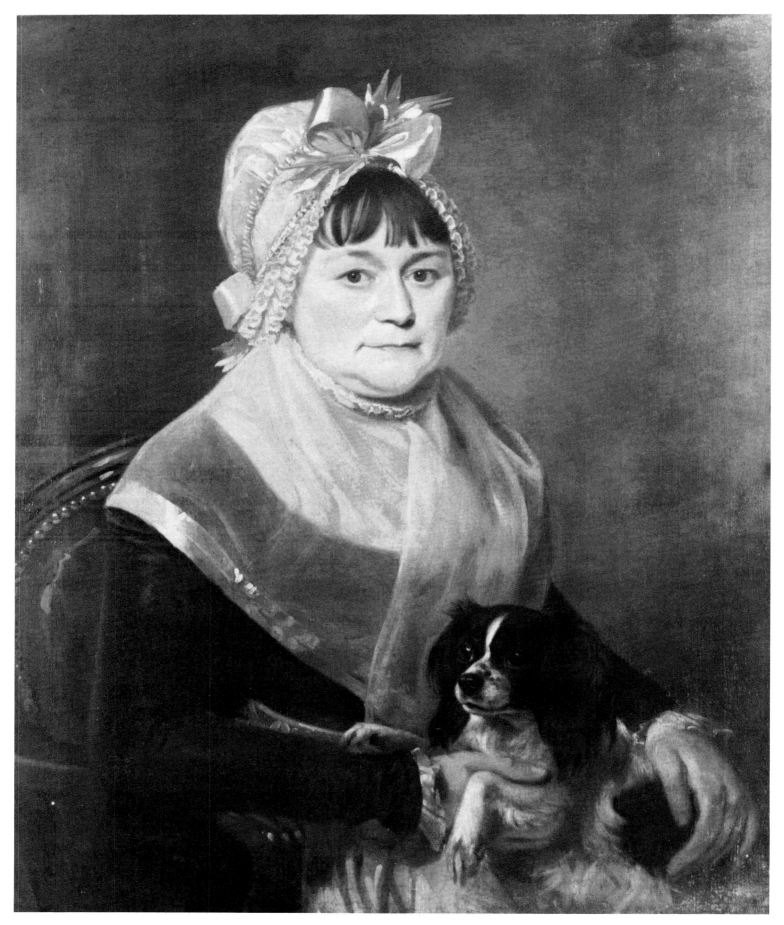

6. *Ann Constable, the Painter's Mother. c.* 1801. Oil on canvas, 76.2 × 88.9 cm. Family collection, Mrs E. Constable

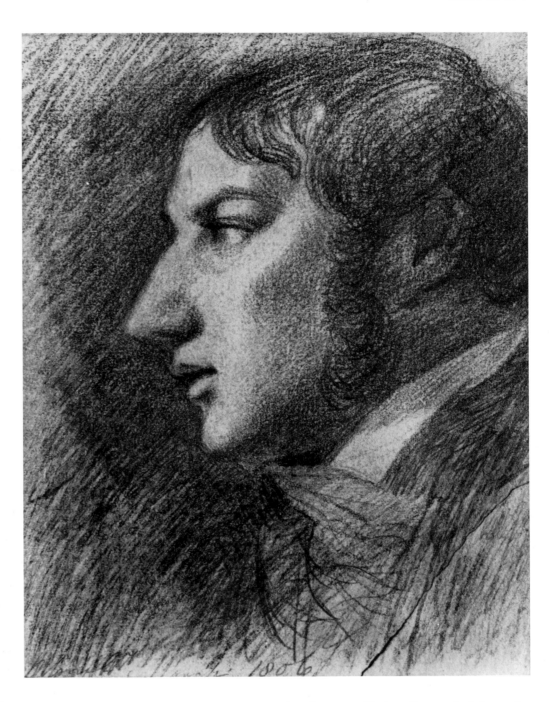

7. *Self Portrait*. 1806. Pencil, 18.4 × 14 cm.
Family collection, Mrs E. Constable

bargemen and crew for his ships.[19] When Golding died in
1816, the estate comprised, in addition to the property, thirty-
seven acres of pasture and arable land in East Bergholt, as well
as land at Brantham and Walton in Suffolk, and at Harwich and
Dedham in Essex. The estate was valued at £13,000, which
could be reckoned as nearly £800,000 in 1985 terms.[20]
Constable received his share. He had been receiving £100 a
year to live on as a painter but could then hope for as much as
£400, or what it would cost to live like a gentleman when he
married in 1816.

Golding Constable had married in 1767, Ann Watts of
London (Plate 6), whose brother, David Pike Watts, a rich
business man, watched over the beginning of Constable's
career. Golding and Ann Constable had a family of six, of
which John was the fourth born. The eldest was Ann, next was
Martha, who married Nathaniel Whalley, and next Golding

Junior, who proved to be mentally handicapped. John, who
should have taken over the family business, preferred to
become a painter. The fifth child was Mary and it was the last,
Abram, who managed the business for the rest of the family on
the death of their father (Plates 7, 8 and 9).

This was the family background.[21] It is clearly too simple to
call John a miller's son. He was still a landowner in the village
when he went there to vote in 1835. The family had a particular
position in the community to keep up, with a complicated
'pecking order' in its relations with the neighbouring gentry,
who are the principal characters mentioned in Constable's
Preface to *English Landscape Scenery*. There was the wealthy and
powerful rector, the Revd. Dr Durand Rhudde, who had such
a baneful influence on Constable's life; the squire, Peter
Godfrey, of Old Hall, East Bergholt, who took a kindly
interest in his activities and commissioned works from him;

Mrs Roberts, in whose fields he painted; and grander neighbours, such as Sir George Beaumont, Bt., and Wilbraham, the 6th Earl of Dysart.

Sir George Beaumont was a regular visitor to his mother, the Dowager Lady Beaumont, in Dedham from 1787 and probably met Constable for the first time in 1795.[22] He became, perhaps, Constable's most important mentor but it was not until 1823 that Constable felt able to lose 'all uncomfortable reserve and restraint'. The Earl of Dysart, Magdalene, the Dowager Countess, widow of the 5th Earl, and Lady Louisa Manners, who became the Countess of Dysart in her own right on the death of her brother in 1821, had estates at Helmingham, where Constable drew in the park in 1801, woods around Bentley, Ham House, and other properties in London. Constable owed his relationship to the Earl through what his sister Mary described as 'a friendly introduction' of Peter Firmin, a Dedham lawyer in 1807. Constable was first employed to make copies after versions of the Earl's portraits but later, in 1825, when his handicapped brother, Golding, was given the job of warden of the woods at Bentley, he found himself trusted to intervene in business matters on the Countess's behalf. There were other local patrons, too, who will be mentioned later, but it is clear that codes of behaviour had to be observed with all of them, caused by the Constable family's position in the village and the fact that their son was a painter. It was a difficult position, to which neither Constable nor his family was always reconciled.

There were, of course, other relationships with which the family were involved. At the lower end of the social scale were the workers, who appear in Constable's pictures surrounded by scenes of agricultural prosperity, to which they contributed and from which the Constable family benefited. As will be shown later, these figures never appear without good reason in the man-made landscape that Constable habitually painted; indeed, Constable has been much maligned for their inclusion. They are of their time and class. They are not dressed in Arcadian robes and idealized. They do not seem to be boorish nor downtrodden. They go about their business with the minimum of commentary, neither sentimentalized nor satirized. There is, perhaps, some affection for the boys who appear so frequently, found on the horse in *Flatford Mill* (Plate 95), or in *The Leaping Horse*, or fishing in *Stratford Mill*, or raising his rod out of the undergrowth across the water in *The Hay Wain*, or slaking his thirst at the side of the lane in *The Cornfield*, but Constable was a fond family man, and too much need not be seen in this.

The early nineteenth century was, nevertheless, a period of change in the countryside, which was not always peaceful. There was unrest, particularly in the 1820s, all over the country, and Suffolk was no exception. John Constable wrote to his friend John Fisher on 13 April 1822, reporting what he had heard from Suffolk:

My brother is uncomfortable about the state of things in Suffolk. They are as bad as Ireland — 'never a night without seeing fires near or at a distance', The Rector and his brother the Squire (Rowley and Godfrey) have forsaken the village — no abatement of tithes or rents — four of Sir William

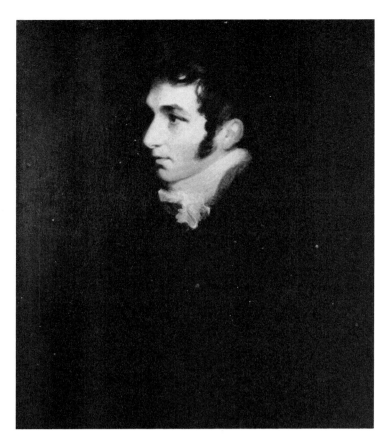

8. *Abram Constable, the Painter's Brother. c.* 1806. Oil on canvas, 76.2 × 63.5 cm. Ipswich Museums and Galleries

Rush's tenants distrained next parish — These things are ill timed.[23]

Constable disapproved of this violence but the implication of the letter is that he equally disapproved of landowners abandoning their responsibilities and behaving harshly and uncharitably towards their tenants. He was very much a conservative in politics, as was his sister Mary, but he and his family had a good record of dealing well with their workers and their kindness was repaid by a lifetime of loyalty.[24] David Lucas told a story that the painter had obviously told him about his father:

He was kind and considerate with his servants ... A bargeman living in one of his cottages he wishes to remove him further. For some time he could not get the man to stir or give a reason for his refusal to do so. At last the man said, 'If I remove from this place I shall never be able to shave again.' This singular remark excited Mr. Constable's curiosity exceedingly. On further enquiry the man said he had for many years on the Sunday sharpened his razor on top of the stairs and could not do without it. 'Well', said his master, 'if that is the only reason my carpenter shall take up the step for you to carry with you and the stairs too if you want them.'[25]

Constable's sister was a 'true blue' in her feeling for acquiring land, when she wrote to her brother in November 1834 from Flatford: 'A.C. can tell you all about "the land" — *one meadow*

9. *Ann and Mary Constable, the Painter's Sisters. c.* 1819 (after an original of *c.* 1814). Oil on canvas, 38.1 × 29.2 cm. San Marino, California, Henry E. Huntington Library and Art Gallery

only which is over the Bridge, & is opposite (as you know) to this house, from the Brook four or five fields up to the Dedham Mill — & this spot is nearly all that remains around these Mills which is not *"Whig" property*.'[26] She had, like her brother, a proper paternalistic recognition of loyalty: 'My father's men were picked men, not men of wood,'[27] she declared, and the family, including Constable, made it their business to keep in touch with retired workers and distribute presents to them when they retired or at holidays. They felt that everyone should know their place, as they knew theirs, and that everyone should remain satisfied with their lot in life. His mother quoted with approval a sermon by Dr Rhudde in November 1811, 'that men would be wise that they would consider their latter end ... in consequence of the untimely exit of poor Joseph Lott', who had been thrown from his gig, 'I have a terror at gigs — they are by no means a vehicle for the aged — his age 75.'[28]

Given the social situation in and around East Bergholt, hers was not an uncommon attitude. Suffolk and Essex were prosperous farming communities, which had by 1800 long been enclosed. The regular pattern of fields and hedgerows was well established.[29] The social upheavals due to enclosures, which were recorded with such sadness in the poetry of John Clare, were largely a thing of the past in Suffolk when Constable began painting.[30] The fertility of the soil, the balance of arable and pasture land had meant there was little dispute over grazing rights on common land, which caused hardship elsewhere.[31] There was very little change from 1731 to 1815 when the only enclosure act of the early nineteenth century in East Bergholt brought into the Constable family the last small area of common land. This is shown being ploughed for the first time in Constable's picture *Spring Ploughing*, possibly dating from the following year, 1816 or 1821.[32] Dedham was fully enclosed by 1805. The general prosperity of the area had undoubtedly been aided by the fact that the River Stour had been a navigable canal since the seventeenth century.[33] It provided regular work and service industries to move the grain and other commodities for which there was so much demand during the Napoleonic Wars.

There was unrest in the 1820s, but the difficulties that affected the labouring classes were less to do with the effects of enclosure — agriculture, the river, the woods and estates, had long provided a varied series of jobs — than with the overall social changes that affected everyone, the Constable family included.[34] Between 1800 and 1831, the population of Dedham increased by 15%, in East Bergholt by 40.2%, only to fall with the widespread agricultural poverty at the end of the nineteenth century.[35] Whereas the cost of wheat rose dramatically by as much as 52% during the Napoleonic Wars when England was closed to cheap imports, which undoubtedly benefited Golding Constable's milling business, the cost declined thereafter, equally dramatically, by 44% and as Abram remarked to his brother in January, 1821: 'Trade is in a bad state just now, & will continue so I fear, there is little profit attach'd to the Milling business now, it is so over done but if I can keep on till times mend, I shall hope to get on when opportunity occurs.' He went on with a countryside stoicism, 'My father had sad times to contend with, in early life, he got through & so may I.'[36]

Meanwhile, the cost of a quartern (4 lb.) loaf of bread increased by 59%, rents per acre of land rose by 38% from 1800 to 1815 and dramatically by 107% between 1815 and 1820. This affected the Constable business in all ways. They were tenants and also owned land but their labourers' wages only increased by 10%. There was clearly distress for the workers who had increased in numbers and whose food cost more but whose wages and the amount of common land available to them had not risen. It was, however, equally hard for tenant farmers, millers and merchants, which the Constable business combined. They paid more for labour and received less for wheat. As has been suggested elsewhere, the explanation for rural poverty lay 'less in enclosure than in the growth of population ... a permanent superfluity of able bodied labour.'[37] Of course, the Constable family were protected from the difficulties of their workers, and by the 1830s, when John's pictures were at their most disturbed, his personal circumstances had much improved, as the family business flourished and he had money to invest in a farm and land.[38] If his pictures did not reflect the social unrest, he was not unaware of the social circumstances. His family correspondence shows that he was well aware of all the details of local life but, in the last resort, his art had different preoccupations.

In fact, the appearance of the Suffolk countryside around East Bergholt changed very little. Even today the field patterns have largely remained undisturbed. Only the barge traffic on the river and the commerce at the mills have ceased to exist. John Stollery of East Bergholt may have been sent to Ipswich Gaol for stealing a pig or Mary Constable's new house at Flatford may have been broken into and their father's watch stolen from the bedhead, but Constable was not likely to paint a propaganda tract against Thievery.[39] His concern with the details of natural appearance and the act of translating these observations into paint caused him problems enough. His anguish was personal and was as much concerned with his own family's affairs or with his reception as an artist: 'The feild [*sic*] of Waterloo is a feild of mercy to ours', he wrote to Fisher in 1823.[40] The Valley of the River Stour was his major interest. On it the prosperity of the family depended. On the river plied the family's barges, which carried the grain, grown and milled in the family's mills, to the family's dock at Mistley, thence to be transported to the family's ship to London, which returned with coal to be sold locally. The pattern of the fields and the interactions of this commerce with nature were the objects of close observation and the subjects of his most important pictures throughout his life. They gave his art its special character.

Chapter 2

'I fancy I see a Gainsborough in every hedge and hollow tree'

The beginnings of Constable's career as an artist were not easy and he was a slow developer. He was not outstanding at school, neither first at a nearby small school in Essex, nor later at Lavenham, where the pupils were neglected by the master and beaten by the usher. He was then moved to the nearby Elizabethan Grammar School at Dedham, and walked to it from East Bergholt down the lane that appears in *The Cornfield* (Plate 169) and over the River Stour by a footbridge, but as Leslie pointed out 'he was not remarkable for proficiency in his studies'.[1] He learnt some Latin but not much French. His wife later had to translate the reviews when his pictures were shown in France. Though his spelling remained erratic throughout his life, he was, however, well read, through a desire for self improvement. His knowledge of and memory for poetry, ancient and modern, were always good and his library eventually was extensive. The headmaster at Dedham, the Revd. Thomas Letchmere Grimwood, is remembered for his tolerance of Constable's early desire to become an artist. A copy of a print exists, apparently drawn when Constable was 13, and in 1792 aged 16 he carved the outline of a windmill on the timbers of his father's mill at East Bergholt (the fragments of which are now in The Minories at Colchester).

This windmill is where Constable was first sent to work at about the age of 17. Golding Constable wanted his son to go into the church, but seeing that Constable was not inclined towards an academic career and unwilling at first to allow him to study art full-time, Golding Constable took him into the family business. Leslie relates that Constable was known locally as the 'handsome miller', and he was employed by his father, in various capacities, for at least six years. Although his heart was not in his work, the knowledge of the changeability of the weather he gained by working in the windmill was later put to good use. 'The natural history of the skies', as he called it, was to be an abiding interest, and Leslie drew attention to Constable's description of clouds on a bright and silvery spring day in his letterpress for *Spring* (Plate 186). The title was given to the mezzotint after his sketch for *Spring Ploughing, East Bergholt* (Plate 185), where this particular windmill appears. Indeed, as Constable later remarked about his own country scenes, echoing Gainsborough, 'I had often thought of pictures of them before I had ever touched a

pencil.'[2] In a small way he had already begun.

He had become a friend of the local plumber and glazier, John Dunthorne, who lived in the village close to the Constable family house, and whose son was later Constable's assistant in his studio, preparing his canvases and involved with painting the versions of his pictures that had been ordered. John Dunthorne, senior, in the patronizing words of Leslie, 'possessed more intelligence than is often found in the class of life to which he belonged'.[3] He was also an atheist, which did not endear him to the Constable family. Nevertheless, he and Constable went painting together in the fields around East Bergholt. According to Lucas, they painted one view for only a certain time each day. When the position of shadows from objects had changed the sketching was postponed until the same hour the following day. When they returned at the end of the day, Golding Constable apparently remarked, 'Here comes Don Quixote with his man Friday!'[4] Golding seems to have tolerated his son's endeavours but the implication by Lucas that Constable's early practice was to sketch *en plein air* is not borne out by the results of his earliest surviving drawings.

What was equally important to him, apart from his overriding desire to become an artist, was contact with two very different figures who could introduce him to the real art world beyond the confines of Suffolk. They were Sir George Beaumont, Bt. (1753–1827), and John Thomas 'Antiquity' Smith (1766–1833).[5] Sir George was a distinguished connoisseur who owned outstanding works of art, a prolific amateur artist, and already had a reputation in the mid 1790s as a patron of young artists. He had been taught at Eton by Alexander Cozens (c. 1717–86) and having been a companion in 1782 of Alexander's son, John Robert Cozens (1752–97) on a tour to Italy, supported him during his last illness. Beaumont had been taught at Oxford by the German-born John 'Baptist' Malchair (1731–1812), but even before going up to college he had become friendly with Richard Wilson's engraver, William Woollett (1735–85), and the topographical watercolourist, Thomas Hearne (1744–1806). As an undergraduate Beaumont had met Thomas Jones (1742–1803), one of Wilson's pupils, and was to become friendly with Joseph Farington RA (1747–1821), another pupil of Wilson's. Farington's abilities as

10. Sir George Beaumont, Bt (1753–1827). *A View of Conway Castle*. 1809. Oil on board, New Haven, Yale Center for British Art, Paul Mellon Collection

a topographical painter were, perhaps, less important than his influence as a politician within the Academy and his activities as a diarist. There we read how Farington and Beaumont supported Constable. In addition, Beaumont had made the acquaintance of J.C. Ibbetson and Jacob More, had portraits of himself and his first wife painted by Reynolds, and his dogs by Gainsborough. He was thus in contact with every aspect of painting in England and, particularly, with the existing tradition of landscape as expressed by its leading practitioners.

Above all, Beaumont valued his friendship with Reynolds, the first President of the Royal Academy, who dined regularly at Sir George's London home in Grosvenor Square at the end of his life. In the spirit of classical piety, Sir George erected a cenotaph in 1812 to Sir Joshua's memory in the grounds of his Leicestershire estate at Coleorton, inscribed with a eulogy written by Wordsworth, whose friendship since 1803 was 'amongst the prime blessings of [his] life'. He also erected a memorial stone to Richard Wilson in his grounds. Reynolds and Wilson were his heroes and, in 1815, Farington reported that Beaumont 'wished that the Painters of the present time would look at and study the pictures of Sir Joshua Reynolds and Richard Wilson in which they would find true art of the first character'.[6] Beaumont's veneration for these two artists, and the academic principles of Reynolds, never abated. His own art certainly reveals the influence of Wilson and, occa-

sionally, Cozens (Plate 10). His later activities as a Director of the British Institution and his successful efforts towards the foundation of the National Gallery are indicative of the emphasis he placed on the art of the past, for which he was sometimes criticized. It is not surprising, therefore, that Constable, equally, had a life-long admiration for Reynolds and all that he stood for. He was to draw the two monuments to Wilson and Reynolds in the grounds of Coleorton in 1823, and from the last study made an affecting painting, in which he commemorated together the memory of Sir Joshua Reynolds and Sir George Beaumont. It was exhibited at the Royal Academy in 1836, the year before Constable died (Plate 223).

When Constable's mother gained him an introduction to Sir George, sometime in 1795, there can have been a no more significant and kindly a figure in the art world for him to meet. It was not only for what Beaumont knew but also what he possessed that was important for the young artist. Chief among his collection of old and modern masters in the 1790s were his paintings by Claude Lorrain. He was so much attached to his *Hagar and the Angel* (Plate 34) that he carried it everywhere in his carriage. He had become a regular visitor to the Stour Valley to see his widowed mother, who then lived in Dedham, and he was shown copies that Constable had made that year, 1795, of Nicholas Dorigny's engravings after Raphael. There were three, of which one, *Christ's Charge to Peter* (Plate 11), still exists, the earliest signed and dated drawing by Constable to survive. It is a painstaking and worthy exercise in pen and wash and reminds us how important copying from works of art was, as part of an artist's education. As late as 1823, Constable produced near facsimile copies after Claude when he stayed with Sir George at Coleorton (Plates 151 and 153). In 1795, however, he was less competent although Beaumont 'expressed himself pleased' with his efforts.[7]

The highlight of the introduction was being allowed to see Sir George's Claudes, and which were probably Constable's first contact with great works of art. Claude was henceforth to be one of Constable's idols, and although he was not as competitive as Turner, nevertheless, Constable's panegyric delivered when he lectured on landscape at the end of his life remains as a clear indication of his admiration.[8]

> The most perfect landscape painter the world ever saw ... In Claude's landscape all is lovely — all amiable — all is amenity and repose; the calm sunshine of the heart. He carried landscape, indeed to perfection, that is *human perfection*. No doubt the greatest masters considered their best efforts as experiments, and perhaps as experiments that had failed when compared with their hopes, their wishes, and with what they saw in nature. When we speak of the perfection of art, we must recollect what the materials are with which a painter contends with nature. For the light of the sun he has but patent yellow and white lead — for the darkest shade umber or soot.[9]

This, however, is Constable speaking with the experience of his own struggles at the end of his life. He went on to show with approval how Claude had learnt from others, as he himself was to do after his first experience of Claude: 'A *self-*

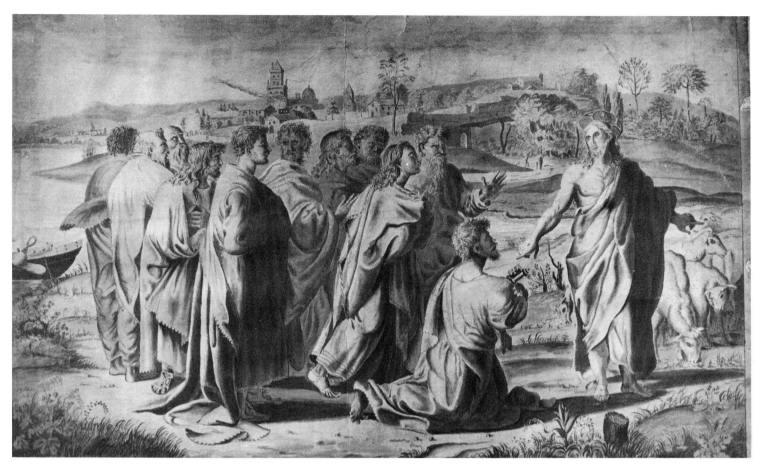

11. *Christ's Charge to Peter*. A copy by Constable of Dorigny's engraving after Raphael. 1795. Pen, ink and wash, 48.9 × 74.6 cm. The Minories, Colchester, The Victor Batte-Lay Trust

taught artist is a very ignorant person. Claude neglected no mode of study that was calculated to extend his knowledge, and perfect his practice.' Constable never stopped making copies of old masters, in general, and Claude, in particular.

Sir George Beaumont's influence did not end with showing Constable his Claudes. His own practice as a painter and draughtsman of landscape out of doors certainly helped the young beginner. He was to have a further decisive effect on his art when Constable reached London in 1799. For the moment in 1795, Beaumont was too grand, knew too much and had too much to offer for Constable, still the young miller, to assimilate all at once.

Constable received immediate practical help from another figure in the professional art world, J.T. 'Antiquity' Smith.[10] In August 1796, Constable went to stay with his uncle Thomas Allen, a businessman with antiquarian interests who had a country house at Edmonton, beyond north London. Through Allen, Constable was introduced to a circle of friends, all interested in old books, old buildings and art. Principal among these were J.T. Smith and John Cranch (1751–1821), a Devon artist. Smith was then engaged in print making and portrait painting, or, as he described it: '*I profiled, three quartered, full faced and buttoned up* the retired embroidered weavers, their crummy wives and tightly-laced daughters.'[11] Constable later approached portrait painting with the same lack of enthusiasm.

At the same time, Smith was putting together a series of drawings of picturesque cottages, which were to be published in 1797 as *Remarks on Rural Scenery: with twenty etchings of cottages from Nature; and some observations and precepts relative to the picturesque* (Plate 12). This was a pioneering enterprise in the craze for old cottages of character. Not even Sir George Beaumont, that champion of a nobler form of art, was averse

12. John Thomas Smith (1766–1833). *Lady Plomer's Palace on the Summit of Hawke's Bill Wood, Epping Forest*, Plate 12 from *Remarks on Rural Scenery*. 1797. Etching, 16.7 × 20.3 cm. New Haven, Yale Center for British Art, Paul Mellon Collection

to drawing them, for example, a drawing of a 'Leasehold cottage' (Plate 13) dated 6 August 1791, in the Yale Center for British Art. Constable, on his return to East Bergholt in October 1796, eagerly provided Smith with examples of drawings of such cottages from his neighbourhood in the hope that Smith would use them. 'I have in my walks', he wrote to Smith, 'pick'd up several cottages and peradventure I may have been fortunate enough to hit upon one, or two, that might please. If you think it likely that I have, let me know and I'll send you my sketchbook and make a drawing of any you like if there should not be enough to work from.'[12]

There survive thirteen such drawings by Constable (Plate 14), which are now in the Victoria and Albert Museum. Smith encouraged the keen young artist but, perhaps, was too canny to use the work of his disciple in the published edition. Constable's drawings are drawn in pen and ink in a manner obviously influenced by Smith's etching needle. He was himself experimenting with etching and, according to Lucas, had a hand in etching Smith's plates but this may not have been the case.[13] One such drawing, which he drew on a letter to Smith in 1797, was the view from his bedroom window (Plate 15), a view that he was to paint several times. It shows the tumbledown barn, which preceded the fine new one that appears in the later painting in Ipswich (Plate 88). It is similar to the drawings of picturesque derelict cottages, and like them, is feathery and hesitant, with, as yet, an insecure grasp of perspective. The drawings are interesting, however, as Constable's first venture into a class of subject, which could be described as 'The Rural Picturesque', a lowly sort of subject, which did not meet with approval in the high world of art. The Revd William Gilpin, one of the high priests of the Picturesque, ranked it low in his scheme of things:

The grand and the rural are the two prevailing characters of the landscape — and that sublimity marks the one and amenity the other ... We seldom however find either of these characters perfectly pure. They are generally inter-

15. *View from Golding Constable's House*. 1797. Pen and brown ink, 27.9 × 18.4 cm. New Haven, Yale Center for British Art, Paul Mellon Collection. Extra illustrated volume of 1843 edition of C. R. Leslie's *Life*

mixed: for little beauty results from sublimity alone: and yet the rural, without a little of the sublime would be low and vulgar. The mixture therefore of these two characters forms a third species; which is the character of most of the following drawings and indeed it is the character of most of the best landscapes we have. We always wish for so much sublimity as to banish everything low, and trivial; and for so much amenity, as to soften the sublime. In this mixed mode of landscape, we hardly admit the cottage. In its room we rather expect the castle. The brook may murmur over pebbles; yet we are better pleased, when it spreads into a river; but as to the appendages of husbandry and every idea of cultivation, we wish them totally to disappear.

For Gilpin the inferior modes of landscape included low vulgarisms such as 'cottages, hay making, harvesting and other employments of husbandry'.[14]

These were, however, the subjects that Constable persevered with, unlike Turner's far ranging quest for the grandiose. In some ways, all Constable's pictures are in this lowly mode, in which Smith had encouraged him, and it probably added to the difficulties of his being accepted by

connoisseurs. Nevertheless, Dutch, Flemish, and English art provided infinite examples of this humble approach, which, in spite of strictures to the contrary, remained popular in the eighteenth century. Smith provided Constable with books, plaster casts, drawings of his own, and prints for him to examine and copy after Dutch masters, such as Hobbema and Antonie Waterloo (*c.* 1610–90). These were precedents both in their plebeian subject matter, in which tumbledown picturesque cottages appear frequently, and in a literal, realistic technique of chalk, pen and ink. Waterloo's drawings, in particular, seem to have been an influence on Constable's early drawing style (Plate 21).

Smith also provided further valuable advice, theoretical and practical. 'Do not', he advised Constable, 'set about inventing figures for a landscape taken from nature; for you cannot remain an hour in any spot, however solitary, without the appearance of some living thing that will in all probability accord better with the scene and time of day than will any invention of your own.'[15] Constable's pictures were peopled entirely with such figures and his sketchbooks are full of rapidly jotted scenes of people going about their business in a natural manner, some of which he used in his paintings, such as men dipping sheep (Plate 92), or ploughing (Plate 73), or shovelling dung (Plate 84). He may have heard the same hints from Sir George Beaumont who had received similar advice from Malchair at Oxford. Malchair also praised the value of constant observation in the open air, the use of a composition suitable to the subject and he emphasized 'marking the changes in the appearance of objects at different times of the day'.[16]

Smith's advice, however, does not mean that the figures were necessarily to be invested with deep symbolical significance. When Constable later showed men at work he attempted to make them accord with the scene and the time of day, as he attempted to do with his effects of weather, rather than to produce pedantic metaphors of Work, such as we find in Ford Madox Brown's celebrated picture of 1852–65 (Manchester City Art Gallery). On the other hand, Constable was not entirely oblivious of their status and their tasks. Many of them he would have known personally, since they worked for his father and neighbours, and there is a studied seriousness of purpose in their activities. Nevertheless, he was to follow loyally Smith's suggestion and remain firmly against figures in a painting that were not based on actual observed fact. 'Ideal art ... in landscape is sheer nonsense,' he wrote to his friend and namesake George Constable in 1835.[17] He was particularly sarcastic to Leslie about those 'high minded' members of the Academy who preferred '*the shaggy posteriors of a Satyr* to the *moral feeling of landscape*' and in this he would have agreed with Gainsborough who wrote to his friend, William Jackson, in 1767: 'Do you really think that a regular Composition in the Landskip way should ever be fill'd with History, or any figures but such as fill a place (I won't say stop a Gap) or to create a little business for the Eye to be drawn from the Trees in order to return to them with more glee.'[18]

Gainsborough also influenced Constable, particularly with his realistic Suffolk landscapes, but his second point in his letter to Jackson can also be applied to Constable's figures.

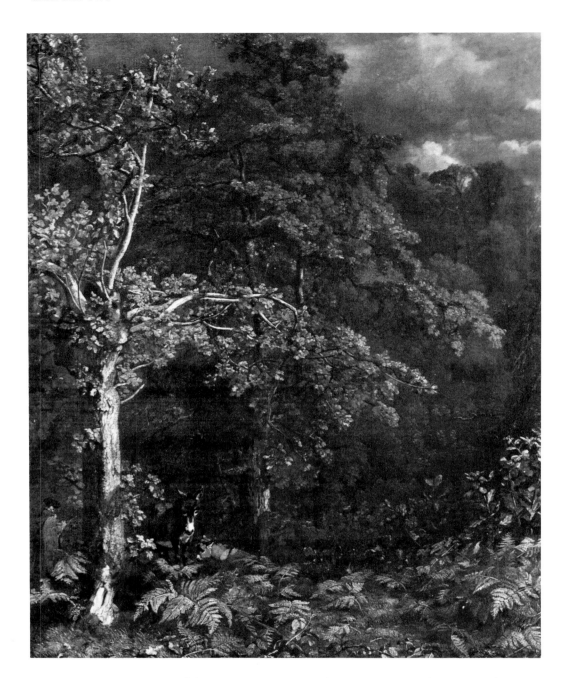

16. *Wooded Landscape*, 1801/2. Oil on canvas, 92 × 72 cm. Toronto, Art Gallery of Ontario, Gift of Reuben Wells Leonard Estate, 1936

They are often manipulated for artistic reasons, such as accents of colour like a judicious touch of a red waistcoat (Plate 60) or a red cloak against a green background, or in other paintings, as pivotal points in a composition, but they are never transformed into characters from some ideal world who are invented or unnatural. His sturdy pragmatism, which Smith had encouraged, was later scornful of 'the climax of absurdity', as he saw it, 'to which the art may be carried, when led away from nature by fashion'. For this the principal culprit was Boucher and he was very scornful of his sort of unnaturalness:

> His scenery is a bewildered dream of the picturesque. From cottages adorned with festoons of ivy, sparrow pots, &C., are seen issuing opera dancers with mops, brooms, milk pails, and guitars; children with cocked hats, queues, bag wigs, and swords cats, poultry, and pigs. The scenery is diversified with winding streams, broken bridges, and water wheels; hedge stakes dancing minuets — and groves bowing and curtsying to each other; the whole leaving the mind in a state of bewilderment and confusion, from which laughter alone can relieve it.[19]

He is unkind to Boucher, and the same criticisms could be made of some of Gainsborough's later works, but in 1796 such a stern point of view lay ahead, and he was happy to see what he could of Suffolk's most famous artist. His interest was stirred by a request from Smith in May 1797, 'for any particulars which he might be able to procure respecting Gainsborough'.[20] Constable was diligent, visited Ipswich and met as many people as possible, including George Frost (1754–1821) and John Smart, who had recollections of Gainsborough. He looked at Gainsborough's pictures, notably the famous collection of Samuel Kilderbee, who had Gainsboroughs of all periods, and tried to identify scenes in the countryside around Ipswich that Gainsborough had painted before he left Suffolk for Bath. On a visit to Ipswich, in 1799,

17. John Cranch (1751–1821). *The Plasterer*. 1807. Oil on panel, 14.5 × 16 cm. New Haven, Yale Center for British Art, Paul Mellon Collection

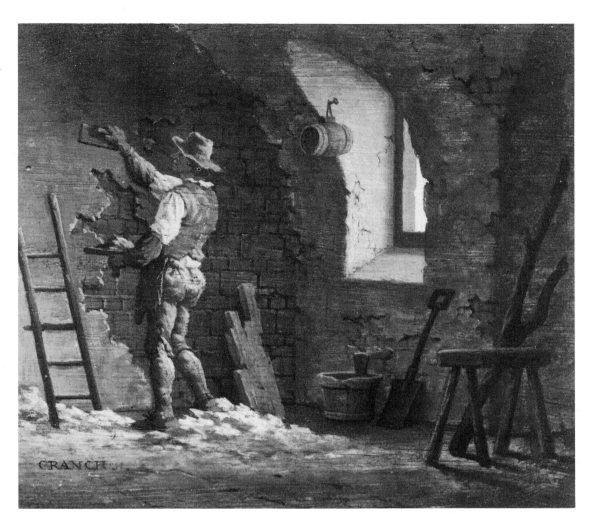

when he had just begun as a full-time artist he commented to Smith: ''Tis a most delightfull country for a landscape painter, I fancy I see a Gainsborough in every hedge and hollow tree.'[21]

Gainsborough remained a constant inspiration. Constable seems always to have preferred early Gainsborough landscapes of Suffolk, such as *Gainsborough's Forest* (National Gallery, London; Plate 18), identified traditionally as a local view of Cornard Wood and which was owned by his uncle, David Pike Watts by 1814, or such intimate views as *Wooded Landscape with a Pool* (Fitzwilliam Museum, Cambridge), because of their fidelity to the wooded country around Ipswich, and the genuine freshness and charm of Gainsborough's vision. Gainsborough himself looked back nostalgically to his 'first imatations [*sic*] of little Dutch Landskips'.[22] Their slightly awkward realism, based on a variety of Dutch influences, from Berchem to Wijnants, Waterloo and Ruisdael, undoubtedly struck a response in Constable who was undergoing the same education. Gainsborough's influence is clear, whether in Constable's drawings, particularly those he made at Helmingham in 1800 (Plate 19), in such pictures as the earliest of the views from Golding Constable's house (Downing College, Cambridge) or the small *Wooded Landscape* (Plate 16) at Toronto of 1801–2. They have a flickering feeling for light and shade, which is not too harsh — what he was later to call *chiaroscuro* — and a density of texture, which is not too impenetrable, achieved by a varied impasto. He paid attention

to similar foreground details, of donkeys and dock leaves, that show he had learnt from the Gainsboroughs he had seen. He told Farington that he disliked Gainsborough's later work because it was 'so wide of Nature'. Perhaps he already had taken a dislike to anything away from nature, such as Boucher's 'bewildered dream of the picturesque'. Later on in his career, however, when his own methods had changed somewhat, he could be very sympathetic to the more romantic side of Gainsborough's art, moved by a landscape of *c.* 1774–7 which he saw at Petworth in 1834:[23]

'With particulars he had nothing to do, his object was to deliver a fine sentiment — & he has fully accomplished it . . . The Landscape of Gainsborough is soothing, tender and affecting',

he wrote for his lectures in 1836, and he went on to give, as Reynolds had done before him, an extremely sensitive description of Gainsborough's art, 'whose exquisite refinement', he was careful to point out, was 'yet not a refinement beyond nature'. Gainsborough's poetic vision of the 'rural picturesque' stayed with him throughout his life, even though Constable realised his own concern with particulars had given his art a different cast.

Two further aspects of Constable's relationship to Smith that were also to have lasting effects need to be mentioned. In addition to introducing him to Gainsborough's work, the art

of the Dutch, and giving him the important legacy of a life-long subject matter, Smith, and his associate Cranch, were instrumental in bringing Constable into contact with the literature of 'the art', which he was never to forget as an essential part of his professional career. At the end of his life, his library was extensive. After he had stayed with his uncle Thomas Allen in the autumn of 1796, Constable brought back to East Bergholt a list of twelve books and hints 'respecting study' which Cranch had made up for him.[24] We know from his letter to Smith, of 27 October 1796, that he was already finding great pleasure in reading two of them, Leonardo da Vinci's *A Treatise on Painting* (English translation of 1721) and Francesco Algarotti, *An Essay on Painting* (1764 edition). In his reading list Cranch also recommended Reynolds' *Discourses*, but he was anxious to warn the budding artist that 'it does not bias you against *Familiar* nature, life and manners', which he thought were as genuine 'as the sublime or the beautiful'. Constable never forgot this advice in his work and, eventually, he owned all the books on Cranch's list, although he did not acquire them immediately. He even attempted at the end of 1796 to paint two genre pictures in the manner of Cranch, *The Chymist* and *The Alchymist*, which are timid and awkward allegories in a vein that he did not persevere with.[25] Cranch's own art, judging from what little has survived, and Constable owned a painting by him, was little better, but Constable was grateful for his help, even though his art was to proceed in a different direction (Plate 17).

Smith had one more important part to play in Constable's development as a painter. He first tried to discourage Constable from leaving the family business, and Constable's mother made it plain to Smith that she thought her son should attend to it, but Smith then stayed in East Bergholt in 1798 and seems to have persuaded Constable's father to let Constable study art full time.[26] In February the following year, 1799, furnished with a letter of introduction from the authoress, Mrs Priscilla Wakefield, whom he had met at the Cobbolds in Ipswich, and armed with 'his sketches of Landscapes in the neighboroud [*sic*] of Dedham', Constable called on Joseph Farington, RA, the chief politician of the Academy's affairs and friend of Sir George Beaumont.[27] Farington told him 'he must prepare a figure'. Constable followed his advice, which he was not later always inclined to do, and as a result of 'the Torso' that he had drawn and shown Farington was able to write with pride to John Dunthorne on 4 March 1799 that he was admitted to the Royal Academy Schools.[28] He drew from the Antique Academy at first, and was properly registered the following year (19 February 1800). His full-time career had finally begun at the relatively great age of 23, when Turner was about to be elected as an Associate of the Academy and a full member three years later in 1802.

He plunged into the art world, copying a Wijnants lent to him by Farington and a Ruysdael.[29] He saw the famous Altieri Claudes at William Beckford's house (*Landscape with the Father of Psyche Sacrificing to Apollo* and *Landscape with the Arrival of Aeneas at Pallanteum*, now the property of the National Trust at Anglesey Abbey), and he copied a Wilson from memory. He drew, not very well, from casts and from the life (Plate 23). He set up student lodgings at 52 Upper Norton St, off Portland Place, with Ramsay Richard Reinagle (1775–1862) who, as the son of an Academician and already having travelled to the Continent, was far more sophisticated in the ways of the world of art. At first, Constable was impressed, taking him to stay with his family at East Bergholt during the summer of 1799. Reinagle, at about this time, painted his portrait (see Constable's self-portrait, Plate 7), now in the National Portrait Gallery. It shows the 'handsome miller' that a seventeen-year-old admirer of his, Ann Taylor, thought was 'so finished a model of what is manly beauty I never met with as the young painter'.[30]

Later that year Reinagle also induced Constable to go half shares for £70 in a Ruysdael, which Constable copied, and which was later sold by Reinagle at a loss. This, unfortunately, seems indicative of Reinagle's character.[31] Eventually, Constable found Reinagle's slyness in dealing and general pushiness antipathetic to his own, more stolid character. In front of Constable, for example, Reinagle pressed Farington about his own chances of being elected an Associate of the Academy as early as May 1799.[32] (Constable, himself, when invited by Stothard in 1807 to put his own name forward for election as an Associate, declined modestly, waiting until his professional achievements were greater.[33]) Above all, what Constable thought were his shallow attitudes to art became less glamorous for the earnest young Suffolk student, and by March 1801 they had parted company, Constable taking new rooms in Rathbone Place. Constable complained at this time to Farington that Reinagle and others 'look only to the surface and not to the mind. The mechanism of painting is their delight. *Execution* is their chief aim.'[34] The previous year, however, it must be remembered, he had written to Dunthorne that he found it necessary to fag at copying, 'to acquire execution. The more facility of practice I get, the more pleasure I shall find in my art, without the power of execution I should be continually embarassed, and it would be a burthen to me.'[35] He presumably had come to realize slowly that landscape painting was capable of pursuing greater aims of realistic naturalism and subtlety of vision, even if for the present they were unattainable.

Then there was the general sinfulness of human nature to cope with. He wrote to Dunthorne, as a fellow provincial, echoing the common complaint of the innocent in the capital city, 'It is difficult to find a man in London possessing even common honesty; and', he went on to the village atheist, 'it is a melancholy reflection, to know we are living in a Christian world and we *Christians*, are devoted to mercilessly preying upon one another.'[36] His high moral attitude about his fellow students and Reinagle is similar to Wordsworth's complaint in *The Prelude*:

> Far more I grieved to see among the band
> Of those who in the field of contest stood
> As combatants, passions that aid to me
> Seem low and mean; from ignorance of mine,
> In part, and want of just forbearance, yet
> My wiser mind grieves now for what I saw.[37]

Constable, nevertheless, for a time had been much impressed by Reinagle and his facile drawing style, with its rapid

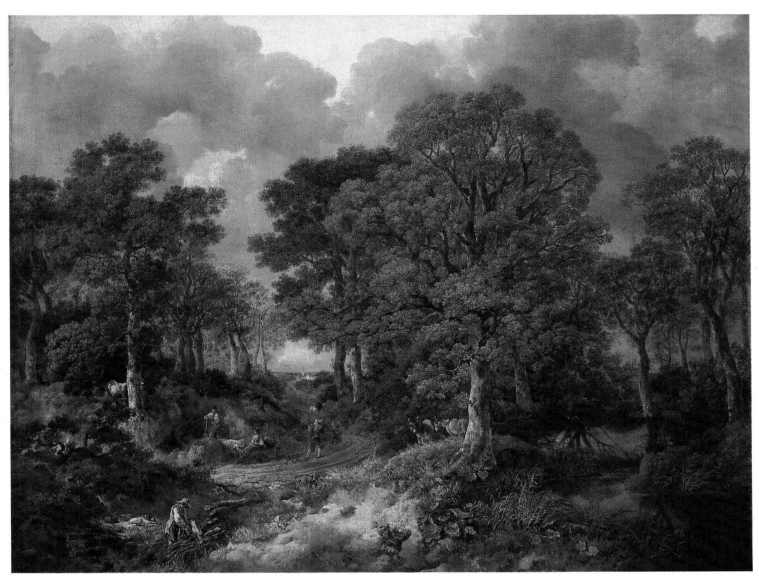

18. Thomas Gainsborough, RA (1727–88). *Cornard Wood. c.* 1748. Oil on canvas, 122 × 155 cm. London, National Gallery

hatching, its shorthand for leaves, and arbitrary effects of light and shade. As Constable admitted, he had tried to be as worldly-wise and rushed into the conventional art world, copying everything he could see by the Carracci, Wilson, Ruysdael, and Claude. Through Farington, to whom Constable confided his hopes and disappointments and who seems to have taken him under his wing, he renewed his acquaintance with Sir George Beaumont.

Beaumont was as helpful as he had been in 1795. He allowed Constable to copy his Claudes, where he had been seen by Farington 'copying the small upright Claude', by which Farington may have meant either the *Hagar and the Angel* (Plate 34), or *The Landscape with Goat Herd and Goats* (Plate 151).[38] The following winter of 1800–1, what Farington described as Constable's 'melancholy', probably caused by his dissatisfaction with Reinagle's methods and inability to see his way forward, seems to have been improved by the sight of Beaumont's gallery. When Sir George came back from his winter stay at Dunmow in Essex, at the end of February 1801, Constable 'animated by the paintings' proceeded 'with resolution'.[39]

There were, of course, many aspects of Claude's art for Constable to admire. Turner had admitted that the Altieri

Claudes 'seemed to be beyond the power of imitation'.[40] The endless throng that viewed them, including Constable, all seemed generally agreed that they were perfect, but the ticketed visitors to Beckford's house, equally, had their differing, and sometimes silly, opinions as to how this perfection had been achieved and what Claude's art consisted of. Farington thought that they would impress 'artists and others' with a due sense of the value of representing nature with 'simplicity and purity'. Claude had '*no coxcomry of touches*'. This sort of opinion would doubtless appeal to Constable in 1801 after his break with Reinagle. At Sir George's Constable revealed to Farington that he preferred 'the little wood scene of Claude to all others'.[41] From the fact that it is woodier than *Hagar*, he must have meant *The Landscape with Goatherd and Goats*. It was less grandiose, more intimate than *Narcissus*, also in Beaumont's collection, and certainly was more accessible than the dignified beauty of the Altieri Claudes. Uvedale Price, a friend of Beaumont's, would undoubtedly have described it as 'Picturesque'. Constable seemed to like it because it had the air of being done from nature. As we shall see later, Constable's early attempts at oil have the same density and soft transitions from plane to plane, which the Claude *Landscape with Goatherd* (Plate 150) has. Even the subject-matter is not

27

dissimilar to Constable's early landscapes except with the important difference that Constable's figures are not Virgil's Arcadian goatherds. Rather like an early Quattrocento primitive painter, Constable insists on a modern subject. The few figures he painted wear sturdy breeches and boots (Plate 33). He makes an effort at representing 'nature with simplicity and purity' and, one might add, accuracy.

There were two modern artists from whom Constable received the same impressions of breadth and simplicity: J.R. Cozens and Thomas Girtin, the works of both of whom were collected by Beaumont, and by Farington's friend, Dr Thomas Monro (1759–1833), the amateur artist and patron of a whole generation of young British artists. We do not know when Constable first visited Dr Monro, but his visits are not recorded until 1808.[42] Monro, of course, owned water-colours by Cozens, and Turner's and Girtin's copies after them, as well as a group of fine early works by Girtin, and drawings by Canaletto, Gainsborough, and contemporary British artists. What is known, however, is the regularity with which Constable visited Sir George Beaumont, for whom Girtin had become a new enthusiasm. It was probably not until 1801 that Constable saw a large number of Girtin's water-colours. While Constable had been in the woods of Helmingham, Suffolk, during the summer of 1800, Beaumont was at Benarth, near Conway, in North Wales with Girtin and Cotman. Previously, in 1798, Girtin had accompanied Beaumont to the Lake District and, in 1799, Beaumont became an associate of Girtin's sketching club. During the winter of 1800–1, Beaumont was at his country house at Dunmow Essex. He returned to London in February 1801 and it is inconceivable that he would not then have mentioned his new protégé to Constable. Beaumont had, after, all, persuaded Girtin to make his first attempt in oil with *Guisborough Priory* (Yale Center for British Art, New Haven) the previous year in 1800. He had drawings of his own from the Lake District tour, which Girtin had worked on and improved, and he eventually owned at least thirty recent water-colours from Girtin's most original period. These, according to Leslie, 'he advised Constable to study as examples of great breadth and truth; and their influence on him may be traced more or less through the whole course of his practice'.[43] Constable himself was to own a late water-colour by Girtin of Ripon Minster, Yorks. (Yale Center for British Art, New Haven), and make a copy after Girtin (Victoria and Albert Museum, R.62). This influence is not easily demonstrated immediately and can be better shown at a later stage in Constable's career. Like many young artists, he grasped the simplest things first, as being more assimilable. The beauty of Claude, the poetry of Cozens (Plate 38) and the breadth and calm of Girtin, which he admired, were only slowly absorbed and were to be revealed in his paintings later.

The expression of Constable's own works during 1800 and 1801 did not embrace the powerful concepts of Claude, Cozens, and Girtin and was much more limited. So far, his work had consisted of drawings of landscapes and cottages, found in and around East Bergholt, done for, and sometimes with, J.T. Smith and reflecting his style; drawings of antiquarian monuments and churches, also done with Smith's antiquarian interests in mind, such as *John Brewse's Monument in*

Little Wenham Church, Suffolk, dated 1798, and some small paintings, two of which have already been described.

In the summer of 1800, however, during his vacation from the Royal Academy Schools, he stayed by himself on the estate of Helmingham Park, owned by the Earl of Dysart. He wrote to John Dunthorne on 25 July 1800:

> Here I am quite alone amongst the oaks and solitude of Helmingham Park. I have quite taken possession of the parsonage finding it quite emty [*sic*]. A woman comes from the farm house (where I eat) and makes the bed, and I am left at liberty to wander where I please during the day. There are abundance of fine trees of all sorts; though the place upon the whole affords good objects rather than fine scenery; but I can hardly judge yet what I may have to show you. I have made one or two drawings that may be usefull [*sic*]. I shall not come home yet and am
>
> Yours sincerely
> John Constable[44]

The drawings, which are thought to represent the parkland, are generally linked by their technique of using a thick lead pencil and their similarity of manner, to the drawings of Gainsborough and George Frost (Plate 40). Some may have been done later. They all represent dense woodland seen close to, and they are small in size.[45] There is one, however, that is larger and more ambitious, and has the appearance of a conscious effort to carry the drawing beyond the stage of a sketch. It may have been started on the spot and is inscribed, '23 July 1800, afternoon' (Plate 19), two days before his letter to Dunthorne. It shows a dell in the woods with a wooden footbridge (now replaced by a stone bridge), over a water-course, surrounded by twisted oaks (some of which still exist). He has made a careful attempt to delineate and accentuate the forms of the trees but he has shied away from grappling patiently with the detail of the leaves. The masses of foliage are suggested either by broad areas of grey wash in the manner of Sir George Beaumont, or generalized squiggles in chalk rather like Reinagle's method. There is a pattern of light and shade but very little obvious direct light. Not much more than six months later, he was highly critical of Reinagle for the same fault. 'He calls it his best picture. It is very well pencilled, and there is plenty of light without *any light at all*.'[46]

The drawing has been divided equally into four by horizontal and vertical lines, and there are traces of other guidelines and measuring points for squaring. It is tempting to think that this was done in working up the drawing from another sketch but, more likely, it was done at the time he used it for the finished picture (Plate 195) he painted in 1825–6 for a Suffolk patron, James Pulham, which is now in the John G. Johnson Collection, Philadelphia. In the finished picture he has carefully followed the basic geometry of the drawing but eliminated the large tree at the left and added more foreground detail such as the heron. A second version of the picture, which he painted in 1830, is identical but the water flows more freely in the foreground (the stream had, perhaps, dried up in July 1800) and there are additions of a cow and a stag. These further details undoubtedly contribute to change the mood. The drawing is the earliest example of Constable keeping a study by

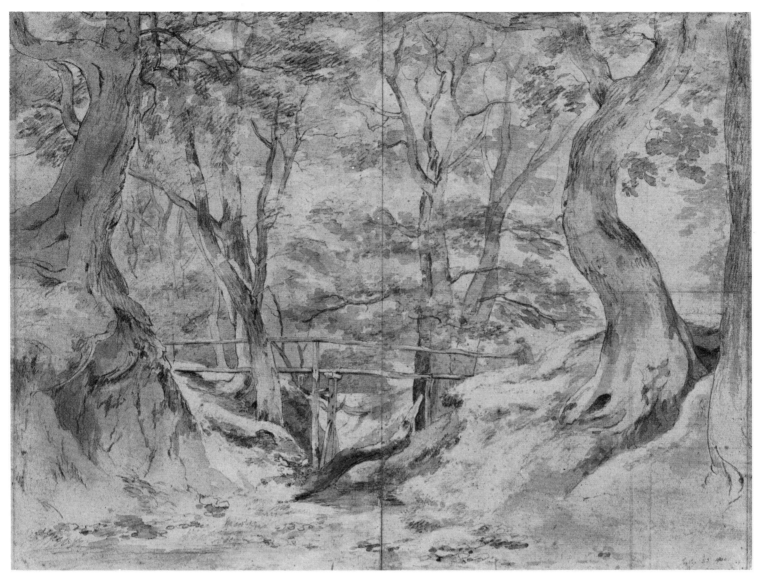

19. *Helmingham Dell*. 1800. Pencil and grey wash, 52.1 × 64.8 cm. Swettenham, The Clonterbrook Trustees

him and using it again later, as much for its early associations as for its suitability of design, for a finished painting — executed in this case at least twenty-five years after he had visited the site. In 1800, however, he could not have foreseen that this was to be his method. He was still trying to come to terms with art and nature.

Later that year, Constable produced highly finished water-colours, which are also prophetic in their subject-matter and local associations of his future interests. Important though his work at Helmingham was, of equal interest were four large finished drawings, which he presented to his friend, Lucy Hurlock, on her wedding to Thomas Blackburne in November 1800. They were important not only because of the close attachment between the Hurlock and Constable families but also on account of what they reveal of his art at this period. Lucy was a keen, early admirer of Constable's art. She had helped to raise subscriptions for Smith's *Remarks on Rural Scenery* in 1797, and she further expressed her admiration in a letter to Constable of April 1800, hoping again to 'obtain a sight of the production of gradual progress of an early

genius'.[47] She had been pleased to meet his early artist friends, Smith and Reinagle. Her father, the Revd Brooke Hurlock, was actually Rector of Lamarsh, near Bures, where Golding's family originated, and a rather timid oil painting of *Lamarsh House*, now at Anglesey Abbey, National Trust, may be an early oil done by Constable for the family and given by her father to Lucy on her marriage. The Revd Brooke Hurlock also acted as curate of Langham on behalf of Dr John Fisher, later the Bishop of Salisbury, but found it convenient to live at Dedham where he, his sons, and Constable, had gone to school.

It was thus through the Hurlocks that Constable made the acquaintance probably in 1798 of Dr Fisher, who played such an important part in Constable's future career. In 1824 he told the Bishop that 'his lordship had been his kind monitor for twenty-five years'.[48] It was through Dr Fisher in 1811 that he formed his close friendship with his nephew and namesake, the Revd John Fisher, who was, after Constable's wife, his dearest confidant. In the letterpress for the mezzotint of his family home Constable emphasized that he 'had a lively and grateful

29

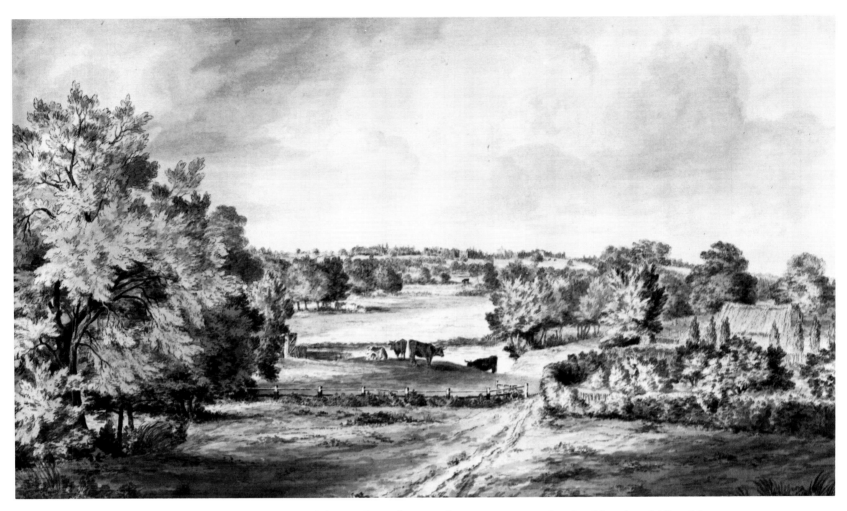

20. *The Valley of the Stour Looking towards East Bergholt.* 1800. Pen and water-colour, 33.8 × 52.3 cm. London, Victoria and Albert Museum

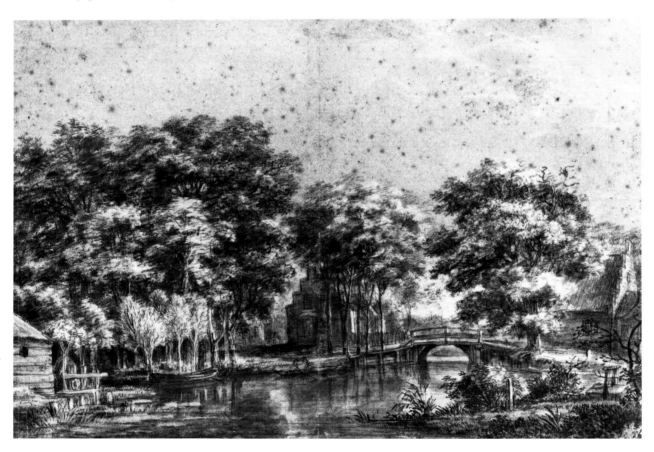

21. Anthonie Waterloo (*c.* 1610–90). *River Scene with Bridge and Trees.* Black chalk, grey wash, heightened with white on grey/blue paper, 38 × 55.3 cm. Cambridge, Fitzwilliam Museum

remembrance' of this acquaintance, made in Dedham, with Dr Fisher (and Sir George Beaumont), which 'entirely influenced his future life'.[49] The early friendship and encouragement by the Hurlocks and this important introduction to the wealthy and influential cleric, Dr Fisher (who was also chaplain to the King, as well as tutor, successively, to the Duke of Kent and Princess Charlotte) undoubtedly meant much to Constable and spurred him to do his best for his wedding present to an attractive admirer. His choice of subject was significant. The four views, when put together, show a wide and detailed panorama of practically the whole of the Stour valley from west to east. They were to remind the departing bride of her home and three are taken from just beneath her father's church on the rising ground at Langham, looking towards the estuary at Harwich, with the tower of Dedham rising in the middle distance (of these three, two are in the Victoria and Albert Museum, and one in the Whitworth Art Gallery, University of Manchester).[50] This was a favourite vista of the painter's and later he painted a similar view of Dedham vale (Plate 84) for another departing bride. The fourth view (Plate 20) is taken from further to the east, and looks towards East Bergholt, the three obvious buildings being, from left to right, West Lodge, East Bergholt Church and Old Hall. These scenes, as he said, made him a painter and meant as much to him as they did to the recipient.

If the subject-matter of these important early water-colours was used frequently in the future by Constable, the manner in which they were executed left room for improvement and reflected his early influences. They are carefully drawn in pen, ink and water-colour in an earnest mixture of what he had learnt from J.T. Smith and Dutch prints, in, for example, the treatment of the foliage, the cows, and the figures which bob up and down the hillside (Plate 20). The water-colour now at the Whitworth was not even immediately recognized as being by Constable, and was attributed to the Swiss artist, Michel Vincent Brandoin (1733–90). The topographical details in the Victoria and Albert Museum, however, have been shown by Col C.A. Brooks to be entirely accurate, and the sheet at Manchester interestingly contains a figure drinking from a stream, who occurs again, most notably in his famous *Cornfield* (Plate 169).

It may be that Constable was also influenced by the 'rage' for panoramas which was prevalent around 1800. His erstwhile friend, Ramsay Reinagle, ever open to the main chance, was to produce some for Robert Barker's *Panorama* in Leicester Square.[51] Constable was critical of this sort of work: 'that is, great principles are neither expected nor looked for in this mode of describing nature. He views nature minutely and *cunningly*, but with no greatness or breadth'.[52] These criticisms could be made of Constable in 1800.

In spite of his break with Reinagle in 1801 and his scorn for his attempt to please the public, Constable was not averse to producing conventional works on commission, or by himself, at this stage in his career. For the then owner of Old Hall, East Bergholt, John Reade, he painted, in 1801, a portrait of the house (Plate 22), which passed to Peter Godfrey when he

22. *Old Hall, East Bergholt.* 1801. Oil on canvas, 71.1 × 106.7 cm. England, private collection

23. *Study of a Seated Male Nude. c.* 1800.
Black and white chalk, 55.5 × 43.8 cm.
London, Victoria and Albert Museum

bought the house in 1804. Godfrey became the local squire in 1811. Constable was clearly anxious to please. The house is placed centrally and is carefully drawn. As Farington remarked, 'His manner of painting the trees is so like Sir George Beaumont's that they might be taken for his.'[53] He had thought of charging five guineas but Farington advised him to ask for ten. A commission such as this would, in part, answer his father's worry that as an artist he was 'pursuing a Shadow'.[54] He had shown that what he could do in this line of house portrait the previous year, sometime before 6 March 1800, when he had produced a large finished water-colour of *The Old Lecture House at Dedham*.[55] It is the equivalent in water-colour of the oil of *Old Hall*, but, perhaps not quite so secure in the draughtsmanship of the foreground. Smith's advice about figures in a landscape was not necessarily put into practice immediately.

Throughout his career he painted, rather reluctantly, similar house views. *Lamarsh House* may be the earliest but more notably, there are views of *Malvern Hall*, 1809 (Plate 49) Tate Gallery, and again in 1821, a further three versions, one of which is reproduced here (Plate 120); *Wivenhoe Park*, of 1816, Washington, National Gallery of Art (Plate 91); and *Englefield House* in Berkshire, of 1833. For all of them, there was some personal commitment, which he felt obliged to fulfil, but at this early stage he probably remembered advice that Farington had given to another young artist, Salt, in 1799:

That landscape painting is not so much encouraged as it has not the advantage of being supported by self love, while portraits from that motive will always be had at from the highest to the lowest prices. That there is a sort of Landscape *Portrait* Painting by which a good deal of money

24. Benjamin Robert Haydon
(1786–1846). *Nude Study*. 1806/7. Black
chalk heightened with white on buff paper,
26.7 × 32.1 cm. New Haven, Yale Center
for British Art, Paul Mellon Collection

is got, viz.: painting views of houses &C but where the picture will only be purchased for its intrinsic merit few will be found to command an income.[56]

Farington was talking from his own experience but these problems were to be Constable's too. They must have discussed them in their talks together about Constable's future prospects. For the next decade, and longer, he was to explore, with lessening enthusiasm, the various professional options that were open to him as a young artist. He had tried his hand at house portraits. He also worked diligently at his life studies, Farington described him attending the Life Academy 'every evening' in 1807, and Wilkie recorded him painting from 'the living figure' as late as July 1808.[57] A male life study is dated *Novr. 1808* (Colchester Borough Council). If this group of later drawings and oil sketches is compared with his earlier works of *c.* 1800, executed in chalk and stump work (Plate 23), we can appreciate Leslie's comment that his chalk drawings 'have great breadth of light and shade, though they are sometimes defective in outline'.[58] There are, however, signs of improvement during these eight years from the unrefined early studies and, by 1808, he is certainly no worse as an academic draughtsman than his friend, Benjamin Robert Haydon (1786–1846), for whom such life studies were the required discipline of a budding history painter. (See, for example, Haydon's drawing of a female nude of 1806–7 (Plate 24) in the Yale Center for British Art.) Constable also took the trouble in 1802 to attend Brook's Anatomical Lectures, making drawings from dissections, which he found interesting, not only for their practical effect but also, significantly, for their moral

purpose because they carried 'the mind to the Divine Architect. Indeed the whole machine which it has pleased God to form for the accommodation of the real man, the mind, during its probation in this vale of tears, is as wonderfull as the contemplation of it is affecting.'[59] He felt it a melancholy truth 'that a knowledge of the things created does not always lead to a veneration of the Creator. Many of the young men in this theatre are reprobates.'[60] This highly moral point of view remained with him, even though figure drawing and figure compositions were not to be his main interests.

He did, however, paint three altarpieces for local churches, perhaps his least attractive works, interesting only as curiosities. They were *Christ Blessing the Children*, *c.* 1805–8 (St Michael's, Brantham, Dr Rhudde's church), *Christ Blessing the Sacraments*, 1810 (St James's, Nayland), and *The Risen Christ*, 1822, for St Michael's Church, Manningtree (now at All Saints, Feering, Essex). We must not forget, nevertheless, that although the figures in his paintings are subsidiary to his major aims, as it is hoped to show, in his landscapes, they are never unimportant, and they are generally perceived and blocked in accurately. The shorthand for the rapidly painted boys fishing in the sketch for *The Young Waltonians* (detail, Jacket), to cite just one example, could not have been achieved without the underlying knowledge gained by patient study in the life class.

Another means to professional success, which Farington had mentioned, and Constable's family urged on him, was to paint portraits on commission, but, unless he was deeply involved with the sitter, the portraits that resulted cannot be claimed as his most arresting works. The two vibrant exceptions come from later in his career: the lively portraits of his

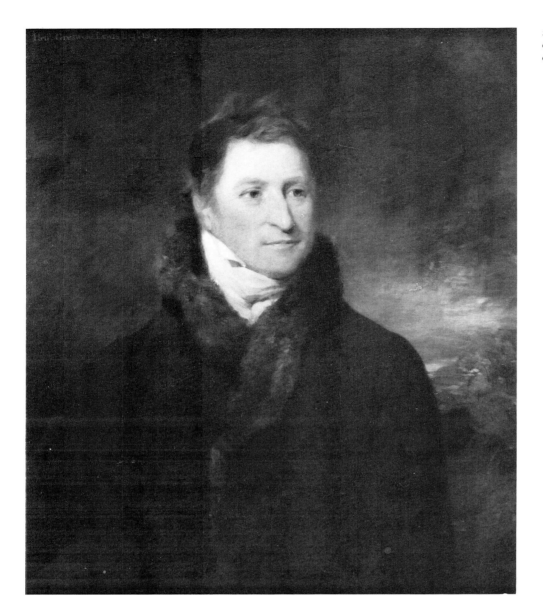

25. *Henry Greswolde Lewis*. 1809–11. Oil on canvas, 78.8 × 66 cm. Weston Park, collection of the Earl of Bradford

wife *Maria Bicknell* (Plate 26) of 1816, Tate Gallery, and his closest friend *The Revd John Fisher* (Plate 93), also painted in 1816 (see p. 102), Fitzwilliam Museum, Cambridge. He clearly responded directly to his involvement with them and to their affection for him. He wrote to his wife in July 1816, after he painted her portrait and just before they were married:

> I am sitting before your portrait – which when I look off the paper – is so extremely like that I can hardly help going up to it – I never had an idea before of the real pleasure that a portrait could afford – 'this sweet remembrance of one so dear' has caused no small sensation here in a party last Thursday evng of the Bowens – the Curators &c &c – but no observations have been made excepting as to likeness – which (?Robinson) says is extreme.[61]

Fisher, for his part, was delighted with his portrait, and that of his wife (Plate 96), which Constable had painted on his honeymoon in Dorset. But Constable had a lot to learn about portraiture.

Farington reported in 1804 that Constable 'has of late been much employed painting portraits large as the life for which He has *with a hand* 3 guineas — without 2 guineas — This low price affords the farmers &c to indulge their wishes and to have their Children and relatives painted — Constable has a House of His own near His Father's where He works hard and has time in the afternoon to cultivate Landscape painting.'[62] These prices were absurdly low even if we remember that none of them would be more than the so-called 'three quarter size', that is, head and shoulders, measuring approximately 30 × 25 inches. Reynolds at the end of his life (1792) was receiving the large sum of 50 guineas; Lawrence, £20 in 1807, to be doubled shortly after; Hoppner and Beechey about 30–40 guineas for this size. Even Hoppner, at the beginning of his career in dire straits, in the 1790s, received 8 guineas for a '3/4', while Romney earned 30 guineas.[63] He wrote to Maria on 30 June 1813 that his price for a head was 15 guineas and he could be 'tolerably expeditious when I can have fair play at my sitter'. In 1818, when Constable produced some more portraits at about £10–20, Henry Thomson, William Owen (1769–1825), and Martin Archer Shee were earning 50 guineas, while Lawrence received the huge sum of £500 for a full-length, probably

26. *Maria Bicknell, Mrs Constable.* 1816. Oil on canvas, 20.2 × 25.1 cm. London, Tate Gallery

27. *Mary Freer*. 1809. Oil on canvas, 76.2 × 63.5 cm. New Haven, Yale Center for British Art, Paul Mellon Collection

28. *Rear Admiral Thomas Western. c.* 1813.
Oil on canvas, 76.2 × 63.5 cm. England,
Jane Findlater

nearly £100 for a '3/4'.[64] In 1830 Constable still only received
£25.

There are a number of commissioned portraits which
survive from the first two decades of Constable's career, for
example, the *Bridges Family*, 1804, *Henry Greswolde Lewis* (Plate
25), 1809, *Mary Freer* (Plate 27), 1809 and *Rear Admiral Thomas
Western* (Plate 28), *c.* 1813. Many of the sitters were known to
the Constable family and lived locally. Doubtless there were
more of 'the farmers', which have since been lost. He also
copied family portraits for the Earl of Dysart by Hoppner and
Reynolds, as well as painting originals, and *Mary Freer* perhaps
reflects this influence, but there is no doubt that Constable's
heart was not in it.[65] He hated being beholden to the sitters,
with all the demands portraits made on him, even though the
sitter's reception of the portrait was not always unfavourable,
sometimes even enthusiastic, and he needed the money.[66]

He wrote to Maria Bicknell, in 1812, when his prospects as a
suitor were by no means certain, 'My father is always anxious
to see me engaged in Portrait, and his ideas are most rational,
but you know Landscape is my mistress — 'tis to her I look for
fame, and all that the warmth of imagination renders dear to
man.' He went on to describe Mrs Godfrey's enthusiastic
championing of his portraits: 'She hopes to perswade Captain
Western of Tattingstone to sit to me, if so I must procure a
supply of the crimson, ruddy, and purple tints and of the
deepest dye.'[67] The small portrait that survives of this fat-faced
naval officer may be a sketch for a larger portrait.[68]

There was to be a brief flurry of portraits around 1818, one
or two of which have a direct liveliness and honest look, such
as *The Revd and Mrs Andrew* (Tate Gallery), or *Mrs Pulham*
(Metropolitan Museum of Art, New York), which was praised
for its 'masterly execution' by the husband of the sitter, a
patron of his. Constable's attitude to portraits was, it must be
admitted, casual, if not romantic. He does not seem to have
flattered, although with these later portraits there is, at least, a
sparkle of surface, which he has carried through from his
landscapes of the same period and which he may have learned
from Lawrence, or his friend John Jackson (1778–1831).

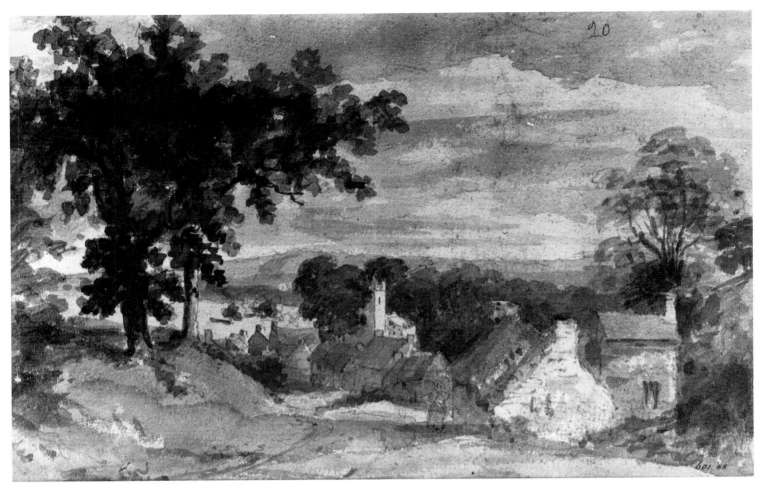

29. *The Entrance to the Village of Edensor, Derbyshire.* 1801. Pencil and sepia wash, 17 × 25.7 cm. London, Victoria and Albert Museum

When his finances improved, portraits tailed off, although a pair of astonishingly inept portraits exist dating from *c.* 1830. He was uninterested in pursuing this further branch of his profession and he was, apparently, not concerned with the depths of the human psyche, in the extreme manner of, say, Géricault's horrific portraits of the inmates of a lunatic asylum. Constable made little attempt either to become professional, that is, to display the sitters to their advantage, or to learn a repertoire of fashionable poses. Almost from the beginning, then, this particular artistic route was a cul-de-sac, and his best

30. Sir George Beaumont, Bt (1753–1827). *L'Ariccia.* 1782. Pencil and grey wash, 18 × 26 cm. New Haven, Yale Center for British Art, Paul Mellon Collection

portraits are an exception, where he has carried over to those he loved the same eager, penetrating vision that he reserved for landscape.

Constable also went, for a time, dutifully in search of the Picturesque, for which 'a course of summer travelling', wrote Robert Southey in 1807 (*Letters from England*), 'is now looked upon to be as essential as ever a course of spring physic was in old times'. He travelled to the Peak District in Derbyshire, in August 1801, visiting the obligatory beauty spots, such as Matlock High Tor, Dovedale, Chatsworth and Haddon Hall and meeting, coincidentally, Farington. Farington described Dovedale as 'having a very Picturesque pass where the River flows, between high rocks that form side screens, and intersecting each other so as to prevent all distant view', (a typical distinction between the Sublime and the Picturesque).[69]

The sketches which Constable produced (Plate 29) were correctly described as 'slight and general', without the 'beautiful finish or force of chiaroscuro seen in his later studies'.[70] They have also been compared with drawings by Sir George Beaumont and the example reproduced here is very close in its use of monochrome for foliage. Even the point of view, with the village of Edensor tumbling away down the hill, is chosen carefully to look like an Italian hill town, *L'Ariccia*, drawn by Sir George (Plate 30).

Sir George was, incidentally, the friend of the Revd William Gilpin and Uvedale Price, the authorities on the Picturesque. Nevertheless, although at this early stage in his career Constable was trying hard to work in a conventional mode, and his

31. *Windsor Castle from the River*. 1802. Pencil, red chalk and water-colour, 26 × 37 cm. London, Victoria and Albert Museum

mentor, Farington, thought that the area was 'well worth seeing', Constable never went back even though he had relatives nearby. He was to make a similar decision after a quest for the Sublime through the Lake District in 1806.

He also tried his hand at seascapes, as a result of a free voyage he took in 1803 on the East Indiaman *Coutts*, captained by a friend of his father's, Robert Torin. In four weeks he went down the Thames, around the Kent coast, to the Downs in the Channel (Plate 35). He saw and drew HMS *Victory* at Chatham, which provided information for a large finished water-colour of *His Majesty's ship Victory, Capt. E. Harvey, in the memorable battle of Trafalgar between two French ships of the line*, which he exhibited at the Royal Academy in 1806 (Victoria and Albert Museum, R. 65). He returned by way of Deal and Dover to London after his first and only sea voyage of any length. Apart from sea coast studies made on his honeymoon near Weymouth in 1816, and those done at Brighton in the 1820s, the sea never seems to have attracted him as a subject. When in July 1824 the British Institution offered prizes for the best sketches of pictures of the Battle of Trafalgar and the Nile, he could tell Maria, 'It does not concern me much.'[71] His

Brighton sketches are as full of Constable's art as anything he painted, for example (Plate 159), but we know he went there mainly for reasons of his wife's health. He wrote to Fisher in August 1824: 'The magnificence of the sea . . . is drowned in the din . . . and the beach is only Piccadilly . . by the seaside.'[72] Perhaps the monotonous horizontality of the sky and sea were not altogether attractive to him, and he preferred the man-made variety of the landscape in his own Stour valley.

As one final experimental option, Constable considered becoming a drawing master, often the last desperate throw of an unsuccessful artist. It was occasionally profitable, and West reported that drawing masters at Bath made fortunes.[73] Dr Fisher seems to have helped Constable through his connections and Constable duly went to Windsor to be interviewed by General Harcourt for a post at the military academy at Marlow. He also painted a number of water-colour views in and around the Castle (Plate 31). Benjamin West advised against it and Farington thought 'that as he stood in no need of it, He should not accept a situation which would interfere with his professional pursuits'.[74] He decided to turn down the offer of drawing master, even though Beaumont thought he lacked

application, because, as he wrote to Dunthorne on 29 May 1802, 'it would have been a death blow to all my prospects of perfection in the Art I love'.[75] It was for him a wise decision. William Alexander (1767–1816) complained to Farington in 1807 that his duties at Marlow were far too onerous and that he was unfit for anything.[76]

Thus, by 1802, Constable had tried, or was about to try, every possible course open to him as a professional artist and with some he would regularly persevere, much against his personal inclinations. He had to make a decision about his future and in the same letter to Dunthorne in May 1802 he wrote that: 'For these few weeks past I beleive I have thought more seriously on my profession than at any other time of my life — that is which is the shurest way to excellence.' Having seen Sir George Beaumont's pictures again, he returned 'with a deep conviction of the truth of Sir Joshua Reynolds's observation that "there is no *easy* way of becoming a good painter." It can only be obtained by long contemplation and incessant labour in the executive part.' Constable continued these 'reflections' on his art for his own benefit, and which he thought Dunthorne would be interested to hear. We are grateful that he did, for in them we find a plan of campaign for his entire career:

> However one's mind may be elevated, and kept up to what is excellent, by the works of the Great Masters — still Nature is the fountain's head, the source from whence all originally must spring. ... An artist is in danger of falling into a manner. For these two years past I have been running after pictures and seeking the truth at second hand. I have not endeavoured to represent nature with the same elevation of mind — but have neither endeavoured to make my performances look as if really *executed* by other men.

He decided not to waste his time with 'common place people'; clearly he thought Dunthorne was not, and he proposed to 'return to Bergholt where I shall make some laborious studies from nature — and I shall endeavour to get a pure and unaffected representation of the scenes that may employ me with respect to colour particularly and anything else — drawing I am pretty well master of'. 'There is little or nothing in the exhibition worth looking up to.' (He had exhibited *A Landscape* at the Royal Academy of 1802.) 'There is room enough for a natural painture. The great vice of the present day is, *bravura*, an attempt at something beyond the truth.'

In his hopes to be independent from the pressures of the art world, Constable was no different from many other young artists. A little over 100 years later the young Mark Gertler saw 'more unfortunate artists . . ., talking art, Ancient art, modern art, Impressionism, Post-Impressionism, cubists, spottists, Futurists, Cave Dwelling, Wyndham Lewis, Duncan Grant, Etchells, Roger Fry. I looked on and laughed to myself . . . and I walked home disgusted with them all.'[77] Constable was also disillusioned with the contemporary art scene. In his belief that '*Truth* (in all things) only will last' he was also no different from young students, but what was special about Constable's declaration was that he would keep to it. Henceforth, he was to be lukewarm about earning his living in the conventional modes that have been described.

He had made the acquaintance of three important figures in the world of art, Beaumont, Smith and Farington who had encouraged him. They, in turn, had introduced him to three great masters, Claude, Gainsborough, and Girtin, who were to be of equal influence. In the face of the success of his contemporaries, and the pressure of his family, he kept on with an independent quest for 'natural painture' and attempted to avoid 'bravura', an attitude that he knew to be unfashionable. He returned to East Bergholt in the summer of 1802 and painted, on a small scale, landscapes from nature, in which he attempted to realize his aims.

Chapter 3

'Room enough for a natural painture'

The group of five small paintings that can be dated to Constable's summer campaign of 1802 were an entirely new departure for him in technique and style (Plates 32, 33, and 37). They mark an original awareness of reality, of space and the texture of things, as if seen and felt for the first time. There is hardly anything like them in the work of his contemporaries anywhere. These small modest works were done for no one but himself, but in them can be found the seeds of his entire career, and it is not too much to claim for them, that they point the way to the major artistic revolutions of the nineteenth century. If one of the important general tendencies of that revolutionary period was to look at nature more closely, and if this, in turn, required that each individual hand had to make its own way, without subservience to higher ideals or social necessity, then these private works can be cited as pioneer steps along that way.

Admittedly, as in most revolutionary movements, antecedents can be claimed. The composition of *Dedham Vale* (Plate 32) has long been seen to be dependent upon Constable's knowledge of Sir George Beaumont's Claude of *Hagar and the Angel* (Plate 34), which, in 1802, was fresh again in Constable's mind. The dominant tree at the right and the distant view are, in any case, essentially Claudian, apart from their particular source. Similarly, the seated figure at the left of the *View of Dedham Vale* (Plate 33) is a piece of conventional staffage, 'a loitering peasant', in Gilpin's terms, to be found in the works of Sir George himself (Plate 13), and in Gainsborough's early Suffolk painting. At this stage in his career, Constable had not entirely heeded the advice of J.T. Smith about selecting figures from the real world. Nevertheless, the feeling of rough immediacy in all this group is remarkable and individual. To find anything comparable for their texture and naturalistic appearance, we have to look at certain anonymous small sketches of Rome, previously attributed to Gaspard Poussin, of *Sta Trinità Dei Monti and Palazzo Zucchero*, and *The Circus of Maxentius, with the Tomb of Cecilia Metella in the distance*, of the seventeenth century; or *plein-air* sketches by Desportes, Thomas Jones, or Valenciennes, for example, in the eighteenth century.[1] Apart from hearing of Jones through Farington and Sir George Beaumont, it is very unlikely that Constable would have known of these other sketches. A little

later, other artists in England under the tutelage of John Varley attempted to work afresh from nature — artists such as David Cox, Peter De Wint, William Henry Hunt, John Linnell, and Cornelius Varley, and there was, of course, the prodigious example of Turner, but Constable seems to have been equally unaware of their private efforts. He was doing what he said he would do, making 'laborious studies from nature', as if other art did not exist.

In these works of 1802, Constable used for the first time a reddish-brown ground, out of which the banks of earth, the trees, the foliage, and the distant fields emerge. His method of applying paint is not glib, and we get the first division in his technique between that of a water-colourist and that of a painter in oils, which occurs throughout his career. The paint strokes are opaque, laid one upon another, and become the objects they describe. The declivities and hollows are expressed by a lighter or darker tone laid over the ground, in which the texture of the canvas itself is a constituent part, to emphasize the roughness of the earth. The distant fields are painted in a lighter tone dragged across textured canvas. The foliage of the trees, while it owes much to the example of Gainsborough, is suggested by dabs of green, laid on in a series of solid smudges and touches, rather than as areas of wash. These block in the masses and yet give the appearance of shimmering leaves, green against the red ground: the beginning of a life-long confrontation of complementary colours, particularly green against red.

Light, however, he was not yet master of. The effect in all of these paintings, in spite of the blue skies, is the even, moist light of an English cloudy sky. Sunshine and its effect on the colour of objects has so far not made an appearance. His transitions go from black to white in tonal gradations, or in what he was later to call 'chiaroscuro', to which he eventually returned at the end of his career. Even the branches and boughs of the trees are painted as dark brown or black structures, against which the light elements emerge. The light of the sky appearing through the trees is added later, or the ground is left uncovered. From these beginnings, he found a method to draw trees, which he adhered to for the rest of his life. The variety of light and dark over the surface, achieved by the simple opposition of light and dark tonal elements, as a

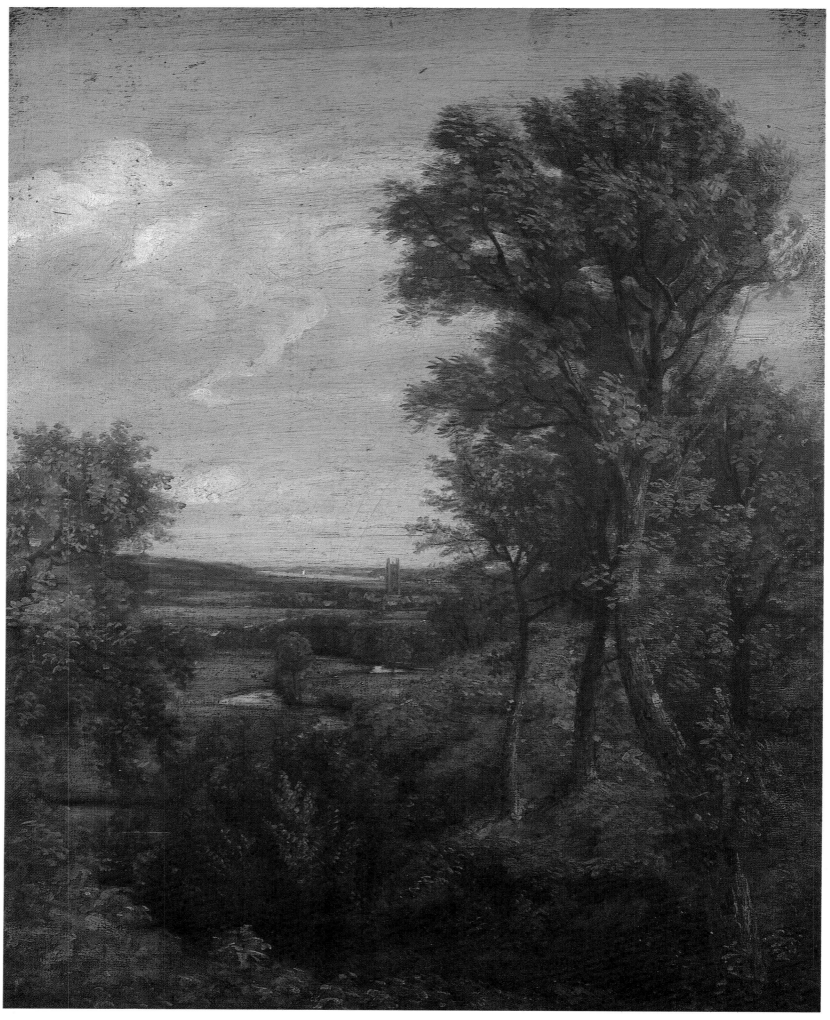

32. *Dedham Vale*. 1802. Oil on canvas, 43.5 × 34.4 cm. London, Victoria and Albert Museum

33. *Dedham Vale*. 1802. Oil on canvas, 33.5 × 41.5 cm. New Haven, Yale Center for British Art, Paul Mellon Collection

method to render mass and depth, is also something he kept to, even when he was much more colouristic. He also forgoes the smooth and subtle transitions of radiant light that he had admired in Claude.

The scenes themselves are equally bluntly chosen. They were what lay around him within, as far as we can identify them, roughly two square miles of his home in East Bergholt. This area, and similar views of it, were to provide him with subject-matter for most of his major works for the rest of his life. These small works are neither grandiose nor sublime, nor obviously 'Picturesque', except for the *View of Dedham Vale* (Plate 32). They do not easily fit the requirements of the picturesque in terms of 'the well-chosen prospect', but they are not mawkish, with a tale to tell. It was not as if, in 1802, he was

unaware of academic requirements. He already knew, through Cranch, Smith, and Beaumont, of the principal preceptors, and he was, perhaps, also remembering Cranch's early warning against Reynolds, that 'it does not bias you against Familiar nature, life and manners which constitute as proper and as genuine a department of imitative art as *The Sublime* or *The Beautiful*'.[2] These Dedham Vale scenes were, in subject and handling, things apart, and were to be the inspiration for all of his future work. He was to find, however, that his approach was not entirely acceptable in the art world, and to gain success he had to enlarge his subject matter by providing greater narrative incident, even as his technique for coping with this wider point of view became more sophisticated and thus more individualized.

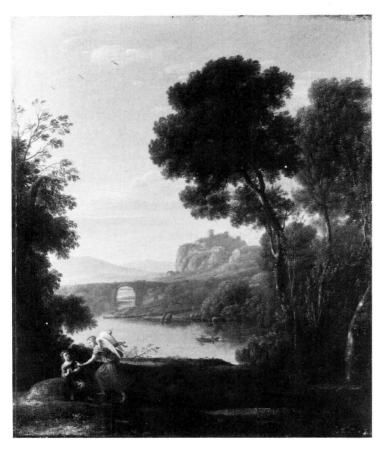

34. Claude Lorrain (1600–82). *Landscape with Hagar and the Angel.* 1646–7. Oil on canvas on wood, 52.7 × 43.8 cm. London, National Gallery

His way forward for his first ten years as an independent artist was not immediately so clear, both for what he should do, and how he should do it. The friendships he had already made with Farington and Sir George Beaumont remained important to him and, on the whole, they supported him, but their attitudes were conservative and, it would seem, occasionally inhibitory. It took time for him to progress on his own. If we examine what we know year by year of this period of establishment, and it is less than at later periods of his life, we can see that he was active, as has already been suggested, in different directions, and with a variety of styles.

He had, in the autumn of 1802, acquired a studio in East Bergholt, diagonally opposite the family house.[3] It was in this studio that Constable worked on his sketches and portraits when he was in East Bergholt, a routine he continued nearly every summer and early autumn, apart from 1807, until 1817. He would sometimes stay months on end, and he was often there at Christmas as well. It was through this regular pattern of work in the fields around his home village and in his small studio that the foundations of his art were laid.

In March of the following year, 1803, he showed and lent his small studies made in the neighbourhood of Dedham to Farington who, in turn, lent him a Wilson to copy. He was to copy other old masters continually and, in May, he bought prints and drawings by Waterloo, and two paintings by Gaspard Dughet. In April he had been on his excursion to the Channel on board Captain Torin's East Indiaman, *Coutts*

(Plate 35). His descriptions of the weather as 'delightful', and 'melancholy', the situation of Rochester and Chatham, as 'beautiful' and 'romantic', of HMS *Victory* and the set of its sails, as 'a charming effect', and of Rochester Cathedral as 'picturesque', are conventional enough. But he was clearly not to be a sea painter in the manner of a Willem van de Velde, the Younger, whose drawings his most resemble (Plate 35), even though this visit was to find a later echo in his large, finished water-colour of *HMS Victory at Trafalgar*, exhibited at the Royal Academy in 1806. Two of the four works he exhibited at the Academy of 1803, immediately after his tour, the first works since the expression of his personal artistic aims the previous year, were described as 'studies from Nature', along with two others called merely 'Landscapes'. The first two may have been those done the summer before. Significantly, however, they were landscapes, as were to be all his exhibited works at the Royal Academy, in spite of his involvement with other sorts of work. As has already been mentioned, in September 1812 he had written to his future wife Maria Bicknell, after a decade of uncertain progress when he was again unwillingly detained by portraits, 'but you know Landscape is my mistress — 'tis to her I look for fame . . .'[4] (see p. 37). The only portrait he ever exhibited at the Academy was to be his portrait of his closest friend, the Revd John Fisher (Plate 93), which Constable had painted on his honeymoon in 1816, and exhibited at the Academy in 1817, perhaps partly out of friendship, or as an attempt to earn money to set up his new home.

If he thought his landscapes were to be well received he was mistaken. They were simply not noticed. He thought that the exhibition of 1803 was in the main 'very indifferent' and 'in the landscape way most miserable'.[5] He criticized Turner for being 'more and more extravagent and less attentive to nature'. He would have keenly noticed the contrast between his earnestly wrought works and Turner's loftier and eclectic visions: *Calais Pier, The Holy Family, Chateau de St Michael, Bonneville, Savoy,* and *The Festival upon the Opening of the Vintage at Macon.* Constable, in his criticism, may well have been echoing the opinions of Sir George Beaumont, who had taken a particular dislike to Turner's art and his challenge to Claude in his *Macon* picture.

Constable did not abandon his original attempts to further his own art, even if he could not rival Turner, and could only feel disappointed at the indifferent reception of his more modest works. As far as we can tell, he spent most of his time between 1803 and 1806 drawing in chalk and water-colour. Very few oils survive that can be dated from this period and those are mostly commissioned works, portraits, and an altarpiece. In October 1803, he visited his friend George Frost, the Ipswich amateur. He and Frost sat and drew at Ipswich two almost identical drawings of *Warehouses and Shipping on the Orwell* and the differences between the two artists is not very obvious.[6] If anything, Constable's hand is firmer and slightly more competent than Frost's, a strength that is revealed in another fine drawing in the Victoria and Albert Museum of *The Windmill* (Plate 36). Constable's study of Ruisdael gave this work a sound basis, to add to his own careful observation, which Frost, inspired only by Gainsborough, could not

35. *Four East Indiamen at Anchor.* 1803. Pencil, 19.3 × 32.5 cm. New Haven, Yale Center for British Art, Paul Mellon Collection

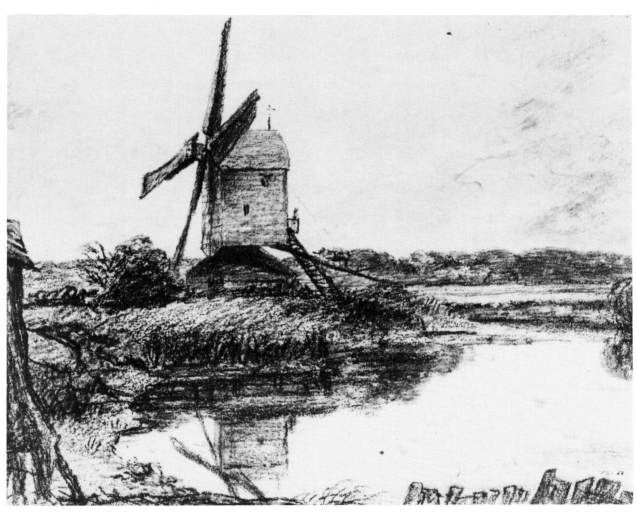

36. *A Windmill.* 1802. Black and red chalk, charcoal, 24 × 29.8 cm. London, Victoria and Albert Museum

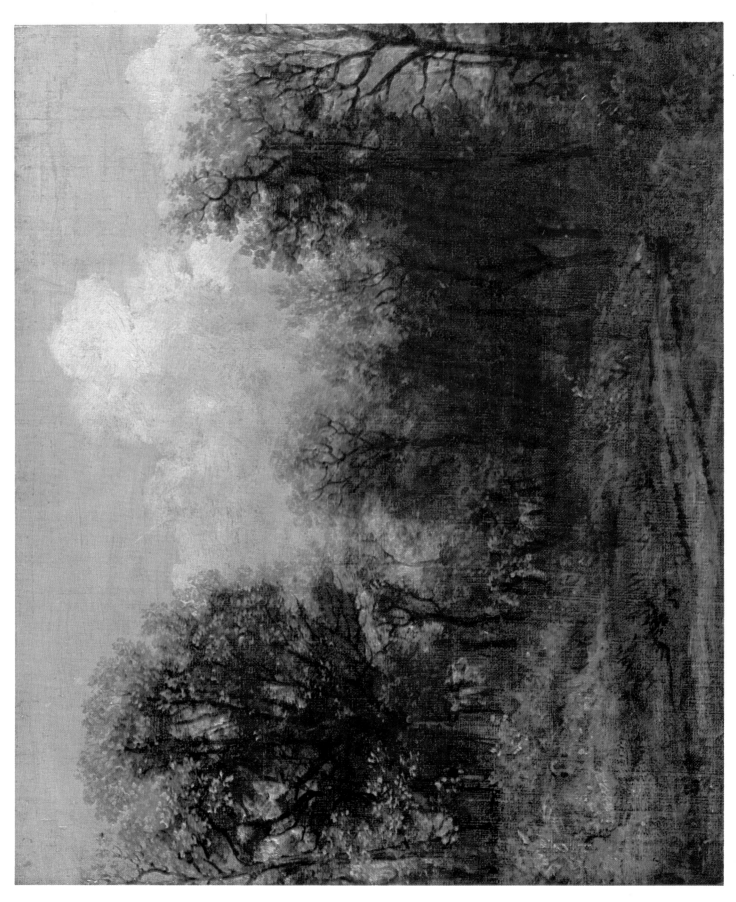

37. *A Wood. c.* 1802. Oil on canvas, 34 × 43 cm. London, Victoria and Albert Museum

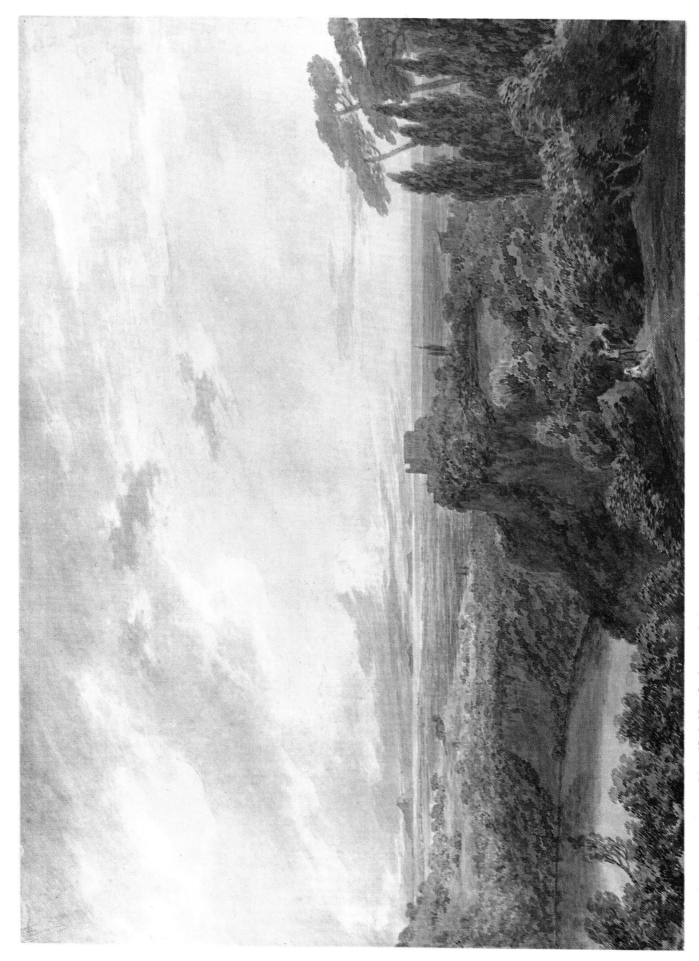

38. John Robert Cozens (1752–97). *View of Lake Nemi Looking towards Genzano. c. 1785.* Pencil and water-colour, 14 × 53.3 cm. London, British Museum

39. *A Wooded Landscape with a Track.*
c. 1805. Possibly by George Frost. Black
chalk with stump, with white chalk,
34.5 × 57 cm. New Haven, Yale Center for
British Art, Paul Mellon Collection

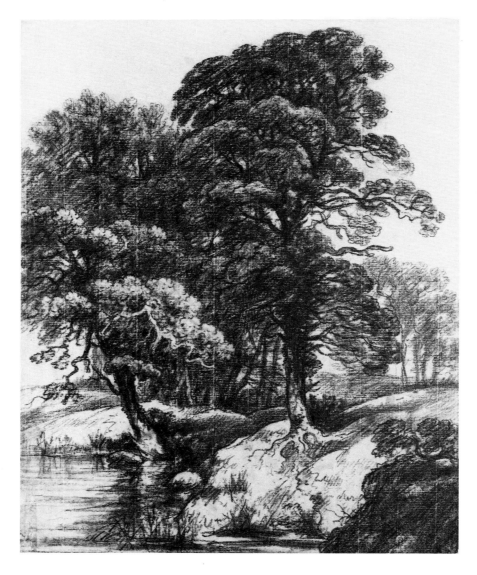

40. George Frost (1745–1821). *Wooded
Landscape with a Pool.* Black chalk,
40.5 × 32.5 cm. New Haven, Yale Center
for British Art, Paul Mellon Collection

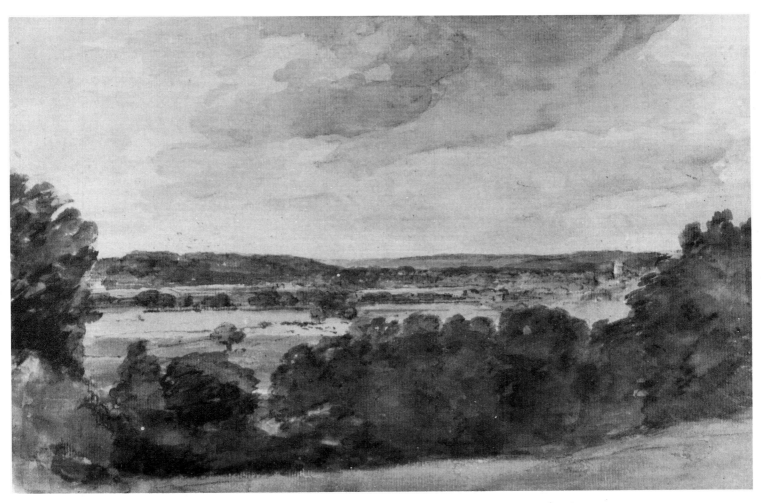

41. *Dedham Vale from near East Bergholt*. 1805. Pencil and water-colour, 18.1 × 29.9 cm. Dublin, National Gallery of Ireland

match. Even as late as *c*. 1805, however, their drawings are difficult to tell apart (Plates 39 and 40). To an obvious debt to Gainsborough, Constable has added a tendency to simplify the forms of the trees into abstract forms, as if he was unable to cope immediately with all their complexity.

He showed the same characteristics in his water-colours where he also attempted to combine his knowledge of the recent past with his own original observation, in a technique of his own. The wide panorama of *Dedham Vale* (Plate 41), probably dating from 1805, was already very familiar to him and he had already painted something similar in oil, but in his water-colour he began to incorporate what he had learned from Gainsborough, Cozens, and Girtin in a new way. What he knew of the locality of the landscape obviously gave the sheet its sense of confident structure, but there is also a broad and airy vista expressed simply in a succession of blue-grey washes. What Constable described as the 'poetry' of J.R. Cozens (Plate 38) was undoubtedly an inspiration. In his attempt to render breadth and depth of space, however, he may not only have been influenced by these masters of water-colour but also by the example of Rubens. Lady Beaumont had purchased for her husband, in May 1803, the large autumn landscape by Rubens known as *The Chateau de Steen* (Plate 122), for 1500 guineas from William Buchanan, the dealer. Constable saw it in Benjamin West's studio on 10 February 1804,

when he thought it 'the finest of the Master he had seen'.[7] He was not able immediately to come to terms with its overwhelming impact, and the lessons of Rubens' baroque landscapes are not fully integrated in his art until his masterpieces of the 1820s, in such works as *The Hay Wain* (Plate 125), or his Hampstead Heath pictures (Plate 124). Nevertheless, the confident sweep and breadth of the Dublin water-colour are an advance on his 1802 landscape studies, which his knowledge of the water-colour masters and Rubens may have helped to bring about.

Discouraged by the lack of success in 1803, Constable confessed to Farington on 9 February 1804, that he did 'not think of exhibiting, conceiving that nothing is gained by putting pictures in competition with works which are extravagent in colour & bad taste wanting truth'. The gist of his worries about exhibiting publicly his original studies from nature is clear. Farington sensibly advised him that 'much would be gained by it as He would in an Exhibition see his own works with "A Fresh eye" & better judge of their real quality'.[8] Lady Beaumont, in April 1804, asked about him and thought that Constable 'seemed to be a weak man', but he stuck to his decision and did not exhibit.[9]

That summer of 1804 his lack of confidence that his pictures would stand up to competition seemed to result in his producing few landscapes for public consumption, other than

the drawings and water-colours already mentioned. He told Farington that he had been painting local portraits, as part of his varied attempts to diversify his professional career. He did, however, travel to Hursley, Hampshire, and a fairly finished wide panorama resulted, now in the Victoria and Albert Museum, (R.53), and a view in oils of the *Stour estuary*, Beecroft Art Gallery, Southend, has also been dated to then, as well as an unusual view of the *Stour Valley, from Higham*, in Berlin.

He seems to have been more active in 1805, from which dated water-colours survive. His apparently deliberate campaign to expand his researches into water-colour and not exhibit his experimental oils, produced a number of fine examples of which the Dublin sheet is one.[10] An oil of *The Valley of the Stour* (Plate 42) is painted almost like a water-colour with the same globular conventions for trees and thin washes of colour. It is particularly important, however, in his choice of subject, as a comparison with a present-day aerial photograph of the view demonstrates (Plate 43). The vista is one that he had already painted, and one that he was to return to as late as 1828. It is that from Gun Hill, near Langham, looking down the Stour Valley towards its estuary, with the tower of Dedham Church prominent on the horizon. This is his country. We can see by the comparison how accurate Constable has been for the principal features, allowing for the more recent growth of trees and the dominance of the new road bridge for the Ipswich-Colchester road. The meandering river and the character of the valley remain, and in this unfinished picture we find an early expression of his hopes to make something eternal out of his own homeland.

He exhibited, however, at the Royal Academy of 1805, a *Moonlight Scene*, now lost, which must have been another sop to contemporary taste, and he was equally busy that summer with an altarpiece for St Michael's Church, Brantham, Suffolk, of *Christ Blessing the Children*, which was probably commissioned for Dr Rhudde, the Rector of East Bergholt. Constable's uncle, David Pike Watts, criticized it for losing by too much reworking what he called '*The Devotional Sentiment*': . . . 'It may be a more finished work of Art, but the Spirit, the Devotion, the Effect is gone, at least the Effect on my eyes, like a portrait in its *free* state perfectly resembling the original & afterwards the Likeness partly lost by finishing.'[11] The retouching may have continued until 1807 or 1808.

This criticism must have been depressing to read. His uncle was quick to criticize his next altarpiece of *Christ Blessing the Sacraments*, of 1810, St James, Nayland, for exactly the opposite reason, in twenty-five detailed points, for its lack of 'finish'. 'It is scarcely justifiable for any picture to be shewn so *raw*' and 'its present *smear'd* state' grieved the writer, but in both letters he hit upon an important dilemma for Constable.[12] The degree of 'finish' was a crucial element in his attempt to 'get a pure and unaffected representation of the scenes that may employ me', as he had proposed ambitiously in 1802. 'Extravagance' he abhorred, but how was he to express the spirit of the place without the roughness and variety of what he saw? So far, his drawings, water-colours, and paintings had been endeavours to solve this dilemma, which was made more complicated by his need on the one hand, to assimilate the sophisticated examples of the old master he admired, and on

the other hand, to please contemporary taste. His constant tinkering with, and reworking of, his mature finished works was a continuation of this worrying problem, that his uncle had drawn attention to early in his career, of how to make permanent nature's fleeting effects. As late as 1833, he confessed to Leslie, in a moment of frustration after a visit by a 'connoisseur' rather like David Pike Watts: 'Good God, what a sad thing it is that this lovely art — is so wrested to its own destruction — only used to blind our eyes and senses from seeing the sun shine, the feilds [*sic*] bloom, the trees blossom, & to hear the foliage rustle — and old black rubbed-out dirty bits of canvas, to take the place of God's own works.'[13]

And yet, in 1806, he went through the motions of doing what had to be done. His appearance at this time is recorded in a self-portrait, still in the family collection (Plate 7). He exhibited his finished water-colour of *HMS Victory at Trafalgar* at the Royal Academy. He received his first commission for the illustration of a book of epitaphs and monumental inscriptions, for which he used his local knowledge of the East Bergholt Churchyard as the background for an allegorical design of a tombstone in the manner of Stothard. It incorporated a quotation from one of his favourite poets, Gray, and his *Elegy*. He went to Markfield House, Tottenham, near the haunts of his old friend, J.T. Smith, in the summer of 1806, to produce a series of drawings of the young ladies of the Hobson family. Regardless of the circumstances of a possible portrait commission, we wonder which one he was attracted to. Emma seems to have been a favourite. In August he stayed with his relatives, the Gubbins at Epsom.

David Pike Watts was, however, helpful that autumn. He paid for his nephew to make a conventional excursion to the Lake District. As Leslie records, 'he spent about two months among the English lakes and Mountains [from 1 September to at least 19 October], where he made a great number of sketches, of a large size on tinted paper, sometimes in black and white, but more often coloured'. Leslie realized they abounded 'in grand and solemn effects of light, shade, and colour but', he went on, 'from these studies he never painted any considerable picture, for his mind was formed for the enjoyment of a different class of landscape'. This is not entirely fair, for Leslie does not allow these sketches their originality in contemporary terms. Constable travelled to Ambleside at the head of Lake Windermere, and then stayed with his hosts, the Hardens, at Brathay Hall. Mrs Harden recorded that he was 'the keenest at the employment I ever saw and makes a very good hand at it. He is a nephew of Mr Watts the late proprietor of Storrs, but chose the profession of an artist against the inclinations of his friends, at least so he says and I don't doubt him. He is a genteel handsome youth.'[14] He was aged 30, and was painted by John Harden.[15]

It was at the Harden's that he met James Lloyd, whose portrait he painted and whose sister, Priscilla, was married to Christopher Wordsworth, William Wordsworth's brother. Through his hosts and their friends, therefore, he met the poet and his friend, Coleridge. Much has been speculated about the ensuing relationship and its influence upon Constable's art. We know more since the discovery of a letter from late in Constable's life, but at this stage in his career he was obviously

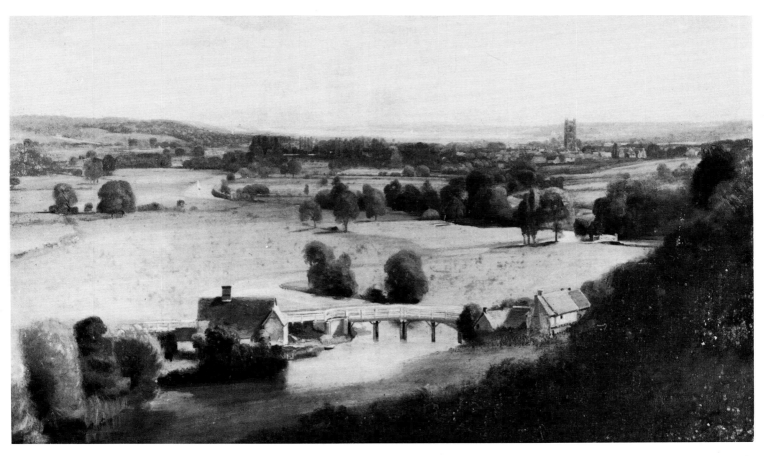

42. *The Valley of the Stour, with Dedham in the Distance. c.* 1805. Oil on paper laid on canvas, 49.8 × 60 cm. London, Victoria and Albert Museum

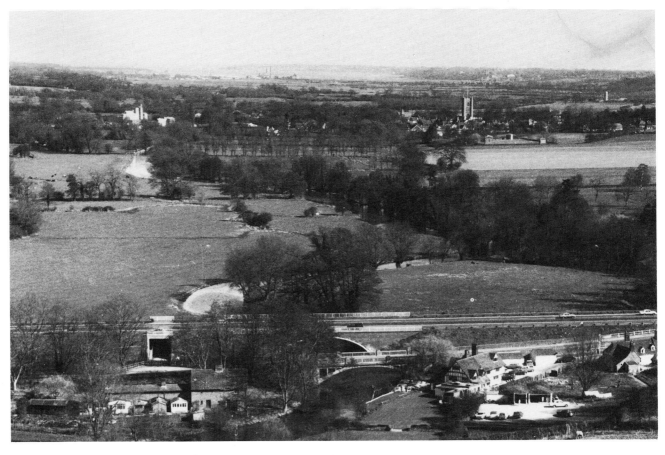

43. Aerial photograph of Dedham Vale

44. *The Vale of Newlands*. 1806. Grey wash and pencil, 15.5 × 23.9 cm. Cambridge, Fitzwilliam Museum. Inscribed: 'Sunday 22 Sepr.–1806–Vale of Newlands very stormy afternoon'.

impressed by this new literary lion, of whom his friends in London all spoke, and whose own home territory he was for the first time visiting.[16] At a dinner given the following year by his uncle, David Pike Watts, he was actually to be rather sharp about 'the high opinion Wordsworth entertains of Himself'.[17] For a moment, his eyes were on the hills which he then explored, but through the Lloyds, he also gained some portrait commissions which took him to Birmingham in December.

From Lake Windermere, he travelled with George Gardner, the son of Daniel Gardner, who had painted Constable's portrait in 1796 (Victoria and Albert Museum), to north Keswick and on to Saddleback (21 September), and Skiddaw. They then went back to Borrowdale, where George 'got tired of looking on' at Constable's industriousness and returned to Brathay. Constable kept at it for nearly another month. The last dated drawing is from 19 October 1806 done at Langdale, back on the route to Brathay. In spite of the awful rainy weather that most visitors experience in this area (and some of his drawings have rain spots on them), he worked diligently. A particular stormy afternoon is recorded in the *Vale of Newlands* (Plate 44), on 22 September 1806. It is one of many such instances of his noting the time of day and the actual weather conditions that obtained when he executed this dramatic monochromatic drawing, a habit he continued. Leslie tended to discount this Lake District tour, recounting how he 'had

heard him say the solitude of mountains oppressed his spirits. His nature was peculiarly social and could not feel satisfied with scenery, however grand in itself, that did not abound in human associations.'[18] But in a frenzy of activity Constable had produced over seventy known drawings rather like Turner's hectic activity on his first trip to the Alps.[19]

In spite of what he later said to Leslie, there is no doubt that Constable's Lake District studies have a particular strength and originality. They can be compared with any of the contemporary productions of the recently formed (1803) 'Old' Water Colour Society. These dramatic water-colours were not known because they were not exhibited, but it is clear that to the poetic atmospherics of Girtin he has added a more vigorous interpretation, which Girtin only rarely achieved in, for example, his water-colour of *Storith Heights*.[20] The stark grandeur of Constable's view of *A View in Borrowdale* (Plate 45), bears comparison with Girtin, not only in his ability to render the craggy hills at the left, and the flat expanse of water, but even in the monochromatic ochres of his palette, which is so like the appearance of many of Girtin's water-colours (Plate 64). The mountainous landscape and stormy weather obviously affected how and what he drew, but he had also learned something from the powerful example of Turner and the doctrines of the sublime. In 1814 he encouraged Maria Bicknell to take up an invitation to go to Wales for 'the

change, the air, and then the sublime scenery. I did hope that we might have visited these delightfull places together for the first time' but the trip fell through.[21]

From 1806, for the next three years, Constable's experience of the Lake District was to be the source for the majority of his exhibited works at the Royal Academy and the British Institution. Unfortunately, none of these finished works can be identified, though several of the Lake District drawings are squared up as if for transfer to a painting, and we know from Farington's *Diary*, for 3 April 1809, that he was working on a large five-foot picture of Borrowdale. Farington advised against sending it into the Academy, 'being in appearance only like a preparation for finishing, wanting variety of colour and effect'.[22] This was Constable's perennial problem, but although he remained grateful for Farington's support and friendship, we wonder if he swallowed this advice easily, in view of Farington's own tepid and monochromatic topographical works. Constable's attempt to take advantage of the fashionable interest in the sublime does not seem to have been successful, and none of the pictures he produced in this vein seems to have been sold or has survived.

The five years, however, from 1806 to 1811 can be seen, in retrospect, to have been crucial in his slow development, even though at the time they must have been a disappointment to him. At the end of this period his 1802 plan of campaign, to be a 'natural peinture', slowly brought him to the point of serious experiment that was completely original, and he finally seems to have realized his own artistic individuality. He matured, too, as a person. During this period he became deeply attached to Maria Bicknell, the granddaughter of the powerful Rector of East Bergholt, Dr Durand Rhudde, and met John Fisher, the nephew of the Bishop of Salisbury. They were to become, respectively, his wife and dearest friend. To them he confided all his hopes, and from their correspondence we have invaluable information about his progress. In 1806, however, his prospects did not seem so clear.

He had made his first and, as it turned out, only Grand Tour to the mountains, not, admittedly, to the Continent, now closed to British artists. He was never to go in search of conventional landscapes again. All his future excursions were to be for other, personal, reasons. He had had no success with his attempts at conventional subject matter; the seapiece of Trafalgar and his Lake District scenes had not sold. His altarpiece of 1805 for Brantham, and that of 1810, for Nayland were severely criticized by his uncle David Pike Watts. He had actually been commissioned to copy portraits for the Earl of Dysart in 1807, but the invitation had the air of a special local favour. His own portraits, which he disliked doing, did not bring in the income that his parents expected him to make as an independent artist in his thirties. He certainly could not be ranked in professional success with those younger contemporaries against whom Farington fulminated in 1809: 'The prices demanded by some of the young men for their pictures is extravagent even to be ridiculous. Douglas for *The Riposo* — three figures — 300 gns. Mulready for a Carpenter's Shop — 300 guineas.' Constable, meanwhile, had to thank his mother for interceding on his behalf to his father to pay off his debts in June 1808, and she sent him constant presents, such as shirts.[23]

She hoped her parcel would be acceptable: 'So little as we have to do with fashion I cannot answer whether the cambric frills are deep enough — to me they appear far beyond any I have ever made — but Abram says they will do; — if they prove too deep, it will be easy to cut off the hem and rehem them.'[24] She also sent 'country fare', a 'small turkey' for his landlord, at 13 Percy Street, where he had been since 1807, and, when she could, small sums of money 'for travelling extras', but as she wrote, frankly, in 1809: 'dear John how much do I wish your profession proved more lucrative, when will the time come that you realise!!! [I much] fear — not before my glass is run out.'[25] She was, unfortunately, proved right.

Nevertheless, having made up his mind in 1802 what he wanted to do, he had persevered. He may have been encouraged at just the right time to keep to his own course by the success and ambitions of younger artists with whom he had become friendly, principally David Wilkie and Benjamin Robert Haydon. Their work was very different from his. Haydon's grandiose and extravagant aims to rival the Ancients were a world apart from Constable's naturalistic bent. In 1805, for example, Haydon had proposed 'a Colossal Statue of Britannia', 150 feet high, 'with her Lion at her feet, surveying France' (from the top of the White Cliffs of Dover), 'with a lofty air'.[26] Not surprisingly, as Haydon so often found with his acquaintances, his friendship with Constable did not last.

Wilkie, on the other hand, an awkward and provincial Scot, had also befriended Constable, an awkward and 'guileless' East Anglian (as Mrs Fisher had described him). He had painted with Wilkie in the Academy life classes and their different views of what form realism should take were an obvious point of sympathetic discussion. Constable's studies from the life of November 1808 certainly are the equal of Haydon's inept striving for 'the great purposes of art' (Plate 24) of the same year. Wilkie had already achieved fame, much to the scorn of Haydon, with his *Blind Fiddler* and *The Rent Day*, purchased by two leading patrons of British art, Sir George Beaumont and Lord Mulgrave. Constable had not yet received such patronage from the 'refined, educated, classical Noblemen', whom Haydon despised, but Wilkie's success in his own version of Dutch genre may well have encouraged Constable to explore his own avenue of natural landscape.

The only year he did not visit Suffolk was 1807. In the second half of the year he was busy copying portraits for Wilbraham Tollemache, 8th Earl of Dysart, and his sister, Lady Louisa Manners at their town house in Piccadilly. From August to October 1808, however, he managed a trip to East Bergholt. His landscape sketches, done before the dated academic studies of November, show where his real interests lay. The view from the back of his parent's home, looking towards the Rectory (Plate 47) is, at first sight, slight and unimportant. It has no obvious centre of interest, apart from the firm accent of the tree at the left, yet it is a quiet gem, which continues the aims of his 1802 studies and looks forward to his major achievements.

Significantly, it is in the opaque medium of oil, which allows reworking. It shows a much greater grasp of atmosphere than his earlier sketches. Because of his wider experience of art and nature in its more turbulent moods in the Lake District, he is

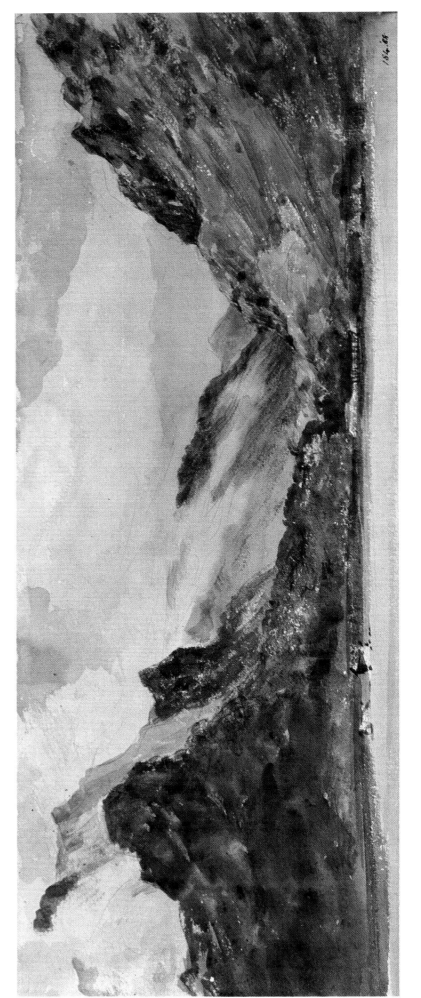

45. *A View in Borrowdale*. 1806. Pencil and water-colour, 14 × 38 cm. London, Victoria and Albert Museum

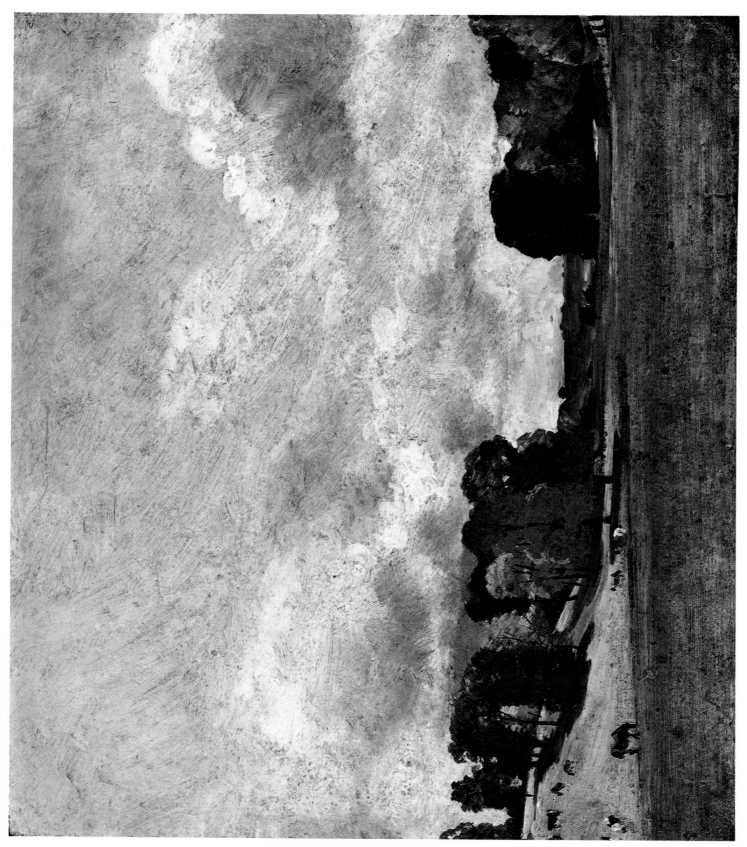

46. *A View at Epsom.* 1809. Oil on board, 29.7 × 35.8 cm. London, Tate Gallery

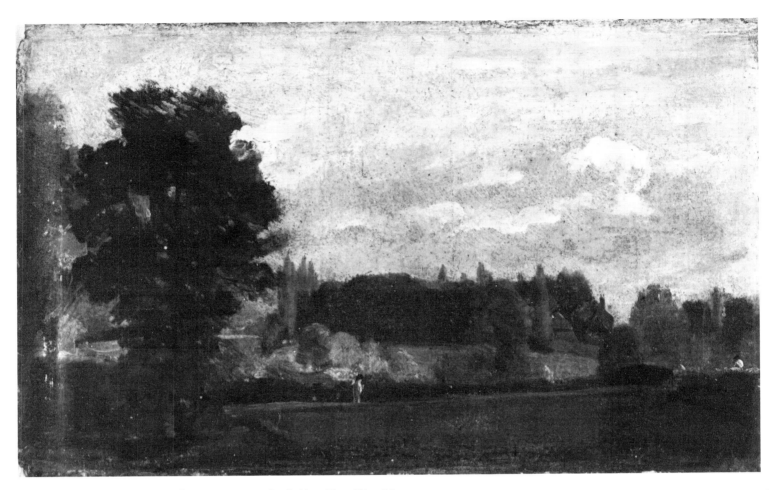

47. *East Bergholt*. 1808. Millboard, 16.2 × 25.1 cm. Cambridge, Fitzwilliam Museum

now able to render sunlight and shadow by careful tones of dark and light greens, with his reddish-brown ground used as a complementary accent to enliven the overall effect. Constable, the previous year, had criticized Callcott to Farington, for his 'pedantick manner', which 'did not have the air of *nature*, that the trees appeared crumbly — as if they might be rubbed in the hand like bread; not loose & waving, but as if the parts if bent would break; the whole not lucid like Wilson's pictures, in which the objects appear floating in sunshine.'[27] The generalized masses of foliage and fields in Constable's small sketch, and the light of a changeable sky, are definite steps towards a total lucidity, and the objects begin to float in light.

The following year, in July 1809, he received a commission to visit Solihull, Warwickshire, and produce for Henry Greswolde Lewis, brother of Magdalene, Dowager Countess of Dysart, a view of his house, *Malvern Hall* (Plate 49). The exigencies of a commissioned house view put his work more firmly in the realm of Wilson but, like Wilson, he was not entirely subservient to the demands of his patron. The light across the lake and the shadows beneath the trees give the picture a depth and a resonance that does owe much to Wilson, but his sense of the actuality of the trees is individual. He had also produced the original of the portraits of his fussy patron (Plate 25), probably in 1807, and in 1809, he painted Lewis's thirteen-year-old ward, *Mary Freer* (Plate 27), a patchy study in

the anxious reinterpretation of his idol, Reynolds, influenced no doubt by his copies for Lord Dysart. Lewis was to prove a nuisance throughout Constable's career.

That year, however, in October 1809, he was able to resume his adventurous sketching in oil. The sketch of a *Lane near East Bergholt* (Plate 48), painted very near a position which he later used for more finished pictures, is notable for his increased mastery of light. It is in a higher key and its contrasts of light and shade are stronger than his work of the previous year. It is, in addition, more richly textured by the opposition of thick and feathery strokes to represent the hedges and trees. The traveller sprawled in the foreground has the air of having just thrown himself down and is a more realistic piece of staffage than his earlier conventional figures. In the distance is the tower of Stratford St Mary church, and his viewpoint, looking westward along the Stour Valley, is one he used in his finished picture of *Dedham Vale, Morning* (Plate 67) exhibited at the Royal Academy in 1811.

From 1809 on, there is a series of studies and finished works that express his new-found confidence in his aims of 1802. From a modern point of view, his studies remain among his most attractive works, mostly because of their impressionistic character, but it must be emphasized that to Constable and to such contemporaries as saw them, they were merely homework towards finished pictures and were not intended to be exhibited in their 'raw' state. Indeed, these small objects of

private concern, some, done on the spot, in oil, sometimes on paper, pinned to his box on his knees, differ distinctly in technique from the finished works, done in his studio, which he exhibited. They are linked by a common subject-matter of the Stour Valley, and he put all his impassioned quest for natural appearance into both; but whereas the finished works, where they can be identified, are refined and make a conscious attempt to take Farington's criticisms of his 'lack of finish' into account, the sketches explore many different effects of handling and composition, so that no two works look alike. Occasionally, by a 'coup de main', they achieve a spontaneity and brilliance, for example, in Constable's sketch of *Barges on*

the Stour (Plate 68), that, later in the century, Manet strived to achieve. As Constable's eye grew keener, so he increased his variety of effect.

To some extent, this broadening of perception can be traced sketch by sketch during this concentrated period of work. It was made more intense by his need to make a success of his career, and his courtship of Maria Bicknell may have been the spur. He seems to have met her first in 1800, when the Rector, Dr Rhudde, had his grandchildren to stay at the Rectory. In 1809, when she was 21, and Constable was 33, he fell in love. Later on he wrote: 'It is gratifying to me to think that the scenes of my boyish childhood should have witnessed by far

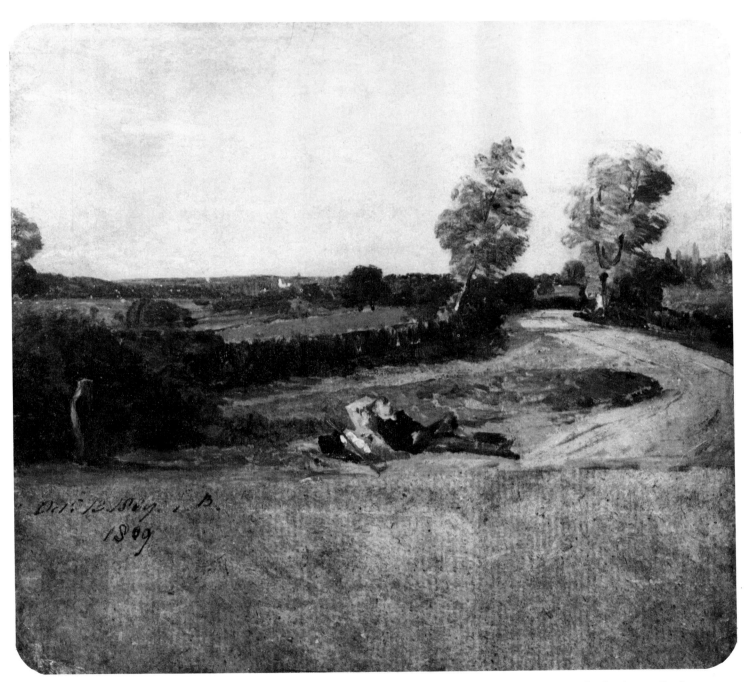

48. *A Lane near East Bergholt with a View of the Stour Valley.* 1809. Oil on paper laid on board, 21.6 × 32.7 cm. England, private collection

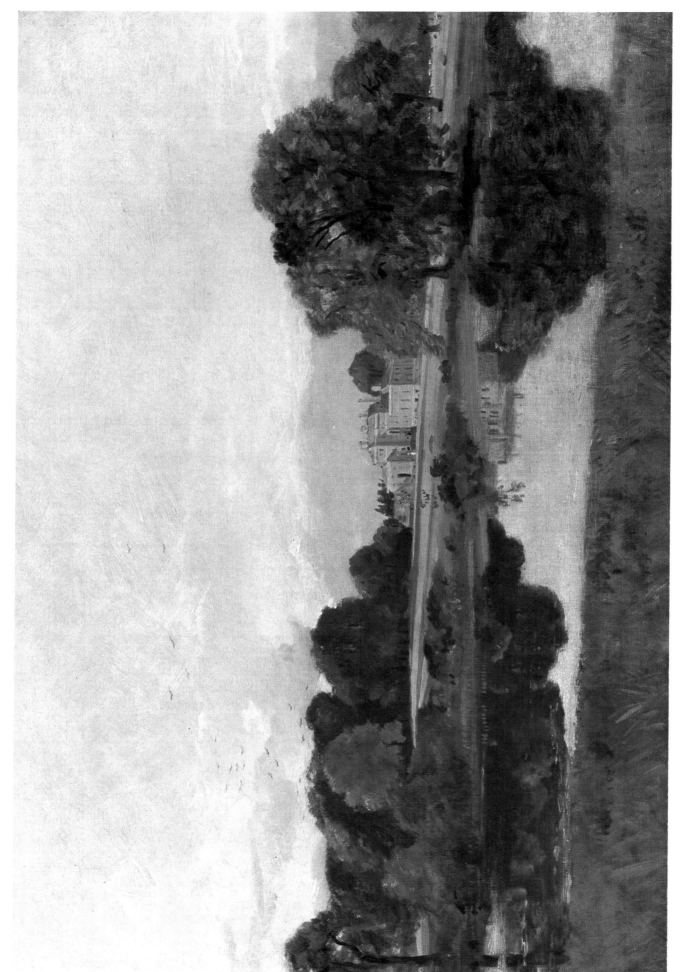

49. *Malvern Hall, Warwickshire*. 1809. Oil on canvas, 51.4 × 76.2 cm. London, Tate Gallery

50. J. M. W. Turner, RA (1775–1851). *The Thames near Walton Bridge. c. 1807.* Oil on panel, 37 × 73.5 cm. London, Tate Gallery

the most affecting event in my life.' To his already 'overween-ing affection' for these scenes, was added his feelings for the places of his courtship.

During 1809 when he had completed his work for Henry Greswolde Lewis at Solihull, and at the beginning of 1810, he and Maria appear to have become close. The Bicknells, at Spring Garden Terrace, near Whitehall (see map, Plate 51) were glad to receive the aspiring artist, though his mother was cautious, as mothers can be, about his becoming too involved. He had shown three pictures to Farington, which he intended to exhibit at the Royal Academy, and for which Farington recommended him to 'imitate nature and not to be affected by worse remarks of critics'. He exhibited, in fact, two works: *The Churchyard* now in the Tate Gallery, and a kitcat landscape (28 × 36 ins), which Constable was overjoyed to report to Farington, had been bought by Lord Dysart in July, for thirty guineas.[28] The good review of the latter painting in the *Repository of Arts* as 'a fresh and spirited view of an enclosed fishpond — a very masterly performance' was especially pleasing, since his father still thought he was 'pursuing a shadow'. Yet Stothard and Farington both agreed that he should put his name down as a candidate for an Associateship

of the Academy. 'However uncertain it may be . . . it would keep Him in the minds of the members. . . . It would have a great effect upon his Father's mind by causing him to consider his situation more substantial: at present (his father) thinks what employment he has he owes to the kindness of friends.'[29]

The Churchyard, although clearly representing East Bergholt porch, can be considered as an essay in poetic nostalgia, in the manner of Gray's *Elegy*, a poem that he had already used in his illustration of 1806. His later work was to return to this romantic vein. His sketches of the same year, however, are confident and vigorous expressions of the here and now, given greater emphasis by what the subjects meant to him person-ally. *A View towards East Bergholt Rectory* (Plate 52), dated 30 September 1810, is a personal hymn to nature. The rectory, where Maria stayed, is seen from behind the Constable home at dawn. Forms are dissolved by the early morning light and the contrast of reds and greens is extreme. It is tempting to read into its intense visionary quality a love-lorn dawn vigil towards the abode of his beloved Maria, but a sketch made three days earlier (27 September), *On the Stour, near Flatford* (Plate 53), has the same violent, colouristic effect. This scene is looking westwards, up river towards Flatford and the setting

52. *A View towards East Bergholt Rectory*. 1810. Oil on canvas laid on panel, 15.3 × 24.5 cm. Philadelphia Museum of Art, John G. Johnson Collection

53. *On the Stour near Flatford*. 1810. Oil on paper laid on canvas, 26.7 × 26.7 cm. Philadelphia Museum of Art, John G. Johnson Collection

54. *Dedham Vale. c.* 1810. Pencil, 75 × 99 cm. Cambridge, Fitzwilliam Museum

sun. It is, in technical terms, a major step from his tonal studies of the year before. Light, its colour, its power to dissolve the forms of the trees and provide coloured reflections on the water, has been expressed in a liquid technique of oil, which is matched by a vibrant and rapid brushstroke. Shadows have become as solid as the forms of the trees, and the overall, even tonality of the previous year has been expanded into a greater range of dark and light, warm and cool colour, thick impasto and thin washes. To find an equivalence for such a study we need to look forward — in France, to Daubigny's, or Monet's, studies from a boat on the river. Constable's contemporaries led by Varley along the Thames, did not achieve such fluidity in oil. Only Turner in his sketches was so outrageous (Plate 50).

Yet not all of Constable's studies of 1810 are concerned with colour to this extent. He was still experimenting with light, in terms of tone, to explore depth and space. The pencil drawing of *Dedham Vale* (Plate 54), shows how he expressed the distant

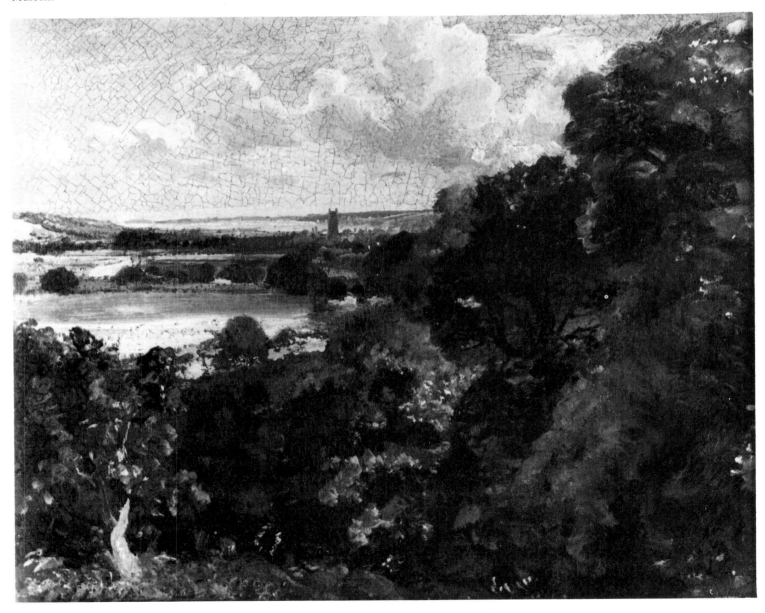

55. *Dedham from near Gun Hill, Langham. c.* 1810. Oil on paper laid on canvas, 25.1 × 30.5 cm. London, Tate Gallery

56. *A Lane near Flatford. c.* 1810–11. Oil on paper laid on canvas, 20.3 × 30.3 cm. London, Tate Gallery

view towards the estuary of the Stour, in respect of the underlying structure of the landscape and the sky above, by the dark and light strokes of his pencil. The dense, cross-hatching of the foreground provides a *coulisse* for the open ground beyond, which is then punctuated by selected, darker details, of which the tower of Dedham Church is a key accent. When he translated the same view into oils on paper, *c.* 1810 (Plate 55), which may antedate the pencil sketch, the overall effect is one of bold, tonal, transitions, from the darks of the dense foliage, to the highlights of the meandering river, and the foreground flickers of white, which presage his 'whitewash' and 'snow' of the 1830s.[30] As Beckett and Parris have pointed out, the view looks eastwards from near Gun Hill, at Langham, (see map, Plate 2), with Dedham Church prominent in the middle ground and the estuary at Harwich in the distance. It was a view he was to paint often, from his earliest water-colour at the Whitworth Art Gallery, Manchester, to his latest oil of 1828 (Plate 169). He was to draw and paint it in horizontal and vertical formats, over and over, but the sketches of 1810–11 for this, and other views of his homeland, had particular significance, when it came to working them up into finished pictures. In all of them, his own researches into the variety of effects of light, and his personal involvement with the scenes that he knew so well, seem to have meant more to him than imitating other art, or creating bland essays in the

Picturesque. On the other hand, these experimental sketches, in view of his way of work, do not seem to have been making a comment on the landscape and what it stood for in social terms, other than what it meant to him.

A Lane near Flatford (Plate 56) of *c.* 1810–11, is a case in point.[31] In it, we can see, with the recumbent figure of the boy drinking from the ditch at the left, the genesis of his *Cornfield* (Plate 169) of 1826. This rapid sketch is no social diatribe against the downtrodden condition of the peasant class who had no decent drinking water. With our piped and filtered water we may wonder at the boy's courage, but in the context of the times it is a perfectly reasonable act of everyday life. (To Constable the cause of typhoid, from which his friend Fisher died in 1832, was then unknown.) More important is Constable's memory of his early instruction from J.T. Smith about choosing figures in a landscape and his skill at translating the figure into a vibrant touch of red within the ravishing naturalistic sketch of a breezy summer's day. The strong contrasts of red against green, the blue figure against orange at the right, the bold hint of a double view into space at the left and right, the fluid and juicy impasto are all part of his wholehearted attempt to render nature in its complexity. Light and dark, the movement of atmosphere, the solidity of trees and the density of shade were enough of a struggle for him to comprehend.

57. *A Lane at East Bergholt.* c. 1809–10. Oil on paper laid on canvas, 23.9 × 30.2 cm. London, Victoria and Albert Museum

Not all of these sketches are dated, but some can be placed between 1810 and 1811 by their increasing complexity and freedom of handling. The earliest of this group may well be the rear view of Constable's home, *East Bergholt House* (Plate 59), although dated by Reynolds to 1811. This long panoramic view with the church at the left and the stables at the right, is rubbed, cracked, and creased, and has been particularly damaged at the left, but what remains is sharp and precise in tone and may possibly date from as early as c. 1809, the supposed date of another view of the house in the Tate.[32] The treatment of the trees in both views is very similar. Another relatively simple sketch of a *Lane at East Bergholt* (Plate 57) may date from c. 1809–10, and can be compared for its fairly conventional composition, its overall tonality and the wet, dense, flat areas of colour, with the dated sketch in a private collection of 1809 (Plate 48). It can be seen as a transitional work leading to the greater freedom of the two sketches (Plates 52 and 53) of September 1810.

A number of sketches of Flatford Mill seem to have been produced that summer of 1810, as his mother wrote to him on 8 January 1811: 'Your uncle (David Pike Watts) . . . was so much taken with one of your sketches of Flatford Mills, House &c that he has requested you to finish it for him. It struck him forcibly as the place where his much loved and valued Mother breathed her last.' In December 1810 his uncle had already asked him if he had 'touched the small "Flatford Mill?"' He wanted it 'worked up', 'to bear close examination', and he most emphatically did not want 'Effect', which is what these sketches had in abundance. None can be considered 'finished'. One (Plate 58) may date from 1810, in view of its calmer appearance and slight yellowing of the trees at the right, which, perhaps, denotes the coming of autumn. The boy at the right, opening the lock, is clearly an everyday figure at this spot, where the locks ran parallel to the mill-race, and he was to be the prototype of his figure in *A Boat Passing a Lock* (Plate 183), of 1826. This Flatford sketch can be compared in technique with the view near Flatford (Plate 53) of September 1810. His uncle was trying to help and, in fact, gave another supper party for his benefit on 25 January 1811, with Farington, Stothard, Owen, and Lawrence among the guests.

58. *Flatford Mill from the Lock. c.* 1810–11. Oil on canvas laid on board, 15.2 × 20.9 cm. Private collection

It is not clear, however, whether Constable ever did work up a picture by touching up a sketch, which was not his normal method of operation and at least three other, almost identical and unfinished views are known. The finished picture (Plate 60), which was finally exhibited in 1812, and which has only recently been rediscovered, is the same design but it is very different in technique and does not seem to have been owned by David Pike Watts.

He was at work on further Flatford Mill scenes the following summer, either in June, when he told Farington that he had been sketching from nature for three weeks, or later that summer, when he wrote to Maria on 12 November, that he had 'tried Flatford Mill again'. The vigorous sketch, *The Flatford Mill* (Plate 63), may date from the summer of 1811. Stooks of corn can just be made out as a series of dots in the meadows at the right. An almost identical sketch in the collection of Lord Binning has the same detail. Another, presumably earlier, sketch in the Royal Academy shows the reapers still at work. The meadows are near those that appear again in *The Hay Wain* (Plate 125).

The sketch in Plate 66 is painted on a fine grained canvas with much of the red-brown ground showing through, over which he painted in a last bold touch, the dark green of the trees at the right. On the left, the outlines of the mill buildings have been squarely blocked in and the planes of the mill repeated in three subtle tones of brown at the end, red-brown for the front, and a grey-brown for the roof. The sky is worked up from dark to light, with the white clouds added last, but the trees go from light to dark with the almost black branches painted on the surface — an inimitable method since the 1802 sketches, and for the future. Detail and texture are added to the foreground by thick impasto laid on with a small palette knife, and flicks of white and red are used arbitrarily to give sparkle at the left, and at the extreme right. There are dramatic accents of light and dark all over the surface, held together by the unacademic motif of light and dark reflection juxtaposed and coming right down the central line of the picture from the distance out to the spectator. Nothing as adventurous or colouristic had been seen since the Girtin's *White House at Chelsea*, which Turner, significantly, so admired. This was

59. *Golding Constable's House, East Bergholt. c. 1810–11.* Oil on millboard laid on panel, 18 × 50 cm. London, Victoria and Albert Museum

60. *Flatford Lock and Mill*. 1812. Oil on canvas, 66 × 92.7 cm. Washington, D.C., Corcoran Gallery of Art, anonymous loan

61. *A Cart on a Lane near Flatford.* 1811. Oil on paper laid on canvas, 15.2 × 21.6 cm. London, Victoria and Albert Museum

undoubtedly one of the instances of Constable's admiration for Girtin (see Plate 64), and is the closest that his art ever comes to a similar 'impressionistic' phase in Turner's art (Plate 50, *The Thames near Walton Bridges, c.* 1807). *The Flatford Mill* is a key work of this series and shows how far he had come in his sketching between 1802 and 1811.

Other sketches can also be dated to 1811 because of their similar daring effects. *A Cart on a Lane near Flatford* (Plate 61) is actually dated 17 May 1811, and another (Plate 66) may represent the same lane leading down to the river Stour, whose sparkle can be glimpsed at the left, while Dedham Church tower can be just discerned through the trees at the right. This sketch is seen from a closer viewpoint than the Victoria and Albert Museum example, and we are further into the trees. The cart has just gone by, and a boy leans on a log at the left. Both make much use of black and white accents, with rapid squiggles of green against the red ground. There are also flicks of white in the foreground.

Not all of these extreme experiments, many of which were clearly dashed off in front of nature, were done in 1811. A group of Stoke-by-Nayland sketches are equally vigorous, but in a paler hue. They may have been painted when he visited

Stoke-by-Nayland to fulfil a commission from his aunt Martha (Patty) Smith, his father's sister, to paint an altarpiece for the parish church of the adjacent village of Nayland about seven miles up the river Stour from East Bergholt. This may have been ordered in 1809, but was not actually delivered until November 1810, as he changed its design from one representing 'The Agony in the Garden' to 'Christ Blessing the Sacrament'. His uncle (and his family) proudly saw it installed and he conceded it 'had strong claims to praise', but promptly sent him the twenty-five points of detailed criticism, mainly about its lack of 'finish' already mentioned. The same could certainly be said about his sketches at Stoke-by-Nayland. Its distinctive church tower is recognizable in a number of pencil drawings in a sketchbook of *c.* 1810–11, a number of oil sketches possibly of 1810, where a figure carrying faggots appears, taken from drawings done on the spot and the sketch reproduced here (Plate 62), where the figure does not appear.[33] They all date from *c.* 1810, and although his handling is loose, the paint is applied in flat areas rather than the nervous, broken touches and accents of the 1811 sketches. There are, however, further drawings and sketches from 1813, 1814, and 1815, and the subject was obviously thought well enough of to be

62. *Stoke-by-Nayland*. 1810. Oil on canvas, 28.3 × 36.2 cm. New York, Metropolitan Museum of Art, Charles B. Curtis Fund, 1926

included in the published engravings for his *English Landscape Scenery* (see p. 198). Its accompanying text emphasized 'the solemn stillness of Nature in a summer's Noon, when attended by thunder clouds'. The scene was to make its final appearance in his late picture of 1835 (Plate 213).

It is from these sketches in the valley of the Stour that the basis for his later mature work was laid. This group of sketches is revolutionary, not only in the context of his own career, but also when compared with anything done by his contemporaries. Their compositions and handling are entirely free and without any hint of conventionality. His commitment to the area was already clear, as has been suggested; but his finished works were to be something else, more than extensions to the ground work of 1810–12. His finished statements were attempts to create something more lasting, that would be less private and immediate, and appeal to the world at large.

Outstanding among his early finished works is *Dedham*

Vale: Morning (Plate 67), which he exhibited at the Royal Academy in 1811. Leslie knew it well and described its qualities sympathetically:

> In the 'Dedham Vale' an extensive country is seen through a sunny haze, which equalises the light, without injuring the beauty of the tints. There is a tree of a slight form in the foreground, touched with a taste to which I know nothing equal in any landscape I ever saw. Such pictures were, however, too unobtrusive for the exhibition, and Constable's art had made no impression whatever on the public.

David Lucas later commented that Constable 'has often told me this picture cost him more anxiety than any work of His before or since that period in which it was painted, that he had even said his prayers before it'.

It was based on the view from near the junction of Fen Lane

63. *Flatford Mill from the Lock on the Stour. c.* 1811. Oil on canvas, 24.8 × 29.8 cm. London, Victoria and Albert Museum

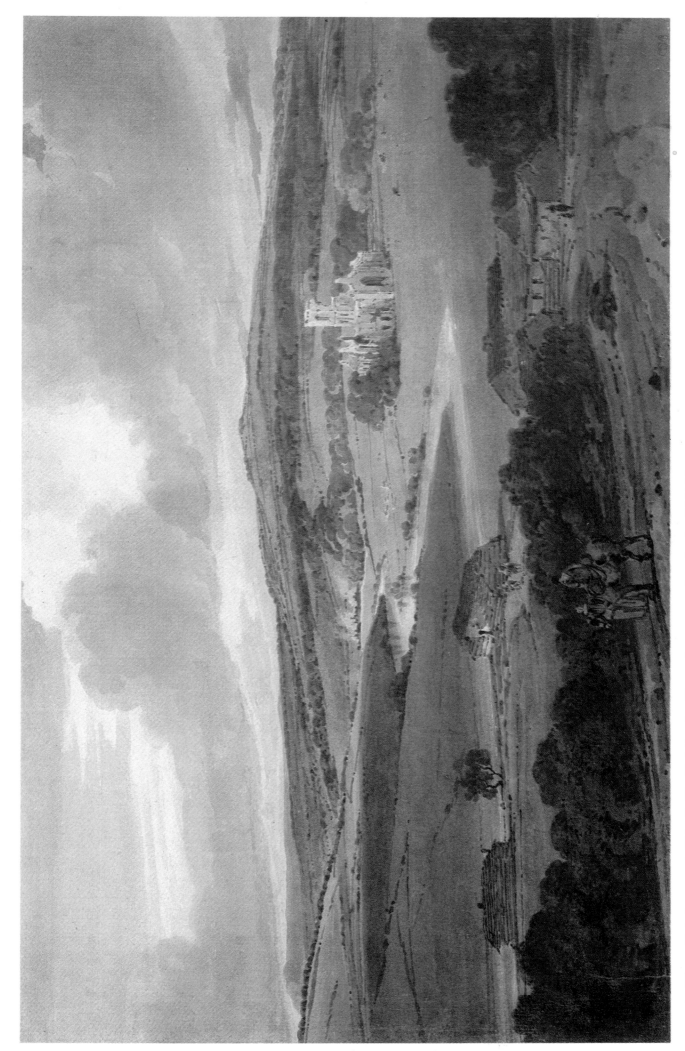

64. Thomas Girtin (1775–1802). *Kirkstall Abbey, Yorkshire*. 1800. Water-colour, 32.1 × 51.8 cm. London, British Museum

65. *East Bergholt Church*. 1811. Water-colour, 40.6 × 61 cm. Port Sunlight, Lady Lever Art Gallery

and the road from Flatford to East Bergholt, which swings round to the right. The lane at the left, marked by the accent of red, leads down to Dedham and the Stour Valley beyond. It was Constable's daily route to school, and much of his early experience of life and art went into its creation. The scene came from his own observation in the sketches of 1809 (Plate 48), coupled with his memory of J.T. Smith's advice, not to invent but to wait for the landscape to be suitably peopled. The figures, however, the trees, and the animals, have all been carefully placed to provide subtle accents along the way. The composition of one diagonal crossed by another is meticulously organized. It opens out to the valley, with Dedham at the left, Langham in the middle, and the white accent of the Church of Stratford St Mary at the right, providing a distant echo of the white cow in the foreground. There was in it, too, his love of Claude and his keen knowledge of Dutch art, of Ruisdael, Waterloo, and Hobbema. Above all else was his feeling for the refinement of Gainsborough in the feathery delicacy of the trees at the right, and in the single tree at the left, whose tasteful touch Leslie recognized. Thriving husbandry and the patriotic virtues of a well-tended landscape

were not his major concerns. It was a conscious effort to make his way as an artist, and it remained unsold.

While he was engaged on this, the largest picture he had so far exhibited, he also made a large water-colour copy of an earlier drawing of *East Bergholt Church* (Plate 65), which his mother 'presented in testimony of Respect to the Revd Durand Rhudde. D.D. the Rector on February 25th 1811', as its inscription, lettered by Dunthorne, dutifully recorded. Its aim was obvious enough, to curry favour with the Rector over Constable's courtship of his granddaughter, and its style is equally heavy-handed and careful. The Rector was grateful but distant. He felt obliged enough to send a bank note to purchase 'some little article' by which he may be remembered. After his death in 1819, and his sustained will rattling displeasure towards the young couple, Constable erected a memorial tablet to the Rector and his wife in East Bergholt Church. He had got away in March 1811 to recover his health at his relatives, the Gubbins, in Epsom. His illnesses were nearly always connected with artistic or personal difficulties. He then saw his exhibited pictures, including *Dedham Vale, Morning*, 'much approved' at the Royal Academy. His father, thinking

all was still well between his son and the Bicknells, asked him to intercede on behalf of the mate of the family ship, *The Telegraph*, who had been taken by the press-gang. Mr Bicknell was Solicitor to the Admiralty. Maria, meanwhile, was packed off to Spring Grove near Bewdley, Worcestershire, to stay with her step-sister, Mrs Skey, either to get over the death of her younger brother Durand, or, more likely, to take her away from the attentions of Constable. Their mutual attachment had become obvious, and his uncle David Pike Watts rushed in with letters of portentous advice for his birthday, 11 June 1811: 'A cure for love. Take half a grain of sense, half a grain of prudence, &c &c.' He even attributed the darkness of Constable's landscapes and their lack of cheerfulness 'to the visible traits of an inward anxiety', an early and perhaps prophetic example of Constable's agitation of mind being used to account for the appearance of his paintings.[34]

Constable, during Maria's absence from April until the end of the year, busied himself sketching in the fields at East Bergholt. He then took up an invitation from his prestigious friends, the Fishers, to stay with them at the Bishop's Palace in Salisbury, where he remained from September to October 1811. They arranged a trip to Stourhead, where they were able to spend a few days with Sir Richard Colt Hoare, the banker, antiquarian, and patron of Turner, and to Longford Castle, to see the Earl of Radnor's famous collection of pictures. Constable was for a moment in a privileged world of high patronage, made palpable by the Picturesque of Stourhead and its gardens, and the sight of one of its progenitors, the Radnor 'Rubens' of the Escorial. His response was personal and tentative. He made some pencil sketches of Salisbury and its surroundings, a future source of subject-matter. He gained a commission for a portrait of the Bishop, which was liked enough for a duplicate to be made for the Bishop's old seat at Exeter. Most important of all, he met the Bishop's nephew, Archdeacon John Fisher, who was to become his closest friend.

On his return to London, having gained official permission to continue corresponding with Maria, he told her what he had seen. There thus began the most moving correspondence of his life. The loving, and agonizing, letters to and from Maria continued until her death. In them we find expression of his private hopes and his deepening understanding of his knowledge of art, which is essential for a better appreciation of what his pictures meant to him. There also began a correspondence of equal importance, that to and from his new-found friend, John Fisher (see Plate 93). It enabled him to expose his aims to a more objective outlook, and receive another sympathetic hearing when he was depressed. As Beckett essentially described it: 'They also had in common a deep strain of unaffected piety, in which the enjoyment of landscape was inextricably mingled with gratitude towards its creator, and which was not found to be inconsistent with a fund of healthy ribald humour.'[35]

The strands of his life and art were now coming together but they were not to be without further private and professional strain. Maria had written that her father's only objection to their marriage 'would be on the score of that necessary article Cash, what can we do?' She thought they should cease corresponding. Constable, who was in the process of moving lodgings from Frith St, Soho, where he had been for two years, to 63 Charlotte St, opposite Farington, knew well enough the problems. He had just had to ask for more money from his parents to pay his increased rent. His mother had earlier that year thought, loyally, that her son should be able 'with diligence and attention, be the performer of a picture worth £3000'. She was referring to Benjamin West's *Christ Healing the Sick*, which had been bought by subscription for eventual donation to a proposed National Gallery for that amount. It is doubtful if Constable earned as much by his art in his whole lifetime, and his *Cornfield* was bought after his death by subscribers for the National Gallery for one tenth of the amount, 300 guineas. In November 1811, his mother wondered that a climbing professional man should have to pay £100–150 a year for two rooms and then have to find 'board washing and firing etc'.[36]

Constable was to receive a further shock. Maria begged him to 'cease to think of me, forget that you have ever known me'. His impulsive answer was to take the coach immediately to Worcester, and make his way to Bewdley and Spring Grove. The weekend passed happily enough, but on the last day of 1811, his father wrote counselling prudence:

> Suppose you were to take a help mate with a small income and your house became furnished like poor sturgeons; what would your situation then be. . . .
>
> My further advice recommends a close application to your profession and to such parts as pay best. At present you must choose your subject or waste your time by invitations not likely to produce further advantages, when once you have fixed on a subject, finish it the best manner you are able, and not through despair put it aside and so fill your room with lumber. . . . Think less and finish as you go. Be of good cheer John; as in me you will find a parent and a sincere friend.

The next month, the New Year of 1812, he sent him £20.

His father must have been exasperated at seeing his sketches accumulate, particularly of Flatford. None appeared to be finished, and an order was waiting for one of them. His bluff advice did, however, seem to have some effect on his son's art, even though his personal circumstances did not improve. The Rector's displeasure at his daughter's attachment to the impecunious artist, son of someone 'in trade', became increasingly obvious, and, by 1813, Constable was even forbidden access to Spring Garden Terrace. He did, however, finish a *Salisbury, Morning,* perhaps that in the Louvre for the exhibition of 1812; an *Evening Landscape*, a scene from Mrs Roberts' meadows that had been 'quite a pet' with him, and which is probably that now in the Victoria and Albert Museum (R. 98); *Landscape: A recent shower*; and *A Water-Mill, Flatford Lock and Mill* (Plate 60), which has recently been discovered in a private collection in the U.S. If it is compared with one of the most magical of his Flatford sketches, possibly painted the previous year, *Barges on the Stour with Dedham in the distance* (Plate 68), the extent of a new-found resolve 'to finish as you go' is plain. Equally clear are the differences between what he wanted to

66. *A Lane near Flatford. c.* 1810–11. Oil on paper laid on canvas, 22 × 19.5 cm. New Haven, Yale Center for British Art, Paul Mellon Collection

67. (right, above) *Dedham Vale: Morning.* 1811. Oil on canvas, 77.5 × 127.5 cm. Elton Hall Collection

68. *Barges on the Stour with Dedham in the Distance. c.* 1811. Oil on paper laid on canvas, 26 × 31.1 cm. London, Victoria and Albert Museum

achieve publicly and what he still needed to learn privately. His father could not fault him for not 'fixing on' a subject. Both pictures are of the family mill at Flatford, a scene fixed in his mind since childhood. The finished picture looks downstream, based on the sketches done in 1810–11 (see Plates 58 and 63), while the sketch is from the left bank, looking over to the peculiar cross beams of the lock. The subject-matter in both is the activity of his father's business and his life-long obsession with the Stour. But, whereas the exhibited picture has a controlled precision of detail in, for example, the architecture of the mill, the foreground foliage, and the reflections on the water, the sketch is ephemeral, the paint is as fluid as the water and sky he attempts to capture, and the composition is unified only by the horizontal bands of his brushstrokes, as if it were a water-colour, rather than by a complicated recession of light and dark. Neither painting is traditional, and both deliberately ignore the influence of the Old Masters, which had been obvious in his *Dedham Vale, Morning* (Plate 67) of the previous year.

He dispatched his pictures to Somerset House and as he wrote to Maria, 24 April 1812, he was pleased and satisfied with them. 'These are new sentiments to me, but I have done my best, but Leonardo da Vinci tells us to mind most what our enemies say of us — it is certainly one of the great ends of a publick education and exhibition . . . that we hear the truth.' [37] After they had been shown, Benjamin West, the President of the Royal Academy, stopped to speak to him and 'told me that he had been much gratified with a picture (the Mill &c) . . . He said it had given him much pleasure and that he was glad to find that I was the painter of it. I wished to know if he considered that mode of study as laying the true foundations of real excellence. "Sir" (said he) "I consider that you have attained it." '

The stubborn pursuit of his aims since 1802 now seemed to have been attained professionally, but it was actually six years before the private vision of his sketches was consolidated into public excellence and four years before he achieved private happiness.

Chapter 4

'I have now very distinctly marked out a path for myself'

If Benjamin West thought that Constable had attained excellence, the rest of the world was not so sure. During the next seven years, from 1812 to 1819 he indeed achieved a standard of naturalistic landscape painting that was unequalled elsewhere, and attained a measure of personal happiness and professional success. He had, however, to survive a further four years of strained separation from his beloved Maria, which brought him close to despair. He had also to remain optimistic in face of the apparent indifference of his professional colleagues who, while they saw his works exhibited every year at the Academy and occasionally gave him encouragement, nevertheless elected lesser figures such as Reinagle and Collins, and gave him either no votes at all, in 1814, or only one, in 1818, the year before he finally became an Associate of the Royal Academy.

Yet his application was dogged with a strength that came from an inner conviction. He wrote to Maria on 12 May 1812: 'You know I have succeeded most with my native scenes. They have always charmed me and I hope they always will — I wish not to forget early impressions. I have now very distinctly marked out a path for myself and I am desirous of pursuing it uninterruptedly.' Later that year he told Maria that he loved painting 'more and more dayly'. After feeling satisfied at the 'excellent situation' his landscapes had in the exhibition of 1812 he could hardly wait to get away to East Bergholt: 'I am sighing for the country. I am told the trees never were more beautiful.'

He had portrait commissions to fulfil for Lady Louisa Manners and Lady Heathcote, and a small portrait of his uncle, David Watts, but found time for an excursion with Stothard to Coombe Wood, near Wimbledon. He was able to return to Suffolk at the end of June. He wrote to Maria that 'Nothing can exceed the beautiful appearance of the country at this time, its freshness, its amenity — the very breeze that passes the window is delightfull, it has the voice of Nature.' This feeling for the beauties of nature was where his sympathies lay, and during July 1812 he tried to capture 'the very breeze' in a further series of sketches, probably done out of doors, many inscribed with their dates. They are marked by a greater rapidity of handling than in 1811 which give them a fluid elegance. On 4 July he painted a twilight view of a *Hayfield at*

East Bergholt (Plate 69). It was painted quickly on paper, and the holes made when he pinned it to his box are clearly visible in the top left-hand corner. It is a 'nocturne', in Whistlerian terms, of pink and grey. *A View of Dedham from Langham* (Plate 71), dated 13 July 1812, is another example of his favourite view down the valley towards the sea. It may have been painted as a preliminary for an intended finished picture of Dedham Vale, as other similar sketches exist. Constable did indeed begin such a view, it has now been discovered by Charles Rhyne, which he painted under his sketch for *The White Horse* (Plate 107). The small Oxford sketch is painted rapidly with confident strokes, which follow the contours of the land. The foreground is denser with opaque touches applied with a knife. Both sketches have a high viewpoint falling away to a long vista, and his easy ability in July 1812 to render distance by the materiality of his paint may have been helped by his knowledge of Rubens.

He had already seen the *Chateau de Steen* (Plate 122) and he saw Lord Longford's panoramic view of *The Escorial*, then attributed to Rubens, when he visited Salisbury in 1811. In May 1812 John Fisher was promising to get permission for Constable to copy it. Another early instance of his love of Rubens is a rapid sketch (Plate 70), dated 28 July 1812, of a double rainbow. The rainbow and its effects later became an obsession with him, and he was to paint another sketch, recently discovered, dated 1 October 1812, but it is also an important early example of his interest in skies and atmospheric effects. The trees and windmill are barely discernible, brushed in with rapid, feathery strokes on a roughly torn piece of paper, stuck down on canvas, as if he was impatient to grasp this rare phenomenon of nature. The repeated pinholes are, again, clearly visible. He was beginning to show equal facility whether he looked long, or upwards, or at art.

He wrote confidently to Maria after a 'hermit-like life': 'How much real delight I have had with the study of landscape this summer. Either I am myself improved in "the art of seeing nature" (which Sir Joshua Reynolds calls painting) or Nature has unveiled her beauties to me with a less fastidious hand.' He managed to meet Maria briefly in August but was back again in Suffolk during September. He was busy with a portrait commission for General and Mrs Rebow at Wivenhoe Park,

69. *A Hayfield near East Bergholt at Sunset*. 1812. Oil on paper laid on canvas, 16 × 31.8 cm. London, Victoria and Albert Museum

70. *Landscape with a Double Rainbow*. 1812. Oil on paper laid on canvas, 33.7 × 38.4 cm. London, Victoria and Albert Museum

71. *Dedham from Langham*. 1812. Oil on canvas, 32 × 19 cm. Oxford, Ashmolean Museum

71a. Detail of Plate 71

Essex, who became new friends and the patrons of one of his finest early landscapes. That autumn he managed, apparently, to sketch apart from the rainbow of 1 October, an evening scene (Plate 74). It was engraved by David Lucas in 1832, entitled, presumably with the artist's approval, *Autumnal Sunset*. Constable called it simply *Evening with a Flight of Rooks*. The view is a vista westwards from the fields at the end of the lane that ran by his studio in East Bergholt. It is only a step from a cemetery, by what is now a Chapel, where some of 'the rude forefathers of the Hamlet sleep'. It is tempting to cite it as a visual equivalent of Gray's *Elegy Written in a Country Churchyard*, as the woman with her basket and the man on the horse plod their way home, and 'Now fades the glimmering landscape on the sight'. Although Gray was a favourite poet of Constable, he did not, however, quote him when the subject was engraved, and the prevalence of twilight scenes that year may have been because of his fear of hurting his eyes in the bright sunlight, as he had done the previous year.

Yet these views of East Bergholt embody something of his personal feelings for Maria, when he wrote to her on 22 June 1812: 'From the window I am writing I see all those sweet feilds where we have passed so many happy hours together.' It is almost a paraphrase of Cowper's 'dear companion of my walks', and the question of poetical equivalents also arises when we consider the aim of his finished works done during this period. By 1812 he had already made a distinction between his sketches and the paintings he exhibited. To achieve a material success so that he and Maria could marry, he needed to produce more complete statements for the public, which, for his own satisfaction, would also embody the results of his private sketching. He had felt in December 1811, 'that it is our duty to make every manly exertion' to justify himself in his art and to her, and he wrote bravely to Maria the following September: 'I will never leave the feild while I have a leg to stand on.'[1]

His exertions took the form of more portraits at the end of 1812 and during 1813. Through the influence of Mrs Godfrey, he gained a commission for a 'whole length' portrait of Captain Western (see Plate 28), which, because of the sitter's promotion to Admiral, needed more work the following year, 1814. To the British Institution exhibition of 1813 he sent his *Dedham Vale, Morning* of 1811, obviously thinking it was most likely to sell. To the Royal Academy he sent, *A Morning Landscape* and *Landscape, Boys Fishing* (National Trust, Anglesey Abbey). Here his amount of finishing has almost gone too far, and it looks almost like a laboured replica. His uncle, David Pike Watts, perceived '*Unfinished* Traits'. Early that summer, through the kindness of his uncle, he had attended a large exhibition and banquet in honour of Sir Joshua Reynolds, his hero. He noted with approval the Earl of Aberdeen's speech, which praised Reynolds for the attainment of 'Nature, simplicity and Truth'.

'Now let me beg of you', he wrote to Maria, 'to see these charming works frequently and if possible form your mind of what painting is from them — here is no vulgarity or rawness' (for which he had been criticized by his uncle), 'and yet no want of life or vigor' (which he hoped to achieve), 'it is certainly the finest feeling of art that ever existed.' These general characteristics are clearly what he admired and, again, 'Nature simplicity and Truth' would seem to have verbal equivalents, of which he was well aware. He told Maria the year before, that he had Cowper's poems, letters, and his life by Hayley on his desk. At first he used them to make an immediate reference from Cowper's poems 'with your arm fast locked in mine' (24 April 1812). By June 1812, he declared that Cowper 'is the Poet of Religion and Nature'. In a way, Cowper's attitude to nature was an influence on Wordsworth, and on Constable. To the painter, Cowper's descriptions of the prospect over the Ouse gave a literary parallel to what he was seeing over the Stour. In contrast, although he admired Byron for his 'great ability', 'his poetry is of the most melancholy stamp', that is to say, for Constable, it was cynical and agnostic. He approved of Cowper because his poetry paralleled his own devotion to nature as a 'moral duty'.[2] By this he meant partly what he had to do for his own art to progress — 'not only by being occupied with what I love' — and partly what he needed to do for a future with Maria, and lastly, that by being true to nature, he was being true to God.

We gain some sense of this 'moral duty' by his efforts in the fields during the summer of 1813. He had left London with, for once, 'pockets full of money' from his portraits. But he was also smarting, perhaps, over a little joke his friend Fisher had made over his *Boys Fishing* at the Academy. Fisher had admired it but he liked 'one better and that is a picture of pictures — the *Frost* of Turner [*Frosty Morning*]. But then you need not repine at this decision of mine; you are a great man like Bounaparte & are only beat by a frost.'[3] Constable had sat next to Turner at the Academy dinner and had reported to Maria that 'he is uncouth but has a wonderfull range of mind'. Turner, for his part, may have been attempting to outdo Constable's *Dedham Vale, Morning*, in the receding diagonals and careful placing of the tree and his figures. Constable, his head full of larger visions, those of Turner, Reynolds, Cowper and Rubens, his pockets full of money, parted and kept away from Maria, left London for the fields of Suffolk, where he filled a sketchbook, a 'journal', as he called it, of his walks over his landscape around East Bergholt. There are seventy-two pages of drawings of the fields, and details of the activities he found there: 'picking up little scraps of trees, plants, ferns, distances &c. &c.' No heroic retreat from London, but a keen ear to the insistent 'voice of nature'. The pages are a microcosm of his creative activity.[4] Postage stamp-size sketches in lead pencil are juxtaposed and, although they are not in chronological order from 10 July to 22 October, an enlargement of his vision can be perceived. In the development of his technique as a draughtsman, we are reminded of Wilson's advice to Thomas Jones, that he believed coloured drawings were a positively misleading guide to light and shadow. None is in watercolour. From these 'native scenes' Constable established his path for the future and in these pages are found motifs for his later finished pictures, which have a larger, more encompassing aim than these immediate jottings from nature.

A particular case is the genesis of his *Landscape: Ploughing Scene in Suffolk* (Plate 75), which was exhibited the following year, 1814, at the Royal Academy. The view is one he knew well, from behind Old Hall Park of the Godfrey Estate,

looking over to Dedham Vale, a little nearer Flatford than the view he recorded in *Dedham Vale, Morning* (Plate 67). It is shown on a page of the sketchbook (Plate 72), dated '25 July [1813] noon'. On another page is a study of a ploughman (Plate 73). These two, and other drawings provide the basic material for the finished picture. Both drawings give some idea of his developing powers. The general view is a sensitive and atmospheric apprehension of the spread of the landscape, rendered with a full control of the pencil; the other is a rapid study of men at work, as he had been taught by J.T. Smith. The sketches were made in July. He worked on the picture through the autumn and winter along with other works, and then on 22 February 1814 he wrote to Dunthorne: 'I have added some ploughmen to the landscape from the park pales which is a great help, but I must try and warm the picture a little more if I can. But it will be difficult as 'tis now all of a piece — it is bleak and looks as if there would be a shower of sleet, and that you know is too much the case with my things.' John Dunthorne, the amateur artist and atheist, was still, by 1814, the only artist he knew well enough to reveal his artistic problems. Maria would not understand, and Fisher might make a joke. He went on, to his first local helpmate, to hope the trees would not be felled.[5]

For the first time in his career, Constable exhibited the finished picture with an accompanying quotation. It was fashionable, and Turner did it, even writing his own verse. It may have been part of Constable's aim to make a finished 'poetic' statement. He did it by quoting from the Suffolk poet, Robert Bloomfield's, *The Farmer's Boy*, (Spring, I, 71–2): 'But unassisted through each toilsome day,/With smiling brow the ploughman cleaves his way.' On the face of it, the lines draw attention to the happy labour of the scene, which we know he

72. *Page of a Sketchbook, Study of Fields Overlooking the Stour Valley.* 1813. Pencil, 8.9 × 12 cm. London, Victoria and Albert Museum

73. *Page of a Sketchbook, Study of a Ploughman.* 1813. Pencil, 8.9 × 12 cm. London, Victoria and Albert Museum

74. *Autumn Sunset. c.* 1812. Oil on paper laid on canvas, 17.1 × 33.6 cm. London, Victoria and Albert Museum

75. *Landscape, Ploughing Scene in Suffolk, 'A Summerland'.* 1813–14. Oil on canvas, 51.4 × 76.5 cm. Private collection

76. *A View of Dedham Vale, 'The Skylark'*. 1813. Pencil, 8.9 × 12 cm. London, Victoria and Albert Museum

position as in a drawing in the sketchbook of 1813, which he entitled 'The Skylark' (Plate 76). The trees are even more autumnal, and the general effect is even bleaker than in his first version, when he had every opportunity to make it more spring-like.

Constable appears, then, to be making a general poetic comment on ploughing in a local landscape, not so much to emphasize the ploughman's place in the order of things, but to make his description of the Suffolk topography into a general example of life, 'Nature, simplified' and fairly 'Truthful', as part of the 'moral duty' of landscape. Bloomfield's lines are used as a Suffolk simile, as an extension of his own local and 'vigorous' vision, not as a justification for the painted landscape. When it was 'all of a piece', the painting's own 'inner necessity' could sometimes dispense with total accuracy, and in this respect his work of 1813 looks forward to his mature statements of a decade later.

During the autumn and winter of 1813–14 he seems to have been engaged in other finished works that would make public statements from his close sessions in front of nature. In addition to his ploughing scene, he showed at the RA of 1814 what Farington described as an upright landscape called *The Ferry*. A picture in the collection of Lord Forteviot, known as *The Valley Farm*, may be the exhibition piece that was described as 'large' and 'upright'.[8] The finely wrought painting (Plate 77), which came to be called *The Mill Stream* when engraved by Lucas in 1831, is closely connected with this subject, even if it is not actually the exhibited picture. As in the earlier Flatford Mill pictures, the scene is carefully composed with trees framing the high-light in the middle. The view is downstream from the platform over the mill-race, whose disturbed waters can be seen in the foreground, looking towards the well-known house of Willy Lott, where a ferry crossed to the main course of the River Stour at the right. The painting is in Constable's 'finished' technique in contrast to the dramatic chiaroscuro of the raw and vigorous sketch (Plate 78). This small sketch may have been done at the same time as other sketches at Flatford, *c.* 1810–11. It is not so tightly organized as the finished work, and it is instructive to compare, for example, the progression into the distance at the right within the two paintings as typical of the difference in Constable's technique. In the sketch the brick wall at the right practically breaks up as a cohesive object. The rough brush-strokes are dragged across the lines of the perspective and become obtrusive. In the painting the wall reads coherently and the black marks become lichen and weeds. The dab of red becomes a boy fishing, a Flatford 'extra' who is to have a larger role in one of his greatest pictures of Stratford Mill. Here he serves to lead the eye into the diagonal. The sketch, having been painted rapidly, has crude tonal transitions from tree to bush, which in the painting are refined. The two major trees in the sketch are superimposed last as two general black areas. The cracking suggests they were hurriedly painted before the underneath was dry. In the finished painting these transitions are made smoother and more refined. Some of this overall refinement and subtlety may be due to the influence of Claude, who may also be responsible for the classical structure of the composition.

added later, but what, in fact, is represented? When the picture was engraved, even later, it was called 'A Summerland'. This is a reference to the local Suffolk practice of ploughing a field, in the spring, to leave it to lie fallow during the summer. But this is no spring scene. The flowers are blooming, the trees are full leaved and are even turning yellow with autumn. 'The Summerland' could be a field being re-ploughed for winter wheat. Constable's later title may well be a piece of local nostalgia.

The subsequent history of the ploughing scene is remarkable. It did not sell at the Royal Academy of 1814, and he exhibited it again at the British Institution in 1815, from which it was bought by a patron of British art, John Allnutt.[6] Allnutt, having bought it, was not satisfied with the sky, and eventually asked another artist, identified by Lucas as John Linnell, to repaint the sky. Allnutt, when he bought a landscape by Callcott, asked Constable to reduce the size of his original picture, and restore the sky. Most artists would have jibbed. Constable, because he was so pleased that, at a crucial state in his career, someone he did not know had bought a picture of his from an exhibition, made no charge, and, indeed, took back the original. Possibly around 1826, he gave Allnutt a replica of the required size (Plate 79).[7] In the replica, which is, admittedly, more laboured and stormy than the original, Constable has included a bird, which hovers in exactly the same

77. *The Mill Stream.* 1813–14. Oil on canvas,
71.1 × 91.4 cm. Ipswich Museums and
Galleries

78. *The Mill Stream. c.* 1810–11. Oil on
board, 20.8 × 29.2 cm. London, Tate Gallery

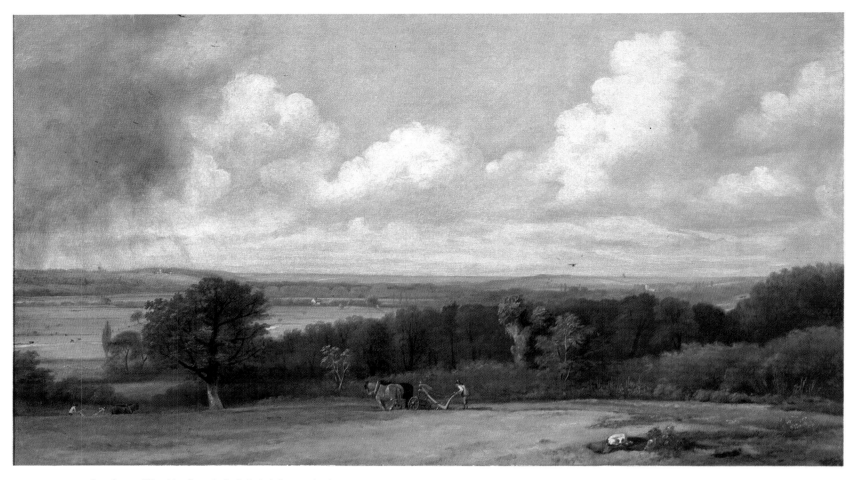

79. *Landscape, Ploughing Scene in Suffolk, 'A Summerland'. c.* 1826. Oil on canvas, 42.5 × 76 cm. New Haven, Yale Center for British Art, Paul Mellon Collection

During the winter of 1813–14, 'every day seemed a week, and every week a month', as he remained parted from Maria, who felt the impropriety of their even walking together. They met hastily in the foyer of Covent Garden Theatre, or at Somerset House for the Academy exhibition. He was pleased with his exhibits there and felt he would rather be the author of his landscape with the ploughman than of Turner's *Dido and Aeneas.* He was in East Bergholt during May when he took 'beautiful walks in search of food for my pencil this summer' and, then, in June, he visited his father's old friend, the Revd W.W. Driffield in Essex, who had baptised the artist. He wrote to Maria on 3 July 1814:

> Sometime ago I promised him a drawing of his home and church at Feering, and during my visit he had occasion to visit his living of Southchurch, and I was happy to embrace his offer of accompanying him — by which I saw much more of the country of Essex than I ever had before and the most beautiful part of it, as I was at Maldon, Rochford, South End, Hadleigh, Danbury &c &c.
>
> While Mr D. was engaged at this parish I walked upon the beach at South End. I was always delighted with the melancholy grandeur of a seashore. At Hadleigh there is a ruin of a castle which from its situation is really a fine place — it commands a view of the Kent hills, the nore and north foreland & looking many miles to sea. . . . I have filled as

usual a little book of hasty memorandums of the places which I saw which you will see. My companion though more than seventy is a most active and restless creature and I never could get him to stop long at a place, as he could outwalk and outrun me on any occasion — but he was so very kind and good tempered.

His letter shows that he could be attracted to other types of landscape than his own domesticated Suffolk, but it is significant that the 'melancholy grandeur' that he admires hardly appears in his art until after the death of his wife in 1828. Much affected, he drew upon this earlier experience, and from his book of 'hasty memorandums' found the subject of one of his most dramatic and personal pictures, *Hadleigh Castle* (Plates 177, 179). The sketchbook that he used there has been broken up, and only occasional pages survive, such as the sketch of *Hadleigh Castle,* but, fortunately, another sketchbook used later that summer between 1 August and 23 October still exists. In it, we find the same interest in local detail but with an even freer handling of the pencil than in the 1813 sketchbook. There are also considerable numbers of preliminary sketches for important pictures that he had in mind. Two of these paintings, at least, seem to have been worked on almost entirely in the open air. He wrote to Maria on 18 September 1814: 'This charming season as you will guess occupies me entirely in the fields and I believe I have made some landscapes

80. *The Stour Valley and Dedham Church.* 1814. Oil on canvas, 39.4 × 55.9 cm. Leeds, City Art Galleries

that are better than usual with me — at least that is the opinion of all here.'

His own opinion about the paintings he produced in the autumn of 1814 has, since Leslie's *Life*, generally been upheld. They can be considered as masterpieces of his early career, in which there is the complete attainment of his original aim for a 'natural peinture'. On 2 October, he wrote more modestly to Maria:

> We have had a most charming season, and I hope I have endeavoured to avail myself of it. It is many years since I have pursued my studies so uninterruptedly and so calmly — or worked with so much steadiness and confidence. I hope you will see me an artist some time or another — but my ideas of excellence are of that nature that I feel myself yet at a frightful distance from perfection.

One of the paintings was commissioned by Thomas Fitzhugh, a rich landowner from Denbighshire, for his bride-to-be, Philadelphia Godfrey of Old Hall, East Bergholt. The Godfreys had been good supporters of Constable's art and such a commission for such a 'grand match' must have pleased him. A preliminary oil sketch (Plate 80), at Leeds, dated '5 Sepr. 1814' has the composition rapidly brushed in, more or less as painted, but curtailed at the left and with heavier accents of light and dark. There are at least nine pencil sketches of the men at work and of the general disposition of the scene in the

sketchbook. One of which (p. 81) is reproduced here (Plate 81), dated 9 October. It is a dramatic statement of light and shade, drawn with heavy black strokes, in which the sky is almost palpable but again much more dramatic than the finished painting. There are two detailed oil sketches of the cart and horses, which appear in the finished painting but not

81. *Page of a Sketchbook, the Stour Valley with a View of Dedham.* 1814. Pencil, 8.1 × 10.8 cm. London, Victoria and Albert Museum

82. Composite photograph of Stour Valley

in the Leeds oil sketch. Both, in the Victoria and Albert Museum, are exquisite little studies of realism where the objects materialize out of the red-brown ground and could rank on their own as the sort of oil sketch beloved of connoisseurs of the eighteenth century. One is dated 24 October 1814, the other reproduced here (Plate 83) presumably dates from the same time and is closer to the appearance of the group in the commissioned work. The farmworker, however, is taken out and two other workers from page 74 in the sketchbook are substituted. The perky black and white sheepdog remains as a brilliant accent to offset the red harness of the horses. We follow his gaze down the field in the painting. On 25 October, after all this careful preliminary work for an important local commission, he wrote to Maria that he had 'almost done a picture of the valley for Mr Fitzhugh (a present for Miss Godfrey to contemplate in London!)'. He may even have finished it in time for the wedding on 11 November though it is possible that, in his dissatisfied way, he added to it when it was exhibited the following year at the Academy.

The finished painting (Plate 84) is now in the Museum of Fine Arts, Boston. It is the view that Philadelphia Godfrey saw from the back of Old Hall Park, looking over the valley of the Stour to Dedham. A comparison with the composite photograph, taken from nearly the same spot (Plate 82) shows how Constable has extended his panorama from the anchoring tree introduced at the left, all the way to Langham Church on the hill at the extreme right. In some ways, Constable never forgot his first early experience of the Panorama shows in London, for, although he despised its aims, his own pictures are always trying to include more than can easily be seen. There is a confident feel of the fall of the land to the ploughman at the right, and, equally, the dip over the corn down to the meandering river Stour. There is a hint of the compositional device he was to use in the future of having almost two perspectival viewpoints, so that the painting, in an attempt 'to get it all in', includes a span wider than can be seen with one direct look. Turner, who was Professor of Perspective at the Academy at this time, was aware of the same problem.[9] The tenacity of Constable's steady gaze is clear in the wealth of detail he has included, which suggests that much of the picture may have been painted on the spot under a morning light. As in all his finished pictures the objects emerge

from the ground with greater or lesser density according to their distance. There is the detailed texture of the wildflowers in the hedgerow, as opposed to the feathery poplars near the river which lead to the brilliant accent of Dedham Church tower. There is no realism so sharp, and yet atmospheric, in European art until the advent of Rousseau and Corot in the 1820s, who may well have been influenced by Constable's example.

Perhaps the most remarkable feature for a wedding present is the pile of manure in the foreground at which the men are digging. This has been identified, indeed categorized, as a 'runover dungle',[10] Suffolk dialect for a dung hill, which was left to mature and then spread over the field before it was ploughed in for winter wheat. Its inclusion shows how far Constable was willing to take his quest for local detail, and, in this respect, the painting more accurately represents the labour of the seasons than his earlier ploughing scene (Plate 75). This prominent detail raises again the general question of what he thought his pictures were about. Philadelphia could have been well satisfied with a straightforward topographical view, but Constable was no view painter in the manner of his friend at court, Farington, and he may have intended the whole scene to be an indirect comment on the fecundity of his and her native Suffolk. There could be no more apt reminder to all her senses of her home.

While he was working in the fields in August, he was also reading *Principles of Taste* by the Revd Archibald Alison, and he commended to Maria (28 August 1814) the association in our minds 'of comprehending the "beauty and sublimity of the material world", as the means of leading us to *religious sentiment* — and of how much consequence is the study of nature in the education of youth'.[11] Constable's own thoughts of nature and of marriage must have been sharpened by the commission. But his painting of the Stour valley for a loyal local patron, to whom he was beholden, is not only, as it were, a gift of God, but it also provides a visual parallel to similar ideas expressed by Wordsworth in his *Prelude*: 'To that sweet valley where I had been reared' and 'The thoughts of gratitude shall fall like dew', and for Philadelphia, 'her common thoughts/Are piety, her life is blessedness'.[12]

Simultaneously, while he was involved with this 'desca da parto', or marriage donation, he was also painting, probably during the afternoons, a picture that he is traditionally sup-

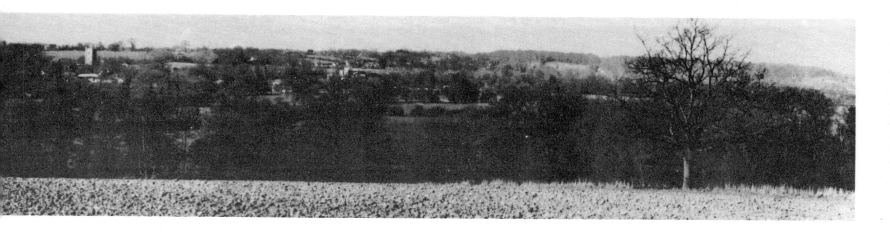

posed to have executed entirely in the open air. Even more than the Stour Valley scene which, as we have seen, was composed and organized, his celebrated *Boat Building* (Plate 85), in the Victoria and Albert Museum, thus ranks as a landmark in the history of 'plein-air' painting in the nineteenth century. Leslie's description, in his *Life*, is our evidence, and remains the most telling:

> Among the landscapes mentioned in this letter was one which I have heard him say he painted entirely in the open air. It was exhibited the following year at the Academy, with the title of Boat-Building. In the midst of a meadow at Flatford, a barge is seen on the stocks, while just beyond it the River Stour glitters in the still sunshine of a hot summer's day. This picture is proof that in a landscape, what painters call warm colours are not necessary to produce a warm effect. It has indeed no positive colour, and there is much of grey and green in it; but such is its atmospheric truth, that the tremulous vibration of the heated air near the ground seems visible. This perfect work remained in his possession to the end of his life.

The barges were Golding's own, built in a dry dock just upstream from Flatford Mill. There is a page in the 1814 sketchbook which records the bustling scene in a breezy, atmospheric manner, with many more figures than appear in the painting. The canvas is small enough to have been painted out of doors, but certain details may have been added, or eliminated, in his East Bergholt studio. No wonder, as he said to Maria, 'he was never at home 'till night — I was wishing to make the most of the fine weather by working out of doors'.[13] It is painted thinly with a high degree of 'finish'. Perhaps he was taking to heart the lessons he had learnt from studying the Angerstein Claudes for 'finishing', on Farington's recommendation, during July. The influence of one of them, *The Embarkation of St Ursula* (National Gallery, London), has also been noted in the receding lines of the perspective.[14] There are the feathery but precise touches for the trees, his characteristic method for blocking in details, in the shirt of the seated figure in the foreground and the addition, last of all, on the surface, of dark bituminous strengthenings for the branches of the trees and the shadows. The objects emerge from the ground, and the highlights are created with flicks of white, particularly on the trees at the left and right and on the water, to give a sparkle,

which looks forward to his 'whitewash' at the end of the 1820s. The whole has the air of a hot sultry afternoon, as opposed to the cool morning light of the *Stour Valley*. It may well, however, have given him trouble. The variety of light and dark over the surface, with the clutter of tiny detail is almost too bewildering, and it appears to be slightly unfinished at the left. Of the very few further candidates for pictures done entirely in the open air, *Wivenhoe Park* (Plate 91), *Flatford Mill* (Plate 95), and *Hampstead Heath* (Plate 121) were done shortly after *Boat Building*, when his energies were closely bound up with this type of exactitude. Painting in front of nature was still too full of 'raw' problems.

Drawing out of doors was easier to cope with. He never stopped producing highly wrought drawings in black and white on a fairly large scale, very distinct from his finished water-colours. They almost have the air of academic presentation sheets, but whereas the French, and Haydon, were producing detailed studies of nudes, Constable was drawing trees. His drawings, in this vein, are remarkable for their incisive and patient study of natural facts, and are as impressive for the control of hand and eye, as are his more rapid, impressionistic jottings on a small scale. One such is the view from the back of the family house (Plate 86), which can also be allotted to this productive summer of 1814. It looks over the family vegetable garden at the right, and the flower garden at the left, and then over the family's fields towards their windmill on the horizon, where Constable first began as a miller (see map, Plate 3). The rectory of Dr Rhudde is behind the distant trees on the right. It represents the scenes of his boyhood and his courtship of Maria. From it were produced two minor masterpieces of realism (Plates 88 and 89), now at Ipswich, which, because they show wheat ripening where there is a ploughed field in the drawing, and threshing in the barn at the left, were probably, therefore, painted in August 1815.[15] There is at least a year's growth of the climbing roses up the wall of the flower garden at the left, while a circular flower bed has taken the place of the large bushy tree in the foreground. An almost miraculous, well tended, lawn has also appeared in a year. These two paintings are introduced here, in conjunction with the drawing, to show the increasing precision of his eye, but much had intervened between the summers of 1814 and 1815.

He had returned to London in November 1815 after his

83. *Study of a Cart and Horses*. 1814. Oil on paper, 16.5 × 23.8 cm. London, Victoria and Albert Museum

84. *The Stour Valley and Dedham Church*. 1814–15. Oil on canvas, 55.5 × 77.8 cm. Boston, Museum of Fine Arts, William W. Warren Fund, 1948

85. *Boat Building near Flatford Mill.* 1814–15. Oil on canvas, 50.8 × 61.6 cm. London, Victoria and Albert Museum

sessions in the fields and wrote to Maria, who was in Brighton, that he was hardly yet reconciled 'to brick walls and dirty streets, after leaving the endearing scenes of Suffolk', and admitted that he was not so avid to seek for honours in his profession when 'four or five years ago when I was more youthful, I was a little on tiptoe both for fame and emolument'. She replied immediately that she must have no more of his 'propensity to escape from notice'. He did, in fact, receive some success, when his *Landscape Ploughing Scene in Suffolk* was bought by Allnutt at the British Institution. His father was ill during the winter which meant a hasty visit to Suffolk, but on 23 February 1815, Maria wrote with the good news that 'I have now obtained from Papa the sweet permission of seeing you again under this roof to use his own words as an occasional visitor.' Constable, however, stood off until he had received a formal invitation. During March, however, while his father was recovering, his mother had a stroke. He rushed to her bedside but she lingered, and it was after his return to London

that she died before the end of the month. His brother, Abram, tried to persuade him to attend the funeral on 4 April, even though he acknowledged that John was busy with his works for the Academy exhibition, but John did not go. It is charitable to suppose he was too upset, though he seems to have excused himself on the grounds of urgent business. Abram, with the decline of their father had taken over the family's affairs, and continued to do so henceforth. His father was well enough on 6 May, however, to write to his 'Honest John', that his 'late loss brought [him] almost to the grave'. He mentioned, pointedly, that he had managed to see a catalogue of the Academy exhibition with his son's exhibits and wished it had suited him to visit them in East Bergholt. Meanwhile, Maria's mother had died on 12 May. The family had worries, too, about the fate of their cousins at the Battle of Waterloo and, eventually, they learned that one, James Gubbins, had been killed.

Constable, in the midst of this domestic turmoil, showed

more works than usual at the Academy exhibition. He had, apparently, got back from Mr Fitzhugh his view of Dedham, which he was going to 'send home' at the end of June. He also exhibited a *Landscape sketch*, his *Boat Building*, a *Village in Suffolk*, another *Landscape*, and three drawings, one of which may have been his detailed drawing of the family's gardens. None was sold. He returned to Suffolk just after the 12 May, probably feeling guilty after his father's hint, and began a portrait of him (Plate 5), in which the sitter took a lively interest, and which remains as a family icon.

After a brief visit to London, Constable was back in Suffolk by July. He went to Brightwell, near Woodbridge, to paint a view, recently rediscovered, of the church and village for the Revd F.H. Barnwell, now in the Tate Gallery. On his way back he made at least four drawings of *Framlingham Castle*, two of which are in the Fitzwilliam Museum, Cambridge, one dated 5 August 1815. It can be linked with the undated sheet (Plate 87), which is the larger of the two and is in his 'presentation' style. This shows his ability to render in the black and white of his strong chiaroscuro the details of architecture, the spread of the landscape, and even the passage of the breeze across the reeds in the foreground, suggested by the change in direction of his pencil stroke. During August, as he wrote to Maria on the 27th, he lived 'almost wholly in the fields' and he saw 'nobody but the harvest men. The weather has been uncommonly fine.' It must have been at this time that he gathered material for a harvest scene, which he exhibited the following year, but which has since been lost. Drawings and oil sketches of reapers survive. He was so much out-of-doors that on 14 September he confessed to Maria that he was 'perfectly bronzed'.

It was at this time, too, that the two views from the back of the family house (Plates 88 and 89) must have been painted, either from an upstairs window or from the roof. The house no longer exists. He was not entirely out of doors, then, though the pictures give the air of immediacy. Their consummate realism has already been mentioned, but their originality of composition is equally daring for their time. We can see how he has divided the scene from the original drawing into two, in order to spread his view, again, to the outer edges. The hedge dividing the two gardens is a linking factor. The morning light accentuates the activities of the family gardeners in the *Kitchen Garden* (Plate 89), while the evening shadows, emphasizing the long diagonals of the composition, fall across the flower garden, to bathe the ripe corn in a warm glow. In other words, cool light for morning briskness, warm for evening luxuriance. Through his pairing of morning and evening scenes the two pictures could be interpreted as modern, sturdy Suffolk variants on pastoral landscapes by Claude. But they may well make not only a reference to a mode of the past which he admired, but also to a particular feeling for the scenes represented. As far as we know, he made no comment on them, they were not exhibited, they were not chosen to be engraved with any literary quotation, and they remained unsold. He kept them, perhaps, as reminders of his own life. His mother had died, his father was ailing, and legal discussions were already underway about the breakup of the family estate after his father's inevitable death, when the house and its immediate grounds would be sold. They embody his

happiness with Maria, and they describe the fields where they had walked when they first met. There may well be literary parallels to Thomson, to Bloomfield, to Cowper, which speak of the blessings of husbandry and the well-kept fields, which are so lovingly delineated, but it is not likely that these notions were the spur for such personal images. He was putting his achievements towards 'natural peinture' in the service of his own emotions, and, thereby, breaking the mold of conventional representation. There is nothing like them in the nineteenth century until Ford Madox Brown's views over his garden at Hampstead or at Clapham (*Pretty Baa Lambs*) about which R.A.M. Stevenson said, 'By God! the whole history of modern art begins with that picture, Corot, Manet, the Marises', or Manet's touching scenes of his own garden at Rueil, painted when he was dying in 1882. They all, equally, describe gardens that encapsulate moments of personal time.

Constable was tired of communicating with Maria only by correspondence, but he received, during October 1815, strictures for not writing, while he was involved with his pictures. He had finally sent his drawings of Feering Parsonage to the Revd Driffield but, after a brief visit to London, he was back again in Suffolk during November, where he remained until January 1816. The long stay shows his anxiety about his father's health (but how meanwhile did he pay his rent in London?). He was, presumably, working on his pictures for the following year's exhibition. One strange event during this extended period in Suffolk was Constable's breaking off with his old friend Dunthorne, perhaps because of Dunthorne's reputation for 'perverse and evil ways'. Dunthorne's son, Johnny, became Constable's assistant in spite of this estrangement. More seriously, Dr Rhudde had learned of Constable's visiting the Bicknell household, which, as Maria wrote on 7 February 1816 'for our mutual advantage [had] been kept *a secret from the Doctor*. . . . perhaps the storm may blow over'. Unfortunately, she had to report on 13 February that 'the kind Doctor says he "considers me no longer his grand daughter" '. This was a blow to their prospects of her inheritance, but the effect determined Constable in his resolve that they should get married whatever the cost. He was, after all, aged forty.

Two events made him more certain. His father finally died on 14 May. There is a detailed drawing of a gamekeeper's hut, dated May 21, the day after the funeral, which may have a general reference to the refuge his father, and family, provided, and, two days afterwards, he drew a fallen tree. Its symbolism is more obvious. Golding Constable's will gave his children equal shares in the estate, which was valued at £13,000. The business would carry on, and John would receive a share of the profits, but the capital to be divided among the six children would come from the sale of the house.[16] Constable could now be more independent, but it must be remembered that his income from art was so small that the commissioners of Income Tax regarded it as negligible. The other important happening was that on 2 July, his great friend, John Fisher, married Mary Cookson, who was, incidentally, a cousin of Wordsworth. Farington recorded that Constable 'had made up his mind to marry Miss Bicknell without further delay and to take the chance of what might arise'. He visited the Revd Driffield at Feering, who had

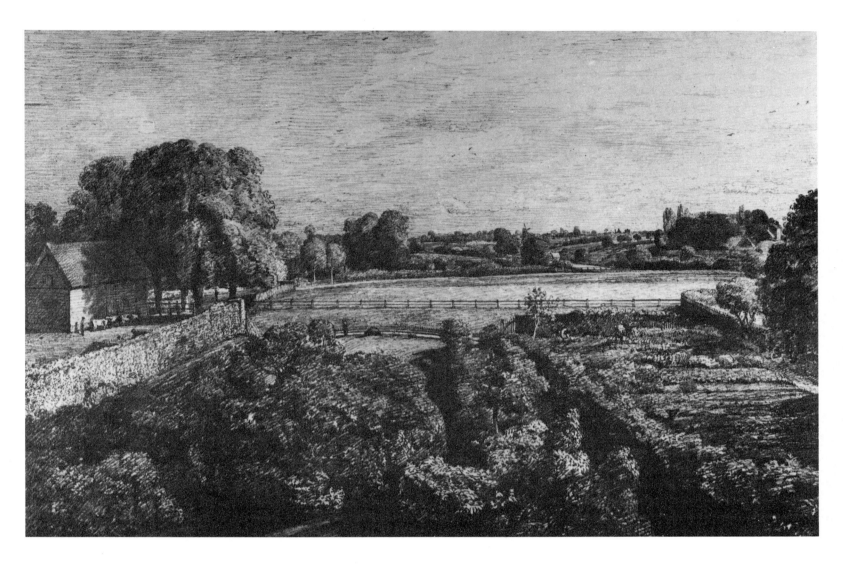

86. *View at East Bergholt over the Gardens at Golding Constable's House.* 1814. Pencil, 30.2 × 44.9 cm. London, Victoria and Albert Museum

87. *Framlingham Castle from the West.* 1815. Pencil, 19.8 × 25 cm. Cambridge, Fitzwilliam Museum

88. *Golding Constable's Flower Garden.* 1815. Oil on canvas, 33 × 50.8 cm. Ipswich, Museums and Galleries

89. *Golding Constable's Kitchen Garden.* 1815. Oil on canvas, 33 × 50.8 cm. Ipswich, Museums and Galleries

offered to marry them if Fisher could not, and spent one day at Wivenhoe Park. Constable's charming portrait of Maria (Plate 26) was painted at this time and we know he kept it by him. 'The sight of it calms my spirit under trouble', he later wrote on 16 August, 'and it is always the first thing I see in the morning and the last at night'. He needed strength to counter the next crisis.

His uncle, David Pike Watts, who had bought one of his exhibits at the Royal Academy, *A Wood, Autumn*, died and, much to everyone's surprise, the favourite nephew received nothing. The local busybodies, including Dr Rhudde, thought it odd and hinted that he had been supported by his uncle, which annoyed the artist. He admitted to receiving affection: 'I had a right to expect it, but the rest has been my own industry.' He wrote on 16 August to counter the tittle-tattle, 'As for me I never was the least disappointed ... wealth will not give happiness.' His pride had been hurt, and he was anxious to prove his independence to Maria and her family, by arguing that the extent of his uncle's help came through his own time and productions. He did not want it to be thought that he was coming to her for her money.

He persevered with his plans for their marriage, but his painting commissions nearly interfered with their arrangements. He had to 'repair', that is, restore a picture, which helped to pay his expenses going back and forth to London. He was called on another brief visit to Major General and Mrs Slater-Rebow at Wivenhoe Park, south of Colchester, and when he returned he wrote to Maria on 21 August that they were 'determined to be of some service to me'. They knew of his intended marriage and probably wanted to help with his expenses: 'I am going to paint two small landscapes for the General, views one in the park of the house & a beautifull wood and piece of water and another scene in a wood with a beautifull little fishing house, where the young Lady (who is the heroine of all these scenes) goes occasionally to angle.' The first landscape was *Wivenhoe Park* (Plate 91) and the second, *The Quarters, Alresford Hall, near Wivenhoe*, National Gallery of Victoria, Melbourne. He continued that he was 'getting on as well as I can with my own pictures but these little things of the General's rather interrupt them and I am afraid will detain [me] here a week or two longer than I could have hoped'. He may already have begun the large picture of *Flatford Mill*, which he mentioned on 12 September, and there may have been other riverside sketches similar to the painting at Ipswich, dated 29 July of *Willy Lott's House* (Plate 90), since he mentioned in his letter of 21 August, that he had been 'out by the river'. The prospective commissions did not seem to inhibit a little excursion to Bentley, just north of East Bergholt, where he was attracted by a lively scene of sheep being washed before their summer shearing (Plate 92). The atmospheric pencil drawing, dated 24 August, embodies, on a small scale, his major interests in the bustle of rural activity, with the reflections of water.

On Monday 26 August, however, he was at Wivenhoe where he remained until 7 September. During the short period of eleven days he produced two outstanding examples of his naturalistic style. The scene at Alresford was based on a detailed pencil study, now at Truro, Cornwall, but the larger of the two paintings, *Wivenhoe Park* (Plate 91), may well have been done entirely on the spot, on a size just manageable out of doors. He wrote on 30 August that he was getting on very well — 'the park is the most forward. The great difficulty has been

90. *Willy Lott's House*. 1816. Oil on paper laid on canvas, 18.4 × 22.5 cm. Ipswich, Museums and Galleries

92. (opposite) *Washing Sheep, Bentley*. 24 August 1816. Pencil, 8.8 × 11.8 cm. Cambridge, Fitzwilliam Museum

91. *Wivenhoe Park, Essex.* 1816–17. Oil on canvas, 56.1 × 101.2 cm. Washington, D.C., The National Gallery of Art, Widener Collection, 1942

to get so much in as they wanted to make them acquainted with the scene.' He had to stitch two strips at each side, one at the left showing the grotto with the daughter, Mary Rebow, barely discernible in her cart, and the other at the right, to include the deer house. The commission implied a conventional country house portrait, but, as with Wilson, his great predecessor in this vein, there is much of Constable in the finished picture. The house is only just visible behind the trees and the view is equally concerned with the spread of the park and the expanse of the artificial lake. It is above all a study of an

English summer's day, where the opposition of light and shade suggests the movement of the clouds. Although he may have had to add the strips to include the details which the proud owner required, and which caused him some difficulty, 'as my view comprehended too many [distances]', its abnormal width may also have been caused by his tendency to extend his views at the sides. The view of *Dedham Vale* (Plate 84) is an example of this. In any event, he was happy with his solution, 'and begin to like it *myself*', even though he talked of making a larger picture, which does not seem actually to have materialized.

The fencing in the foreground leads the eye down the bank to the water and across the lake to the highlight of the avenue and water at the right, punctuated by the white swans and the red waistcoat of the fisherman in the boat, which also helps to disguise his addition. The eye is then turned back by the line of floats of the net. This detail may have been inspired by the drawing he made rapidly on his brief visit on 27 July, which is now in the Victoria and Albert Museum. The painting is divided equally into two halves, by the line of the fall of light, which comes from the house, and its reflection across the water towards the spectator, a device he had also used earlier with his Flatford Mill scenes. It is also divided by the opposition of the dark area at the right, to the clear sunlit vista, which leads out to the left, accented by the black and white cows. It is a pastoral scene with a balanced, but unconventional, composition. It may have overtones of Claude, or Cuyp, but its overwhelming effect is one of immediacy. As with his finished pictures, there

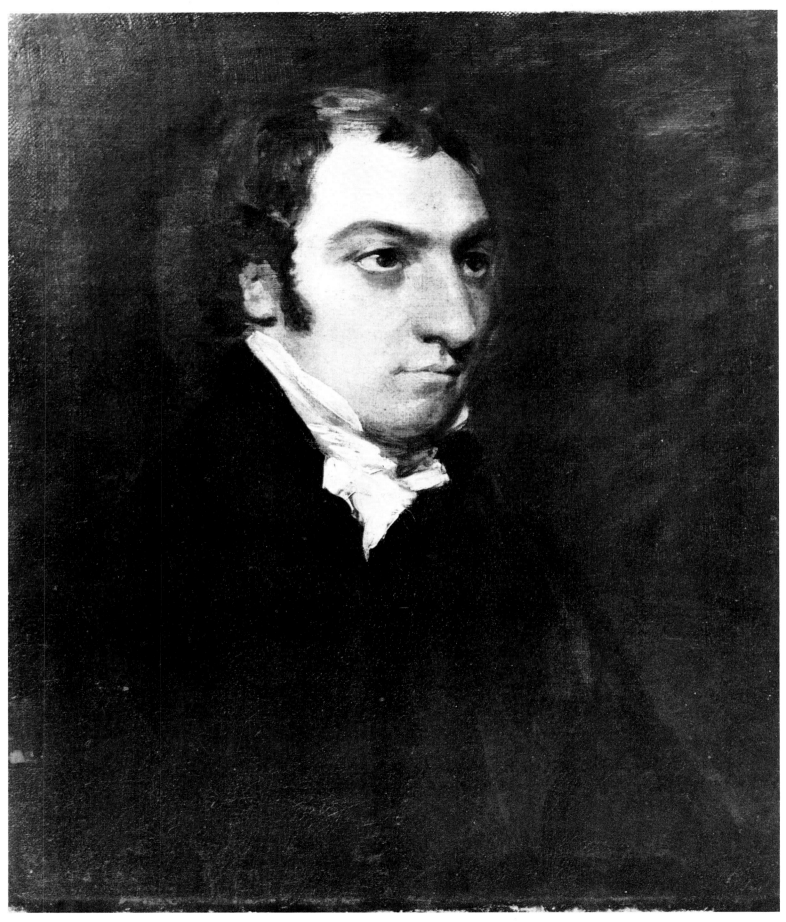

93. *Archdeacon John Fisher*. 1816. Oil on canvas, 35.9 × 30.3 cm. Cambridge, Fitzwilliam Museum

is a wealth of detailed touches, particularly in the foreground, but they never distract from the overall effect. In this intense burst of creativity, when Constable, as he put it, lived in the park, and Mrs Rebow complained of his unsociability, he produced a triumph of naturalism, which vindicated his struggles of the previous fourteen years. He revelled in the sunlight and the variety of greens of the English landscape, which are pointed up by his judicious touches of red at the left, in the centre, and at the right. *Wivenhoe Park* can be compared with any number of contemporary topographical views, and his *Alresford Hall* is more conventional, but *Wivenhoe Park* is a great advance on his own *Malvern Hall* of 1809 (Plate 49), and it remains a very special phenomenon in the early nineteenth century. He went back again on 17 September 1816 to give the finishing touches to these two paintings.

While he was at Wivenhoe working on these views, he received, on 6 September, a letter from John Fisher at Osmington, which had been written on 27 August and which he hastened to send on to Maria because of its importance. It deserves to be quoted in full:

My dear Constable,

I am not a great letter writer: and when I take the pen in hand I generally come to the point at once. I therefore write to tell you that I shall preach at Salisbury on Sunday Sep: 22 on the occasion of an ordination: and that I intend to be in London on Tuesday Eveng. September 24. I shall go directly to my friend W. Ellis's no 39. Devonsh: St. Port: Place. And on Wednesday shall hold myself ready and happy to marry you. There you see I have used no roundabout phrases; but said the thing at once in good plain English. So do you follow my example, & get you to your lady, & instead of blundering out long sentences about the 'hymeneal altar' &c; say that on Wednesday 25 you are ready to marry her. If she replies, like a sensible woman as I suspect she is, well, John, here is my hand I am ready, all well & good. If she says; yes: but another day will be more convenient, let her name it; & I am at her service. Reply to this letter under cover to the Bishop, and I shall receive your Answer —

And now my dear fellow I have another point to settle. And that I may gain it, I shall put it in the shape of a request. It is that if you find upon your marriage that your purse is strong enough, to make a bit of a detour, I shall reckon it a great pleasure if you and your bride will come & stay some time with me & my wife. That Lady joins with me in my request. The country here is wonderfully wild & sublime & well worth a painter's visit. My house commands a singularly beautiful view: & you may study from my very windows. You shall [have] a plate of meat set by the side of your easel without your sitting down to dinner: we never see company: & I have brushes paints & canvass in abundance. My wife is quiet & silent & sits & reads without disturbing a soul & Mrs Constable may follow her example. Of an evening we will sit over an autumnal fireside read a sensible book perhaps a sermon, & after prayers get us to bed at peace with ourselves & all the world.

Since I have been quiet down here out of the way of turmoil bustle & Douglas's great dinners I have taken much to my easel & have improved much — Your visit will be a wonderful advantage to me — The inside of the Mail is both a rapid and respectable conveyance & would bring you hither in 16 hours.

Tell your Lady that I long to be better acquainted with her as does Mrs Fisher & beg her to use her influence on you to see yours with real sincerity

John Fisher

There can be no more affecting letter written between friends, and neither Constable nor Maria could resist it. She replied that 'He has answered for me. I cannot you know let him suppose I am not a sensible woman, you my dear John, you who have so long possessed my heart. I shall be happy to give my hand, but I must go on, the day must be named.' Her father had said that without the Doctor's consent, he would 'neither retard, or facilitate it, complains of poverty'. (In fact he left £40,000 in 1828.)

Even now events did not proceed smoothly. Constable replied on 12 September that he was 'now in the midst of a large picture which I had contemplated for the next Exhibition — it would have made my mind easy had it been forwarder'. This was the beginning of his important *Flatford Mill*, and he was anxious about lack of money, lost time, and his reputation for the future, 'at this delightfull season'. This was a little tactless, and he did not help matters by talking of another commission that he had received for a portrait of an old clergyman who lived near Woodbridge. He was also rather offhand about the clothes she should wear: 'I always wear black myself and think you look well in it.' Maria replied sarcastically that she hoped his painting could be postponed and she flatly refused to wear black at her wedding. She also sadly revealed that 'Papa is averse to everything I propose'. In the event, because of their need for money, Constable did go to Woodbridge to paint the old clergyman who was 'declining fast', did get on with *Flatford*, and was eventually married by John Fisher on 2 October 1816 at St Martin's in the Fields, with a Mr and Mrs Manning, probably neighbours, as witnesses. Constable had asked his sister Martha Whalley too late for her to attend and there were no family members present from each side. Warm words had apparently passed the night before between Mr Bicknell and Constable.

They travelled first to Southampton, where they visited the ruins of Netley Abbey. They then went on to Osmington for the remaining six weeks of their honeymoon. It was new country for Constable. The village is up in the Dorset Downs 3 miles east of Weymouth, and is close to the sea. From it views look across to Portland Island, which appears in a number of drawings and oil sketches done at this time. Fisher fulfilled his promise of providing materials, even supplying freshly ground paints. Constable's honeymoon was, not surprisingly, one of the happiest times of his life. He never went there again, but a number of finished works resulted from his studies, one exhibited at the British Institute of 1819, and he was to include a view of Weymouth bay in his first issue of *English Landscape Scenery*. His prime reason was, perhaps, to include a marine subject, but there is no reason to doubt it had an importance as

94. *Weymouth Bay*. 1816. Oil on canvas, 52.7 × 74.9 cm. London, National Gallery

95. 'Scene on a Navigable River' (Flatford Mill). 1817. Oil on canvas, 101.7 × 127 cm. London, Tate Gallery

a memory of his honeymoon. It equally impressed him as the place where the *Abergavenny* was wrecked, in which Wordsworth's brother, Capt John Wordsworth, was drowned, for when he sent Mrs Leslie a proof of his print in 1830 he quoted lines of Wordsworth, which he remembered as 'That [this] sea in anger and that dismal shore' (*Elegiac Stanzas Suggested by a Picture of Peele Castle, in a Storm, Painted by Sir George Beaumont*). He would have heard of the disaster from Fisher's wife, Mary Cookson, Wordsworth's cousin. The poem had been published in 1807, its inspiration being a picture by the mentor to both Constable and Wordsworth.

An oil sketch in the Victoria and Albert Museum (R155) is very stormy and another (Plate 94) that shows the same scene looks as if a storm has just passed with the coming of evening. Their size and sketchiness suggest they both were done on the spot, although it is hard to see where Constable sheltered in such a storm. The National Gallery version has the foreground rocks rapidly noted and much of the red ground is used to suggest the beach and cliffs. In this respect, it continues his first ventures into naturalism of 1802 (Plates 32, 33 and 37), but by 1816 his ability to suggest light, atmosphere, and depth is much more sophisticated, with the diagonal into space of the beach to the right being balanced by the parallel lines of luminous clouds. The finished painting, which he exhibited in 1819, was entitled *Osmington Shore, near Weymouth* and it has been connected with a version in the Louvre. This particular painting, however, may be a copy after the mezzotint (S. 13) identified as *Weymouth Bay*, and the actual view of Osmington Bay, which is a different place may yet have to be discovered.

In gratitude for his stay, Constable painted the two intimate portraits of his hosts (Plates 93 and 96), now in the Fitzwilliam Museum, Cambridge. Mr and Mrs Constable returned in a leisurely fashion, via Salisbury, and Binfield in Berkshire, finally arriving in London by 9 December. They lived at first in his lodgings in 13 Charlotte St, which he had had newly decorated, but they proved not to be large enough, and the following June, after much searching and discussion, they eventually moved to 1 Keppel St, near the British Museum. They still remained estranged from Dr Rhudde, but Mr Bicknell was willing to forget their differences, and even made Maria an allowance of £50, which helped to set up their new home. We catch glimpses of their newly married domesticity through his brother, Abram's, letters and from Farington's *Diary*. Abram bought them a present of silver sugar tongs with a 'cypher', (25 December 1816), as well as sending to London the jumble of belongings that Constable had left in East Bergholt: pictures, drawings, an umbrella, a flute, books, and his portrait of Maria. Farington entertained them to dinner on New Year's Day 1817 and helped Constable with advice about his personal circumstances, as well as his pictures.

One of them was the large view of *Flatford Mill* (Plate 95), which Farington strongly advised him to finish and exhibit. He showed only one work at the winter exhibition of the British Institution, *A Harvest Field, Reapers, Gleaners*, connected with sketches he had made in 1815, and since lost, but at the Royal Academy, he showed his view of *Wivenhoe Park* (Plate 91) of the previous year; *A Cottage*, the National Museum of Wales, Cardiff, based on a drawing of 1815; his portrait of the

Revd John Fisher (Plate 93); and, most important of all, *Scene on a Navigable River* (Plate 95), the Flatford Mill view that he reluctantly left off for his wedding. This was his most important exhibit to date. It is as large as anything he had previously exhibited and it embodied all his hopes from the past and for the future. He had 'marked out a path for himself', stubbornly since 1802, within a narrow range of rural picturesque scenes, painted with all his developing powers of a 'natural peinture'. He was not now about to leave the field. The laconic title, 'Scene on a navigable river', was without the embellishment of a literary quotation to give added point to the view, but we know that the activities by the river Stour and his 'native scenes' had always charmed him. To render their bustle with the maximum of truth had been his major preoccupation. Now that he was married he needed to achieve professional success and painting on a larger scale was, he hoped, a sure way to achieve it. This large work was the forerunner of a series of six-foot canvases that would justify and make permanent his 'laborious studies from nature'.

The viewpoint, from farther upstream than his earlier sketches of the Mill of 1810–11, and the finished picture of 1812 (see Plates 58, 60 and 63), is from beside the old footbridge, a strut of which appears at the left (see detail, Plate 98). We look from this raised vantage point towards the lock, with its characteristic vertical beams, and the Mill buildings, owned by the family, in the distance. The boat building dock, which appears in his *Boat Building* (Plate 85) painting of 1814, exhibited in 1815, is off the picture to the left, while the stream that led to the Mill-race shoots off behind the barges (see detail, Plate 98). These are being poled against the current to go under the bridge, and the boy on the horse and his companion have just disconnected the tow rope. Painting the haycocks in the meadows at the right and a rural figure such as the solitary haymaker are reminders of the advice that J.T. Smith had long ago given him. The preoccupied air of all the figures and the straining of the bargee set up tensions within the picture, as well as give it its verisimilitude. As with many of his finished works its genesis is more complicated than its simple harmonies lead us to suppose. There are drawings in the 1813 and 1814 sketchbooks, which basically set the scene, and there are at least four oil sketches that show various parts of the complete view.[17] One of them, known only from a photograph, shows a horse farther along the towpath, which x-rays reveal has been replaced in the finished picture by the two boys, one of whom carries a fishing rod. The harness lies on the ground.

The whole scene, then, depicts with a calm summer's light, just before noon — his favourite time for his major works — what would have been an everyday occurrence by the River Stour, with no moral other than that of good works. It was not entirely invented and has much of the truth of nature in it. Its highly personal qualities come from what he was able to include in this finished statement, not painted on the spot, at the end of the previous summer and in his studio in Charlotte Street during the winter and spring of 1817. His effects of light are sparkling and have all the refined but flickering detail of his finished pictures. It may be, however, that in this, the first major salvo in his campaign, he was almost too ambitious in

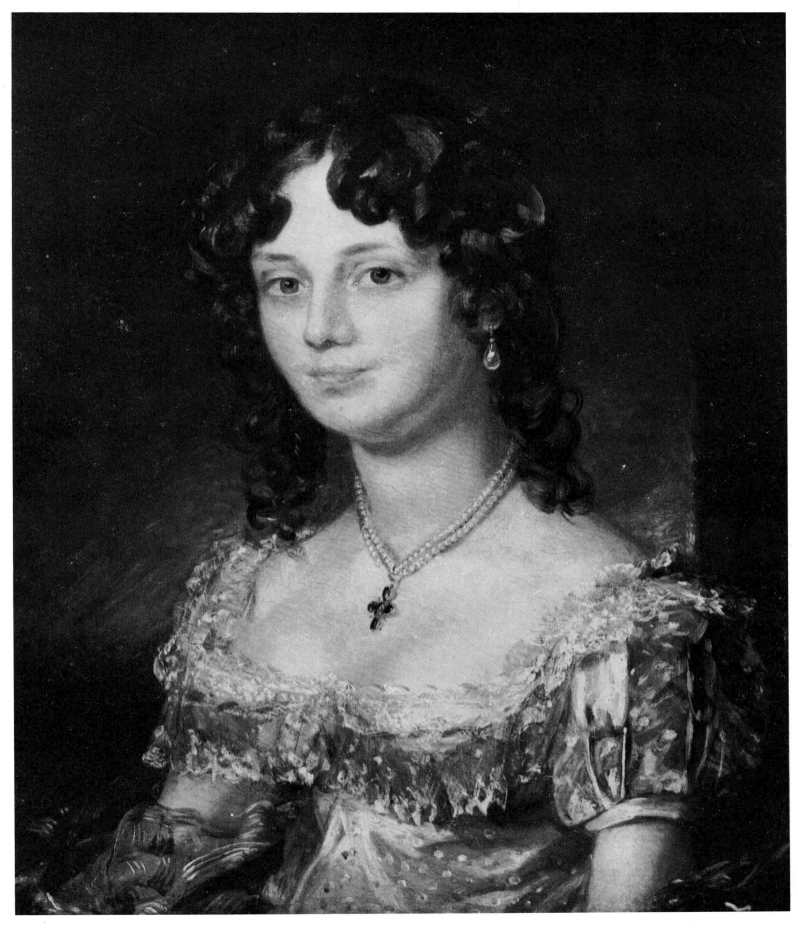

96. *Mrs Mary Fisher*. 1816. Oil on canvas, 35.9 × 30.5 cm. Cambridge, Fitzwilliam Museum

that the myriad combinations of light and dark detract from the underlying structure of the picture. He is particularly bold in the way the curve of shadow from the trees cuts across the compositional curve of the towpath. The profusion of detail of flowers and posts, which he delighted in, are almost too obtrusive in the right foreground. Nevertheless, the interplay of light and shadow with the formal elements give the picture a lively rhythm, so that the basic design on the plane of the picture is not immediately obvious as another variant of his method of dividing the picture right down the middle, and then further subdividing the lower half into two 'V' shaped diagonals which shoot out to the edges. Over this he imposed the vertical accents of the trees, which recede into depth. He appears not to have been entirely satisfied with its structure, for after the picture's exhibition, where it was noticed with approval by academicians, including Beechey, if by nobody else, he made use of a large detailed drawing of trees, dated 17 October 1817, in the Victoria and Albert Museum (R. 161) to alter the prominent trees at the right, so that the eye does not go directly to the mill but curves back to the right, with a

consequent increase in the variety of effect (see detail, Plate 97). It remained, however, unsold, even at the British Institution exhibition of 1818, and was bought in at his sale of 1838, after his death, by C.R. Leslie for the family.

Constable was undoubtedly besotted with his 'mistress', landscape, and the warmth of his imagination can clearly be felt in *Flatford Mill*. He had already given 'the charm of novelty to things of everyday', but if he were to direct the minds of the Academy and its critics 'to the loveliness and wonders of the world before us', as Coleridge described it in his famous passage about Wordsworth in his *Biographia Literaria*, published in 1816, the year of *Flatford Mill*, Constable had to find a way of incorporating his vibrant studies on a satisfactory large scale. He worked on further studies from nature for the last time at East Bergholt during the summer of 1817, but although they were approved of, the oils cannot now be identified. In the elections for two vacancies for an Associateship of the Academy that autumn he received more votes than ever before, but the sculptor, Edward Hodges Baily, and Abraham Cooper, a painter of battle scenes and

97. Detail of Plate 95

animals, were successful. Where were the 'young new men of strong sensibility and meditative minds', of whose fervent admiration for Wordsworth Coleridge speaks?

Constable's future now lay in London. With the birth of his eldest son, John Charles on 4 December his time was taken up with domestic affairs, and he does not seem to have been engaged on major works for his 1818 season. He showed *Flatford Mill* again and *The Cottage* at the British Institution. Farington noted on 6 April that Constable had sold two landscapes for 45 guineas and 20 guineas. 'I recommended him to dispose of his pictures at moderate prices rather than keep them on his hands, as it would be for his advantage to have them distributed — He said he had attended to my advice.' At the RA he showed three earlier works, including a scene *Breaking up of a Shower*, which may date from his Osmington trip, and a detailed drawing of Elms, drawn in Old Hall Park at East Bergholt in October 1817. Fine and detailed though this study is, it was no way to bring himself to the attention of the

Academy, and not surprisingly, he received only one vote in the autumn elections. Portrait commissions further occupied his time during 1818, and he even gave drawing lessons to Dorothea, the Bishop of Salisbury's daughter. He managed two brief visits to East Bergholt in July and October, while Maria was staying at the family cottage at Putney, but he was much preoccupied with the sale of the family house and the continuing estrangement of Dr Rhudde. He received, however, a request from Miss Savile, distantly connected, for 'two or three pictures', 'one of the Valley & the other of the Church — and a small replica of his sisters' double portrait' (Plate 9). But this was small stuff. After the disappointment of the elections, he needed to embark on a large painting. In an all-or-nothing spirit he began a large six-foot canvas, and this time, to·avoid the difficulties of *Flatford Mill* and so that he could work out its execution satisfactorily, he prepared an equally large-scale sketch. His early struggles were to be vindicated with this picture, now known as *The White Horse* (Plate 107).

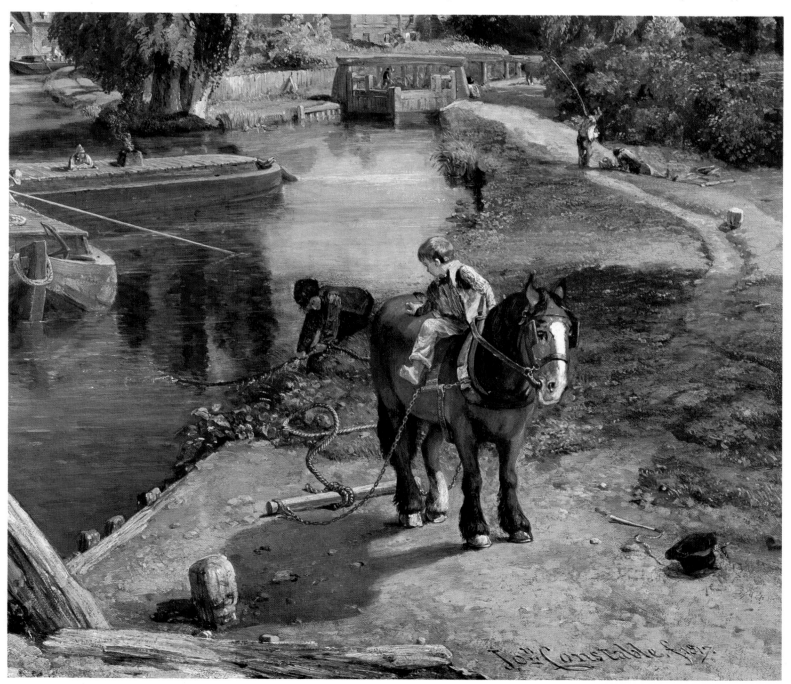

98. Detail of Plate 95

Chapter 5

'But the sound of water escaping from Mill dams, so do Willows, Old rotten Banks, slimy posts, & brickwork. I love such things'

Constable's art now entered its period of maturity, when from his knowledge of both nature and art he produced the masterpieces by which he won recognition, and by which he is best remembered. His works of the next ten years refute Ruskin's surprisingly insensitive comment, 'that he perceives in a landscape that the grass is wet, the meadows flat and the boughs shady; that is to say, about as much, I suppose, might in general be apprehended between them, by an intelligent fawn and a sky-lark'.

By creating finished and naturalistic works of art, away from the motif, but based on his keen observation of over twenty years, he was well aware that a grander lesson than before had to be learned: that the restricting attitude of mind appropriate for a sketch — 'that which you were in at the time' — could be replaced by a timeless vision for the moral feeling of landscape.[1] By his detailed attention to the particular while in the service of a larger aim, he became a pioneer of the Romantic Movement. He realized, too, that for his work to stand out on the walls of the Royal Academy, it had to be large enough for his considered statements to be seen. The 'field of battle' was the Academy. Accordingly, he made another minor attack in 1818, before his major assault on the Academy of 1819 with a view of Dedham Lock and Mill. It may even have been exhibited at the Academy in 1818, as the painting known only as *Landscape, Breaking up of a Shower*, but Leslie says his exhibits at the British Institution the following January 1819 had not been exhibited before, and one was called *The Mill*. It seems to correspond in its framed size with a picture in a private collection of *Dedham Lock and Mill*.[2] If this is the case, then he must have been working on his picture during the previous autumn of 1818, when he and his brothers and sisters were together at East Bergholt to discuss the sale of their family home, and other family arrangements consequent upon the death of their father.[3] He mentioned that he never entered the 'dear village without many regrets'. He was upset by the memory of his parents and their house, and a similar family sentiment may have prompted him to begin work on a view of Dedham Mill (which had family associations) and which he had never painted as a finished composition. There were, however, a small oil sketch (Plate 99), of *c.* 1810, and a drawing of *c.* 1814–15 in the Huntington Library and Art Gallery, San

Marino, California, which provided the basis of the design, and there are, in addition, an unfinished oil (Plate 100), and two finished versions. One (Plate 101) is dated 1820, and the other, in the Currier Gallery of Art, Manchester, New Hampshire, Leslie says was painted in the same year.[4] Plate 121 is close to the picture exhibited, that is, it lacks the barge with the sail at the left, and there is only one horse at the right. He could have abandoned this unfinished sketch before, or after, he had exhibited the finished picture in 1819, and in view of its large size ($21\frac{1}{2} \times 30\frac{1}{8}$ ins.), which is the same as the two later versions, it may have been intended as a large, preliminary 'exercise' in the manner of his six-foot pictures. Its central area, however, is finished to an unusually high degree, while the trees at the right, and the near towpath are only roughly blocked in, over the red ground. He may have decided that he could improve the composition in the 1820 version by including the details of the barge and the horse, which would give a greater emphasis to the passage downstream of the barge, already in the lock. The subject is the same traffic on the river that he had painted at Flatford in 1817, but this time he was describing a different property, and he took the opportunity to make his beloved Dedham Church tower the focal point.

The two finished paintings show clearly the differences in finish between his preliminary work, as represented in Plate 100, and works intended to be exhibited or sold. They also mark the beginning of a new departure for Constable, the provision of highly finished replicas on demand, to fulfil commercial orders. It was not something he liked doing, and some of the later 'editions', such as his views of Harwich, first exhibited in 1820, have a distinct woodenness, and lack of quality. This, however, is not the case with the two finished views of Dedham, which may have been painted on 'spec', because his 1819 picture had sold so promptly to a Mr J. Pinhorn. They are slightly different. In Plate 101 the tow-horse is still attached by his rope to the barge, while in the example in the Currier Gallery of Art, New Hampshire, the horse is free to graze and the rope is tied to a bollard. The former, perhaps, has the livelier surface, but there is very little to choose between them. They were both in his studio sale. Perhaps an agreement with a dealer or patron fell through. They were of a size which

99. *Dedham Lock and Mill. c.* 1811–19. Oil on paper,
18.1 × 24.8 cm. London, Victoria and Albert Museum

100. (right) *Dedham Lock and Mill. c.* 1819. Oil on
canvas, 54.6 × 76.5 cm. London, Tate Gallery

101. *Dedham Lock and Mill.* 1820. Oil on canvas,
53.7 × 76.2 cm. London, Victoria and Albert Museum

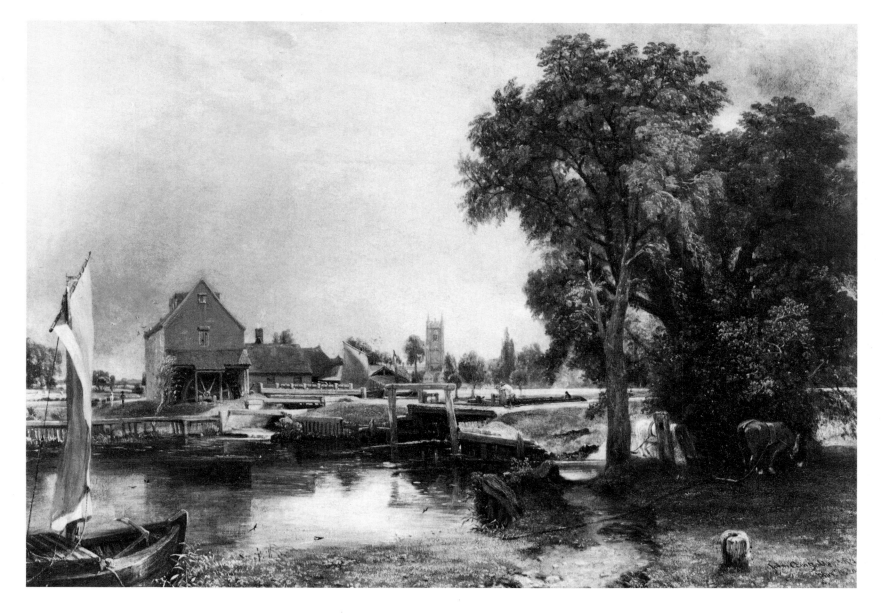

102. *A Study of Dedham Lock. c.* 1820–5. Oil on paper laid on board, 11.5 × 16.5 cm. New Haven, Yale Center for British Art, Paul Mellon Collection

103. *Dedham Lock. c.* 1820–5. Oil on paper laid on panel, 16.5 × 25.4 cm. London, Tate Gallery

104. *Dedham Lock. c.* 1820–5. Oil on paper laid on board, 33.7 × 49.8 cm. New Haven, Yale Center for British Art, Paul Mellon Collection

he had used before '*A Summerland*' (Plate 75) and which he found was eminently saleable with his Hampstead Heath scenes of the 1820s (e.g. Plate 124).

These Dedham views were, nevertheless, the same sort of canal scene that he came to, again and again, during the 1820s, and he seems to have experimented further with other variations of a 'Dedham' design shortly afterwards, which did not reach the stage of a finished picture. Three sketches (Plates 102, 103 and 104) have the same detail of a boat with a sail at Dedham Lock, with another barge coming downstream towards it, but the viewpoint is further to the right, actually by the lock, with the mill excluded because it was off the picture to the left. Dedham Church tower remains as a central axis. The increased vigour and 'rawness' of these sketches, and their subject matter, which comes close to his famous painting *A Boat Passing a Lock*, of 1824 (but first planned in late 1822 and at the beginning of 1823), may indicate that they were painted nearer to 1824 than 1820. The motif of the barge with its sail up also appears in a particularly violent sketch (Plate 105), but the locale seems to be by the boat building yard and Flatford Old Bridge, further downstream from Dedham, and it perhaps denotes a separate idea. As Graham Reynolds has pointed out, he returned to the theme of Dedham again in one of his most

105. *On the Stour. c.* 1820. Oil on board, 20.3 × 23.5 cm. Edinburgh, National Gallery of Scotland

dramatic sepia drawings of the 1830s, *View on the Stour, Dedham Church in the distance* (Plate 214), where the scene, which first appeared as a sketch of a sunny bustling moment on the river (Plate 99), *c.* 1810, and had then been carried through two further stages of finish in the 1820s (Plates 100 and 101), reappears as a nearly abstract and haunting personal memory at the end of his life (see p. 225).

These small and unrealized designs based on *Dedham Mill and Lock* of 1819, and *c.* 1820, seem to have all the ingredients for larger development, but we do not know why he abandoned them, unless he thought their compositions unsatisfactory, or their narrative was too diffused, and lacking in intensity. To the subjects that he chose from his repertoire of River Stour scenes he gave an intensely focused human incident — *View on the Stour near Dedham* (Plate 145) is an exception — and he painted them on a scale to make their mark at the Academy.

During the winter of 1818–19, he embarked upon the first of these grandiose reminiscences of the River Stour and for this he made a large-scale sketch (Plate 106). Its authenticity has been questioned, but there can be no doubt that it is by the same hand that produced the other full-scale sketches for his major works. Of necessity, what he wanted to achieve and the looseness of his handling were different in a preparatory sketch from his finished work. There are further difficulties caused by the dark ground of the Plate 106 sketch having become more obvious with time, which gives an all-over dense appearance. There are, however, small but important differences of design between it and the finished painting, which help to confirm its authenticity. The interesting recent discovery by Charles Rhyne of a sketch for Dedham Vale under the Washington painting is further evidence for its genuineness, and, incidentally, reveals Constable's initial uncertainty about how to begin. As usual with his large-scale works, Constable looked back to earlier sketches, 'food for his pencil', as he had called them in his letter to Maria of 4 May 1814. The 1814 sketchbook provided a compact view of the boat-shed, trees and water at the left, and there are two small oil sketches that are variations of this initial drawing, extending the scene to the right.[5] These small oil sketches may have been painted on the spot as preliminary exercises during 1818, as they have the same dense overall tonality, with their masses simply blocked in, as in the large sketch of Plate 100. At first sight they appear unpromising material from his rich vein of Stour subjects. In common with his earlier scenes going back to 1812, they have a highlight of water in the middle surrounded by an archway of trees which lean towards the centre. The principal buildings are merely indicated and there is no other incident to enliven the view. But, then, through a series of creative changes in the studio, his ideas developed into the masterpiece we know today.

The Washington picture has the same all-over density as the small sketches, but the variety of light and dark is increased, and there are differences of arrangement with the masses that make the whole design more expansive. It is opened out to the right, which is helped by the lowering of the trees, and the addition of the detail of watering cattle to catch the eye. The presence of the double stream at this point on the river is suggested by a subtle division of tones at the left, and the overall effect is at once more complicated, suggesting the flow and movement of the river. The buildings are equally made more emphatic, particularly the boat-shed and Willy Lott's House, but, most important of all, he has introduced the individual detail of the white horse in the barge at the left, which gave the picture its subsequent title. This gives the design a point of focus on a human scale, within the overall feeling for foliage and its density, water and its movement and reflections, and the all-enveloping light. He had also given the foreground a greater definition than it had in the small oil, with the introduction of the landing stage and the prominent reeds on the right.

The finished picture (Plate 107), which was his only exhibit at the Academy of 1819, increased and enlarged these initial developments. He worked on it during the spring of 1819 and seems to have adopted suggestions by Farington. We do not know what these were, but as we see it today, enhanced by its recent cleaning, there is no doubt that the changes from small to large sketch, and from large-scale sketch to finished picture brought a greater coherence. As Leslie remarked, it 'was too large to remain unnoticed', and now in the Frick Collection in New York, it holds its own in powerful immediacy and high key, with Rembrandt, Ruysdael, and other old masters. This would not have seemed possible when he painted it. Its original title was *Scene on the River Stour*, Constable again being laconic and concealing his thoughts and labour. The scene is just downstream from Flatford Mill, where the mill-race behind the island at the left joins the main course of the Stour, along which the barges passed from the lock. At this point the towing horse was put into the barge in the bow, which was then pushed by the bargees straining at their poles, and by one in the stern guiding with his rudder across the river to the other bank, where the towpath continued downstream to Mistley. This moment of poised effort pushes the whole composition, logically, diagonally from left to right. Before its recent cleaning, the brilliant white of the horse and the red of its harness seemed to unbalance the composition. But now, Constable's feeling for light, shade, and atmosphere are all revealed in a masterpiece of balance. The detailed reeds in the foreground help the eye across the break into the distance at the right, up the slope to East Bergholt, where the fence and gate, and the tree on the horizon at the right, which appear in the large sketch, have been removed to create extra space at the right. This sense of an individual, realistic moment in the life of the river is enhanced by Constable's knowledge of telling natural detail: the movement of water, for example, downstream from left to right, can be felt in the flecks of white, as the current breaks on weeds; there are convincing agricultural implements lying about the barn across the river, most noticeably the Suffolk plough. For this detail, he looked back either to a page in the 1814 sketchbook (R. 132, page 69), or to his detailed oil sketch of the same year, both in the Victoria and Albert Museum (R. 136). One of Constable's original titles for the painting was 'The Farmyard'.

But some of his seemingly naturalistic details refer as much to his own artistic education in the 'rural picturesque'. The thatched boathouse in the middle is a tumbledown recreation

of his earliest picturesque cottages, which he had so eagerly offered to J.T. Smith for his 'Remarks on Rural Scenery'. The watering cattle are not only realistically observed and help to suggest the heat of the day, but they can also be found in Gainsborough or Cuyp, as well as in his own sketchbooks. Willy Lott's House appears at the left along the mill-race, but its presence and its owner (who left it for only four days in over eighty years) are, perhaps, symbols of longevity in Constable's Suffolk world. The painting's timelessness is underscored by a rigid structure, to a similar plan of his *Flatford Mill* (Plate 95) of 1817, which is not immediately obvious through his overall subtleties of light and shade. Beneath the horizon line lies a crisscross diagonal that centres on the highlight in front of the boathouse and which spreads out the composition to the sides. Most of his major horizontal compositions have some form of it, and it is possible that he may have been influenced by those Claude drawings which have his unique diagonal 'squaring'.

This carefully composed consummation of his Suffolk hopes 'attracted', according to Leslie, 'more attention than anything he had before exhibited', and it was favourably received in the press. 'What a group of every thing beautiful in rural scenery! This young [*sic*] artist is rising very fast,' exclaimed *The Literary Chronicle and Weekly Review*, 29 May 1819 and, indeed, it can be ranked, as a serene point of Romantic naturalism, with Turner's masterpiece of the previous year, his *Dort*. After the exhibition, Constable could not forbear to fiddle with it, 'subduing the lights, and cooling the tones'. This is something to which he was always prone, and his method of painting right on the surface, in the glazes, and with varnish as a medium, and with constant touches emerging from the ground, gave him endless opportunity for such nervous additions.[6] He was later to describe it (in a letter quoted by Leslie) as a 'placid representation of a serene grey morning, summer'. To him, its natural appearance was the subject.

In an unexpected and impulsive gesture, his friend Fisher asked the price, at the beginning of July, having seen it at the Academy during May, and Constable, not suspecting the real reason, told him the full price of 100 guineas, 'exclusive of the frame'. 'It has served a good apprenticeship in the Academy and I shall avail myself of it by working a good deal upon it before it goes on a second to the British Gallery.' Fisher, to Constable's everlasting gratitude, bought it from him and would not allow a reduction, at a time when he could hardly afford it, though he was not to gain possession of it until the following 27 April 1820, when he wrote from the Close at Salisbury:

Constable's 'White Horse' has arrived safe. It is hung on a level with the eye, the lower frame resting on the ogee: in a western sidelight, right for the light of the picture, opposite the fireplace. It looks magnificently. My wife says she carries her eye from the picture to the garden & back & observes the same sort of look in both. I have shewn it to no one & intend to say nothing about it, but leave the public to find it out & make their own remarks.

Fisher's remark about how his wife looked at the picture shows that the artist and his principal supporter saw it as an

exercise in light and colour. Fisher proved as helpful over Constable's next major picture.

Constable must have thought his prospects were improving that summer of 1819. On a brief visit to East Bergholt to settle the sale of the family home, he arrived in the village 'just as the bell was tolling' for the death of Dr Rhudde, and to their relief, Maria had not been left out of his will. When the will was proved on 22 July, they learned that £4000 of stock had been left to each of his grandchildren. In East Bergholt Constable was impressed again by what was the moving spirit behind his art: 'Every tree seems full of blossoms of some kind & the surface of the ground seems quite living — every step I take & whatever object I turn my Eye that sublime expression in the Scripture "I am the resurrection & the life" seems verified about me.'

It is almost a rubric for The Lakeland Poets, and Lucas was later to point out that 'this remark was originally made by Wordsworth to Constable whilst walking by the side of an hedge the branches of which were just puting [*sic*] for their green buds in early spring.'[7]

Constable, meanwhile, was busy with other things. He was engaged in procuring a J.R. Cozens for Fisher; he had been asked to paint portraits of General and Mrs Rebow at Wivenhoe; and he was also engaged in an annoying commission for Greswolde Lewis to paint a 'warrior' in Norman armour to decorate his house at Solihull. The chain mail proved difficult. He had, in addition, begun a sketch for a picture to commemorate the opening of Waterloo Bridge, which had taken place in 1817. This was in a different, obviously more public mode from his normal subjects, and it caused him trouble. Eventually he did not send a finished version (Plate 203) for exhibition until 1832, and his early sketches and revised compositions for this task during the 1820s will be considered in relation to the finished picture.

Late that summer of 1819 he moved out of smoke-filled central London to the breezy heights of Hampstead Heath where he rented Albion Cottage. The move was for the benefit of his wife's health, who had on 19 July borne him a daughter, Maria Louisa, known in the family as Minna. Fisher consented to be godfather. Maria may already have been showing symptoms of consumption, which became an increasing worry to Constable, as others in her family were also affected. Immediately, however, his move to Hampstead brought him into contact with a new range of subject-matter, which he learned to exploit as much as his Suffolk scenes.

A sketchbook survives with dated drawings from Hampstead done between 9 September and October, though he made another brief visit to East Bergholt in October 'for the division' of the family plate and linen, and there are drawings of his parents' tomb in East Bergholt Churchyard. He returned to Hampstead on 30 October. On 1 November he archly announced to his family in Suffolk, by way of a postscript, that he was 'by a large majority' (in fact, 8 to 5) elected an Associate of the Royal Academy. By an irony, he defeated C.R. Leslie, who was to be his closest friend after Fisher. John Fisher lost no time in writing on 4 November from Salisbury to present his, the Bishop's, and Mrs Fisher's 'congratulations on your honourable election. Honourable it is: for the Royal Academy

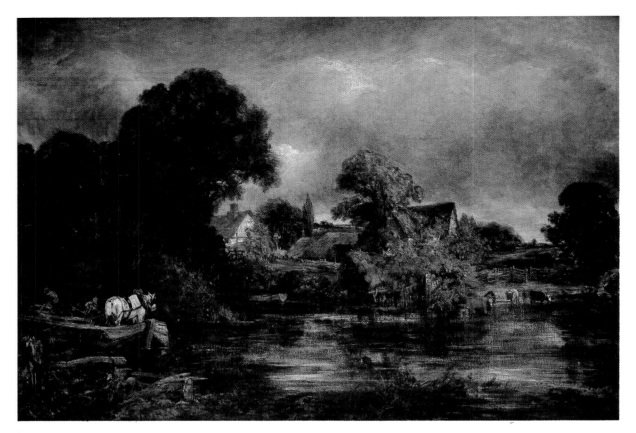

106. *Study for the White Horse.* 1818–19. Oil on canvas, 127 × 183 cm. Washington, D.C., National Gallery of Art, Widener Collection, 1942

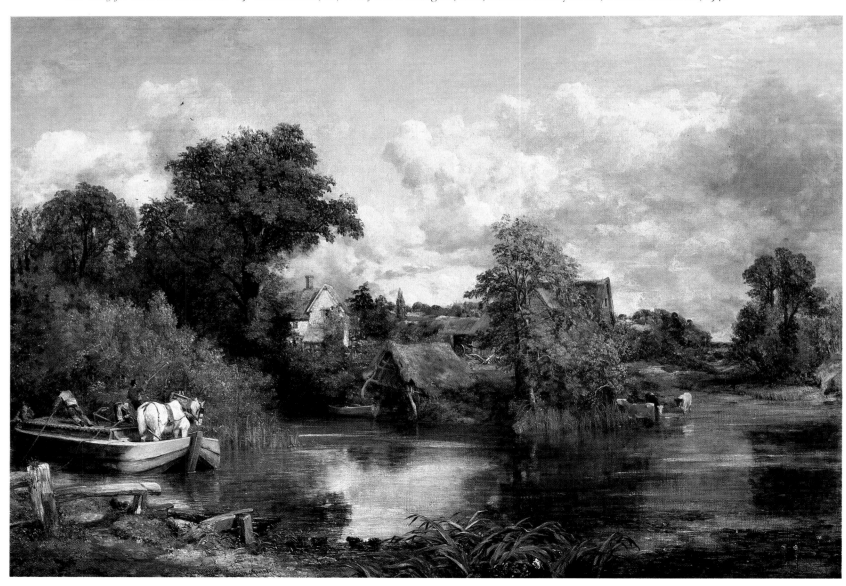

107. *The White Horse.* 1819. Oil on canvas, 131.4 × 188.3 cm. New York, The Frick Collection

108. *Branch Hill Pond, Hampstead Heath.*
1819. Oil on canvas, 25.4 × 30 cm.
London, Victoria and Albert Museum

is in the first place an establishment of the great country such as to be held in great respect: and in the second place you owe your place in it to no favour but solely to your own un-supported unpatronised merits: ———— I reckon it no small feather in my cap that I have had the sagacity to find them out.' Constable, however, had to wait nearly ten years before he became a full member, an unprecedented and agonizing wait.[8]

In the midst of his 'jobs', a new baby, a sick wife, a temporary move to a new house, and a rushed visit to East Bergholt, Constable was not inactive in getting to grips with his new landscape scenery at Hampstead. As well as filling his sketchbook, he was able to show Farington, on 2 November, two paintings of Hampstead Heath. One of these is, possibly, *The Branch Hill Pond* (Plate 109), in the Victoria and Albert Museum, which bears an old inscription dating it 'End of Octr. 1819'. Farington, surprisingly, made no comment on its handling, but it is in Constable's loosest and most dramatic manner. It shows a stormy sky, looking over the pond towards Harrow at the left, with a prominent feature of the sandbank at the right. In contrast to some of his other small sketches of Hampstead Heath, *Branch Hill Pond* has a fury of palette knife strokes and 'raw' impasto, where the dense mass of the sky balances the rough texture of the sandbank. It has no equivalent in European art at that time. Turner's Italian studies of 1819, in comparison, are exquisite attempts to come to terms with the bright light of Italy. Constable also makes use of Hampstead's height to give much greater vistas than are found in his Suffolk landscapes, and from this initial sketch came a number of similar earthy views of Hampstead during the 1820s (Plates 108, 109, 166, and 168). Already, it looks forward to the 'skying', as he called it, of 1821 and 1822 but he

did not actually exhibit a finished Hampstead Heath painting until 1821. At least three, however, may be dated from 1819–20, which will be discussed in conjunction with his work of 1820. They make an interesting comparison with his major exhibits at the Academy of 1820 and 1821.

During the winter of 1819–20, he was hard at work on another major 'six-footer', which represented Stratford Mill on the Stour, and for it he again prepared a large preliminary sketch (Plate 110), hitherto not known to exist, but recently rediscovered, and now at the Yale Center for British Art, New Haven. From *Flatford Mill* onwards, his major works required large-scale preliminary exercises to help him make the further transition from observed facts to remembered reality. This had, in fact, been part of his development since he first distinguished between his sketches and finished works, but on a smaller scale. *Flatford Mill from the Lock* of 1811 and 1812 (Plates 60 and 63) are examples of his procedure. After this period, as his knowledge and capacity grew, this dichotomy had become wider. His greater sophistication of technique and the enlargement of his vision, his difficulties of painting on the spot, as he had done for *Boat Building* (Plate 85) and *Wivenhoe Park* (Plate 91), the increase in size of his pictures, all meant that the large-scale sketch took on an increasingly important function. Scale, in itself, was a factor at the crowded Academy exhibitions, but the development of his own attitude to art and nature required him to rehearse privately, as it were. Each major performance seems to have required a different run through. There were technical reasons, not always obvious, but his comments on the Diorama (see Chapter 2, Note 51), made in 1823 when he was much involved with these problems in his art are worth repeating for the clues they give to his

109. *Branch Hill Pond, Hampstead Heath. c.* 1821–2. Oil on canvas, 24 × 39 cm. London, Victoria and Albert Museum

attitude: 'It is without the pale of the art because its object is deception. The art pleases by *reminding*, not by *deceiving*.' *The White Horse* had attempted to remember 'a serene grey morning, summer', and he attempted the same feat of memory in his next major work of 1820, which was, again, a scene on the Stour, called simply *Landscape*. When it was engraved by Lucas, after Constable's death, it was called 'The Young Waltonians', too descriptively mawkish a title for Constable, even though the young fisherboys are so prominent. It is generally known as *Stratford Mill* (Plate 111).

This time he had gone farther upstream from Flatford to Stratford St Mary, where the water-wheel of the mill worked a paper manufactory, which was not one of the family properties. It no longer exists and beyond its razed site is a garage with broken-down, rusty cars replacing the horsemen behind the prominent trees at the left. In Constable's day it would have been a bustling area, and to the activity of this local early industrial scene Constable has added the timeless elements of the young fishermen's activity and the traffic of the barges at the right. Boys still fish in the same mill pool. For the initial conception, as before, he drew upon earlier oil sketches, which have recently come to light, although hardly any pencil sketches seem to have survived, other than drawings for the mooring post in the finished picture (not in the sketch), and one of waterlilies, both of which could be described as stock

'staffage', from the 1813 sketchbook in the Victoria and Albert Museum, (pages 77 and 55). What seems to be the initial vertical oil sketch (Plate 112) is dated 17 August 1811. It is, actually, the first evidence that he visited East Bergholt at this time, when David Pike Watts had criticized his landscapes for being 'tinctured with a sombre darkness'. This apparent darkness may have been because of his growing love for Maria, but the sketch is cheerful enough, full of the extreme and vigorous play of sunlight and shadow, which his sketches had achieved by that date. In technique, it could be compared with his two views of the lane near East Bergholt of that date (Plates 61 and 66). It is unusual, however, in that it is on board, and the seven figures have even greater prominence in the landscape than in his other small sketches of this date. The awkward position of the figure with a rod against the right edge suggests that this small panel may have been cut down.

The second sketch (Plate 113) on a quarter scale of the finished picture has the two figures at the right, but the figure with the rod at the left has been removed. There are clear traces of him in the full-scale sketch of Plate 110 but he has been painted out. His rod is still clearly visible. In the second sketch (Plate 113) the angle of the principal boy's rod is nearly vertical, but it has been lowered in the full-scale sketch. Its original position can also be still clearly seen in the Yale picture. The girl bending into the sluice channel, at the left,

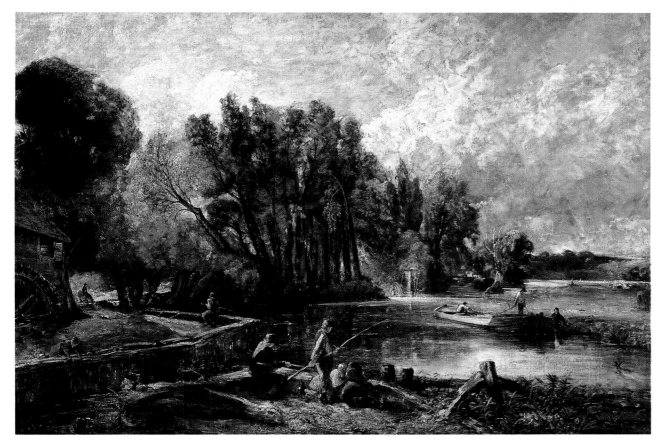

110. *Study for Stratford Mill, 'The Young Waltonians'*. 1820. Oil on canvas, 131 × 184 cm. New Haven, Yale Center for British Art, Paul Mellon Fund

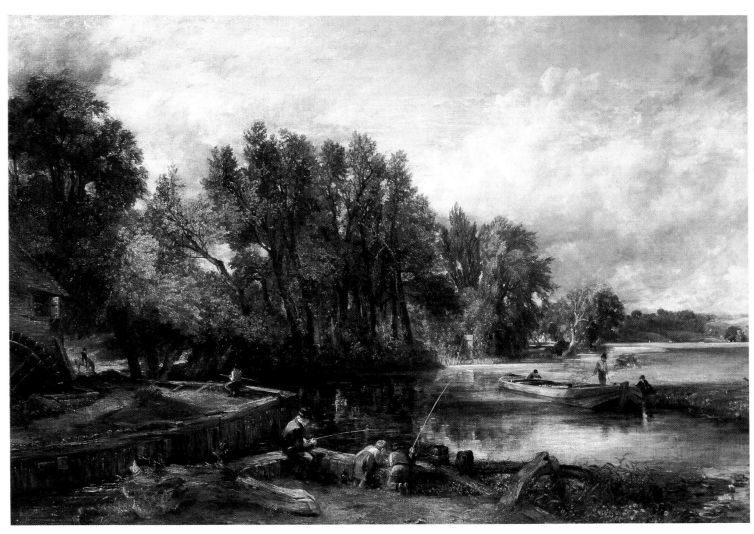

111. *Stratford Mill, 'The Young Waltonians'*. 1820. Oil on canvas, 127 × 182.9 cm. Private Collection

112. *Landscape Study at Stratford Mill.*
1811. Oil on paper on panel,
18.3 × 14.5 cm. Private collection

who occurs throughout the sketches, finally disappears in the finished picture, where the central figures are simplified once more. All these changes show Constable using his previous sketches, but continually concentrating the dramatic effect of the principal figures, so that Sir George Beaumont, when he saw the finished picture, could remark that the largest boy 'was undergoing the agony of a bite'. By simplifying the originally rather diffuse group of figures, and making them less important in the overall scheme of things, Constable has placed them in the context of the river, which moves in a diagonal to the Langham Hills at the right. Thus the landscape assumes its principal importance.

The full-scale sketch can be seen to have contributed to this aspect in a most important way. The initial small sketch of 1811 was full of the flicker of light and vibrant brushstrokes. The full-scale sketch attempted to control the light, silhouetting the horseman, touching the tips of the trees, striking the back of the seated figure, and flooding through the trees in the centre, full force on the sluice gate, as if a holy miracle were

occurring. The light, in fact, falls strictly according to nature, as it appears about 11:45 a.m. on a late summer's day from about South-South-East, Constable's favourite time of day for his pictures. The river at Stratford flows almost in a south-westerly direction, before it takes a turn to the left, towards Flatford and the sea.

Constable was concerned, too, with other natural facts: not only the boisterous piling up of the clouds in the sketch, which are as lively as anything he had painted so far, particularly over Langham ridge, and which are much toned down in the finished picture, but also with what Lucas called its 'natural history'. This was a detailed explanation to Lucas of what Constable recognized as its so-called 'natural phenomena'.

Mr C. explained to me if I may so call it the natural history of this picture among his remarks were the following that when water reaches the roots of plants or trees the action in the extremities of their roots is such that they no longer vegetate but die which explains the appearance of the dead

113. *Study for Stratford Mill. c.* 1819–20. Oil on canvas, 30.5 × 42 cm. England, private collection

tree on the edge of the stream. The principal group of trees being exposed to the currents of wind blowing over the meadows continually acting on their boles inclines them from their natural upright position and accounts for their leaning to the right [left] side of the picture.

The meadows were more exposed to the prevailing south-westerly winds than they are today with the addition of hedges. Constable, as Lucas emphasized, was proud of his knowledge of why things looked the way they did, and in his landscape lectures he was later to say, 'We see nothing truly till we understand it.'[9] It is questionable in the modern urbanized society, whether the trees that are there today would be looked at in the same way.

When he exhibited the finished painting at the Royal Academy in 1820, the contemporary press, for once, seems to have appreciated its natural merits. *The Examiner* thought it had a 'more exact look of nature than any picture we have seen by an Englishman, and has been unequalled by very few of the boasted foreigners of former days, except in finishing'. If the journalist could criticize the finished picture (Plate 111) for lack of finish, we wonder what he would have had to say about the full-scale 'exercise' (Plate 110), on which so much obvious energy has been expended. Its right hand portion has a myriad of 'impressionistic' touches for figures, animals, and patches of light, which, with no lessening of the variety of greens, are smoothed out in the finished work. Similarly, the dense mass of trees at the left, in the sketch suggested by broad transparent glazes, with the branches added last as dark, calligraphic strokes, have all been tidied and made more particular in the finished picture. Ultimately, the refinement is one of art imposed upon nature. The compositional structure, which is again a horizontal criss-cross, has been tightened, but its underlying geometry is disguised by the angle of the barge, apparently about to move upstream through the lock, which was in the channel at the right but without its grazing towhorse at the right which has been removed from the finished picture. The two bright touches of red on the boy's waistcoats at the left also help to strengthen the left-hand diagonal, while the contrast between the dark mill-pond and highlight on the water help to balance that diagonal on the right, and lead our eye down the river. Most important he has widened the scene, so that it is much broader than it is in reality. A modern concrete jetty has replaced the old timbers at the left, and in the foreground, but the river is actually much narrower than Constable makes it appear and can be crossed today by a narrow foot-bridge. His image, apparently so much based on 'natural peinture' is, then, as much the product of his own creativity, rather than a direct transcript of the facts.

He seems to have been highly satisfied with its outcome, and reception, and throughout the 1820s, he continually tried to send it to exhibitions as one of his most representative works, often taking the opportunity to fiddle with it further against the objections of its owner, J.P. Tinney, Fisher's lawyer in Salisbury. Fisher had decided at the beginning of 1821 to buy it from the artist and present it, as a mark of gratitude, to Tinney who had won a lawsuit for him. Tinney, and then his widow, were sorely tried by Constable's constant requests to have it back.

This 'noble picture', as Leslie described it, makes an interesting comparison with his other works of 1820. At the Academy he exhibited as its only companion, a much smaller view of *Harwich Lighthouse*. This is, almost entirely, a seascape in a different mode, and with very little 'subject', compared with *Stratford Mill*. Yet it was to prove popular and a number of variants exist of about the same size ($12\frac{7}{8} \times 19\frac{3}{4}$ ins.), which

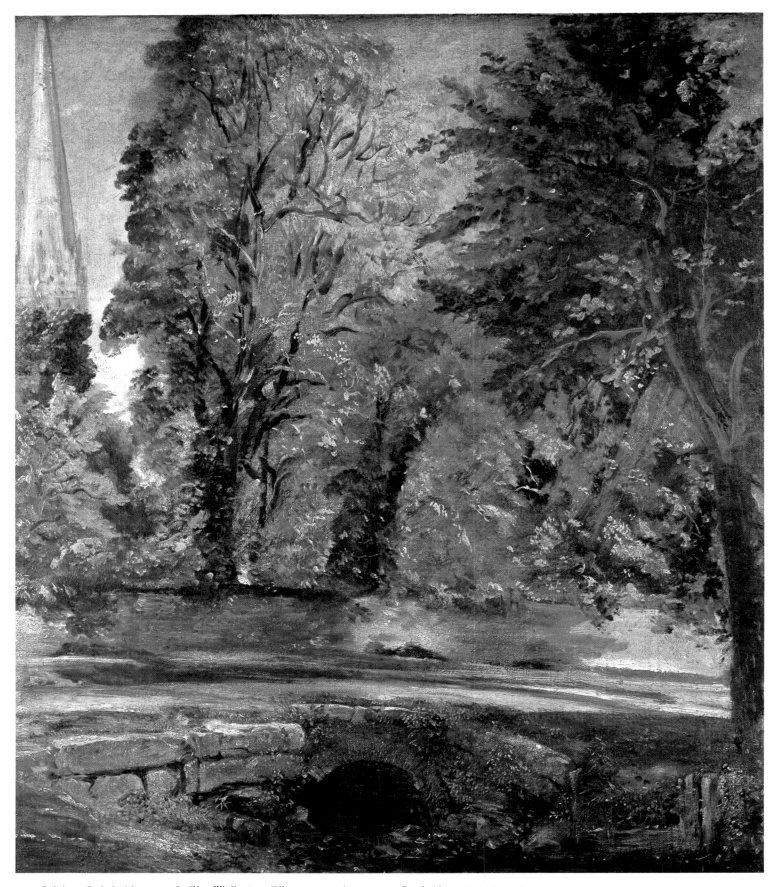

114. *Salisbury Cathedral from over the Close Wall*. 1820. Oil on canvas, 61 × 51 cm. Cambridge, Fitzwilliam Museum

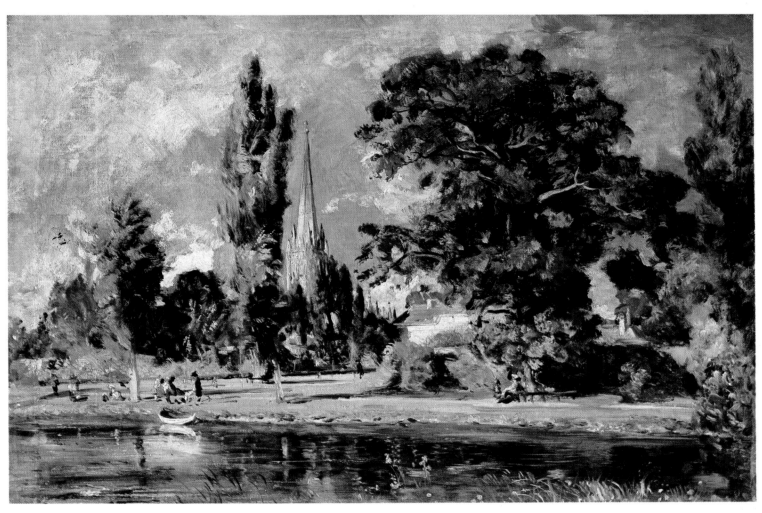

115. *Salisbury Cathedral from the River*. 1820. Oil on canvas, 52.5 × 77 cm. London, National Gallery

Constable had to reproduce because of demand.[10] He was to be busy for the rest of the year, and he found that works begun first, as a result of a trip to Salisbury in July and August 1820, then, at Hampstead Heath, where he moved his family again in September, and, thirdly, at Malvern Hall, where he stayed with H.G. Lewis in September, were all to require replicas. In three months he found not only that his art, of necessity, expanded in scope of subject, but its demands became even more pressing. The next year (October 1821) he was to complain that 'I do not consider myself at work without I am before a six foot canvas'.

His visit to Salisbury was as a result of a long-standing invitation by Fisher which Constable, Maria, and his two children were finally able to take up. They stayed in the Close, at Fisher's house called 'Leydenhall'. Fisher had been made a 'Canon Residentiary' the previous year (shades of *Barchester Towers*), and his residence had a garden that ran down to the river, and from which were views of the Avon and Farnham ridge. Although the trip was by way of a holiday, Constable kept hard at work, sketching in oil and pencil views he made in and around the Cathedral, and further afield. He went to Stonehenge, where he produced the original pencil drawing, dated '15 July 1820', (Plate 225), of his late water-colour of 1836 (Plate 226), both in the Victoria and Albert Museum; to

Gillingham, where Fisher had also been made vicar in 1819; and through the New Forest to Downton in Wiltshire. He drew reed-filled scenes of the river Avon, reminiscent of his Stour Valley sketches, and a detailed study of the façade of the Cathedral seen sideways on, as in his views of East Bergholt church. His drawings have a confident, firm stroke, made with a dark pencil which gave dense effects of chiaroscuro. They mark an advance on his careful, but tentative, sketches from his first visit of 1811.

Of equal brilliance are his oil sketches of the Close where Fisher had materials easily at hand. Although this was new territory for Constable, and he was there barely two months, his oil sketches are among his most lively and immediate. Perhaps his old gratitude to the Bishop, his deep friendship for Fisher, and the happiness of his holiday with Maria, spurred him on to do his best for Salisbury. There are small sketches, showing, for example, Salisbury Cathedral from the Bishop's grounds, with the palace at the left (Plate 116), Victoria and Albert Museum.[12] There are unexpected, intimate corners of the Close, with the spire squeezed in just over the wall (Plate 114), Fitzwilliam Museum, Cambridge, and there are slightly larger sketches full of atmosphere and sunlight, one of which shows Archdeacon Fisher's house, Leydenhall, from across the river (Plate 115), National Gallery, London. In this he has

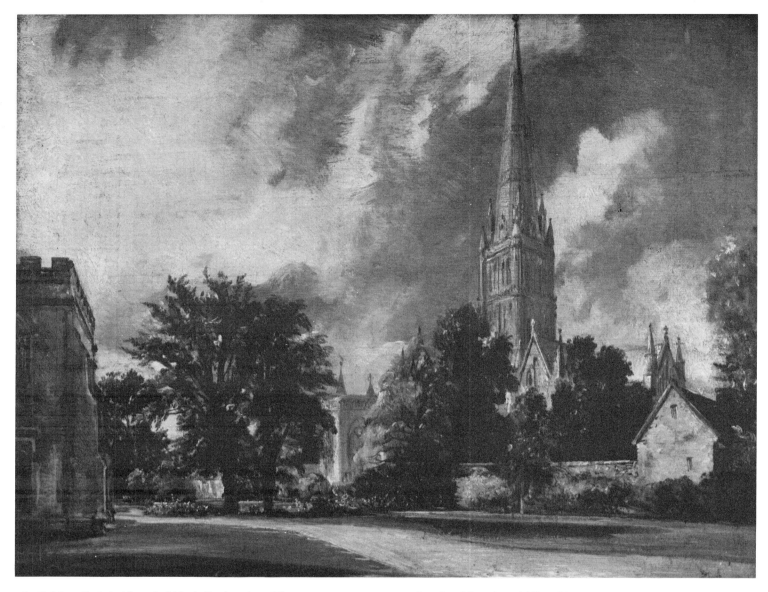

116. *Salisbury Cathedral from the Bishop's Garden.* 1820. Oil on canvas, 25.1 × 30.2 cm. London, Victoria and Albert Museum

made much use of the red-brown ground, which, with his broken touch, give the warm glow of an afternoon's light by the river. It has also vibrant touches of red and yellow, which give a sparkle to his personal vision. An even larger sketch of the Close is in the National Gallery of Art, Washington.

He wrote to Fisher on 1 September 1820, on his return to thank him for his 'unbounded kindness and hospitality', and mentioned that 'My Salisbury sketches are much liked — that in the palace grounds — the bridges [probably Harnham Bridge] & your house from the meadows [Plate 115] — the moat [probably the Fitzwilliam sketch] &c. I am painting my river Thames on a large canvas' [his sketch of the opening of Waterloo Bridge]. The moat was a stream that drained the Bishop's fishpond into the Avon and in this small 'snapshot' scene (Plate 114) Constable has concentrated on a motif that would have been a favourite of his: a small bridge, running water, rotting stumps, and the dappled light and shade under handsome trees, with the Cathedral included almost as an afterthought over the wall.

The sketches were almost certainly done on the spot, directly from nature, but 'that in the palace ground' (Plate 117), in the National Gallery of Canada, Ottawa, was to become important as the original of a number of finished works done on commission for the Bishop. His request came through his daughter Dorothea ('Dolly'), to whom Constable had given painting lessons since 1818.[13] She wrote that 'Papa desires me to say he hopes you will finish for the Exhibition the view you took from our Garden of the Cathedral by the waterside, as well as Waterloo Bridge.' As was his practice, he did not add to the sketch but worked up a finished composition, which dragged on with reminders from the Bishop, and even advances of money, until 1823. The original was based on an 1811 drawing in the Victoria and Albert Museum (R. 105). An intermediate stage, after the Ottawa sketch, seems to be an unfinished sketch (Plate 118), but, eventually, the finished picture (Plate 119) was exhibited at the Royal Academy in 1823. It had caused him much difficulty. His principal complaint was that it had prevented him from sending a six-footer

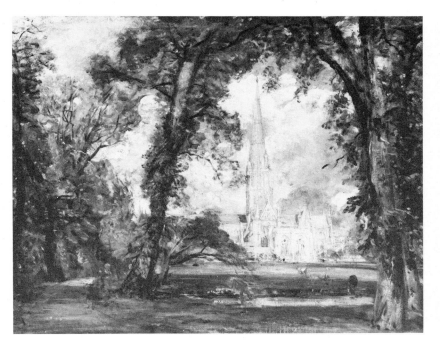

117. *Salisbury Cathedral from the Bishop's Grounds*. 1820. Oil on canvas, 74.3 × 92.4 cm. Ottawa, National Gallery of Canada

118. *Sketch for Salisbury Cathedral from the Bishop's Grounds*. c. 1823. Oil on canvas, 61 × 73.7 cm. London, private collection

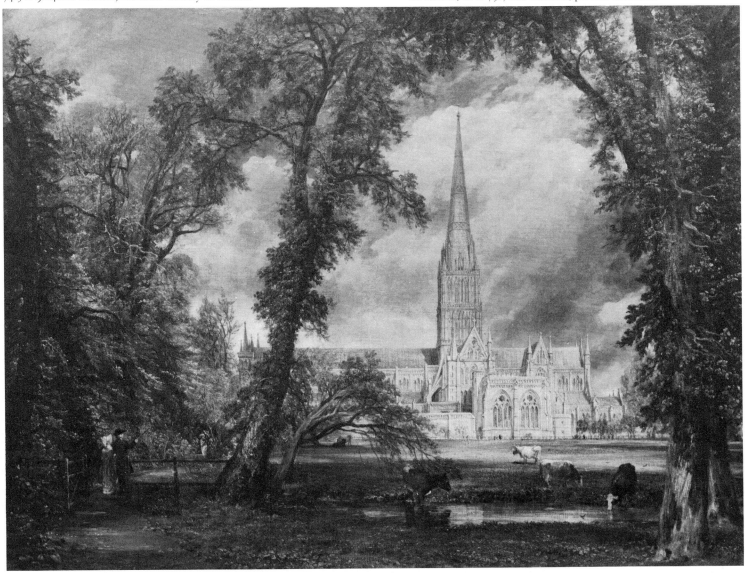

119. *Salisbury Cathedral from the Bishop's Grounds*. 1823. Oil on canvas, 87.6 × 111.8 cm. London, Victoria and Albert Museum

120. *Malvern Hall.* 1820–1. Oil on canvas, 54 × 78 cm. New Haven, Yale Center for British Art, Paul Mellon Collection

121. *Hampstead Heath: The Salt Box. c.* 1820. Oil on canvas, 38.4 × 66.8 cm. London, Tate Gallery

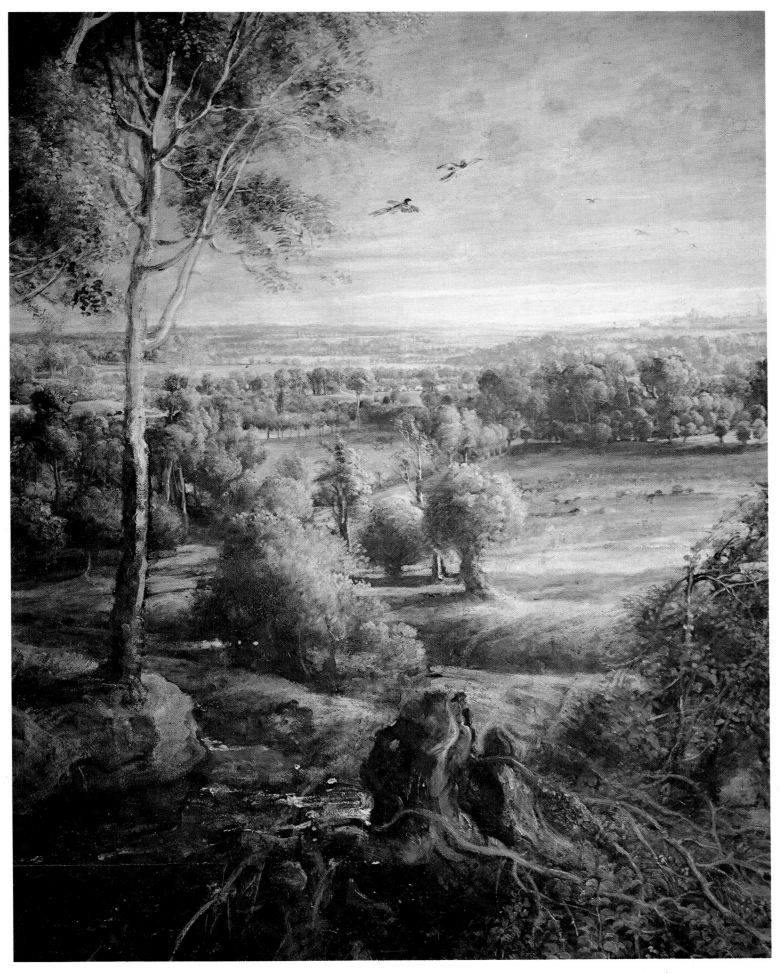

122. Sir Peter Paul Rubens (1577–1640). Detail from *Landscape with the Chateau de Steen*. After 1635. Oil on panel, 131.8 × 229.9 cm. London, National Gallery

to the Academy for 1823, but he was also frustrated by the requirements of the Bishop. He wrote to Fisher, 9 May 1823:

> My Cathedral looks very well. Indeed I got through that job uncommonly well considering how much I dreaded it. It is much approved by the Academy and moreover in Seymour Street [the Bishop's London house] though I was at one time fearfull it would not be a favourite there owing to a *dark cloud* — but we got over the difficulty, and I think you will say when you see it that I have fought a better battle with the Church than old Hume Brogham and their coadjutors have done. It was the most difficult subject in landscape I ever had upon my easil. I have not flinched at the work, of the windows, buttresses &c &c, but I have as usual made my escape in the evanescence of the chiaroscuro.

His difficulties with architectural details can be compared with Turner's confident renderings of picturesque architecture, which he had been engaged upon for forty years.

In spite of Constable's optimism the Bishop was not satisfied with the 'dark cloud', and Fisher detailed the Bishop's objections: 'If Constable would but leave out his black clouds! Clouds are only black when it is going to rain. In fine weather the sky is blue.'

Constable held his tongue and took it back in 1824. He eventually disposed of it to his friend Fisher who, in turn, sadly, had to sell it back to Constable, together with *The White Horse*, at the time of personal financial difficulties in 1829. It was eventually bought by Sheepshanks and given by him to the Victoria and Albert Museum. Today, in spite of, perhaps, an over-elaborate composition, we feel that the Bishop's querulous irritation with the dark cloud was misconceived, and Constable's 'evanescence of chiaroscuro' brings out very well the 'silvery grey' quality of the Cathedral that attracted him, as well as giving his picture an atmospheric three-dimensional quality.

Meanwhile, after its initial appearance at the Royal Academy in 1823, the Bishop commissioned on 3 August 1823 a small replica to give to his daughter Elizabeth as a wedding present. For this he wished 'to have a more serene sky'. Constable managed to finish this, complete with 'a little sunshine', in time for the couple's return by 19 October 1823, and it is now in the Huntington Art Gallery, San Marino, California. The version that Constable painted to replace his original exhibited picture was not actually finished before the Bishop died, and it was eventually delivered to the Bishop's widow. It is now in the Frick Collection, New York. The sky is obviously lighter, and the trees do not meet in an arch at the top. A further version, in the Metropolitan Museum of Art, New York, it has been argued by Graham Reynolds, was probably done in the studio with much assistance by Johnny Dunthorne as a preliminary for the Bishop's second picture. All of these versions, except the original, brilliant sketch (Plate 117), done on the spot, have the figures of the Bishop pointing with his stick at the spire, with his wife on his arm, and one of his daughters walking towards them down the path at the left. These figures, according to Fisher, were considered as recognizable likenesses. Apart from his difficulties with the architectural details, Salisbury Cathedral was a frustrating job

for someone to whom he felt beholden. Plate 117 is attractive because of its atmosphere and light, and in this respect could be compared to *Wivenhoe Park* (Plate 91) painted four years earlier since it, too, was a commission for a couple he admired and on which he worked out of doors. He could not, however, as easily return to Salisbury as he had to Wivenhoe to finish his view and, by 1823, his attitude to painting had become more complicated. By then he could feel such a topographical commission was an interruption from his real imaginative work.

In 1820, on his return from Salisbury, before he could become involved in either a large-scale painting, or complete the work he had begun there, he was off travelling again, this time to Malvern Hall, Solihull, Warwickshire, to fulfil, it would appear, further commissions for Henry Greswolde Lewis who had made alterations to the house since Constable's previous visit in 1809 (see Plate 49), and which he wanted Constable to record. This was another house 'job' that, again, Constable could not refuse, because Lewis's sister Magdalene was the dowager Countess of Dysart, to whom he also owed what could be described as local 'vasselage'.[14] A drawing survives of the entrance front, dated 10 September 1820, but his preliminary oil painting (Plate 120) in the Yale Center for British Art, has a slightly different viewpoint, to show more of the facade of which Lewis was so proud. This picture may even have been done on the spot, or, at least, immediately on his return to London. It is full of sparkle but is obviously unfinished around the trees at the left in just the same way as the sketch for Salisbury (Plate 117). From it, he made a finished version, with the elegant addition of a peacock, now in the Sterling and Francine Clark Art Institute, Williamstown, Massachusetts, which is laboured by comparison with the lively version of Plate 120. He also painted a rear view across the lake, similar to his 1809 picture in London. Both of these were for the Dowager Countess and the latter has recently been rediscovered by Graham Reynolds as that in the National Museum, Havana, Cuba. A further repetition of the front view, dated 1821, is in the Musée de Tessé, Le Mans, and Reynolds suggests it was that exhibited at the Royal Academy in 1822.

Even though Constable was much engaged with these commissions, he was able in the autumn of 1820 to stay again at Hampstead, where he had settled his family before he left for Solihull. There are dated oil sketches from October 1820, but three impressive, finished landscapes may date from this year.[15] They are *Hampstead Heath with the House Called The Salt Box* (Plate 121), Tate Gallery, *Hampstead Heath* (Plate 124), Fitzwilliam Museum, Cambridge, and *Hampstead Heath, Looking towards Highgate*, in the Victoria and Albert Museum. The activities that we find in them can be found recorded in a small sketchbook of 1819, now in the British Museum, and it may be when these pictures were begun.[16] They have the air of being done on the spot, they record fresh summer days, and a passage in Leslie's *Life* certainly suggests this:

> Constable's art was never more perfect, perhaps never so perfect as at this period in his life. I remember being greatly struck by a small picture, a view from Hampstead Heath,

123. Map of Hampstead by J. & W.
Newton, 1814, from J. J. Park, *The
Topography and Natural History of
Hampstead*, London, 1814. New Haven,
Yale Center for British Art

1. The Grange (The Saltbox)
2. Branch Hill Pond
3. Prospect or Judges Walk
 (views towards Harrow)
4. 2 Lower Terrace (1821–2)
5. Admiral's House
6. Stamford Place (1823)
7. Whitestone Walks Albion Cottage (1819)
8. Vale of Health
9. 40 Well Walk (1827–37)
10. 25/26 Downshire Hill = Langham Place
 (1826–7)
11. Holly Bush Inn Hampstead – Assembly
 Rooms (Landscape Lectures 1836)
12. Parish churchyard: Constable's grave
13. Haverstock Hill

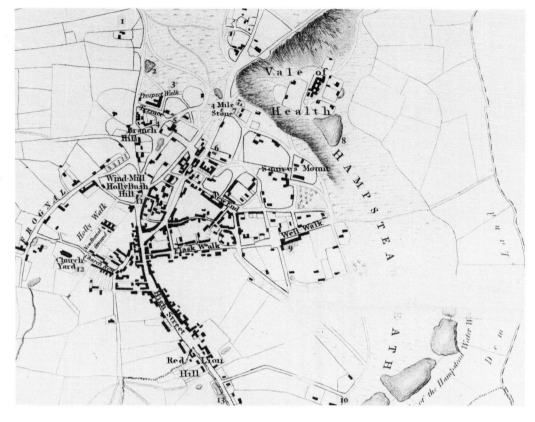

which I first saw at *Ruysdael House*, as Mr Fisher called his residence in Keppel Street. I have before noticed that what are commonly called warm colours are not necessary to produce the impression of warmth in landscape; and this picture affords, to me, the strongest possible proof of the truth of this. The sky is of the blue of a English summer day, with large, but not threatening, clouds of a silvery whiteness. The distance is of a deep blue, and the near trees and grass of the freshest green; for Constable could never content to parch up the verdure of nature to obtain warmth. These tints are balanced by a very little warm colour on a road and gravel pit in the foreground, a single house in the middle distance, and the scarlet jacket of a labourer. Yet I know no picture in which the mid-day heat of midsummer is so admirably expressed; and were not the eye refreshed by the shade thrown over the great part of the foreground by some young trees, that border the road, and the cool blue of water near it one would wish, in looking at it, for a parasol, as Fuseli wished for an umbrella when standing before one of Constable's showers. I am writing of this picture, which appears to have been wholly painted in the open air, after an acquaintance with it of five-and-twenty years; and, on referring to it again and again, I feel my first impressions, whether right or wrong, entirely confirmed. At later periods of his life, Constable aimed, and successfully, at grander and more evanescent effects of nature; but in copying her simpler aspects, he never surpassed such pictures as this; and which, I cannot but think, will obtain for him, when his merits are fully acknowledged, the praise of having been the most genuine painter of English landscape that has yet lived.

These typical laudatory comments by Leslie could equally well apply to Plate 124, which has a similar point of view, looking from the Branch Hill end of Judges Walk towards the distant height of Harrow (see map, Plate 123). It is a companion in size to the picture in the Victoria and Albert Museum, which looks the opposite way towards Highgate Hill. The engrossed figure of the workman in a red waistcoat is prominent, and almost identical, in both (Plates 121 and 124), and immediately reminds us of Constable's use of figures engaged in a recognizable activity, in this case, the removal of sand and gravel for local roads. The Heath, until the middle of the nineteenth century, was considered almost as a public quarry. In Plate 124, however, the cart is upended and appears to be emptying material into a hole. The red waistcoat is a further example of Constable's subtle sense of colour, and the way it could be used to point up a landscape, as Leslie remarked. All three scenes are 'placid', as Constable would describe them and are painted in a refined version of his sketching technique and fit very well in handling with his pictures of 1819–20. We must not forget, however, Constable's perpetual tinkering with his pictures. Further work may well have been added when the two, if these are they, were sent to the Academy in 1821. They are most notable, however, for their sense of distance, emphasized by the luminosity of their skies. If his major works could be considered as highly wrought, definitive statements then these three small works could be described as 'lyrical ballads', where, to paraphrase Wordsworth, 'the incidents and situations from common life' are described with a handling 'true to nature'.[17] Natural factors obviously helped. The views from the Heath, because of its height, were, at that time, more

124. *Hampstead Heath. c.* 1820–1. Oil on canvas, 54 × 76.9 cm. Cambridge, Fitzwilliam Museum

125, *Landscape, Noon, The Haywain*. 1821. Oil on canvas, 130.5 × 185.5 cm. London, National Gallery

extensive than they are today, and were less cultivated than his Stour Valley scenes. The following year (in November 1821) he drew a diagram for Fisher to show that to the north, he could see as far as St Albans; to the south, Dorking; to the east, Gravesend, (including St Paul's and the City); and to the west, Harrow and Windsor. These last two were his favourite views, and were impressive enough, but the skies, too, made their effect, and, as we shall see, became the subject of further investigation. He was obviously also fascinated by the activities in the sand pits, the natural trade of the Heath, as barges had been on a navigable river, but he also includes strolling figures of parents with young children (see Plate 142) suspiciously like the young Constable family out for a walk, particularly as the man is invariably dressed in dark clothes, which Constable himself habitually wore.

There is, however, one further point that needs to be emphasized. Ever since he had first seen Rubens's *Chateau de Steen* (Plate 122), when it was purchased by Sir George Beaumont in 1803, he had doubtless been impressed by Rubens's ability to render light and atmosphere, 'dewy light and freshness', he called it in his lectures, and to suggest vast distances without losing the intricacy of detail in the foreground. An early letter from Fisher to Constable, of 3 November 1812, made the point that 'I have heard it remarked of Rubens that one of his pictures *illuminates* a room,' and he enjoined Constable 'that what appears *depth* near, should not be *gloom* at a distance'. Constable had, by 1820, clearly learned his lesson. Even the balance of detailed human activity against distant scale in Rubens has been achieved in these minor masterpieces, on a more mundane level by the single red of the workman balanced against the blue-green of the rolling heath. He, however, put these lessons into practice on a larger and more impressive scale that winter, with another six-foot picture by which he is, perhaps, best known.

He had shown Farington a version of his 'Waterloo', but Farington on 21 November 'recommended him to complete for the Exhibition a subject more corresponding with his successful picture exhibited last May' (*Stratford Mill*). There thus began what Fisher was to call 'The Hay Wain'. Constable received a further filip when he learned, on 20 January 1821, that Fisher had decided to buy the *Stratford Mill* for his lawyer Tinney. He could thus proceed with an easy conscience that he was not spending time on a large personal work, when he could have been finishing 'jobs' to earn money for his family. Fisher again, as he was to do for the rest of his life, had given Constable moral and financial support at a critical period which Constable fully appreciated, when he wrote at the end of February 1821:

Believe — my very dear Fisher — I should almost faint by the way when I am standing before my large canvases was I not cheered and encouraged by your friendship and approbation. I now fear (for my family's sake) I shall never be a popular artist — a Gentleman and Ladies painter — but I am spared making a fool of myself — and your hand stretched forth teaches me to value my own natural dignity of mind (if I may say so) above all things . . . I look to what I possess and find ample consolation.

His self-confidence at this time can be reckoned by the speed with which *The Haywain* (Plate 125) was finished. In a little under five months, Constable had chosen his subject, again familiar surroundings at Flatford Mill, marshalled his material, and had the painting ready for the Academy on 10 April, with, he thought, '3 or 4 days there' to work on it further. The view is similar to his earlier scenes of the Millstream at Flatford (Plates 77 and 78), but the spectator is not standing on the forecourt of the mill, looking downstream, but is, on this occasion, on the left bank, with Willy Lott's house nearer at hand, looking over the ford by the eyot to the mainstream of the river itself and across the meadows beyond, roughly in a south-westerly direction. By 1821, after two major works in this vein, the inclusion of 'subject' was automatic, and a small oil sketch on paper (Plate 126), now in the Yale Center for British Art, may have been an early stage in the development of the picture (or it is a later reminiscence). In it, the principal elements of the haywain and Willy Lott's House are already in position, and it reveals a furor of imaginative creation. It has the same expressionistic quality as the sketch *On the Stour* (Plate 105). But he also used his earlier sketches, from in front of the subject, to provide himself with significant details. Surprisingly, there do not seem to be pencil sketches in either the 1813 or 1814 sketch-books, which he consulted, although a detailed study of a boat (on blue paper; Plate 127), which had first appeared in *The White Horse* as the ferry boat in the boathouse emerges as the fisherman's boat in the reeds at the right. It can be found again in his later *Salisbury Cathedral from the Meadows* (Plate 188). There is an early oil sketch of Willy Lott's House (Plate 128) probably from as early as 1811 but no later than 1818, from which a portion of the house is used, and the sprightly black and white dog is placed in the foreground of the picture. The back of this sketch has an enlarged view of this scene, and the horse seen from the rear appears in the full-scale sketch (Plate 129). He also made use of the ravishing sketch, dated 1816, of Willy Lott's House (Plate 90), for the right-hand end of the house. A comparison with the photograph of the scene today (Plate 131) shows how 'picturesque' it was in Constable's day — the surrounding area has now been tidied — and essentially, how enlarged was his vision. In all of these sketches appear suggestions of the woman bending over to draw water, with her hand on the rail for support.

By 1821, the full-scale 'exercise' was part of his programme for the creation of his large finished pictures and the six-foot preparatory canvas (Plate 129) is the sketchiest of them all. Perhaps because of his haste, and the need to work out his problems quickly, it is the most tonal in its general effect and is reduced to essentials. Compared with the small oil sketches it is more complicated but less naturalistic. It is full of accents of light and dark in an overall brown tonality and its first effect is one of stormy weather. Large areas are left dense, with the red-brown ground showing through, and there are rough sepia strokes for the drawing of the branches. The meadows and trees at the right are treated in the same way as the sketch for *Stratford Mill* (Plate 110), at the Yale Center, with nervous dots and touches to suggest figures in the distance. Streaks of thick paint drawn across the surface with a palette knife become areas of light on the fields. Nevertheless, certain details are

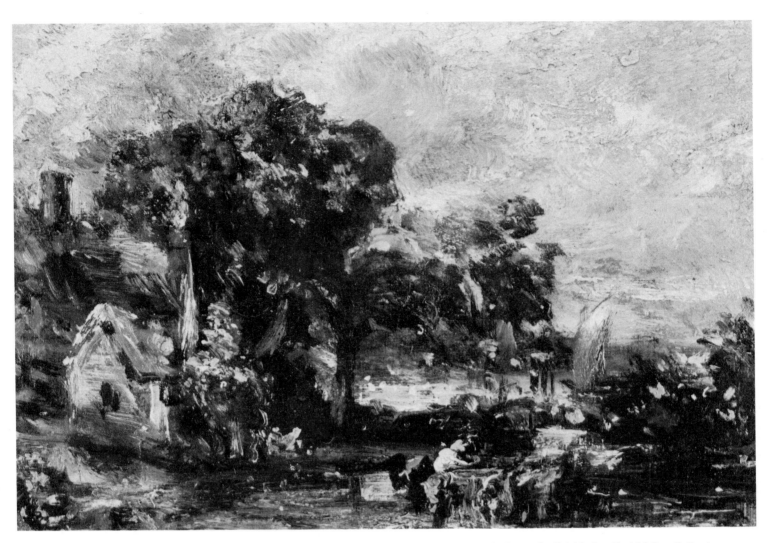

126. *Sketch of The Haywain. c.* 1820 or later. Oil on paper on canvas, 12.5 × 17.7 cm. New Haven, Yale Center for British Art, Paul Mellon Collection

carried over to the finished picture. The house, with its roof line shortened from the 1816 sketch, its chimneys slightly reorganized and the blossoming elder bush remains, as does the woman drawing water (or washing her utensils), a motif, incidentally, that is not dissimilar from the woman bending over in the *Stratford Mill* sketch, and which he was to use again in his next large picture.[18] The dog is back nearer the house, as he was in 1811, his gaze alert. The canal horse was, at first, included, but was painted out, and his traces remain dimly visible in the finished picture. An angler has emerged from the reeds at the right.

'How thrives the "hay wain"?' asked Fisher on 14 February 1821, when Constable was anxiously awaiting 'John Dunthorne's outlines of a scrave or harvest waggon', which Abram promised him a week later, on 25 February. Abram went on, 'I hope it will answer the desired end; he had a very cold job but the Old Gentleman [John Dunthorne Senior?] urged him forward saying he was sure you must want it as the time drew near fast. I hope you will have your picture ready but from what I saw I have faint hopes of it, there appear'd everything to do.' There may well have been. The drawing, used rather like a photographic *aide-memoire*, sharpened up the details of the waggon, by the addition of the plank projecting

127. *Boat at Flatford.* 1800. Black and white chalk, 9 × 12.6 cm. London, Courtauld Institute of Art, Witt Collection

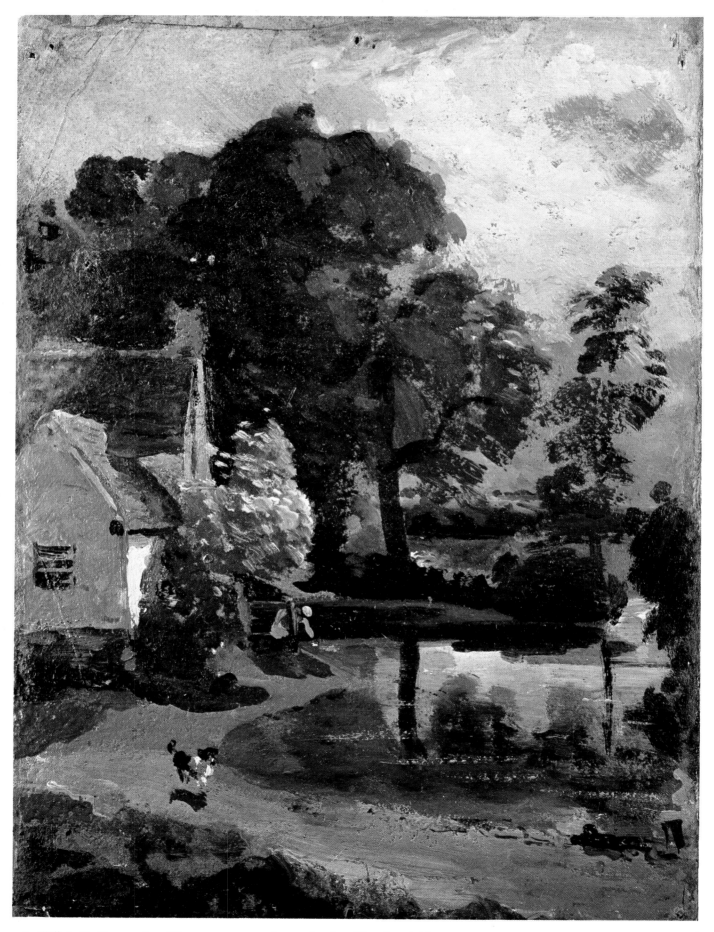

128. *Willy Lott's House. c.* 1811. Oil on paper, 24.1 × 18.1 cm. London, Victoria and Albert Museum

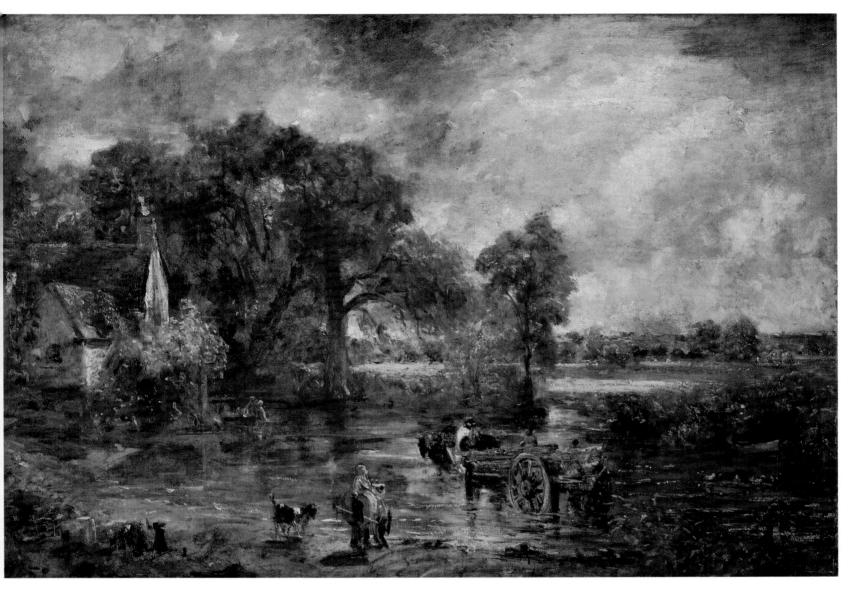

129. *Study for The Haywain.* 1820–1. Oil on
canvas, 137 × 188 cm. London, Victoria
and Albert Museum

130. *Study of a Tree Trunk. c.* 1821? Oil on
paper, 24.8 × 29.2 cm. London, Victoria
and Albert Museum

131. Photograph of Willy Lott's House

from its axles at the rear. Meanwhile, his wife had produced another son, born on 29 March, and named after his grandfather Charles Golding.

His picture was in a frame on 9 April (Farington), and at the Academy by the 10 April, with three smaller pictures, two of which were of Hampstead Heath. He then went back to East Bergholt for a short holiday over Easter and, in thanking Maria for the hot cross buns he had received, he allowed himself a nostalgic reflection on the beauty of the place:

> I visit my old haunts with renewed delight but filled with many regrets & not without many sad & melancholy reflections on the various and solemn changes since the days of my youth. Nothing can exceed the beautiful green of the meadows which are beginning to fill with buttercups, & various flowers — the birds are singing from morning till night but most of all the skylarks — How delightfull is the country, but I long to get back to what is still more dear to me.

To some extent, it could be argued, his major works, such as *The Haywain*, are expressions of these feelings. He had exchanged similar thoughts about nature to Fisher on 1 April, who had recommended him to read the Revd Gilbert White's *The Natural History of Selborne*. For Constable, it 'only shows what real love for nature will do — surely the serene and

blameless life of Mr White, so different from the folly and quackery of the world, must have fitted him for such a clear and intimate view of nature. It proves the truth of Sir Joshua Reynolds' idea that the virtuous man alone has true taste.' He presumably saw himself and his friend Fisher as aspiring towards this moral state in the pursuit of his art. Speaking earlier of pictures in the 1821 exhibition, he was equally scornful of those who did not have such a clear view of nature. The pictures were 'chiefly in the historical and fancy way — I hear little of landscape — and why? The Londoners with all their ingenuity as artists know nothing of the feeling of a country life (the essence of Landscape) — any more than a hackney coach horse knows of pasture.' Into *The Haywain* had gone all his experiences of the country life, and in the same letter to Fisher of 1 April 1821, he gave him his opinion of it: 'The present picture is not so grand as Tinney's owing perhaps to the masses not being so impressive — the power of the Chiaro scuro is lessened — but it has rather a more novel look than I expected.'

Farington saw Constable putting finishing touches to his picture at Somerset House on 1 May. It was exhibited as *Landscape Noon* and is now so well known that either it is, perhaps, never looked at, and its 'novel look' is taken for granted, or it is so much admired above all others of his works to the detriment of *Stratford Mill*, which is less well known, but

which he preferred. The stark transitions from light to dark in the sketch have given way to the serenity of a summer's landscape at noon. Only the dark cloud over the principal clumps of trees was left. His touch, as to be expected in his finished pictures is careful, not only in individual areas, such as the reeds in which is imbedded the angler, but in the careful distinction of tones, for the distant trees. The warm honey-coloured ground is lighter than that in the large sketch, and helps to maintain the blond, sunny appearance of the picture. Over the ground he has contrasted, at the left, sparkling touches of white, greens, blues, and reds. The red harness of the horse, which is adjacent to the brightest highlight, gives a strong element right in the centre of the picture, as we have noticed before with Constable, increased by the contrast between the red and near-black of the horse.

Here in the centre is, again, the focal point of the design, which consists of two horizontally opposed diagonals. One leads the eye over to the right to the haymaking, where the white shirts of the haymakers provide rhythmic accents on the horizon. They also remind us of Sam Strowger's comments about 'the lord' in a Suffolk haymaking line (see Chapter 1). The white smock of the drover nearer at hand is balanced by the light tone of the horizon at mid-left, so that he does not leap out of the picture, but helps the movement into space in the opposite direction. The figures are simply blocked in, and their simple poses also help the timelessness of the scene. Constable, then, to a boundless feeling for nature and twenty years' experience of close observation has created a work which is as pure as he can make it, a memory of his Suffolk home. *The Haywain* owes much of its lasting success to the feeling that in this 'Idyllium', this image of 'rustic life', 'the essential passions of the heart speak a plainer and more emphatic language', as Wordsworth justified his own work in a different context, but we should not forget that, equally, even more than in his Hampstead Heath scenes, it also looks back to the high art of the seventeenth century and, in particular, to Rubens, another important influence on the Romantic Movement.

It received a favourable press but remained unsold. The most favourable criticism of all was one that, significantly, Constable did not see. It was by Charles Nodier who in his *Promenades de Dieppe aux Montagues d'Ecosse* praised it: 'It is water, air, and sky; it is Ruysdael, Wouwerman, or Constable.' His picture was to assume great importance in France and become a significant landmark in the Romantic Movement. It had been seen and praised in London by Nodier and by Géricault, then by Delacroix, Stendhal and Thiers in Paris. This was still to come, however, and Constable remained unaware of any outside interest. His part in the triumph of Romanticism and the acceptance of Realism was in the future.

He accompanied Fisher for seven days of his archdeaconal visitation through Berkshire, including Reading and New-bury, during June when they both sketched together. After-wards Fisher wondered about *The Haywain*: 'For how can one participate in a scene of fresh water and deep noon shade in the crowded copal atmosphere of the Exhibition: which is always to me like a great pot of boiling varnish.' On his return, Constable rented 2 Lower Terrace in Hampstead near West Heath (see map, Plate 123), where he was able to begin a further six footer which at this stage he called *The Bridge* (Plates 144 and 145). He was having to work temporarily in a glazier's workshop and he needed to go down regularly to his studio in central London to work on such a large picture. For smaller pictures he had cleared out a coal house at Keppel St. He wrote to Fisher on 20 September that he had:

little regard for popularity, or to be run after by Ignorance. I work for excellence — and independent of my *jobs* I have done some studies, carried further than I have yet done any, particularly a natural (but highly elegant) group of trees, ashes, elms & oak &c — which will be of quite as much service as if I had bought the feild and hedge row, which contains them, and perhaps one time or another will fetch as much for my children. . . . I have likewise made many *skies* and effects — for I wish it could be said of me as Fuseli says of Rembrandt, 'he followed nature in her calmest abodes and could pluck a flower on every hedge — yet he was born to cast a steadfast eye on the bolder phenomena of nature.' We have had noble clouds & effects of light & dark & colour — as is always the case in such seasons as the present.[19]

Trees were always important to him (see Plate 130), but in his mention of skies we find a further significant development. His *Haywain* had been criticized because the 'dark clouds impart too much of their sombre hue to his trees' (*Repository of the Arts*). Fisher picking up the topic from Constable's letter of 20 September had revealed the objections that had been made to the sky in Tinney's *Stratford Mill*. He had answered them by bringing out prints by Wouwermans and Aert van der Neer, but, apart from showing that for Fisher and Constable there was ample artistic precedent in the 'great masters' for giving prominence to the skies, it also provoked from Constable on 23 September a lengthy and crucial justification of his attitude to such naturalistic observation, which gave an insight into his aesthetic:

I have done a good deal of skying — I am determined to conquer all difficulties and that most arduous one among the rest . . . That Landscape painter who does not make his skies a very material part of his composition — neglects to avail himself of one of his greatest aids. Sir Joshua Reynolds speaking of the 'landscape' of Titian & Salvator & Claude — says '*Even their skies seem to sympathise with the subject.*' I have often been advised to consider my sky — as a '*White Sheet drawn behind the Objects.*' Certainly if the Sky is *obtrusive* (as mine are) it is bad, but if they are *evaded* (as mine are not) it is worse, they must and always shall with me make an effectual part of the composition. It will be difficult to name a class of Landscape, in which the sky is not the 'key note', *the standard of 'Scale'*, and the chief '*Organ of sentiment*'. You may conceive then what a 'white sheet' would do for me, impressed as I am with these notions, and they cannot be Erroneous. The sky is the '*source of light*' in nature — and governs everything. Even our common observations on the weather of every day, are suggested by them but it does not occur to us. Their difficulty in painting both as to

132. *Landscape Study, Hampstead Heath, Looking East.* 14 July 1821. Oil on paper laid on panel, 23.8 × 29.8 cm. London, Royal Academy of Arts. Inscribed: '6–7 P.M. N.W. breeze strong'.

133. *Study of Clouds and Trees.* 27 September 1821. Oil on paper, 16.5 × 31 cm. New Haven, Yale Center for British Art, Paul Mellon Collection. Inscribed: '10 morning/fine morning after Rainy night'.

134. *Sky Study. c.* 1822. Oil on canvas, 48 × 57 cm. London, Tate Gallery

composition and execution is very great, because with all their brilliancy and consequence, they ought not to come forward or be hardly thought about in a picture — any more than extreme distances are.

But these remarks do not apply to phenomenon — or what painters call *accidental Effects of Sky* — because they always attract particularly.

To Constable it was clear that his 'skying', that is the elaborate sketches of skies that he had begun to produce in large numbers during the summer of 1821 at Hampstead, had a three-fold purpose. They were necessary to bind his pictures together, naturalistically and emotionally, that is they gave, not only 'scale', but also 'sentiment'. They were also the source of light, or what Fisher had described in 1812 as Rubens 'illuminating a room'. If Constable's pictures were to be convincing, then he must get his meteorological facts right, as well as other elemental details of water, and the earth. It is a curious fact, however, that he never seems to have used even one part of his innumerable sketches of clouds in a finished picture, in the way he used other sketches as facts to be used and it is a further paradox that he himself was to be increasingly attracted to 'phenomenon', by which he presumably meant rainbows, sunsets, or the violent passage of storms,

135. *View from Hampstead Heath Looking towards Harrow*. August 1821. Oil on paper laid on canvas, 25 × 29.8 cm. Manchester, City Art Gallery. Inscribed: '5 o'clock afternoon: very fine bright & wind after rain slightly in the morning'.

and they had the effect of attracting notice, not always favourable.

The earliest known of these studies (Plate 132) is dated 14 July (1821), on which he had also noted the time, '6–7 p.m.', and the weather conditions: 'N.W. breeze strong', a form of inscription that he normally added to these sketches. He had drawn clouds before; he had also noted meteorological conditions in his Lake District scenes, and, of course, there was not a naturalistic sketch, or finished painting by him, from 1802 onwards, that did not pay attention to the skies, but his campaign of 'skying', which he continued in 1822, where he systematically noted the weather conditions as he rapidly described the clouds was unique in his art. To the extent that it

was so single-minded it was unique in the history of art. He generally painted in oil on paper, and some of them have been laid down so that their support is not immediately obvious and their inscriptions have been lost; but those surviving have recently been systematically analysed by a meteorologist, Dr J.E. Thornes, who compared them to contemporary local weather records, and has shown that to a remarkable extent Constable was accurate, that is to say, the clouds he painted were correct for the weather that ensued on the dates he has noted. Constable's feat is made the more remarkable when his difficulties — of coping with pieces of prepared paper pinned to his paintbox, a slow drying oil paint, and breezy Hampstead Heath, and what is more, of recording accurately, in less than

an hour, something that changes in England so rapidly — are taken into account. Most of the 1821 sky studies include land, trees, or a distant view, but those of 1822 represent, almost entirely, only cloud. He wrote to Fisher the following year (7 October 1822): 'I have made about 50 careful studies of *skies*, tolerably large to be careful', and although only about twenty of these are known today, they are of a larger size than the 1821 studies and have a dramatic quality all of their own, for example, Plate 134.

The earliest of 1821 (14 July; Plate 132) is as much a vista from the ridge of Hampstead Heath, looking towards Harrow, whose church spire is just visible to the left of the branches, as it is a study of evening light between 6–7 p.m., while some are so abstract that clouds and tree tops become intermingled in loose skeins of paint (Plate 133). He painted this example at 10 a.m. on 27 September; by noon it had become 'very bright after rain' (Plate 137). On 19 July he had got up early to record the early morning light at '½p 5 a.m. looking East. Day beautiful', in a sketch in the Yale Center for British Art. He could paint glorious evening effects looking over to Harrow, with its church on the horizon, viewed from near Branch Hill Pond. One, at Manchester, is dated in August, and another at Yale, may also date from August 1821 (Plates 135 and 138). An impressive evening study is dated 31 October (Plate 142). He also painted a series of nearly square studies of clouds, without any horizon, which have previously been dated to 1821 or 1822. Dr Thornes has shown that they accord with a period of rainy weather around 12th–13th September. The one reproduced here (Plate 139), at Yale, is inscribed, 'Sept. 13th [1821] one o'clock. Slight wind at North West, which became tempestuous in the afternoon, with Rain all the night following.' Even if we did not know the actual weather, we could believe it from Constable's accurate recording of the dramatic rain clouds. He remained at Hampstead until the beginning of November, and as he wrote to Fisher, 'the last day of Oct.ʳ was indeed lovely so much so that I could not paint for looking — my wife was walking with me all the middle of the day on the beautiful heath. I made two evening effects.' One (Plate 142) is a panoramic view towards Harrow and painted very freely with touches of pure colour on this 'very fine afternoon of a beautiful day, it began with rain. Wind fresh from West.' It is tempting to see the three figures as Mr and Mrs Constable with their young daughter 'Minna' walking at the right.

Constable had made the naturalistic aims of his intensive programme clear in his letter to Fisher. There was, in fact, some contemporary scientific precedent for his observations, in Luke Howard's essay 'On the modifications of Clouds', which had been published in Tilloch's *Philosophical Journal* of 1803, and then reprinted in Howard's large work *The Climate of London*, in 1820. What Howard had to say could also be found in part in Thomas Forster's *Researches About Atmospheric Phenomena* of 1813. Constable owned a copy of the 1815 edition and recommended it to George Constable, his patron, in 1836.[20] Essentially, Howard and Forster attempted to classify clouds by the names we still know them, such as 'cirrus', 'cirro-cumulus', cumolo-stratus', 'cumulus', and so on. Constable may have used the word 'cirrus' on one of his sketches in the V&A, and this has been claimed as proof that

136. Copy by Constable after Alexander Cozens' *Engravings of Skies*. Pencil with ink inscription, 9.3 × 11.4 cm. London, Courtauld Institute of Art

Constable was solely inspired by Howard.[21] As has been shown, however, by Louis Hawes, Constable would have had a pragmatic knowledge of the skies dating from his time as a miller, and, indeed, used archaic names for clouds in his letterpress for *English Landscape*. Constable's use of Howard's exact terms may have come later in his career. There were, in addition, a host of artistic precedents by contemporaries and old masters for this sort of study. Fisher had named two, but there were clearly others, such as Ruysdael, Rubens, Claude, Willem van de Velde the Younger, who was traditionally supposed to have gone to Hampstead Heath to study skies, Alexander Cozens (see Plate 136 for one of Constable's copies after Cozens), Wright of Derby, Valenciennes, and, most immediately, Turner. Such a study of clouds had also been recommended in the theoretical works on art, which we know Constable read, such as those by De Piles and Gilpin. From his moral standpoint to landscape whereby, as he put it, the sky was the chief 'organ of sentiment', he was bound to look at other masters of natural landscape to see how the sky would effect the emotion of the picture. That very September of 1821 he had been trying to copy a Ruysdael, '*Windmill and Log House*' (*Evening Landscape: A Windmill by a Stream*) (Plate 140), belonging to George IV, when it had been shown at the British Institution summer exhibition. Ruysdael was an artist he would naturally look at as a great example from the past whose subjects were similar to his own. Fisher had jokingly addressed letters to 'Reuysdale [*sic*] House', as he called Constable's home in Keppel St, and there are many examples of Constable's admiration for his 'compass of mind'.[22]

He could, equally, admire classical landscapists such as Nicolas Poussin. In the same letter that he mentioned George IV's Ruysdael (20 September 1821) he went on: 'There is a noble Poussin at the Academy — a solemn, deep still summer's noon — with large umbrageous trees, & a man washing his feet at a fountain near them — through the breaks of the trees is mountain scenery & clouds collecting about them with the

137. *Cloud Study, Horizon of Trees.* 27 September 1821. Oil on paper on panel, 24.8 × 29.2 cm. London, Royal Academy of Arts. Inscribed: 'Noon 27 Sept very bright after rain wind West'.

most enchanting effects possible — indeed it is the most affecting picture I almost ever stood before.' As with many artists he could write well, but like them, too, he tended to see all art through his own eyes, and drew from the past what he needed for his own art. As his own painting had become more of an emotional recollection of past scenes, so he could admire and be affected by other conceptual artists such as Poussin, but he did not ignore his basic realistic interests. In the same letter which he had propounded his theories about 'skying' he also made a reference to a fishing expedition Fisher had undertaken in the New Forest:

But the sound of water escaping from Mill dams, so do willows old rotten Banks, slimy posts, & brickwork. I love such things — Shakespeare could make anything poetical — he mentions 'poor Tom's' haunts among sheep cots & Mills — the Water (–) & the Hedge pig. As long as I do paint I shall never cease to paint such places. They have always been my delight ... But I should paint my own places best — Painting is but another word for feeling. I associate my 'careless boyhood' to all that lies on the banks of the Stour. They made me a painter (& I am gratefull) that is I had often thought of pictures of them before I had ever

138. *Hampstead Heath Looking towards Harrow.* 1821. Oil on paper laid on canvas, 20.5 × 48.2 cm. New Haven, Yale Center for British Art, Paul Mellon Collection

139. *A Study of Rain Clouds.* 13 September 1821. Oil on paper on board, 24.7 × 30.2 cm. New Haven, Yale Center for British Art, Paul Mellon Collection. Inscribed: 'Sept. 13th one o'clock. Slight wind at North West, which became tempestuous in the afternoon, with Rain all the night following'.

140. Jacob van Ruisdael (1628/9–82). *Evening Landscape: A Windmill by a Stream.* c. 1650. Oil on canvas, 75.6 × 100.8 cm. Buckingham Palace, Royal Collection

touched a pencil, and your picture is one of the strongest instances I can recollect of it.

It is interesting to note that he was mis-remembering Gray's 'careless childhood' but, more importantly, his overall attitude to nature had not changed. It had just become more complicated. Together with his studies of natural facts, and his admiration for those artists who took note of them, he could talk of painting as 'feeling', that is, for him, his own personal feelings for the associations of his boyhood and his general feeling for nature. In his next major work, which he had already begun in the summer of 1821, we can see this maturing attitude carried through further.

About 8 November 1821, he made another trip to Salisbury to stay with Fisher and from there he visited Winchester, which he admired, and Longford Castle where he was able to see the famous collection, which included Claudes. He was back in London by about 20 November. His old friend and supporter Joseph Farington RA died on 20 December. Constable would miss his 'politicking' at the Academy in his attempt to become a full Academician. Farington had early taken him under his wing, and helped him through life, with his art, his accounts, and his personal worries, even though Farington's dry, not to say tedious, topographical landscapes had nothing in common with Constable's revolutionary and personal manner. When Constable visited his house, which he was thinking of leasing the following year, he 'could scarcely

believe that I was not to meet the elegant and dignified figure of our departed friend . . . or hear again the wisdom that always attended his advice'. Constable missed his help in the Academy and with the death, the previous year, of Benjamin West, the President of the RA, who had liked Constable's works, Constable found himself without supporters at court. Lawrence, the new President, preferred history painters, so that in February 1822, when Constable might have stood a chance for the next vacancies, he was defeated by a nonentity, Richard Cook, who having married a rich wife had not painted since 1819. The other successful candidate was Thomas Daniell, the nephew of William Daniell, RA, both of whose work we can now see was minor and hack besides Constable's.

During the winter he worked hard on his next major painting which he referred to as *The Bridge*, but was eventually exhibited as *View on the Stour, near Dedham*. When Fisher saw it in January he seems still to have been working on the preliminary version. He so altered and added to this (Plate 144), and left the changes to the finished picture so late, that it has been suggested that he really meant the original sketch to be exhibited, and only began a new version at the last minute through panic, or for conceptual reasons. If we compare the two works, it can be seen that the thickly encrusted image (Plate 144), now at the Royal Holloway College, Egham, so different from the thinly painted monochromatic sketch for the *Haywain*, or the airy breeziness of the Yale sketch, was in no state to be exhibited in the climate of opinion that customarily

greeted his works. The finished painting (Plate 145), at the Huntington Art Gallery, San Marino, California, is an impressive and dignified 'finished' work, with all the different characteristics of handling that have so far been noted in his exhibited pictures. Unfortunately, it is unlikely that the two paintings can ever be placed side by side, because the Californian version cannot be lent, but it may be that the rough texture and 'expressionistic' quality of the Egham sketch would find greater favour today than the finished painting. Our eyes have become accustomed to the increasing freedom of expression from the nineteenth century onwards, which Constable, in part, brought about. From the hard work of the sketch, admittedly with some haste at the end, he thought when he sent the picture to the Academy that 'I have never done anything as good as this one — at least it has fewer objections that can be made to it.' Leslie quoted further comments: 'I have endeavoured to paint with more delicacy, but hardly anybody has seen it.' Allowing for an artist's eternal optimism for his latest work, Constable seems to have been trying to take account of the perennial criticisms.

The scene is Flatford, not actually as near to Dedham as the title suggests, but right by the boat building yard, looking upstream to the Old Bridge. He had used sketches from his 1814 sketchbook, one of which (page 59) actually had the prow of a barge jutting out in the near foreground. Another (page 52) shows the bridge and Bridge Cottage, while the third (page 27) is a view across the river to the trees, which are the elms that appear in *Flatford Mill* (Plate 95). No oil sketches appear to exist of this particular scene, which may account for some of the difficulties he encountered. In the large sketch (Plate 144) he brought these three elements together, which meant turning the river slightly, and he added the 'subject', a barge preparing to shoot the locks downstream, being towed by a man in a skiff, with another barge coming upstream. In the foreground is the entrance to the dock, with two boys fishing. On the bridge are cattle, while in the distance is the much enlarged tower of Dedham Church, and a barge with its sail up, being towed by a horse. The cloud over the cottage is suggested in one of his 1814 drawings (page 52), not, it must be pointed out, in one of his Hampstead Heath sky studies. Alterations can be seen with the naked eye, particularly in the group at the left. A large sail and a figure in the left hand barge have been painted out. The cattle on the bridge were originally in a different position and the figure accompanying them has also been obliterated. The large sketch is painted with extremely dense thick impasto, with patches of glazing or varnish, which have run, having been used, presumably, to tone down certain areas. The same hasty accidents can be seen in the sketches for *The Haywain* and *The Leaping Horse*. It is turbulent and full of his flecks of white, later to be called his 'whitewash', strokes of the palette knife, and areas of bitumen. If his preliminary sketches presage anything, they look forward to his late works, but his method of composing on the sketch is not new. There are indications of vertical and horizontal marks in the sky, 'sighting' marks (which also appear in the *Stratford Mill* sketch). This is Constable working out his aerial perspective by linear means, and there are clearly still difficulties of perspective at the right.

He mentioned his changes to Fisher in April:

The composition is almost totally changed from what you saw. I have taken away the sail and added another barge in the middle of the picture, with a principal figure, altered the group of trees, and made the bridge entire. The picture has now a rich centre, and the right-hand side becomes only an accessory.

He had already painted out the sail in the sketch, and to his list can be added the removal of the fisherboys, the oarsman, the cattle, a barge pole, the distant tow-horse; the reduction of the sail on the distant barge; and the addition of the tow-horse at the left, a rowing boat, a washerwoman, a figure on the bridge at the right, and a rake in the foreground. All of these changes have undoubtedly increased the clarity of spatial definition. The new composition has a tension, particularly in the centre, and the action of the poling bargee gives the finished picture a dignity and structure, which the turgid sketch lacked. Against the curving highlight of the river at the right is balanced the barge and details at the left. The underlying structure is composed of, again, two opposed diagonals whose lines are emphasized by the rake in the foreground. In the centre is his totem of Dedham Church, but its absolute position is subtly disguised by the activity and detailed flora in the foreground. It is, perhaps, his most perfect picture to date, and its grave composure is matched by a sparkling luminosity and high key, painted with the delicacy of touch that he complained no one noticed. It is also, perhaps, the most underrated of his large six-footers, as so few people outside of California have seen it during the rehabilitation of Constable's reputation, yet, with *The Haywain*, it contributed much to his reputation in France during the 1820s.

His other exhibits in 1822 were three Hampstead Heath views (his new open-air laboratory), including a study of trees, and his view of *Malvern Hall* (see Plate 120 for another version). Graham Reynolds has argued that the Le Mans version was that exhibited. If Lewis, or the Countess of Dysart were expecting the cool morning light, or twilight glow of a Richard Wilson view, then they must have been disappointed. In place of Wilson's careful balancing of tones and normal distancing of the house to show its grounds, as Constable had painted the rear of the house in 1809, and in the Havana version, his view of the front is alive with the texture of the fir trees, the brilliance of the flower beds, and a feeling for the changeability of light, which gives a multitude of greens over the lawn and picks out other sparkling detail, such as the peacocks, the white masonry, and the white tower of Solihull Church. The composition is unusual for a house portrait with the main façade placed at an oblique angle off-centre, with as much emphasis placed on the flower beds, and on the grand entrance gateway, as on the house itself.

There was no respite from the hectic activities of his domestic life at the beginning of 1822, and his occasional outbursts of tetchiness are not surprising, with the financial and artistic pressures he was under. Fisher was the only close confidant he now had, apart from his wife, in whom he could discuss his artistic and general problems. He had had 'some nibbles' for *The Haywain* at the British Institution, including

141. *Buildings on Rising Ground near Hampstead.* 1821. Oils on paper, 25 × 30 cm. London, Victoria and Albert Museum. Inscribed: 'Octr–13th, 1821. – 4 to 5 afternoon – very fine with Gentle Wind at N.E.'

142. *Hampstead Heath Looking towards Harrow.* 31 October 1821. Oil on paper on canvas, 26 × 32.5 cm. New Haven, Yale Center for British Art, Paul Mellon Collection. Inscribed: 'very fine afternoon of a beautiful day, it began to rain. Wind fresh from West.'

143. *Hampstead Heath with a View of The Spaniard's Inn*. 20 July 1822. Oil on paper laid on canvas, 31.1 × 52.1 cm. Philadelphia Museum of Art, The John G. Johnson Collection. Inscribed: 'looking N.E., 3 p.m., previous to a thunder squall wind N. West'.

one from the French dealer with the unlikely name John Arrowsmith, who wanted 'to show them [the Parisians] the nature of English art', but he only offered £70 (without the frame). Constable wanted the money and realised its exhibition abroad might bring him fame, but thought the picture was worth more. In the end, in a burst of chauvinism, he declared, 'It is too bad to allow myself to be knocked down by a Frenchman.' The French connection, however, was revived.

To a certain extent, Constable should not have felt so hard pressed. In April 1822, he wrote to Fisher to reveal that Tinney had offered 100 guineas for another exhibited picture to be a companion to his *Stratford Mill*. If Constable was offered more, even 100, he could accept it, and begin another for Tinney. This generous offer would allow Constable to do a large painting 'to add to my reputation'. Constable rightly commented 'this is very noble', but, surprisingly, he never did anything about it. He said he had waived it, but it may have been, as Beckett remarked, that 'he always hated to be under any sort of obligation when it came to painting'. With his involvement from the beginning of the 1820s in the creation of large six-foot pictures, he seems also to have developed a greater consciousness of the possibilities of failure, not surprising in view of the general indifference to his work. But by his unwillingness to accept the safety of the kind of offer made by Tinney, he condemned himself to face the danger of his own naturalistic aims — the alternatives of continual 'jobs' or complete failure. There is a neurotic change from his earlier

confident assertion that he would 'never leave the feild while [he] had a leg to stand on' (September 1812). Significantly, he used the metaphor of the world of art as 'this dreadful *feild of battle*', in a black mood at the beginning of the following year.

He decided to take Farington's old house at 35 Charlotte St on a lease and moved in on 16 June 1822. It needed alterations, which were still going on in October. At the same time he had moved his family again to 2 Lower Terrace for the summer, where his fourth child, Isabel, was born. From July to October he was painting again at Hampstead.[23] Among his Hampstead sketches is the considerable group, once over fifty in number, of large sky studies, which he referred to in his letter to Fisher on 7 October, already quoted. Those that survive representing only clouds on a large scale seem to date from August to the end of September, of which an impressive example, at the Yale Center for British Art, is dated 1 August, and another (Plate 141) at the Tate Gallery is dated 27 August. Slightly earlier sketches done in July, however, are breezy impressions of the Hampstead scene (Plate 143), in the Johnson Collection at Philadelphia, showing the road to the Spaniards, the inn on the road between Hampstead and Highgate (see map, Plate 123). It is inscribed with weather notes, 'looking N.E. 3 PM, previous to a thunder squall wind N West', which accords with the weather on its probable date 20 July. But this accuracy aside, if we did not know this small ($12\frac{1}{4} \times 20\frac{1}{2}$) 'plein air' sketch was by Constable we could be forgiven for calling it 'Corot', or 'Boudin', such is its spontaneity. By 1822, his confidently

casual composition and full command of atmospheric effects enabled him to express what he had earlier described as the 'freshness' and 'amenity' of the country — 'the very breeze that passes the window is delightfull, it has the voice of Nature'.[24]

There were to be other intimate views of corners of Hampstead done during the summer of 1822. One such is *The Admiral's House, Hampstead* (Plate 146), Tate Gallery, which may date from this period. It shows the strange roofline of the house, that had been rigged up as a quarter-deck for the eccentric Admiral who lived there. These small views can be seen almost as exercises to keep his hand in, while contemplating his next great assault on the Academy. Most of them are realistic. Here the ubiquitous horse and rider, who appear elsewhere in his Heath views, have arrived at the pool in the foreground. Generally, however, the views of Hampstead Heath that proved popular, particularly to the French, and here Georges Michel could be cited, were his more extensive open vistas, and it was these, too, that his son, Lionel, imitated, such as his painting *Looking over to Harrow* at the Yale Center for British Art.

Constable was to be prevented by frustrating 'jobs' from working on a large picture. He had won the commission for an altarpiece of *The Risen Christ* for St Michael's Church, Manningtree, now at All Saints Church, Feering, and he spent nearly a year on it, but when he finished it he found the commission had been revoked.[25] In his role as a professional jack of all trades he was also engaged in making copies from eighteenth-century portraits for the Revd William Digby, and there was also a commission from Albany Savile, a distant relative, for a large picture which came to nothing. Most important, he was being pursued by the Bishop of Salisbury, who with Miss Fisher had called at Keppel Street in May while Constable was at East Bergholt. Maria wrote on 11 May:

> He was quite in raptures with your 'Waterloo' sat down on the floor to it said it was equal to Canaletti & begged I would tell you how much he admired & wondered what you could have been about not to have gone on with it. Your portrait he said was a fine one. He rummaged out the Salisbury & wanted to know what you had done.

The 'Salisbury' was the view that he eventually sent to the Royal Academy in 1823. Although he could write to Fisher in October 1822 that he had 'an excellent subject for a six footer canvas', he had only just put it 'in hand' by the following February, this time described as 'a large upright Landscape', probably his first draft for *The Lock*. With a disastrous and depressing winter, he was, in the end, only able to finish the 'Salisbury' and two other landscapes in time for the Academy of 1823.

He had two 'six-footers' on his hands, one of which he intended to send to the British Institution. He sent *The View on the Stour, near Dedham* (Plate 145) and two other landscapes, but they did not sell. He had worked himself into a rumbling dissatisfaction with the British Institution, and its directors, whom he thought encouraged second-rate copyists, and from this he moved to a diatribe against the proposed National Gallery: 'The Reason is both plain and certain. The manufacturers of pictures are then made the criterion of perfection & not nature.' This was unfair and ignored his own practice. He also allowed himself a swing against the Academy, and the new associates of November — 'not an artist among them' — one of whom, Etty, became a full member before him — 'The art will go out', he went on, 'there will be no genuine painting in England in 30 years.' He reviewed his own complete lack of chance at the Academy in the February elections: 'I have nothing to help me but my stark naked merit', and, after a December and January of a house-full of illness, his own included, when he could do no work, he was to be depressingly proved right, when 'Daniell's party' 'got in' the now hated Ramsay Richard Reinagle, 'the most weak & undesirable artist on the list as you said' (see Plate 200). 'The feild of Waterloo is a feild of mercy to ours.' He was also being 'rubbed' by a mediocre artist from Salisbury whom he had mistakenly encouraged.

Meanwhile, he had been engaged in an expensive lawsuit, on the family's eventual move to Charlotte Street, as he had discovered that the house opposite was being run as a brothel, and he took steps to get the 'inmates' out, 'some of whom were the old womans daughters', he reported in shocked tones to Fisher. Inside his own house, he had found, as new occupants often do, that all was not what it seemed. The hollow wall of his painting room was discovered to be over 'the *well* of the *privy*. This would have played the devil with the oxygen of my colours.'[26] A sight of J.L. David's large (35 × 21 feet) painting *The Coronation of Napoleon*, did nothing to uplift his spirits: he thought it marginally better then West, who 'is only hanging on by the tail of the shirt of Carlo Maratti & the fag end of the Roman & Bolognese schools — the last of the Altorum Romanorum, and only the shadow of them'. Fisher's attempt at sarcastic good cheer by sending a favourable review of John Martin and B.R. Haydon misfired. 'The most idle and trumpery quotations', replied Constable, 'I wish you could see Martin's "Paradise" now in the Gallery — all his admirers should have been in it, & it would have been a paradise of fools — but it is always best to give a man the rope.'

Only the eventual finishing of the 'Salisbury' and its good reception at the Academy seem to have ended this prolonged bout of depression and diatribes against those artists he despised. 'However though I am here in the midst of the world I am out of it — and am happy,' he could eventually write to Fisher on 9 May, 'and endeavour to keep myself unspoiled. I have a kingdom of my own both fertile and populous — my landscape and my children. I am envied by many and much richer people.' He wondered if he would ever go to Italy. 'No! I was born to paint a happier land, my own dear England — and when I forsake that, or cease to love my country — may I as Wordsworth says

> Never more, hear
> Her green leaves russel
> Or her torrents roar'[27]

It was to be in France, however, that he was to achieve his most famous success.

144. *View on the Stour near Dedham.* 1821–2. Oil on canvas, 129.5 × 185.4 cm. Egham, Royal Holloway College, University of London

145. *View on the Stour near Dedham.* 1822. Oil on canvas, 129.5 × 188 cm. San Marino, California, Henry E. Huntington Library and Art Gallery

146. *The Grove, Hampstead (The Admiral's House). c.* 1820–5. Oil on canvas, 35.6 × 30.2 cm. London, Tate Gallery

Chapter 6

'I imagine myself driving a nail – I have driven it some way –
by persevering with this nail I may drive it home'

Constable had always found it difficult to resist distractions from his main aim of painting finished pictures for exhibition, partly because, as he put it, he was 'struggling with "*fame and famine*"'.[1] After the interruption to his series of large pictures caused by the Bishop of Salisbury's commission for the picture of his cathedral (Plate 119), Constable needed 'to repair' his finances. The summer of 1823 saw him rushing between Hampstead, where he had taken a new house called 'Stamford Lodge' for his family (map, Plate 123), and where he was able to do some sketching, and his Charlotte St studio, where he had to paint his larger 'jobs'. He was, however, able to report to Fisher that he had got through a 'good deal of work at his "jobs"', probably the 'face on his easil' of May, and a repetition of his *Salisbury*, for the Bishop's daughter, Elizabeth, as a wedding present, and possibly, further versions of his popular Yarmouth, and Harwich beach scenes. Fisher had joked in July that 'where real business is to be done you are the most energetic and punctual of men: in smaller matters such as putting on your breeches, you are apt to lose time in deciding which leg shall go in first'. For the rest of the year, Constable was to allow himself to be distracted from his major aim: 'My difficulty lies in what I am to do for the world, next year I must work for myself — and must have a large canvas.'[2] It was not until the end of the year that he resumed the work abandoned at the beginning on the picture that was to be his next major exhibit at the Royal Academy of 1824, *A Boat Passing a Lock* (Plate 154).

He had wanted to take Fisher up on an invitation to visit him at Gillingham, Dorset, where he also had a living. Fisher had tempted Constable with descriptions of '*three* mills, old small and picturesque' on the River Stour in Dorset, and Constable had found a holiday irresistible. He went on 19 August, via Salisbury, where he saw the Bishop and Tinney, and then went on with Fisher who was anxious to get back to his wife in Gillingham. He remained there until the end of September. Tinney, meanwhile, had asked him to paint two upright landscapes, the size of the Bishop's *Salisbury* (34 × 44 ins), which were to be the cause of further procrastination. While he was there he visited Fonthill, William Beckford's folly, the contents of which were to be sold.[3] As he wrote to his wife, he found it 'a strange ideal romantic place quite fairy

land', 'standing alone in these melancholy regions of the Wiltshire downs', a change from his previous indifference to country house parks except Wivenhoe and Malvern Hall.

But he had also to admit that he had not done much 'in the sketching way', apart from trips to Sherborne, a visit into Somerset, and painting a small view of *The Bridge at Gillingham* (Tate Gallery). He seems also to have begun studies at Perne's (or Parham's) Mill, near Gillingham, 'wonderfull old and romantic', as he described it to Maria. Fisher commissioned a small version (Plate 147), Fitzwilliam Museum, Cambridge, which was delivered to him the following June, and a larger version (Plate 148), Yale Center for British Art, was painted in 1826 for Mrs Hand, who was a friend of the Chancellor of the Diocese at Salisbury. This has additional details of donkeys, ducks, and a changed roofline. In both of them, we can see Constable delighting in the sort of waterside detail in Dorset, which he enthusiastically described to Fisher in 1821: 'The sound of water escaping from Mill Dams ... willows, old rotten Banks, slimy posts and brickwork'. These two paintings have them all, together with the fresh and varied green of the landscape and tumultuous skies. When the mill was burnt down in 1825 Fisher disapprovingly noted that 'A huge misshapen, new, bright, brick, modern, improved, patent monster is starting up in its stead.' He and Constable were both conservative in their politics and preferred the old and picturesque as subject-matter for their pictures, even if Constable's way of painting them needed 'a hatbrush and pressing iron', according to Fisher. Constable thought the 1826 version one of his 'best' pictures.[4]

On his return to London, with his family still at Hampstead, he could still produce lively sketches such as Plate 149, *Study of a House amid Trees, evening*, dated 4 October 1823. He then went off for another, even longer excursion to stay with Sir George Beaumont at Coleorton in Leicestershire. This time he was away so long (six weeks) unable to tear himself away, that his wife began to wonder if he would ever return. When, at the end of November, he mentioned that Sir George and Lady Beaumont would like him to stay on over Christmas, she replied sarcastically on the 21st, that 'it was complimentary in Sir George to ask you to remain over the Xmas, but he forgot at the time that you had a wife'. Constable was renewing an

147. *Parham's Mill, Gillingham.* 1824. Oil on canvas, 24.8 × 30.2 cm. Cambridge, Fitzwilliam Museum

acquaintance with the Great Panjandrum of British art, now aged 70, which dated back to the beginning of his career and to whom he owed early allegiance (see Chapter 2, pp. 19 ff.). This time, however, he seems to have been bowled over by Beaumont's kindness and the fact that after an initial reserve, they treated him as an equal. He had come a long way in his profession since Lady Beaumont had dismissed him as 'a weak man'. The social aspect of his visit, to someone who was not generally keen on the whirl of society was obviously, part of his enjoyment: 'Oh dear,' he wrote to Maria on 21 October on his arrival 'this is a lovely place indeed and I only want you with me to make my visit quite compleat — such grounds — such trees — such distances — rock and water — all as it were can be done from the various windows. The Church stands in the garden & all looks like fairy land.' He seems, again, to have forgotten his previous distaste for parkland. He liked the Beaumonts' punctual way of life: breakfast at 9, he and Sir George painting together all morning, ('& he laughs, sings,

whistles & plays with his dog'); out on horseback at 2, sketching together; dinner at 4, tea at 7, with Sir George reading from Shakespeare or Wordsworth, or Lady Beaumont reading from the newspaper ('The Herald, let us take it in town', he wrote with new-found enthusiasm to Maria).

> Then about 9 the servant comes in with a little fruit and decanter of water and at eleven we go to bed — where I find a nice fire in my bedroom — and I make out about an hour longer, as I have everything here, writing desk &c. I shall have much to say, & I am sure [he went on, in an effort to justify his stay] this visit will form one of the epocks [*sic*] of my life in taste, industry, pride and so on — & I will take care of myself and not let vulgar writers come and insult and intrude upon [me] as I have done, I will have a proper opinion of myself.

These good intentions did not last a year.

To Fisher he wrote: 'I have free range & work in his

148. *Parham's Mill, Gillingham*. 1826. Oil on canvas, 50.2 × 60.4 cm. New Haven, Yale Center for British Art, Paul Mellon Collection

149. *Study of a House and Trees*. 1823. Oil on paper, 25 × 30.5 cm. London, Victoria and Albert Museum

150. Claude Lorrain (1600–82). *Landscape with Goatherd and Goats. c.* 1636. Oil on canvas, 52 × 41 cm. London, National Gallery

151. *Landscape with Goatherd and Goats*, after Claude. 1823. Oil on canvas, 53.3 × 44.5 cm. Sydney, Art Gallery of New South Wales

painting room. It is delightfull to see him work so hard — painting like religion knows no difference of rank. He has known intimately many persons of talent in the last half century and is full of anecdote' about Wilson, Gainsborough and, above all, Reynolds. This would have fascinated Constable with his reverence for Reynolds, and his respect for the artistic establishment, which Sir George embodied. On his last day, 28 November, he made a careful drawing of the cenotaph erected in the grounds to the memory of Sir Joshua, and transcribed Wordsworth's lines. He also made a drawing of the stone placed by it to commemorate Wilson. From the former he was to paint a moving image in honour of Reynolds, Sir George Beaumont (and Michelangelo) at the end of his life, (Plate 223).

What impressed him most of all was the daily contact with the Claudes that Sir George owned: 'Only think that I am now writing in a room [the breakfast room] full of Claudes (not Glovers) — real Claudes and Wilsons & Poussins &c almost at the summit of my earthly ambitions.' He made careful facsimile copies of 'a breezy sunset' (*Death of Procris*, National Gallery, London) and of 'a little Grove — a noon day scene' (*Landscape with Goatherd and Goats*, Plates 150 and 151) as he thought done on the spot, 'which "warms and cheers but which does not inflame or irritate" Mr Price' (Uvedale Price, a friend of Sir George's). This he had seen before, but now as he described it to Fisher in a letter of 2 November, he thought it 'diffuses a life and breezy freshness into the recesses of the trees which make it enchanting. Through the depths are seen a waterfall & ruined temple, & a solitary shepherd is piping to some animals — "In closing shades & where the current strays Pipes the lone shepherd to his feeding flock".' 'It contains almost all that I wish to do in landscape,' he said, on 5

November. His aims had never before been quite so pastoral. He made these faithful copies, as he saw it, to be useful to him as long as he lived, 'to drink at again and again'. Copying was not only a method of learning, but detailed copies after old masters were also saleable objects.

The most immediate effect was felt in a small landscape sketch which he made at Coleorton of *Bardon Hill* (Plate 152), Yale Center for British Art, where his feathery manner of painting the trees, and his feeling for the smooth transition of vistas is much closer to Claude, than Constable's normal method of sketching out of doors. Even when, the following year, he was annoyed that Payne Knight had seen his pictures but had bought nothing, preferring to pay 'Sixteen Hundred Pounds' for drawings by Claude, described bitterly by Constable as 'used & otherwise mauled & purloined from a Water Closet', he did not let this temporary anger that Knight and others at the British Institution had no affection for *new* art change his veneration for Claude. Constable was actually denigrating the great collection of Claude drawings that Payne

Knight was to bequeath to the British Museum that year, but a drawing by him after a Claude drawing of 1825 (Plate 153) then, apparently, belonging to Sir Thomas Lawrence, is a marvel of faithful imitation and shows his obvious love for Claude's drawings. His own pen style was henceforth to be clearly affected by Claude's touch.

His visit to Sir George Beaumont had a significant influence on the course of his art. As we have already seen, he had never ignored the influence of others, particularly Claude, but to his quest for a perfect naturalism from 1823 onwards must be firmly added what he had been moving towards from 1819, an imaginative sense of the values of art, gained from his copies after Claude, after Alexander Cozens, and even, again, the influence of Girtin at Coleorton.[5] The influence of the Picturesque cannot only be seen in his paintings, but also in his drawings, in pen and ink, and wash and water-colour, which from 1823 became more prevalent, and often more generalised in conception. This is not to say that he abandoned detailed drawings from nature. Leslie's famous anecdote that 'At

152. *Bardon Hill.* 1823. Oil on board, 20.2 × 22.5 cm. New Haven, Yale Center for British Art, Paul Mellon Collection

153. *Landscape with Trees*, after Claude. 1825. Pen, brown ink and brown wash. 28.8 × 20 cm. New Haven, Yale Center for British Art, Paul Mellon Collection

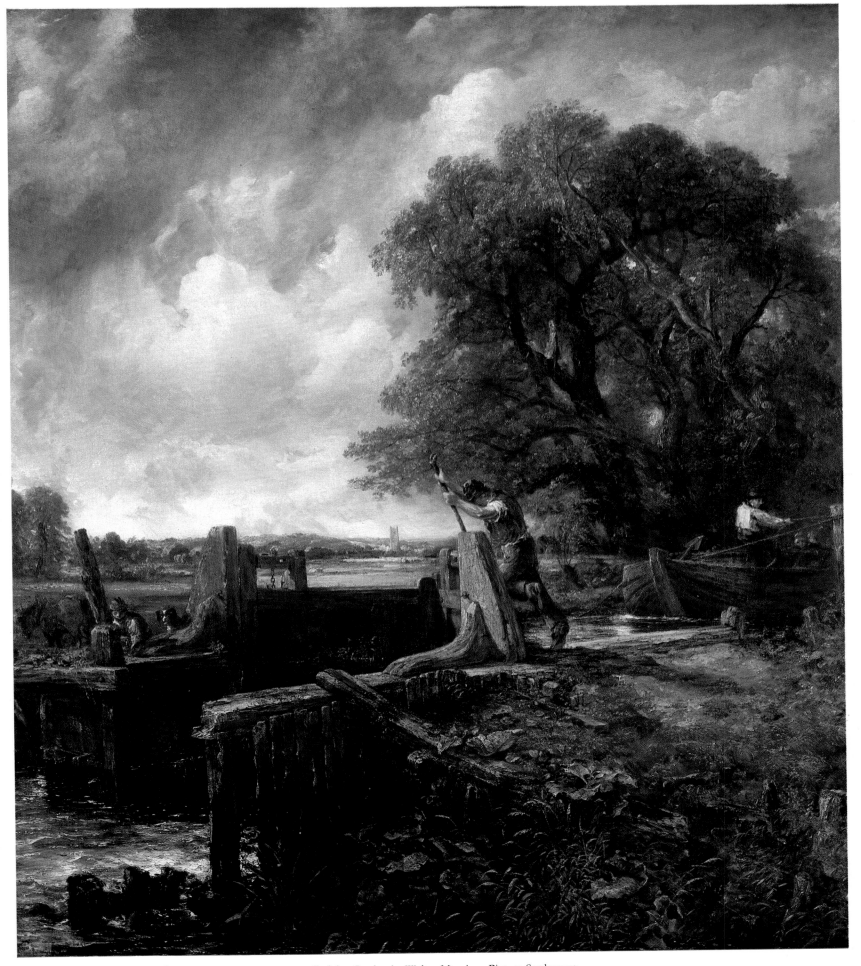

154. *The Lock.* 1824. Oil on canvas, 142.2 × 120.7 cm. Sudeley Castle, the Walter Morrison Picture Settlement

another time, Sir George recommended the colour of an old Cremona fiddle for the prevailing tone of everything, and this Constable answered by laying an old fiddle on the green lawn before the house', shows that Constable held fast to some of his hard-won principles.[6] Nor did he now wholeheartedly accept the mainstream of English water-colour: 'the wretched Varley' and the 'Tinters' gained his scorn, perhaps echoing Beaumont, on his return from Coleorton, but, nevertheless, among his own drawings, from now on, are as many that have an overall feeling for effect in their handling, and which are less obviously studies of detailed naturalistic phenomena. In the grove at Coleorton, in front of the cenotaph to Reynolds and the stone to Wilson, he had clearly paid homage to his old original gods.

Perhaps as much through nervous exhaustion as the neuralgia he complained of, Constable was laid up on his return, but he wrote to Fisher, on 16 December 1823, that his 'Waterloo must be done for the Academy, and one other, perhaps one of Tinney's, Dedham, but more probably my Lock. I must visit to Gillingham again for a subject for the other next summer.' As usual his hopes did not quite work out as planned, but he did resume work on *The Lock* abandoned a year previously. He decided to send only one work to the British Institution in 1824, the *Salisbury Cathedral* (Plate 119) that he had painted for the Bishop. He was not the only contemporary artist to criticize the Institution, not so much for its seeming lack of support for history painting, about which others had complained, but, in his case, for the lack of support for the *new* by the connoisseurs who ran it. 'Consider who are our judges,' he wrote to Fisher on 17 January 1824, 'Carr the Magnus (The Revd William Holwell Carr) — Sir Cs. Long (later Lord Farnborough) — Priapus Knight (Payne Knight)'.[7]

As he worked on the upright Lock in January 1824, Arrowsmith, the French dealer, approached him again about buying the '*Hay Vain*', as he called it, and *The View on the Stour* (Plates 125 and 145). Fisher, who had hoped also to buy the *Haywain*, thought Constable should let it go: 'The stupid English public, which has no judgement of its own, will begin to think that there is something in you if the French make your work national property. You have long laid under a mistake,' Fisher added, with the words of wisdom Constable loved to receive, 'men do not purchase pictures because they admire them, but because others covet them.' Géricault, and then Delacroix, the new leaders of the Romantic movement in France, had already been impressed by the sight of Constable's pictures: *The Haywain* by Géricault in 1821, and a small picture by Delacroix during the autumn of 1823. By 15 April 1824, Constable had followed Fisher's advice and agreed to sell the two paintings to Arrowsmith for £250 the pair, and 'a small seapiece, *Yarmouth*, into the bargain'.

But before the whole brief saga of the French connection of the ensuing year could develop, which, undoubtedly, placed Constable in the forefront of the Romantic movement, to be ranked, in France at least, as the equal of Lawrence, Wilkie and Bonington, he completed his single exhibit for the Academy of 1824, *A Boat Passing a Lock* (Plate 154), and his domestic affairs were to take a serious turn. His major picture for this year's

exhibition was this time in an upright format and not quite a 'six-footer' in dimensions. It is, nevertheless, his fifth scene on the River Stour and, again, there exists a full-scale sketch (Plate 155), the Philadelphia Museum of Art. The sketch reveals, with its additions at the top and bottom, and signs of having been cut on the right, that he originally intended it to be horizontal in format, but there seem to be no other preliminary drawings or sketches. The scene is at Flatford Lock with the Lock gates being opened by 'the Navigator', as Fisher described the principal figure, to allow the passage of a barge downstream. On the horizon, practically dead centre, is the tower of Dedham Church. He has altered the topography slightly, and left off the cross beams over the lock, which can be seen in his 1812 or 1817 pictures (Plates 60 and 95). An x-ray of the sketch shows one beam to have been originally painted in over the lock gates. A local visitor to the Academy exhibition, Mrs Godfrey, who knew the area well, said it 'flattered the spot but did not belye nature'.[8] The overall effect of the sketch is rougher in texture and more exuberant in atmosphere than any of his sketches so far. Skeins of paint and strokes of the palette knife are everywhere visible, to suggest the sky appearing through the tops of the trees, or the texture of the river bank, and its 'slimy posts'. The composition of the sketch is an elementary opposition of vertical and horizontal, which combined with the vigorous handling give a powerful thrust to the picture.

In the finished painting, as might be expected, the surface has been refined and there are various subtle changes in the composition, which make the opposition of vertical and horizontal lines less obvious, principally by spreading out the horizontal elements. He has done this by providing greater detail at the left: both the boy in a red cap, and the grazing tow horse become more prominent. Constable has replaced the fishing rod by a thicker plank at a different angle, and by emphasizing the action of the bargee in the white shirt tying up at the right, spreads the composition at this side. The distance in the centre over the meadows to Dedham is more brightly illuminated, and there is a greater variety of greens in the finished picture. Constable thought it 'a good subject and an admirable instance of the picturesque'. By this he may have meant that it is 'pictorial' and refers back to the Claudes he had just seen at Coleorton. In its unusual vertical composition, which we know was not part of his original plan, can be seen an echo of his two favourite Beaumont Claudes, *The Landscape with the Goatherd and Goats* (Plate 150) and, particularly, *Landscape with Hagar and the Angel* (Plate 34). The mass of the trees at the right is similar, the central bright view through to the horizon is the same, and even the diagonal action of the boy opening the lock with arm and leg raised is close to the attitude of Claude's angel. In other words, he is translating his own world into the 'picturesque' terms of pastoral landscape. 'Pastoral' is not, actually, a word he used much before his stay with Sir George, but it occurs a number of times thereafter, as the aim of a landscape. His frequent debt to Claude in his work, incidentally, seems to have gone unrecognized by his contemporaries.

He reported to Fisher on 8 May 1824 that he found his picture 'liked' at the Academy:

It forms a decided feature and its light cannot be put out, because it is the light of nature — the Mother of all that is valuable in poetry, painting or anything else — where an appeal to the soul is required. The language of the heart is the only one that is universal — and Sterne says that he disregards all rules — but makes his way to the heart as he can. My execution annoys most of them and all the scholastic ones — perhaps the sacrifices I make for lightness and brightness is too much, but these things are the essence of landscape. Any extreem [sic] is better than white lead and oil and dado painting.

For the first time he managed to sell his picture on the opening day to a complete stranger, James Morrison, then a draper of Balham Hill, later MP for Ipswich, for 150 guineas, including the frame. This was, at last, a well-deserved triumph, and his success with the composition may have prompted further versions of it, which ensued during the next two years. He had it engraved by Reynolds, and in November 1825, he was finishing a 'half-length' (approximately 50 × 40 ins.) of it — 'it is a very lovely subject'.[9] Also in the autumn of 1825 he seems to have returned to a horizontal format for James Carpenter, which he signed and dated in 1826 (see Plates 182 and 183). It will be mentioned later, as he was still working on it in 1828.

Meanwhile, after the 1824 exhibition, Arrowsmith had paid him his 250 guineas for his pictures, so that he was in the unusual position of having 400 guineas in hand from the sale of his works, which he proposed to settle upon his wife as a fund. Unfortunately, she was ill again, and, as he told Fisher, 'we must try the sea — on Thursday I shall send them to Brighton.' There thus began a new episode in his life with his wife and family separated from him at Brighton from 13 May until 2 November, and again the following year, 1825, from August until January, and then again during his wife's final illness in 1828. While she was away he kept a journal of his daily activities for her benefit, from which we learn that he was just as bothered by 'loungers' as Maria called those who dropped into his studio regularly and whom he could never easily ignore. Fisher, when he visited London, was as guilty as anyone of constantly disturbing him, but Constable could never refuse his old friend. Consequently, with the increase in orders from Arrowsmith, who added four more in addition to *The Haywain* and *The View on the Stour* and his three others, and other replicas to be produced, Constable was as behind as ever. Arrowsmith had brought with him another French dealer, Claude Schroth, known to Bonington and Delacroix, who ordered two Hampstead views and a small landscape. Fortunately, Constable now had young Johnny Dunthorne 'working hard' for him, making outlines, squaring, and transferring his pictures, for Arrowsmith, for Schroth, a small view of *Perne's Mill* for Fisher, another *Salisbury* and the perennial *Waterloo Bridge*. Constable himself could not resist further work on the picture of *Stratford Mill* belonging to the unsuspecting Tinney, with which even Sir George Beaumont helped him. Constable went down to Brighton when he could, and his first oil sketches of the locality date from the beginning of June 1824. He went there again for the remainder of the summer on 17 July, and described it cynically to Fisher in August:

> Brighton is the receptacle of the fashion and off-scouring of London. The magnificence of the sea, and its . . . everlasting voice is drowned in the din & lost in the tumult of stage coaches — gigs — 'flys' &c — and the beach is only Piccadilly . . . by the sea-side. Ladies dressed and *undressed* — gentlemen in morning gowns & slippers on, or without them altogether about knee deep in the breakers — footmen — children — nursery maids, dogs, boys, fishermen *preventive service men* (with hangers & pistols), rotten fish & those hideous amphibious animals the old bathing women, whose language both in oaths & voice resembles men — all are mixed up together in endless confusion.

He clearly hated it.

> The genteeler part, the marine parade, is still more unnatural — with its trimmed and neat apparance & the dandy jetty or chain pier, with its long and elegant strides into the sea a full ¼ of a mile. In short there is nothing here for a painter but the breakers and the sky which have been lovely indeed and always varying, The fishing boats are picturesque, but not so much as the Hastings boats which are luggers. But these subjects are so hackneyed in the exhibition, and are in fact so little capable of that beautifull sentiment that landscape is capable of or which rather belongs to landscape, that they have done a great deal of harm to the art — they form a class of art much easier than landscape & have in consequence almost supplanted it, and have drawn off many who would have encouraged the growth of a pastoral feel in their own minds.

(In the letter he included sketches of the fishing boat and the lugger, with their different sails — a comparison that he made between the local differences of ploughs.) The painters he was referring to were the legion of water-colourists whose beach scenes filled the walls of The Old Water Colour Society. He also named Callcott and Collins as, by implication, lacking the 'pastoral feel', rather than looking to the examples of Wilson and Gainsborough. Constable's head, after Sir George Beaumont's strictures at Coleorton, seems still to be full of the 'pastoral feel'.

These antipathetic attitudes, however, did not stop him from later embarking on a view of *The Chain Pier* (Plate 172) of 1827, and producing a series of beach scenes, this 'easier' class of art, for engraving at the end of the year. Arrowsmith engaged him to make twelve drawings to be engraved, 'all of boats or beach scenes'. The sketchbook from which these drawings came has been broken up, but a number remain in the British Museum and the Victoria and Albert Museum.[10] They are mostly very carefully drawn, in pencil, pen and grey wash, with ruled horizon lines. Some are so mechanical that one wonders whether Johnny Dunthorne had more to do with them than has been supposed. Arrowsmith was obviously hoping to cash in on the boom that Constable had mentioned, and which was felt in Paris too, where similar beach scenes in water-colour by Francia and Bonington were particularly admired.[11] This set, which might have continued Constable's

155. *Study for The Lock*. 1823–4. Oil on canvas, 141.7 × 122 cm. Philadelphia Museum of Art, The John H. McFadden Collection

156. *Brighton Beach with Colliers*. 1824. Oil on paper, 14.9 × 24.8 cm. London, Victoria and Albert Museum

fame abroad, as similar ventures did for other English draughtsmen, Fielding and Prout, for example and had done for Turner, does not seem to have been published. Constable's desire to work for 'excellence', or 'fame' only on his terms was not easily compromised.

For all his stuffy distaste for the vulgarity of the seaside, he did produce some exquisite oil sketches of the sky and the sea, which can be compared in brightness and immediacy with anything he had done at Hampstead, or in Suffolk. Sketching was all he could do. He could not take down a six-foot, or even 'half-length' canvas on the stagecoach to Brighton. Model boats for the children, fresh butter and a travelling cloak for Maria was all he could manage. Of course, the light by the sea was so much brighter than what he normally saw, or painted, but the high key of *Brighton Beach with Colliers* (Plate 156), the Victoria and Albert Museum, of 19 July is particularly notable. He inscribed it with the same sort of notes that he had made in Hampstead, that it was a 'very lovely Evening, looking Eastward ... very white and golden light'. The glittering contrasts are made even greater by the precise detail of the black coal ships, the same use of black and white contrasts and refined draughtsmanship that Turner was to exploit in his *Keelmen Heaving in Coals by Night*, 1835 or his *Peace-Burial at Sea*, 1842. Constable's small painting, however, is a small immediate sketch, expressing the state of mind he was in at the time, rather than the finished, didactic statements of Turner.

Constable also produced, the day after his beach scene, an impressive view of *Shoreham Bay* (Plate 157) above Brighton, the route that Maria took to Chalybeate Well for the waters, dated 20 July. This beautiful little sketch seems to belie his comment on another sketch that 'the neighbourhood of Brighton consists of London cowfields — and Hideous masses of unfledged earth called the country'. The area obviously did not have the well-tilled look of Suffolk, but the texture of the downs in the foreground and his variegated greens gave him subject enough. A study of *Gleaners* (Plate 158) gave him an opportunity to paint a countryside activity, and windmills. These small sketches, as at Hampstead, gave Constable constant opportunity to paint out of doors and, similarly, they were 'done in the lid of my box on my knees as usual', as he described them to Fisher on 5 January 1825. Constable had sent a group to the Fisher family who had been ill, in the hope that 'the sight of the sea may cheer Mrs F'. Another such atmospheric seaside scene, which may date from 1824, or even later, shows the west end of Brighton where Maria stayed, looking along *Hove Beach*, Yale Center for British Art, New Haven, into the setting sun. He seems to have been less fortunate with the weather for his Hove views. Even more dramatic is a study of the sea with rain clouds (Plate 159) which may be dated between 1824 and 1828.

In the same August letter that he condemned Brighton he had to admit some positive points. Constable, whose sym-

157. *Shoreham Bay, near Brighton.* 1824. Paper laid down on canvas, 14.9 × 24.8 cm. Cambridge, Fitzwilliam Museum

pathy for Gilbert White has already been mentioned, had struck up a friendship with a botanist, Henry Phillips, because of his specialized knowledge. Phillips was later helpful in the creation of one of Constable's paintings when he was stuck for authentic detail. Constable also made a trip to the Dyke, and his comments on the view, not much broader than that from Chalybeate help us to understand the current rationale of his art:

> Overlooking ... the most grand & affecting natural landscape in the world and consequently a scene most unfit for a painter. It is the business of a painter not to contend with nature & put this scene (a valley filled with imagery 50 miles long) on a canvas of a few inches, but to make something out of nothing, in attempting which he must almost of necessity become poetical.

This is an important statement about the long-term aims of his art. He has rejected, as he had in 1806, the Sublime and 'awful prospects' of mountain vistas, but also he is not an Impressionist or an Aesthete. His approach is closer to contemporary Romantic attitudes, and develops ideas that he had expressed earlier. His opinion, nevertheless, could be taken as a useful text for the rest of the nineteenth century. Anything can be chosen, according to Constable, as a suitable subject, but it is the artist's skill, for example, at suggesting

atmospheric truth, and thus penetrating the essence of landscape, which gives his work lasting value. He is also repeating what he had already pointed out: that the object of landscape is not to deceive but to remind.

He had himself contended with fifty miles of nature, as it were, with the broad views from Hampstead Heath, which he attempted to put on a canvas of a few inches, but, generally, his own experience had been, from the very beginning, concerned with a relatively small area of Suffolk, painted with very precise local detail. He had, moreover, deliberately chosen an unfashionable and lowly subject-matter. From the moment he had begun to paint large pictures from memory, he had had to face the problem of what his naturalistic art was about. He knew his handling and subject matter were not for 'gentlemen and ladies', but his recent contact with Sir George Beaumont and the 'ideal' world of his collections had brought home again his separation from the mainstream of landscape art. He could only justify his perseverance in the face of fashionable criticism, by claiming that he had distinguished artistic forbears, particularly with Ruysdael and the Dutch, who had 'all made something out of nothing', and thereby they (and he) had become 'poetical'. This is his attempt to place his lowlier art on a level with Claude and Poussin.

He may well have been consciously quoting William Hazlitt's comments in his *Table Talk* (1821), who compared

Wordsworth with Rembrandt for his 'faculty of making something out of nothing, that is', Hazlitt continued, 'out of himself, by the medium through which he sees and with which he clothes the barrenest subject.' Sir George Beaumont, with his strong advocacy of Wordsworth, could have read it aloud after supper at Coleorton. This parallel with Constable's famous literary contemporary, Wordsworth, who had suffered similar criticism, helped to justify Constable's own position in the creation of works of art. Such an attitude is clearly part of the Romantic Movement and looks forward to Zola's idea of 'nature seen through a temperament'. It is not, however, for Constable a justification to make something out of nothing by elegant skeins of paint, or beautiful 'effects'. He was not a Whistler, and, indeed, he knew his 'handling' was actually found to be offensive. The single-minded quest for truth in whatever direction was more important for him than keeping up the appearances of his art.

Further it is not quite the same thing as Hazlitt's somewhat similar statement about Turner, that his works 'were pictures of nothing and very like'. Constable would have considered his own moral feeling of landscape to be far from nothing, and his naturalistic approach far from abstract, which Hazlitt's remarks about Turner imply. Constable has moved to a more complicated position, then, from his simple hopes in 1802, that 'there was room enough for a natural peinture'. He was not advocating grand mountain scenery, or sunsets, because they were sublime, but he was arguing that his more mundane Suffolk valley scenes could become 'picturesque' or 'poetical', (the words, in his sense, become almost interchangeable) by the accuracy and intensity of the artist's vision. His further comments of 1802 still had some validity for him, when he saw that 'the great vice of the present day is *bravura*, an attempt to do something beyond the truth'. That had become, by 1824, the chimerical 'nothing' of Martin, Danby, and, sometimes, Turner, which he would not pursue.

His 'truth' to nature was what seems to have been recognized and admired in Paris. Constable had written to Fisher on 8 May 1824: 'Think of the lovely valleys mid the peaceful farm houses of Suffolk, forming a scene of exhibition to amuse the gay & frivolous Parisians.' He had underestimated them. When his pictures were shown they caused much serious interest. Delacroix noted in his *Journal* on his first sight of *The Haywain* and *The Bridge*, on the 19 June, that, 'This man Constable has done me a power of good.' Others, too, must have seen his pictures at Arrowsmith's gallery, which had been delivered earlier. On 16 June, Constable received an unexpected visit in his studio from M. le Vicomte de Thulusson and his wife who spoke of his fame in Paris, and with what 'éclat' he would be received if he went to Paris. He was equally glad to hear on 21 June, from his rival William Collins, RA, that he was 'a great man in Paris', to be ranked with Wilkie and Lawrence. He finally heard that his large consignment had arrived safely and he gave permission for *The Haywain* and *The View on the Stour* to be shown at the Salon, which opened in the Louvre on 25 August. Delacroix went to see them again on 25 June, and during this period he is supposed to have retouched his *Massacres at Chios*, as a result of Constable's influence. There was clearly no time to recast his picture entirely, and Lee

Johnson has argued plausibly that his reworkings may have been confined to adding broken touches of pure colour to the foreground figures.[12] Yet Delacroix seems to have been impressed by the bright, naturalistic look of Constable's work and, by contrast, the greyness of his own picture, which still has very much a 'studio' appearance. Later in 1824 visitors to the Salon were reported as commenting, 'Look at these English paintings,' [Bonington, Lawrence, Copley Fielding and Wilkie were also exhibiting] '— the very dew is upon the ground.' Even the conservative critics in Paris were forced to admit the realism of Constable's pictures, which they felt would dangerously seduce the younger artists: ' "They are not in style" say our rhetoricians; and often enough we have a stream running between banks that have little of the picturesque, combined with a horizon of no significance. Let it be so,' judged Adolphe Thiers, 'but the whole is full of delicacy, perspective and truth; and to use the usual expression, it is filled with air.' Stendhal was of a similar opinion: 'I have given my enthusiastic praise to M. Constable. That is because the *truth* has for me an immediate and irresistible charm.'

Constable proudly relayed to Fisher the effect his pictures had made. They had been moved to a better position, after their initial success, but Constable had to do justice to Count Forbin, the Director of the Louvre, who had thought that 'as the colours were rough, they must be seen at a distance' but 'they then acknowledged the richness of the texture & the attention to the surface of objects in these pictures.' Constable here made an important distinction for his finished works, that they were not mere impressions, and needed to be seen close to and not hung high. He went on, 'they wonder where the brightness comes from'. He thought the French ignorance was due to their being taught to study only individual objects, apart from the whole, '& they neglect the look of nature altogether under its various changes'. With Monet and the French Impressionists this fault was rectified and it was the English critics at the end of the century, Ruskin, for different reasons, and R.A.M. Stevenson apart, who had forgotten Constable's lead. The French government had offered to buy the *Haywain* for the nation, but Arrowsmith would only sell it with *The View on the Stour*. If he had sold it, it would have taken its place with Delacroix's *Massacres at Chios*, which was bought for the nation, and the triumph of the new Romantic school would have been complete. Constable, like Delacroix, was awarded a gold medal from Charles X, which he received from the French ambassador in March 1825, while Lawrence had been made a Knight of the Legion of Honour.

Schroth ordered another three pictures and Firmin Didot, a collector and publisher from Paris, ordered three small paintings. The bearer of Schroth's letter of thanks, of 17 May 1825, was Delacroix himself.[13] Delacroix in his journals later recounted what he had learned from Constable, and what he says has a ring of truth. As well as seeing Constable's studio, with its unsold works, he would also have seen Constable's major exhibit at the Royal Academy of 1825, *The Leaping Horse*, and further Hampstead Heath scenes. 'Constable says that the superiority of the greens in his meadows is due to the fact that they are made up of a large number of different greens. What gives a lack of intensity and life to the verdure of the

158. *The Gleaners*. 1824. Oil on canvas, 16 × 30 cm. London, Tate Gallery

159. *Seascape Study with Rain Clouds at Brighton. c. 1824–8.* Oil on paper laid on canvas, 22.2 × 31 cm. London, Royal Academy of Arts

ordinary run of landscape painters is that they do it with a uniform tint.'[14] Constable had already demonstrated this important point in his work. His use of broken touches and complementary colours, which Delacroix could see, may also have had at the beginning of the 1820s a theoretical underpinning, in addition to his years of experience. Significantly, a mention of George Field, the colour merchant, and the person who may have been behind his theories, appears for the first time in Constable's correspondence of 1825.[15]

Field had first become known for his success at cultivating madder during the Napoleonic Wars but became a successful colour merchant and colour theorist. He had moved to Hounslow in the London area by 1813. His *Chromatics* had been published in 1817, and it contains a number of suggestions, which are developed in his later, and better known, *Chromatography* of 1835, to which Constable subscribed. What Delacroix had been impressed by, and what Constable may have demonstrated to him, were the transient effects of reflected light, and adjacent colours, which we have already seen occurring in Constable's pictures. Field noticed in his 1817 publication:

> the illusory reflections observable when colours are opposed in strong lights: thus a white drapery opposed to a green wall in a good light often appears to be beautifully pink, and if by any accident there be an undulation of light upon the wall, a similar undulation will appear upon the drapery, which effects belong to the eye, and not to the object, and excite the illusion and anomaly of a red reflection from a green surface. The same extends to other colours.

Field also developed this theory to account for the changes produced by the introduction of a new colour into a painting. Field is, in 1817, laying down a programme for Impressionism, and the divisionism of colour called Neo-Impressionism. Even if Constable had not read the 1817 edition, by 1825, when he met Delacroix, he was a friend of Field's. Constable's art was never so formally colourist, but Delacroix had noticed an important individualistic trait in Constable's work, which had ramifications for nineteenth-century developments in colour theory.

Delacroix also used another characteristic technique of Constable's, the use of glazes to give luminosity to shadows, which, in the history of nineteenth-century technique, gets short shrift, or is, at best, considered old fashioned. There is no evidence that, in this case, Delacroix had any particular knowledge from Constable but he must have noticed it in Constable's and other English painters' work. When the *Massacres at Chios* was being cleaned in 1854, Delacroix was most anxious about the effect on his picture when the varnishes were removed.[16] Delacroix had been impressed by Veronese's and Rubens's use of this technique, but when he altered his picture in 1824 he could easily have applied glazes to give vibrant depth and transparency to shadows, as Constable did. Both Delacroix and Constable would have been equally alarmed if their surface touches and glazes were removed. To Delacroix, Constable could give confirmation of what he had already seen in Rubens and Veronese, and it is not without

interest that Renoir, that other great colourist of the nineteenth century, continues in this older tradition.[17]

There was one further technical effect that Constable and Delacroix had in common, which influenced nineteenth-century painting, and for which there was also a theoretical justification in the literature of the time. It can best be described in the words of John Burnett, which we know they both read, and that is the general 'vivacity of light and dark', brought about by abrupt and sharp transitions of tone, as opposed to the smooth transitions of, say, Glover, which Constable hated. In Burnett's *Practical Hints on Light and Shade in Painting*, 1826, and his *Practical Hints on Colour in Painting*, 1827, where Burnett talks about the contrast of warm and cool colours, this variety of tone and colour is also referred to. Constable recommended both books to Fisher, but Delacroix would have seen the effects in Constable's paintings, as well as reading about it for himself.

Constable's general influence on French art for subject matter and technique spread via Géricault and Delacroix, to the other young French artists by means of the considerable number of his pictures then in France, to artists such as Paul Huet or Constant Troyon (see Plate 160), and thus to the Barbizon painters, and from them to the young Impressionists.[18] Nevertheless, his *immediate* influence was very short-lived. Without Fisher's knowledge, he sent his *White Horse* to Lille in August 1825, where he won further acclaim. Ward, the engraver, reported his further success in Paris, but by the autumn of 1825 the tide was turning, and it was partly his own fault. He broke off with Arrowsmith over an imagined slight and did no more work for him. Arrowsmith became insolvent by the end of 1825, and Schroth gave up dealing in 1826. Constable's *Cornfield*, when it was sent to the Salon of 1827, attracted very little notice and he had difficulty getting it back. His moment had gone by. Bonington remained more popular with the French in spite of his early death. Constable was much more concerned in gaining an *English* success and had steadfastly refused to go to France, after the initial temptation to travel with Tinney and Fisher, to further his career on the Continent. To a later generation of French artists he would have been only a name. When Monet and Pissarro visited England in 1871, there were a number of Constables on view in public collections, including his most famous plein-air picture *Boat Building*, from the Sheepshanks Collection, which had been on view with other English works at South Kensington since 1857.[19] The Sheepshanks gift was, perhaps, the most important, but it must be remembered that the large number of 'impressionist' sketches were still with the family, not to be seen in any number until Isabel Constable's gift of 1887 and her bequest of 1888. Nevertheless, his large-scale sketches for *The Haywain* and *The Leaping Horse* were on loan from the Vaughan Collection between 1862 and 1900. Camille Pissarro bemoaned the lack of English pictures in France during the 1890s when by an irony *The Haywain* was back in England, having been presented to the National Gallery in 1886. If Arrowsmith had not been so greedy it could have been in the Louvre, to commemorate, with Delacroix, a moment of Romantic vision.

After the heady activity of the summer of 1824, Constable

160. Constant Troyon (1810–65). *Landscape. c.* 1846–51. Oil on canvas, 34.8 × 45.1 cm. Boston, Museum of Fine Arts, Bequest of Thomas G. Appleton

reported to Fisher from Brighton on 29 August that he was 'getting on with [his] French jobs. One of the largest is quite complete, and is my best, in freshness and sparkle — with *repose* — which is my struggle just now.' Then his own repose seems to have left him. He found the work too pressing. He could not continue with Tinney's order for two landscapes: 'after a time they become a burthen — dead weight', and he implored Fisher on 2 November 'Help me in these matters as you always do.' He was also irritated that Tinney was not willing to lend his picture of *Stratford Mill*, yet again, to an exhibition of British Art. Constable expected his pictures once sold, to be available constantly for exhibition and, as it often turned out, further retouching. His method of painting out to the surface from the ground, which went back to 1802, allowed him to add, in a constant quest for perfection, as he saw it.

Fisher had hoped he could 'diversify' his subject this year as to *time of day*. 'Thompson [*sic*] you know wrote, not four Summers but *four Seasons*. People are tired of mutton on top mutton at bottom mutton at the side dishes, though the best of flavours & smallest size.'[20] If this was meant as friendly advice, Constable, in his nervous state, reacted with all the strength of his stubbornness about the direction of his art, which he thought had not changed, but had only been widened since his

first beginnings, as his sharp answer reveals:

I am planning a large picture. I regard all you say but I do not enter into that notion of varying one's plans to keep the Publick in good humour — subject and change of weather and effect will afford variety in landscape. What if Van de Velde had quitted his sea-pieces — or Ruisdael his water-falls — or Hobbema his native woods — would not the world have lost so many features in art?

This is slightly special pleading on Constable's part. He is naturally turning to those artists with whom his name had most often been linked but, as we have seen, he was equally interested in Rubens and Claude. 'I know that you wish for no material alterations — but I have to combat from high quarters, even Lawrence, the seeming plausible arguments that subject makes the picture.' Lawrence, the President of the Royal Academy, Constable knew was not in favour of landscape and was to make grudging remarks when, eventually Constable was elected a full Academician.

Perhaps you think an evening effect — or a warm picture — might do. Perhaps it might start me some new admirers — but I should lose many old ones —
Reynolds the engraver tells me my 'freshness' exceeds the

161. *Study for the Leaping Horse.* 1824. Chalk and ink wash, 20.3 × 30.2 cm. London, British Museum

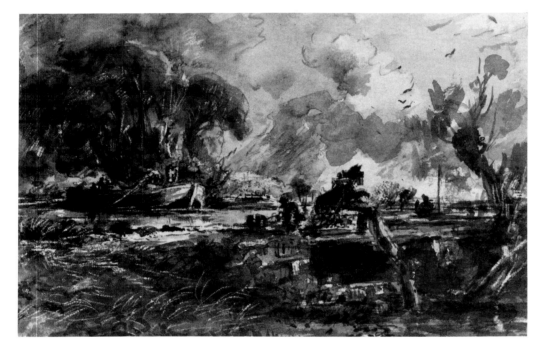

162. *Study for the Leaping Horse.* 1824. Chalk and ink wash, 20.3 × 30.2 cm. London, British Museum

163. *Study of a Willow. c.* 1813. Pencil, 8.9 × 11.4 cm. London, Courtauld Institute of Art, Witt Collection

freshness of any painter that ever lived — for to my zest of 'color' I have added 'light': Ruisdael (the freshest of all) and Hobbema, were *black* — should any of this be true, I must go on. I imagine myself driving a nail. I have driven it some way — by persevering with this nail I may drive it home.[21]

Constable, after twenty-five years of single-minded endeavour, now felt he could be compared with the great Dutch artists of the past, but he did not want to be side-tracked, as he thought Turner had been, from the naturalistic bias of his work. His technique and attitudes might have become more complex, but, when pushed, he felt he was progressing in a straight line with sound principles.

The new year, 1825, when Constable had already begun sketching and working out his next major picture, ('planning' by November, and 'putting in hand' by 17 December), brought a prophetic letter from Fisher, who had been ill, but

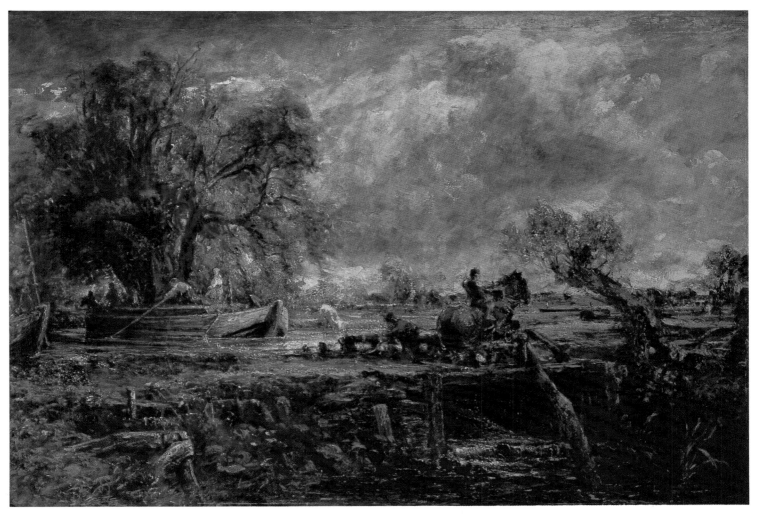

164. *Study for the Leaping Horse*. 1824–5. Oil on canvas, 129.4 × 188 cm. London, Victoria and Albert Museum

was pleased to hear that Constable's pictures were being engraved, the sure track for wider success;

> but I am almost timid about the result. There is in your pictures too much evanescent effect and general tone to be expressed by black and white. Your charm is colour & the cool tint of English daylight. The burr of mezzotint will not touch that.[22]

This proved only too true when Constable was involved later with the engraving of his work. To the richness of handling, and the 'freshness' of his colour from now on can be seen in increasing resource to even more violent contrasts of light and dark, achieved by bitumen and glazes, which give his work, for the rest of his life, an agitated but increasingly sombre appearance.

He was conscious of pursuing a particular end, and when he learned of his medal from France he deeply felt 'the honour of having found an original style & independent of him who would be Lord over all — I mean Turner — I believe it would be difficult to say that there is a bit of landscape that does not emanate from that source'. For the time being, he took Fisher's point about his colour, but persuaded himself that the engraver could cope with 'the chiaroscuro & the details [of which he was so proud] & the taste and with it most of my sentiment'. But at this moment he agreed it was 'quite impossible to engrave the real essence of my landscape

feeling'. Reynolds did not, in fact, finish engraving *The Lock*, and Constable later chose to ignore what he had said to Fisher, and he had to justify his 'feeling' by elaborate written justifications.

His exhibit for the Royal Academy in 1825 caused him more trouble than any of his previous large works and it proved to be his last, original six-foot canvas based on the traffic of the Stour. Something of his nervousness of the autumn of 1824 seems to have been carried over into its creation, and his method of work reveals uncertainties about its composition and an increasing ambivalence between the sketch and finished subject, which he was still altering in September long after its exhibition. The two drawings (Plates 161, 162) in the British Museum can be associated with his preliminary work of November–December, 'putting a 6 foot canvas in hand', while an early pencil sketch (Plate 163), probably from a sketchbook of *c.* 1813, was used for the detail of the willow tree and water at the right hand part of the composition. There appear to be no other earlier oil sketches that can be linked with the design. There is a large six-foot 'sketch' (Plate 164) in the Victoria and Albert Museum, and the finished picture (Plate 165) is now in the Royal Academy, having been presented in 1889.[23]

On 5 January 1825 he wrote he was 'before a 6 ft canvas which I have just launched with all my usual anxieties'. He had the example of Waterloo Bridge to give him a constant, silent rebuke about the outcome of his finished pictures. He had been

busy on his beach scenes but in the two weeks or so over Christmas he had obviously progressed further with his design. He was, however, to be interrupted by a portrait commission for the Lamberts at Woodmansterne in Surrey and he complained at the interruption, 'but it is my wife's connection & I thought it prudent to put a good face on it'. He went on to say his large subject was 'most promising & if time allows I shall far excell my other large pictures in it. It is a canal and full of the bustle incident of such a scene where four or five boats are passing with dogs, horses, boys, & men & women & children, & best of all old timber props, waterplants, willow stumps, sedges old nets &c &c &c.' This description, with its accumulation of details, suggests that Constable was trying to add everything from his repertoire. In the final version, he, in fact, painted only three boats.

The willow stump and view down the river in the early drawing seem to have provided the initial inspiration, with a brief scrawl to suggest the moorhen that he was pleased to mention later, but the drawings in the British Museum are clearly not drawn on the spot and contain all of these elements he mentions in one form or another. The most notable feature of his picture, which also appears in these two drawings he nowhere mentions, is the leaping horse. It gave the work its present title, but when it was sent to the Academy it was called simply *Landscape*. This central element is, however, a local detail of particular Suffolk significance, which dominates the picture, as if Constable was proudly drawing attention to something he had closely observed, and which could be seen nowhere else. In fact, as Hugh Honour has perceptively remarked some of the 'matter' enlivens his major works because it is slightly odd and unexpected: a horse *in* a barge, a haywain *in* the water, a cart horse *leaping* over a barrier. Leslie's description perpetuates this local pride and, incidentally, explains what is happening:

> The chief object in the foreground is a horse mounted by a boy, leaping one of the barriers which cross the towing paths along the Stour (for it is that river, and not a canal) to prevent the cattle from quitting their bounds. As these bars are without gates, the horses which are of a much finer race, and kept in better condition than the wretched animals that tow the barges near London, are all taught to leap.

Ian Fleming-Williams reasonably argues that Plate 161 was the first of the two British Museum drawings. It incorporates the willow tree, but leaves out Dedham Church tower. The horse, however, is stationary, and there are two barges. The basic mass of the trees at the left, the low viewpoint, which emphasizes the horse, and the sluice in the foreground are all in place. These elements are almost an amalgam of *View on the Stour* (Plate 145) of 1822, and *The Lock* (Plate 154) of 1824, with some of the motifs hinted at, but never brought to completion in the Dedham Lock series of 1820–5 (see p. 109, and Plates 102, 104). The overall drama of the second drawing in the British Museum (Plate 162) is even more noticeable than the first. The bold strokes and scratching into the paper have greater prominence and the all-over flutter of chiaroscuro is more prevalent. There are differences of detail: there is only one barge in the centre, there are suggestions of

barges at the right and the horse is shown, dramatically silhouetted, in the act of leaping. Essentially, these two drawings mark a new stage in his draughtsmanship, but in their generalized forms, and mannerisms for the detail of trees, the brown wash, their scratching, and the flicker of nervous pen strokes, they look back to Claude's drawings from nature, and to certain drawings by Gainsborough.[24]

In the absence of Dedham Church tower, and Constable later identified the scene as Dedham in the finished picture, it is difficult to be sure, for the first time in his work, where, exactly, the scene is located. It has been suggested that the drawings were done with a spot on the south bank nearer to Dedham than Flatford, where there was a sluice running from the river, and where the bridge suggested in the distance could be identified as Fen Bridge.[25] Initially, then, the view was looking towards the northeast, but with the progress of the work, however, the viewpoint was turned round to look the other way towards the southwest, the bridge was removed, and Dedham Church was placed at the right. This lack of concern with the niceties of topography reveals how far Constable's art has progressed since we could follow his walk in Old Hall Park to find an exact spot for Philadelphia Godfrey's wedding present (Plate 84), but as that seemingly accurate view encompassed a much wider viewpoint than the eye can take in, so *The Leaping Horse* takes in all that he has learned of the Stour Valley, and of art. By 1825, he drives in his nail by an imaginative reconstruction.

He must have turned to the finished canvas at a very late stage and it left out a number of details from the two preparatory drawings. The sketch at the Victoria and Albert (Plate 164) has two barges again, and a cow has been introduced. This, and a barge, are removed in the finished picture (Plate 165) which was changed again in September. In some ways the 'second' drawing (Plate 162) is closer to the finished picture and the 'first' sketch (Plate 161) is close to the Victoria and Albert 'sketch' (Plate 164). The most obvious and important factor in these drawings and paintings is the liveliness of the scene, the 'bustle', which he felt in January was its essence. This is achieved by a suitable painterly agitation. The essential composition of the design is a much more aggressive criss-cross diagonal into space than he had hitherto used, and there are a greater number of lines that do not tend towards the horizontal (as Seurat was to describe them, to express vitality), which increases the liveliness. The lower viewpoint involves the spectator in a direct way, but, undoubtedly, the surface is where the greatest excitement occurs. In the Victoria and Albert sketch there are obvious semicircular sweeps of the palette knife at the right. There are flecks of black and white, blue and yellow against the brown ground, to give the effect of scattered light through the willow tree and the mass of trees at the left. There are direct contrasts of black and white touches almost in the centre of the picture, apart from the deep shadow of the run-off from the sluice.

When we turn to the finished painting, there is not as much refinement as in his previous exhibited works. Strokes of the palette knife and spots of pure colour for the highlights of water and the suggestions of two barges in the distance are as obvious at the right as they were in the Victoria and Albert

sketch, although the overall effect is richer in colour and less coolly monochromatic than the sketch. After a difficult confinement of Maria with her fifth child, Emily, he wrote to Fisher in April to report proudly the ceremony at the French ambassador's where he received his medal. He also mentioned the exhibition of his latest '6 footer'. He admitted 'that no picture ever departed from my easil with more anxiety on my part with it. It is a lovely subject, of the canal kind, lively — & soothing — calm and exhilarating — fresh & blowing, but it should have been on my easil a few weeks longer.'

This list of opposites shows how he was trying to increase the range of his pictures, atmospherically and, accordingly, as he would have thought, towards a greater range of 'feeling'. As part of his new theories, his pictures are no longer 'serene' but 'lively' and 'soothing', 'calm' and 'exhilarating', and, of course, 'fresh and blowing'. Fisher had encouraged him with a quotation about the power of originality (10 April), which Constable acknowledged was relevant for what he called his 'grand theory'. He was slowly, as has already been noted, working towards an overall theory to explain his art as it developed. He was not to put his theoretical ideas into written form until the end of his life, with the landscape lectures he was to give at Hampstead and Worcester, and the Royal Institution, and in the letterpress he wrote for his 'English Landscape' mezzotints. These remain as a remarkable summary of what he was 'driving home', but notes and sketches about natural phenomena, clouds, rainbows, and his interest in colour were never put together into any coherent form.[26] It is from hints such as his descriptions in his letters to Fisher that we can follow the direction of his thought and intentions.

When his picture returned from the Academy, he revealed in his journal to Maria on 7 September 1825, that he had 'got up early — set to work on my large picture. Took out the old willow stump by my horse, which has improved the picture much — almost finished — made one or two other alterations.' These can still be seen. Traces of the cow drinking in the river, the altered prow of the barge are faintly visible, but there is now the new dramatic diagonal of the sail set against the strengthened vertical of the main trunk of the tree behind, and the willow is set absolutely in the centre and has silvery foliage, all of which changes lead the eye to the right and emphasize the movement of the horse. He described his picture, matter-of-factly, to a prospective client as 'scene in Suffolk, banks of a navigable river under which is a flood gate and an elibray [an eel dike, or trap], river plants and weeds, a moorhen frightened from her nest — near by in the meadows is the fine Gothic tower of Dedham'. This sounds straightforward enough, but it had been a complicated matter to bring these elements together. His picture did not sell and remained in his studio until the sale of 1838 after his death. It was eventually given to the Royal Academy in 1889.

He had less difficulty with his other exhibits at the Academy of 1825. These were variants of the pair of Hampstead Heath scenes, 'two of my best landscapes', which had been ordered by Claude Schroth in May 1824 and had finally been finished in December. Constable had made copies and thought it 'immaterial', which were sent away. It was these copies he exhibited at the Academy (at 75 guineas each). A London merchant, Henry Hebbert, had put down a deposit for one of them, but reverses in trade forced him to give up the order. Constable, luckily, found another purchaser with whom he made a deal, to Hebbert's slight annoyance. The new client, Francis Darby, was the son of the ironmaster at Coalbrookdale, the man who had built the first iron bridge across the Severn in Shropshire.

He was one of the new breed of patrons, such as Morrison, Hebbert, and later Sheepshanks, and Vernon, who were representatives of the new entrepreneurs from the rising English middle class. They had none of the prejudices against contemporary British art that the old aristocratic patrons only too often revealed. This new class saw Constable's pictures, perceived they were cheap, liked them, and paid cash on the spot, unlike the awkward commissions, the patronizing attitudes, late payment, or even chilly indifference of H.G. Lewis, Sir Thomas Neave, Bt., (although his son (Sir) Richard Digby Neave was a friend and admirer), The Earl of Egremont, Payne Knight, and R. Benyon-De Beauvoir. Sir George Beaumont may have genuinely liked him, but did not understand his art. Lady Dysart remained extremely kind, but he was her 'man about the pictures', who could be summoned immediately for a copy or a free consultation about frames or restoration, or the state of Bentley woods. Even the 'good' Bishop of Salisbury, for all his tolerance, could sometimes demand his copy of Salisbury to be completed and hung at very short notice. Unfortunately for Constable and for Fisher, the Bishop died on 8 May and his kindliness was missed by them both. He had, after all, been Constable's 'monitor for twenty-five years'.[27]

Constable hastened to reply to Darby's enquiry, with descriptions of his Academy pictures, which help to identify his pair of Hampstead Heath scenes:

No 115 A scene on Hampstead Heath [Plate 167], with broken foreground and sand carts, Windsor Castle in the extreme distance on the right of the shower the fresh greens in the distance (which you are pleased to admire) are the fields about Harrow, and the villages of Hendon, Kilburn, &c. No. 186 Companion to the above [see Plates 166 and 168] — likewise a scene on Hampstead Heath called Child's Hill — Harrow with its spire in the distance. Serene afternoon, with sunshine after rain, and heavy clouds passing off, Harvest time, the foreground filled with cattle & figures, and an Essex market cart.

For all his precise descriptions about the weather, the season and the cart, the picture was painted in his studio in the winter, and the same cart that had moved dung in 1814 was now painted moving gravel at Hampstead. After a little bargaining Constable agreed in his letter of 6 August on 130 guineas for the pair, although the frames had cost £20, and added the revealing comment about his attitude to someone like Darby: 'When I took the liberty of saying I am desirous that you should possess them, I feel flattered that an application should be made to me from an entire stranger, without interest or affection or favour, but I am led to hope for the picture's sake alone.' Darby remained an admirer of Constable's, but Constable, to his credit, had carefully tried not to play off one

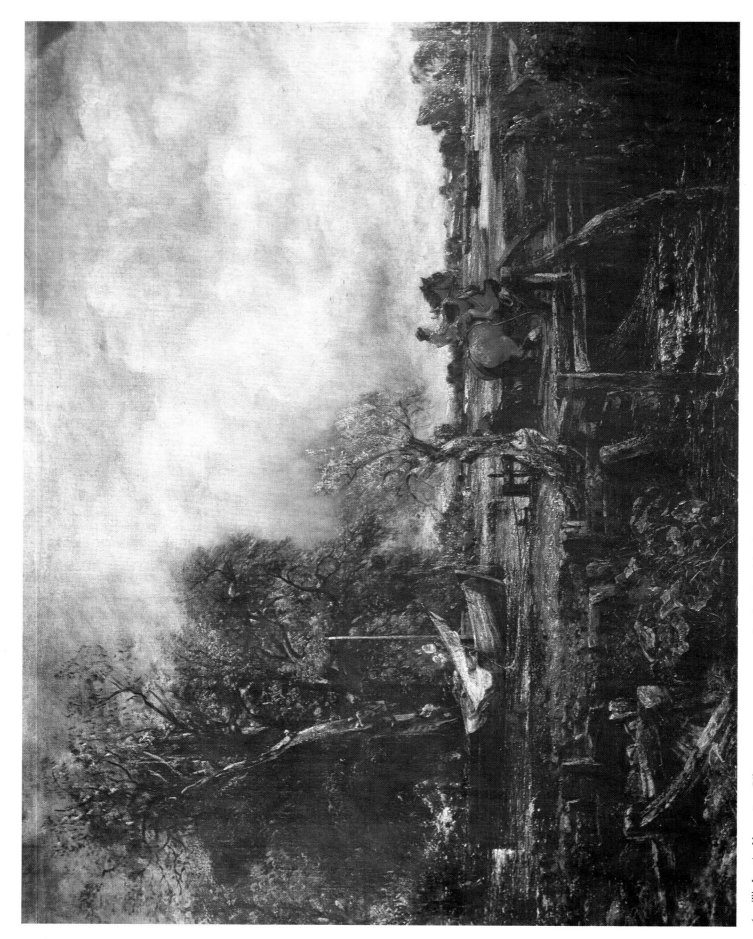

165. *The Leaping Horse*. 1825. Oil on canvas, 142.2 × 187.3 cm. London, Royal Academy of Arts

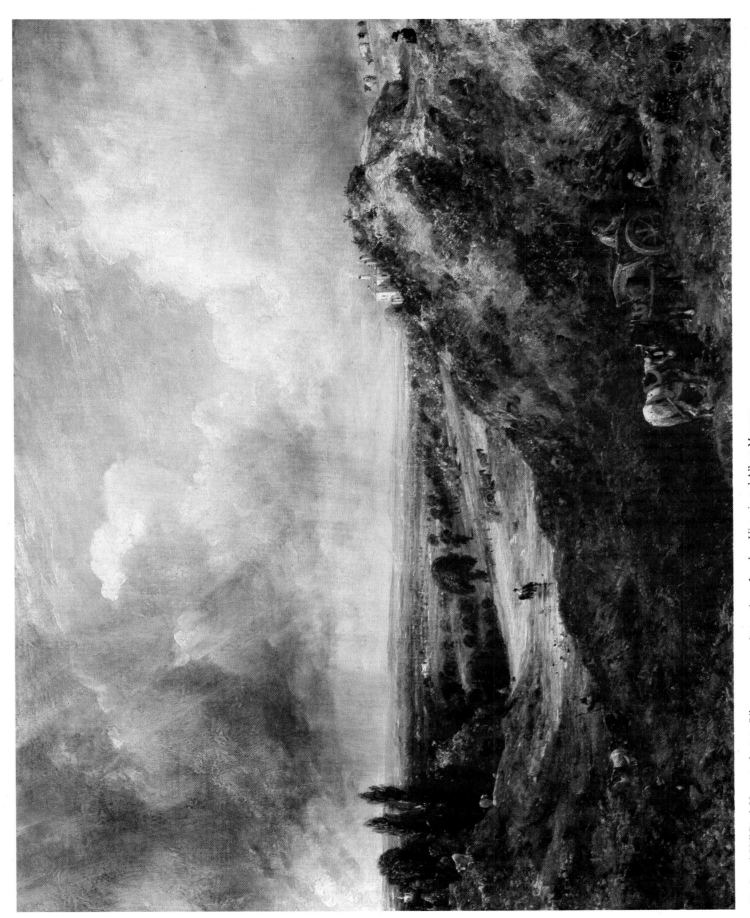

166. *Branch Hill Pond, Hampstead*. 1828. Oil on canvas, 59.6 × 77.6 cm. London, Victoria and Albert Museum

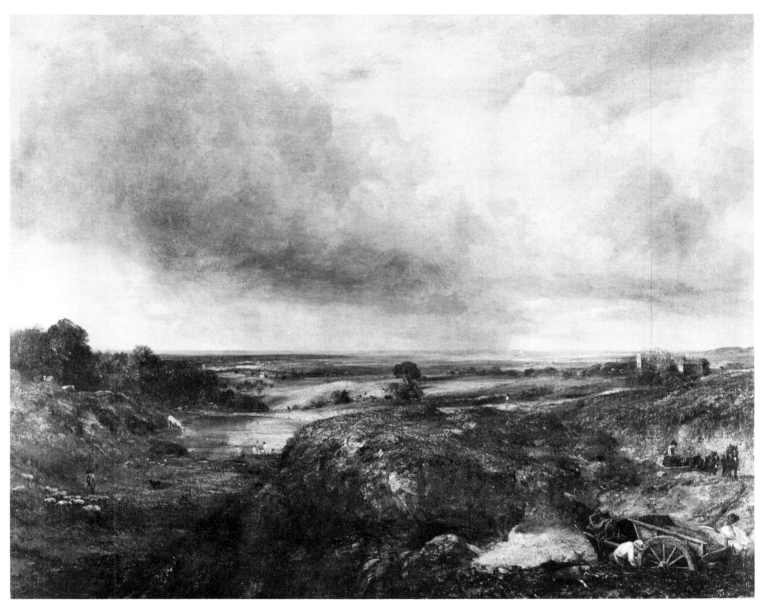

167. *Branch Hill Pond, Hampstead Heath.* 1825. Oil on canvas, 62.2 × 78.1 cm. Richmond, Virginia Museum of Fine Arts

prospective purchaser against another. It was Hebbert, in fact, who cashed Darby's cheque, and lost a guinea down the floorboards for his pains while giving change. Constable, with his punctiliousness about behaviour to people he liked, felt guilty, tried to replace the guinea, and eventually bought a plaid cloak from Hebbert to travel to Brighton. When he had exhibited another version of the second picture (Plate 166) for the Royal Academy of 1828, he then painted a further version of the same view for Hebbert (Plate 168), at a time when his own personal circumstances were much disturbed after the death of his wife. The corresponding view from Darby's pair is not known.

These permutations of his two basic views of Hampstead Heath (Plates 166, 167 and 168), which originated with the sketch of 1819 (Plate 108), were landscapes done on demand, not on the spot. They embodied all his realistic observation at Hampstead, which survives in lively, heavily textured oil sketches of sandbanks (see Victoria and Albert, R. 228); there

are the sky studies of 1821–2; and there are the sketches of houses, labourers, donkeys, cattle watering, and the Essex cart, which are all part of his repertoire. The finished pictures, however, also have references in them to other art. The herdsman and his sheep (Plate 167), for example, in the left foreground suggest similar elements in Gainsborough or in Gaspard Dughet. These Hampstead Heath scenes are exercises in the tumble of land, its texture, the sweep of distance, the feeling for atmosphere, the chiaroscuro of the composition, with which he was much involved and which gave them their popularity. More than one patron of these Hampstead Heath scenes spoke of their 'freshness' as their most attractive quality. Jack Bannister, the comic actor, who had studied at the Royal Academy Schools ordered one because 'he can feel the wind blowing on his face'. Constable told Fisher on 26 November 1825 that 'he says my landscape has something in it beyond freshness, it's life, exhilaration &c'. W. George Jennings was equally enthusiastic in 1836: 'To the extraordi-

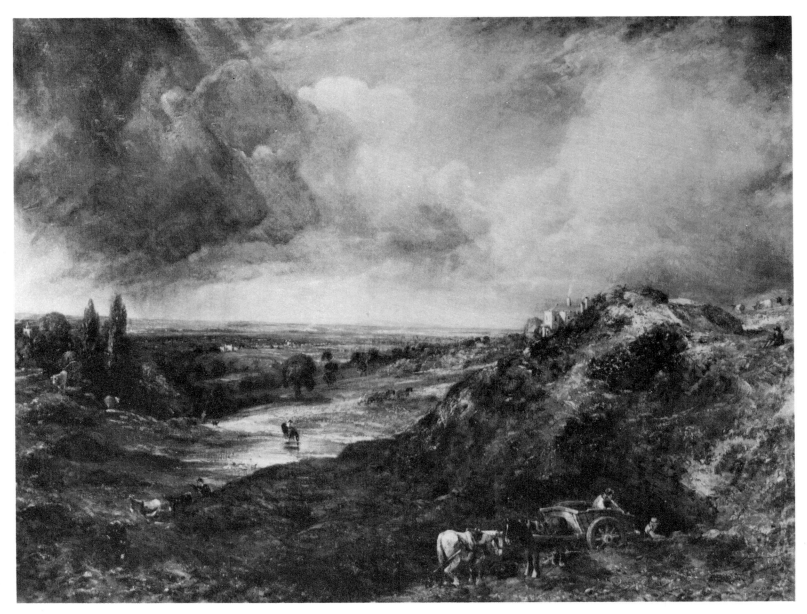

168. *Branch Hill Pond, Hampstead*. 1828. Oil on canvas, 60.6 × 78 cm. Cleveland, Museum of Art, Leonard C. Hanna, Jr., Bequest

nary power of Art you have added all the *Truth* of Nature & what more can painting accomplish?'[28] Bannister was to be a neighbour of Constable's at Hampstead, so that it can be assumed he already liked the area. His version is now in the Tate Gallery, but even if it is supposed that he and Jennings were repeating what they had heard from Constable himself, their testimony seems genuine enough. Whether, in the face of this welter of artistic and life-enhancing imagery, and their common sense reaction to it, Constable and his patrons were also subconsciously recognizing what has been described as Freudian regression is doubtful.

The summer of 1825 saw Constable's family for a brief moment at Hampstead Heath again, at 'Hooke's Cottage', but the illness of his eldest son, John Charles, made him decide to pack them off once more to Brighton. This time they were there from September to January. Constable hoped that the one positive result would be that he could get on with his work, not distracted by continual trips back and forth to

Hampstead. He again kept a journal, a detailed account of his activities, as a touching reassurance to his wife, of what he ate, what he wore, who visited him, and the daily doings of the household pets. His autumn, however, was to prove frustrating. He had his break with Arrowsmith, which he regretted. He had borrowed from their owners what he thought were his three best pictures, *The White Horse* from Fisher, *Stratford Mill* from Tinney, and *The Lock* from Morrison, for an exhibition of modern masters at the British Institution, a new departure on its part for which he was grateful. He was then angry when Tinney would not lend his picture again for a proposed inaugural exhibition for a new Scottish Academy. Tinney could not understand why Constable did not produce what he had asked for so generously. Fisher tried to act as an intermediary, explaining that Tinney had become vain, and that Constable was 'tormenting himself by imaginary evils'. But relations with Tinney were never the same again. Fisher, incidentally, was not to see *his* picture until February of the

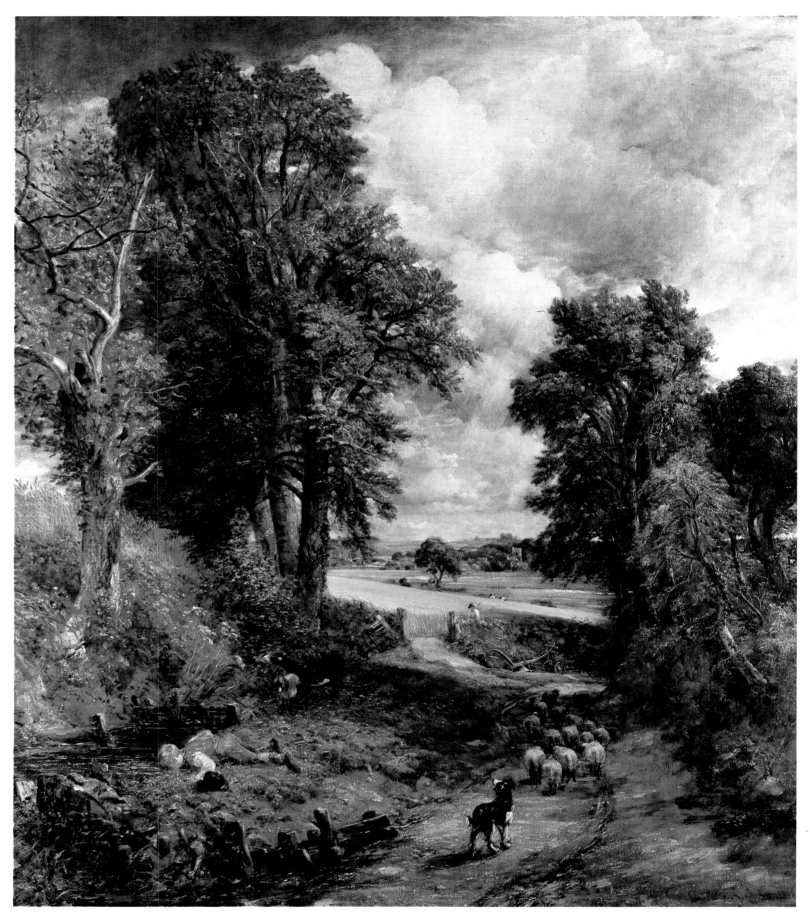

169. *The Cornfield.* 1826. Oil on canvas, 142.9 × 122.5 cm. London, National Gallery

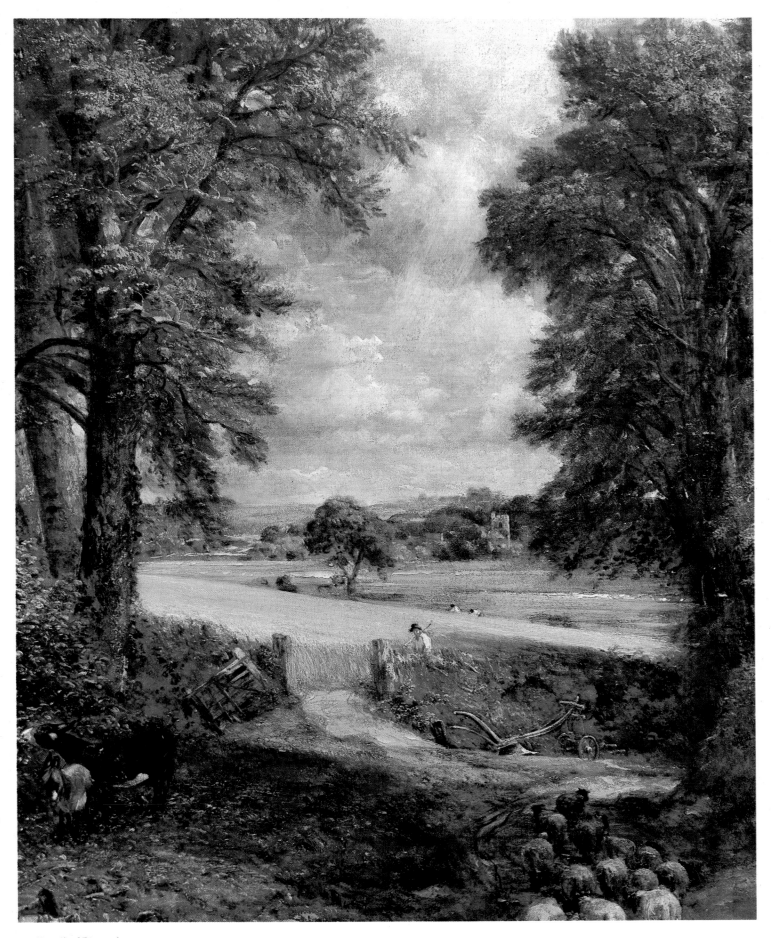

170. Detail of Plate 169

next year, as Constable had sent it to Lille, without asking Fisher's leave, where it eventually won a gold medal. 'All things considered,' admitted Constable to Fisher on 14 January 1826, 'the gold medal should be yours.'

Sometime in 1825 Constable seems to have begun a *View in Helmingham Dell* (Plate 195) for his old Suffolk patron, James Pulham, the lawyer at Woodbridge. This is, perhaps, the first of a number of pictures that Constable was to paint, in which he not only incorporated his own memories, but which were also prompted by the associations they had for old acquaintances. In addition to *Helmingham*, his *Glebe Farm* was probably begun in 1825–6 as a memorial to Dr Fisher who had died in 1825 (see Plate 202 for another version); his *Dedham Vale* (Plate 176) of 1828 has reminders of his early beginnings, and reiterates his debt to Sir George Beaumont, who had died in 1827. Beaumont was to be further commemorated in the *Cenotaph at Coleorton* (Plate 223) of 1836. Constable's *Hadleigh Castle* (Plate 179), is, in effect, a memorial to himself, as a ruin; while *Salisbury Cathedral from the Meadows* (Plate 188) is a hymn to the Fisher family, but after Fisher's death in 1832, there are other works that can be connected with his friends. Constable's art, by 1825, had moved on from the direct symbolism of his detailed drawing of the fallen tree, made after his father's death. As he worked on Helmingham again extensively in 1833, and its present appearance is so much in his style of the 1830s, it is best considered with the other version of *Helmingham Dell* (Plate 196), painted in 1830. In his journal for 1 October 1825, he talked of his 'dead horses' that he must finish to earn money: two versions of *Salisbury Cathedral* (one, for Mrs Mirehouse, to be altered); 'Mr Ripley's picture', (a view of *Hampstead Heath*, possibly hanging over since 1822); 'three for Arrowsmith' (before the break); and 'Mr Carpenter's picture', which may be the first intimation of the horizontal version of *The Lock*, dated 1826, for James Carpenter and eventually finished in 1829.

Over a Christmas visit to his family at Brighton he worked on the largest of the versions of *Parhams' Mill* (Plate 148) for Mrs Hand. While he worked his wife read to him Poussin's letters, where he was gratified to learn that the letters were, in part, 'apologies to friends for not doing their pictures sooner'. He also produced a wintry beach sketch on 1 January, in the Tate Gallery, his only known winter sketch done on the spot. He complained to Fisher on 14 January 1826 that his 'large picture is at a stand — owing in some measure to the ruined state of my finances'. He was probably referring to his large *Waterloo*, which he had been 'getting on the real canvas' with Johnny Dunthorne on 31 October. He had, meanwhile, £400 worth of commissions in hand, on which he was obliged to work. One was a portrait of Henry Edgeworth Bicknell. He was still thinking of working on his *Waterloo* in January, when he showed it to Sir Thomas Lawrence: 'I never saw him admire anything of mine so much.'[29] He also admired the portrait of his father-in-law (*c.* 1820–3). This was gratifying to Constable who knew that Lawrence generally did not like his work, but any hopes that he might now succeed at the Academy were dashed when he failed disastrously in February for both vacancies caused by the death of his friends, William Owen and Fuseli. He received two votes and one, respectively, for

each place against the successful candidates, C.R. Leslie and Pickersgill. Was there to be no hope? He buried himself in work on a new subject for the Royal Academy exhibition, *The Cornfield* (Plate 169), which he had finished by 8 April, as he described in a letter to Fisher:

> I have dispatched a large landscape to the Academy — upright, the size of my Lock but a subject of a very different nature — inland — cornfields — a close lane, kind of thing — but it is not neglected in any part. The trees are more than usually studied and the extremities well defined — as well as their species — they are shaken by a pleasant and healthful breeze — '*at noon*' — 'while now a fresher gale, sweeping with shadowy gust the feilds of corn' &c &c. I am not without my anxieties — but they are not such as I have too often really deserved . . . they are not sins of omission.

This time he hoped to sell it, as it had 'certainly got a little more eye-salve than I usually condescend to give to them'. So hard had he concentrated on this work, begun so late, that he admitted to Fisher that it had occupied him wholly: 'I could think of and speak to no one — I was like a friend of mine in the battle of Waterloo. He said he dared not turn his head to the right or left, but always kept it straight forward, thinking of himself alone.' His feelings are very understandable. As he had remarked, he had worked hard at extra-finish, with his refined touches emerging elegantly from the warm buff ground particularly noticeable in the banks at left and right, and he had not stinted on accuracy of detail, especially in the flowers and trees. Leslie quotes a letter from Henry Phillips, his botanist friend, date 1 March, with advice for his picture: 'I think it is July in your green lane. At this season all the tall grasses are in flower, bogrush, bullrush, teasel. The white bindweed now hangs 'its flowers over the branches of the hedge, the wild carrot and hemlock flower in banks of hedges, cow parsley, water plantain &c.'

From his list a number of his suggestions, for example, cow parsley, plantain, butterburr, mallow, bramble and poppies, are recognizable in the finished picture, with distinct touches of red, blue, and pink in the hedgerows. Constable had made use, too, of his own previous observation for other details, the plough in the centre from an oil sketch in the Victoria and Albert (R. 136), the donkey and foal, Victoria and Albert (R. 287), and the dead tree at the left appears in the painting at Toronto (Plate 17).[30] The prominent motif of the boy drinking can be found in an early oil sketch (Plate 56), which may well represent the same lane from further round to the right. No other pencil or oil sketches are known except the half-size oil sketch (Plate 171), which omits the figures and animals. From its loose technique, particularly in the sky, it may have been painted as a preliminary exercise, immediately before his finished picture.

Constable saw his picture as a pendant to his *Lock* of 1824, regardless of the fact that that had already been sold. *The Cornfield* was upright, and not quite his six-foot size. Its proportions and main lines of composition are similar. The tree in the distance in dead centre matches the position of Dedham Church tower in the *Lock*, but, although the construction of the painting is not so obvious, the design of

171. *Study for The Cornfield. c.* 1826. Oil on canvas, 59.7 × 49.2 cm. London, private collection

diagonals below the horizon line, which is placed identically in both pictures, reverts to his earlier methods of a criss-cross diagonal. There is also his tendency to expand real space at the left and right. *The Lock*, however, was a river Stour scene. *The Cornfield* was of 'a very different nature' — an 'inland' view of the area away from the river towards East Bergholt. For his point of view he has reverted to an overall high position, which gives a gentler effect than the low, dramatic viewpoint of *The Lock*. The lane was, in fact, identified by Charles Golding Constable, as the one that Constable travelled down daily to school, called Fen Lane, on his way to Dedham. It has such a bend turning to the right, there is still a sloping field with its entrance looking over the river meadows, and there is a trace of the ditch at the left, as Attfield Brooks has pointed out. No church, however, can be seen as a focal point and Constable's son drew attention to the fact that 'it is one of the rare instances where my father availed himself of the painter's license to improve the composition'. Not so rare as Charles Constable claimed. Attfield Brooks has identified the church, plausibly, as that at Higham, some way upstream, beyond Stratford St Mary, and it is not the only instance of Constable moving topographical detail (see detail, Plate 170).

The scene, then, is a general reminiscence of an area equally beloved of Constable, but 'improved' by him. When he exhibited it first at the Royal Academy he called it only *Landscape*, but as it did not sell, he showed it again at the British Institution the following year, entitling it *Landscape, Noon*, with the full quotation from Thomson's *Seasons*, which he had half remembered in his letter to Fisher:

A fresher gale
Begins to wave the wood, and stir the stream,
Sweeping with shadowy gust the fields of corn

The lines are from *Summer* (1654–6), from a passage actually describing evening, and they draw attention, by literary overtones, to the 'freshness' and breeziness that was an attractive feature of his Hampstead Heath scenes. For all his apparent accuracy of detail, however, there are some anomalous details (Plate 170, detail). The sheep, who would surely have been shorn by July, are disastrously close to wandering into the cornfield, if the dog and boy do not soon remember their duties. The field itself is without a proper hinged gate, which hangs broken and open. There is a remarkably reduced work-force, to cut a field of wheat in 1825, one of whom is already going home at noon. Where is Sam Strowger's 'Lord' of the harvesting team? Constable seems to have forgotten his earlier beliefs in convincing realistic figures.

There does not seem, however, to be any moral lesson to be drawn from these details. The broken gate, the aimless sheep, the drinking boy were not put there as symbols of neglectful duty, as the Pre-Raphaelite Holman Hunt was so earnestly to paint in his cornfield picture, *The Hireling Shepherd* of 1851. It, too, is about summer, but in it we are not allowed to forget the insistent moral of the neglectful shepherd as a symbol of the parson who neglects his flock. While we know Constable had

opinions about these matters, which he aired in his correspondence to Fisher, the figures in his *Cornfield* are not straining after a moral. They are there as gentle reminders of a pleasant rural life, observed lovingly, even if not too realistically. His moral feeling comes from the moral 'feel' for nature itself. There are resonances, too, of the landscape art and artists he admired from the past. Graham Reynolds has drawn attention to Constable's debt to Gaspard Dughet with the motif of the flock of sheep moving in and out of shadow, as in Gaspard's *Landscape near Albano*, which he could have seen at the British Institution in 1822. The sheep in Constable's picture are moving away from the spectator down a Gaspard-esque rutted lane, but equally have as much of Gainsborough's pastoral feel, with his innumerable inventions of sheep in curving lanes. There are also Claudian overtones in the subject and in Constable's depiction of the balanced masses of trees with light and space beyond.

Constable's increasing interest in 'pastoral' scenes has culminated in a definite attempt to please the public. It is a summer scene, sunny, blond and changeable, but with not quite the bright high-key sunlight of his early sketch. Its dappled shadows are achieved as much by tone as by colour. His 'eye-salve' has taken the form of an acceptable subject, a modern equivalent of a musical or painterly *pastorale*, rendered with calm and careful, less 'ferocious' handling. He had previously foreseen that his 'pictures will never be popular for they have no handling. But I do not see handling in nature.' On this occasion, at least, his eyes were open to the possibilities of a greater finish. He has also slightly compromised his desire to be true to nature, even if not in its essence, and has let slip his earlier resolve that he did 'not enter into that notion of varying one's plans to keep the publick in good humour'.[31] Perhaps the conversations of Sir George Beaumont, and the visit of Sir Thomas Lawrence had temporarily persuaded him 'to start some new admirers', as he had sworn to Fisher he would not do. Certainly his bitter comments to Fisher about the necessity for 'eye-salve' show that his recent failure in the Academy's elections still smarted.[32] If his aim was popular success, and he had driven his nail home more gently in this instance, then again he was disappointed. 'The voice in my favour is universal — " 'tis my best picture",' he told Fisher, but his work did not sell, even in Paris, when it was exhibited at the Salon of 1827, and its success was only to come posthumously. A body of subscribers, in 1837 immediately after his death, including Beechey and Wordsworth, paid the large sum of 300 guineas, for it to become his first painting in the National Gallery. It was chosen over his late *Salisbury Cathedral from the Meadows* (Plate 188), because, according to Leslie, that picture's 'boldness of execution rendered it less likely to address itself to the general taste'. Ironically, with the loan of *Salisbury* to the National Gallery they both now hang side by side. *The Cornfield* remains today, however, everyone's idea of the ideal English countryside, and is accessible in exactly the way Constable hoped it might be through countless reproductions. As Kenneth Clark pointed out, when an Englishman describes 'beauty', he tends to start describing a landscape.

Chapter 7

'I shall never feel again as I have felt, the face of the world is totally changed to me'

Constable's major works of the next three years, *The Chain Pier, Brighton*, 1827, *Dedham Vale* of 1828, and his *Hadleigh Castle* of 1829, for all their apparent naturalism, are inward looking and have a lack of calmness, which may, partly, be attributed to the increasing gloom of his own personal circumstances. His work is also nostalgic, which took the form of his reworking old themes, such as further versions of *The Lock, The Mill at Gillingham, The Dell at Helmingham, The Glebe Farm, The Valley Farm*, as well as further variants of Hampstead Heath scenes. He had, it is true, orders to fulfil and money to make. His financial position was never sound, until it was almost too late to make any difference. That his pictures were expressions of a deep personal involvement had been obvious almost from the beginning, but the continuing lack of professional honours, and public misunderstanding of his art certainly brought frustration. He could only view the worldly success of such rivals as William Collins with cynicism. It is not surprising, therefore, that to the increasing complications of his art is coupled a defiant need to be didactic, to justify his isolated position.

It is, nevertheless, patronizing to the rich development of his painting, to which he had stubbornly devoted so much of his energies, '20 years of hard uphill work' if his personal affairs are seen as the overriding factor in his development, and it is demeaning to his deeply pictorial art to interpret his last works solely in terms of his personal distress.[1]

After sending off his *Cornfield* to the Royal Academy in April 1826, he had to rush to East Bergholt for the sudden illness of his brother Abram who, fortunately, recovered. For his own family's health he was forced to take lodgings again in Hampstead at Langham Place, Downshire Hill. He had to send John Charles to Brighton to recover, but the family remained in Hampstead. Maria was pregnant again, and 'very far from well'. His sixth child Alfred Abram was born prematurely on 14 November 1826: 'I am now satisfied and think my quiver full enough,' he wrote to Fisher on 28 November 1826. He began looking for a permanent home in Hampstead and was thinking of letting part of Charlotte St, to help towards the expenses of his two households. He rationalized his situation to Fisher: 'I am three miles from door to door — can have a message in an hour — & I can get away from idle callers — and

above all see nature — & unite a town & country life.' He was to find such a house the following summer of 1827, at 6 Well Walk, Hampstead (see map, Plate 123), of which he took a lease in August 1827 at £52 per year. It was to become his permanent home and was to 'Maria's heart's content. Our little drawing room commands a view unequalled in Europe — from Westminster Abbey to Gravesend — The *dome* of *St Paul's* in the air.' Jack Bannister was his neighbour, 'very sensible, *natural*, and a gentleman'. Maria had in fact only a year left to live there and Constable's plans in search of health for his family had been ruinous. He had managed to let part of Charlotte Street at £82, 'and kept 2 parlors, large front attic painting rooms kitchen &c.' He was forced to ask Fisher for a loan of £100, but Fisher was also going through a difficult period and was unable to help him.

During the autumn of 1826 he was at work on a *Glebe Farm* (see Plate 202, for a later version) and Carpenter's horizontal *Lock* (see Plates 182, 183). The *Glebe Farm*, probably that version in Detroit, he sent, unusually for its first showing, to the British Institution, to which he also sent Mrs Hand's *Mill at Gillingham* (Plate 148). We know less about his activities during the winter of 1826–7, in the absence of letters to and from Fisher, but he must have been working on his exhibit for the Royal Academy. He had remembered Fisher's advice about mutton for every course and his exhibit was a new subject, a six-foot view of *The Marine Parade and Chain Pier, Brighton* (Plate 172). For this he has used a carefully finished pen and pencil study of the pier and beach in the Victoria and Albert (R. 289), which he has extended in the finished picture. Changes consequent on a lengthening of the pier and painting out a sail are still visible in the finished work at the right. In addition, there are detailed drawings of fishing implements, of *c.* 1824, which appear in the foreground (Victoria and Albert, R. 273), and there are drawings, and oil studies of boats, and a section of the beach with a boat approaching the shore, which also occur in the finished picture.[2] In one of them there is a 'preventative service man', or excise officer, whom he had mentioned in his letter to Fisher of August 1824 and who can be seen in his blue jacket in the centre of the scene.

In the use of small sketches, and details of paraphernalia, he was obviously following his normal procedure for his six-

172. *The Marine Parade and Chain Pier, Brighton*, 1827. Oil on canvas, 127 × 184.8 cm. London, Tate Gallery

173. *A Stormy Coast Scene at Brighton*. 1828. Oil on canvas, 14.5 × 25.5 cm. New Haven, Yale Center for British Art, Paul Mellon Collection

footers. *The Chain Pier* also has a similarity in one other respect, and that is its construction, in the use of crossing diagonals beneath the horizon line, to give the picture its inherent structure. The line of the anchor in the left foreground projects a line to the right, while the line of the beach projects another to the left. The horizon line, however, and his point of view are lower than in his Suffolk scenes and there is, consequently, a greater interest in the breakers and the sky, which as he had said in 1824 'have been lovely indeed and always varying'. He seems conveniently to have forgotten his dislike of the place in creating such a work and painting these 'hackneyed views', as he had called them. Fisher called it 'a useful change of subject' and it was, no doubt, another conscious attempt to win new admirers.[3] When he later chose another Brighton beach scene to be engraved by Lucas in 1830 (S. 17), his description for the public of *c.* 1834, contradicted in every way what he had previously said privately to Fisher ten years before, so much so that it has the air of an advertisement from the town's Tourist Bureau: 'Of Brighton and its Neighbourhood, now so well known, it is enough to say that there is, perhaps no spot in Europe where so many circumstances conducive to health and enjoyment are to be found combined ... the largest, most splendid, and gayest places in the kingdom.'

At least he puts forward as his prime attraction what he had also previously acknowledged, the exhilarating effect of the sea and the sky. Constable, in his large *Chain Pier*, seems to be attempting to transfer the 'matter' and liveliness of his Stour scenes into an image of 'the busy haunts of fishermen', or 'the bustle and animation of the port or harbour', to use his own words from 1834. Fisher, when he saw it in April, wrote to his wife that 'it is most beautifully executed & in a greater state of finish and forwardness, than you can ever before recollect. Turner, Callcott and Collins will not like it.' He was naming those principal members of the Royal Academy who had also painted similar beach scenes, as well as condemning those hordes of lesser marine artists, whom Constable had felt had been drawn away from the 'pastoral feel', as he too, in fact, had been tempted.

His painting, however, received, on the whole, a bad press. *The Morning Post* thought 'the colouring of this picture is, to our eye, singularly defective; one would say that there were *streaks of ink* dashed across it'. His *Brighton*, Constable wrote to Fisher 'was admired "on the walls"', and he had 'a few nibbles out of doors', while 'a man or rank' wanted to know its '*selling*' price. 'Is not this too bad?' he asked Fisher on 26 August 1827. It did not sell, either at next year's British Institution, or when it was engraved in 1829 by Frederick Smith, the first of Constable's large works to appear as a print (other than Reynolds' unfinished engraving of *The Lock*). Smith's print reveals, incidentally, that at some later date Constable's picture has been cut down at the left, much to its detriment, as the surviving fisherman was offset by further figures and a large sail. Even Fisher, writing in December 1828, asked him 'to mellow its ferocious beauties. Calm your own mind and your sea at the same time, & let in sunshine & serenity.' But Fisher was also trying to help Constable's state of mind after the death of Maria. Constable's other exhibit at the Royal Academy of 1827 was a vertical version of Parham's Mill, seen from a

slightly different angle, a subject which had become by now an obsession. It is probably that painting now in the Victoria and Albert (R. 288).

Sometime during the summer of 1827 Constable's inclination to gossip got him into trouble with Linnell and Collins again.[4] The subject of his remarks was William Collins whose sentimental work Constable thought would 'never do as Landscape painting ... far too pretty to be natural'. The story, which was going the rounds and which had appeared in the press was retailed to Linnell by Constable as they travelled down to the city on the Hampstead coach. It related to the exorbitant price Collins was supposed to have received for a commission from Sir Robert Peel for his painting *A Frost Scene* (Plate 174) then at the Royal Academy of 1827. *The Standard* had said he demanded £200 more than Peel's original price of 500 guineas. Unfortunately, and Constable should have known better, Linnell and Collins were friends. Linnell promptly descended from the coach and told Collins. Mulready investigated and Collins was pleased to answer his detractors publicly that Sir Robert Peel was perfectly satisfied with the transaction, and that no such price (700 guineas) had ever been demanded. Collins had received 500 guineas which was more than Constable ever obtained and he must have been jealous. It was, in fact, the highest price that Collins ever received although he regularly earned 200–400 guineas for his landscapes. Collins, after all, had had a more rapid professional success than Constable and had defeated him for election as an RA in 1820. Since then he had also put on airs, which Constable disliked. When Constable was finally elected in 1829, Collins is supposed to have said it would reduce the value of his diploma by fifty per cent. A year later, Constable wrote to Collins's brother-in-law William Carpenter: 'I despise no man but Collins the RA.'

The differences between Collins's popularity and Constable's struggles can be seen in a comparison with his *Frost Scene* (Plate 174), and Constable's unsuccessful exhibit at the same Royal Academy exhibition of 1827, his *Chain Pier, Brighton* (Plate 172). Collins's patrons included George IV and the highest ranks of nobility, including the Marquis of Stafford, the Duke of Newcastle, the Earl of Liverpool, Sir John Leicester, the Earl of Essex, and Sir George Beaumont. They also comprised the bankers Hoare and Baring, as well as the newer class of patron, such as James Morrison, who had bought his *Fisherman's Departure* in 1826 for 350 guineas, and to whom Constable had been pleased to sell his *Lock* for 150 guineas, including the frame. Mrs Hand, who had ordered *Parham's Mill* from Constable owned at least eight pictures by Collins, and even Jesse Watts Russell, Constable's relative, paid 200 guineas for *Morning on the Coast of Kent* in 1821, the year after Collins's election as an RA, which must have particularly irked Constable. Collins's *Frost Scene* had all those elements of 'eye-salve' which Constable's exhibit did not have. The *Frost Scene* has a rich sunset on a cold day, 'heightened by rich flashes of red', as it was described by Wilkie Collins, and it is full of anecdotal incident, such as the encounter between the publican with his mobile bar, and the pretty rider wrapped in her cloak on the horse; the boys falling over on the ice and the children gazing longingly at the hot apples, which could be

174. William Collins, RA (1788–1847). *A Frost Scene.* 1827. Oil on canvas, 84 × 109 cm. New Haven, Yale Center for British Art, Paul Mellon Collection

easily appreciated by the spectator and commented on, as Wilkie Collins does in his *Memoir* of his father. It has a series of carefully observed isolated details, and posed studio figures, which give little points of emphasis in the composition, but which are not seen in an overall atmospheric manner, for example the main figures of the man and woman on the 'pillion' saddle, the gaping children, the careful still life of the apples on the brazier, and the baskets and ice skates in the foreground. Constable's figures, on the other hand, are naturalistic but neutral. They go about their business on the beach with no tale to tell, other than the commerce of the sea and the sky. Collins's sky is lurid and richly painted to give a warm juxtaposition to his cold scene.

It is, above all, in his handling that the telling differences occur. His transitions are smooth, his details carefully drawn, so much so that even Wilkie Collins was moved to remark that 'though a picture of large dimensions it presented throughout an appearance of elaborate, and in some places of almost excessive finish'. Constable's picture is 'ferocious' and rough in comparison. Collins appealed to just that feel for highly-wrought Dutch genre painting that had brought equal success to Wilkie, from the same patrons such as Sir Robert Peel, who owned a famous collection of Dutch old masters. Constable's debt to Dutch art was, as we have seen, more elemental and less concerned with anecdotalism and sentimental details. These two works, exhibited together in 1827, give a case history of two divergent approaches to naturalism in the 1820s, of which Constable's was clearly the less successful but which he would not change.[5]

After this episode Linnell and Constable, nevertheless, remained friendly, even though Linnell was a Baptist and Constable tended to dislike all Dissenters, while Linnell and

Collins became cooler. Constable was on better terms with Collins's more humble brother Frank, a picture restorer, and his old mother. When, however, Leslie was writing Constable's *Life*, Collins did have kindly and objective things to say about Constable's originality.

In October 1827, against the advice of his brother, Abram, who thought the mills and locks would be too dangerous, Constable took his two eldest children, John Charles and Minna, to Flatford. This was their first visit to Constable's old haunts, which he had only visited briefly during the 1820s. The holiday was a success and Constable's letters to Maria proudly report that Minna who had been travel sick, thought Suffolk very like Hampstead. He wrote on 4 October, 'When we arrived at Stratford Bridge I told her we were in Suffolk — she "O, no, this is only feilds."' She must have heard so much about it as a sort of special Paradise. John was 'crazy about fishing — he caught 6 yesterday & 10 today'. His mother, ever anxious for their health, particularly John Charles's, the eldest, who had been ill, replied the next day, 'Do not let John fish too long at once for fear of cold.' The father and his two children slept together at Flatford Mill, and Constable rushed around visiting old friends and noting changes and new inhabitants in the village. He seems to have had to sublet Downshire Hill for tenants, and thought that Well Walk was superior to the houses now inhabited by his brothers and sisters in East Bergholt 'for comfort and convenience'. He filled a sketch-book of numbered drawings on a fairly large scale, approximately $8\frac{1}{2} \times 13$ inches, of exactly the sort of scenes he always drew. There are barges, in one of which John Charles and Minna are fishing, the lock at Flatford, willow trees along the river, and even a scene from an almost identical viewpoint as his *View on the Stour near Dedham* (Plate 145). Ian Fleming-

175. *Men Loading a Barge on the Stour*. 1827. Pencil, pen and grey wash, 22.5 × 33 cm. London, Victoria and Albert Museum. Inscribed: 'Silvery Clouds/Bright/Blue'.

Williams has suggested that while the children fished, he kept an eye on them, and sketched (Plate 175). His drawings have a feathery, open appearance, particularly in the loose handling of the washes for the trees, which is reminiscent, again, of Claude, and less detailed than his earlier drawings from nature of 1813–14 or even his drawings of the lock at Newbury of 1821, or his Salisbury drawings of 1820.[6] As Fisher could always judge Constable's peace of mind by the state of his handwriting, then these drawings have an air of impatient but loving regard for the scenes he knew so well. There is a disturbing dichotomy between careful observation of some details and a rapid agitated disregard for the background trees. Little points of light and dark are accentuated which give a windy, volatile appearance, and increase the effect of the chiaroscuro. They are 'snapshots' from a holiday he felt guilty at taking.

When he returned, he found himself once more involved in those distractions which he felt obliged to honour, but which always made him impatient to get back to his 'easil' — 'a cure for all ills'. Since 1818, when he had been elected a Director, he had been constantly involved in the affairs of The Artists' General Benevolent Institution (AGBI). He was always concerned with charitable activities, for those who had fallen on hard times through their life in 'the art'. He had a number of 'lame ducks' (in the English sense!) under his wing, and in this

respect he can be compared with Turner. He also had a personal regard for the family's old servants in East Bergholt, to whom he was constantly sending money and presents. He could, however, have extreme reactions to those 'Mechanicks' who responded violently to their downtrodden position.[7]

That November Constable had to sit as chairman for the AGBI, but he may have wondered whether he was himself a deserving case. To his relief, Fisher brought £30 at the beginning of December, which was all he could muster, having had to pay off a debt of £1500 during the last year. Then there is silence between the two men for more than six months, and when their correspondence was resumed Constable's circumstances were very different.

On 2 January 1828, his seventh child, Lionel Bicknell, was born. Maria was exhausted, the nursing tired her, and she was slow to recover. He sent his *Chain Pier, Brighton* to the British Institution without success. He began the dreaded, but necessary, canvassing of members for the forthcoming election at the Royal Academy caused by the death of Flaxman. His rival, unfortunately, was Etty, a former pupil of Lawrence's, whose fleshy nudes could pass as 'high art' as long as their subject was ostensibly classical. Constable was 'pounced upon' by Mr Shee, 'Mr Phillips likewise caught me by the other ear.' He faced Turner on his doorstep, Chantrey, as always, was equivocal, but respected his 'honourable

176. *Dedham Vale*. 1828. Oil on canvas, 14.1 × 121.9 cm. Edinburgh, National Gallery of Scotland

character'. Others flatly refused to see him. He hoped, through Leslie, to gain some support, but in the end Etty was elected by eighteen votes to five. As some mitigation for his disappointment, Constable unexpectedly found himself better off by the death of Maria's father, Charles Bicknell, aged 75. He was found to have been richer than anyone expected, and although the settlement of the estate took some time he had the promise in the will of nearly £20,000 for his family. From now on he could paint independently of worry over his income. 'It will make me happy,' he wrote to Fisher finally on 11 June 1828, 'and I shall stand before a 6-foot canvas with a mind at ease. (Thank God).'

His picture for the Academy of 1828, *Dedham Vale* (Plate 176), can be seen, on the one hand, as a defiant gesture to the Academy to remind them of what he had always stood for, and, on the other hand, as an act of homage to Sir George Beaumont, who had died the year before. The scene is one that he had painted right at the beginning of his career, looking down the Stour Valley from Gun Hill, Langham to the estuary of the River Stour (see Plates 32, 33 and 42), but a comparison with these early works, shows how far his art had progressed since his initial strivings to be a 'natural' painter.

His finished picture, exhibited with the simple title *Landscape*, is large but not quite his six-foot size, being as large as his upright *Lock*. His trip to Flatford the previous autumn may have been part of his original inspiration, and this time he needed no preliminary sketches. He had his own painted sketches from 1802 and *c*. 1805 before him, and there were also pencil drawings. They all provided inspiration. The topographical details are in this work extremely accurate, even including the white building of Mistley Church, which can be clearly recognized in the distance at the right, as Attfield Brooks has pointed out. To them he has added the wealth of his mature style. Essentially, he is now drawing from within himself. The distant clouds and shadowy hills are reminders of his views of Hampstead Heath; the watering cattle by the river and that at the right are short-hand symbols from his own repertoire of staffage. Dedham Church Tower is his constant talisman, and is placed nearly at the centre. His trees and foreground detail are marvels of his tenacity in realistic observation, and are painted with his increasing freedom of manner, by knife and touch, as much as by brush. His construction of space is also typical of his own previous procedures. The viewpoint is higher than in the *Lock*, but the horizon line divides the canvas in the same proportions. Underneath it are the two crossed diagonals, by now not unexpected, one leading from the roots of the tree at the right by means of deeply glazed shadow to the distant hills at the left, the other beginning with a touch of red at the bottom left, and progressing across the slope of the hill to the cottage on its brow. But, again, as in his previous major works, his basic rigorousness of design is offset by a spaciousness of depth, achieved with a vibrancy of touch and a variation of his greens, and an intricacy of curves on the picture plane, such as the trees, which keep the surface, with its skeins of paint, and our interest, alive. His painting is homage enough to his own development.

There are, however, conscious references to other art as indeed there had been in 1802, when he was supposedly running too much after pictures. The obvious debt is still to Claude, and in this powerful work he makes a modern reinterpretation of Claude's 'pastoral' feel, as he had in 1802, and as he had with his *Lock* of 1824. The trees alone are reminders of what he had learnt from Claude, through the kindness of his first patron Sir George Beaumont. But in making this homage to Sir George, whose Claude of *Hagar and the Angel* (Plate 34) — so influential for its composition — had just entered the National Gallery, Constable is, possibly, also remembering his first sight of Rubens's *Chateau de Steen*, also in the Beaumont collection and subsequently bequeathed to the Gallery. The tangled undergrowth and depth of the thickets, its enlarged vision which stretches to a distant horizon, and even, perhaps, its subject of Rubens' castle and territory, show Constable's debt to Rubens. In his *Dedham Vale*, modestly entitled *Landscape*, Constable is making a claim for a modern landscapist to be considered equally with Claude and Rubens, with a picture that included all his experience and depicted his own home and countryside. In taking on a confrontation with the art of the past, he is finally daring to move into the same league as Turner, for whom such confrontations had been part of his ambitious achievement. Michael Rosenthal has suggested that Constable's painting could be seen as a belated answer to Turner's *Crossing the Brook* of 1815, which also echoes Claude's *Hagar and the Angel*. As Turner had done much earlier, Constable deliberately included the picturesque detail of gypsies in the foreground, whose smoke from their fire wafts a romantic air, which he would not have allowed himself a year before. This was his answer, 'perhaps my best' to Lawrence's demand for subject and a rebuke for those who voted for Etty.

His other picture at the Royal Academy was a Hampstead Heath scene showing Branch Hill Pond (Plate 166), which Chantry appeared to want but which by 1832 had still not been taken. This version, in the Victoria and Albert, is a variant of his popular Hampstead Heath views, with a high bank at the right, 'heavy clouds passing', and an 'Essex market cart', as has been described previously (pp. 172–3). Constable clearly felt he had made a good showing after his lack of success in the elections. His laconic comments on his rivals to Fisher in his letter of 11 June give a good idea of where he stood in relation to his peers.

> The Exhibition is poor . . . Lawrence has many pictures and never has his elegant affetuoso style been more happy. There is a grand but murky dream by Danby . . . Turner has some golden visions — glorious and beautifull, but they are only visions — yet still they are art — & one could live with *such* pictures in the house . . . Etty has a revel rout of Satyrs and lady bums as usual, very clear & sweetly scented with otter [*sic*] of roses — bought by an old Marquis (Ld. Stafford) — coveted by the King (from description), but too late. . . . Some portraits that would petrify you . . . atrocious.[8]

Constable's letter, however, also contained bad news: 'My wife is sadly ill at Brighton — so is my dear dear Alfred . . . Hampstead — sweet Hampstead that cost me so much is

deserted.' Fisher replied with words of comfort, but Maria's pulmonary tuberculosis was now entering its last galloping phase. Constable tried to persuade himself that she was recovering, and he went to Brighton on 30 May. There is a short pathetic note from Maria, of about this time, longing to see her husband, and sadly parting with Minna. He was there again, probably between 20 and 25 July, and a dramatic oil sketch (Plate 173), was painted on 20 July (according to an old label). It is an evening scene, painted almost entirely with strokes of the palette knife, and its ominous, lowering quality may have had something to do with his wife's health, which was deteriorating so rapidly that she had to be brought back to Hampstead. At the end of August he wrote to Dunthorne, 'she is sadly thin and weak', and on 15 September he wrote to Dominic Colnaghi: 'I am greatly unhappy at my dear wife's illness. Her progress towards amendment is sadly slow, but still they tell me she does mend; pray God that this may be the case!!' Fisher could not visit, but exhorted him, on 4 October, to 'support yourself with your usual manliness'. Constable did find time, in the midst of his distractions, to send a version of his *Parham's Mill* to an exhibition at Birmingham. It was probably that now at Yale, then belonging to Mrs Hand (Plate 148). Leslie recounts a month later: 'I was at Hampstead a few days before she breathed her last. She was then on a sofa in their cheerful parlour, and although Constable appeared in his usual spirits in her presence, yet before I left the house, he took me into another room, wrung my hand, and burst into tears, without speaking.' Hebbert wrote at this time complaining about pictures, to which Constable replied: 'I am intensely distressed & can hardly attend to anything.' Maria died on 23 November 1828. Although Constable habitually wore dark clothes, from this time on according to Leslie, he never ceased to wear mourning.

Her death was a severe blow from which Constable never recovered. In spite of the letters of condolence, which came from every quarter, and including advice from Fisher: 'Set about something to show the world what a man you are, & how little your powers can be depressed by outer circumstances', Constable felt that 'I shall never feel again as I have felt — the face of the World is totally changed to me, though with God's help I shal endeavour to do my next duties.'[9]

Constable was worried at the prospect of looking after his seven children, and, because of their friendship and proximity, he turned to C.R. Leslie more and more to unburden himself with his sad thoughts

of her who is now an angel in heaven. . . . I have been ill, but I have endeavoured to get to work again — and could I get afloat on a canvas of six feet, I might have the chance of being carried away from myself. I have just received a commission to paint a '*Mermaid*' for a 'sign' on an inn in Warwickshire. This is encouraging — and affords no small solace to my previous labours at landscape for the last twenty years — however I shall not quarrel with the lady — now — she may help to educate my children.

This sarcastic aside concerns a typically eccentric request from H.G. Lewis of Malvern Hall for the Mermaid Inn at Knowle, near Solihull. He was, of course, related to the Dysarts.

Constable, actually, did finish a drawing for the sign.

Fisher had hoped to stay with Constable at the beginning of January, but was delayed because his mother, whose sister had died, did not feel strong enough to have him and his boys until February. His arrival at Charterhouse, where his father, Dr Philip Fisher, the 'good' Bishop's brother, was still Master, coincided with an event that Constable would have hoped for earlier. After reluctantly 'running the gauntlet', and receiving the 'kicks' from ' "high minded" members who stickle for the "elevated & noble" walks of art — i.e. preferring the *shaggy posteriors of a Satyr* to the *moral feeling of landscape*',[10] Constable was persuaded by Leslie, to whom he wrote on 21 January, to stand again for the Royal Academy. The vacancy was caused by the death of his old friend, William Redmore Bigg.[11] On 10 February 1829, in the final ballot Constable defeated Francis Danby by one vote.

It was almost too late, as he complained to Leslie. 'It has been long delayed until I am solitary, and cannot impart it.' What should have been an occasion for joyous relief was spoilt by Lawrence's grudging remarks, according to Leslie, 'that he considered him particularly fortunate in being chosen an Academician at a time when there were historical painters of great merit on the list of candidates . . . Constable was well aware that the opinions of Sir Thomas were the fashionable ones; he felt the pain thus unconsciously inflicted.'[12] Leslie was obviously referring to Danby and what he stood for. Constable, however, after receiving the congratulations of fellow artists, was elated to report that Turner, with Jones, visited him and stayed until one in the morning, 'mutually pleased with one another'. Fisher wrote immediately on 11 February from Charterhouse, 'It is in the first place the triumph of real Art, over spurious Art; and in the second place of patient moral integrity over bare chicanery & misrepresented worth. . . . Turner's presence was a high compliment. The great landscape painter by it claimed you as a brother labourer.'

Fisher did not stay long in London, but already, Constable seems to have been engaged on his next major work, as a vindication for his election. In a kindly letter of congratulations from his brother of 13 February 1829, which passed on the Dunthornes' pleasure, Abram commented on 'the original manner in which you have endeavoured to represent your ideas & views of nature', and hoped Constable would 'now proceed with your picture of the Nore'.

He implies that Constable had already begun his picture, possibly even before Maria's death, and, as early as 1826, Constable was asking Fisher for the return of his 'Gravesend' sketchbook and 'shoar opposite Woolwich' which must be a reference to a book with sketches Constable had made in 1814, when he visited the Revd W.W. Driffield in Essex.[13] From this sketchbook of 'hasty memorandums', and his memory of the 'melancholy grandeur of a sea shore' (see p. 86), Constable selected a slight sketch for the basis of his major exhibit (Plate 177), now in the Victoria and Albert (R. 127). He must have been searching for a subject, as he had on the deaths of Dr Fisher (*The Glebe Farm*) and Sir George Beaumont (*Dedham Vale* and *The Cenotaph*), which would match his own mood.

Why Constable should have deliberately chosen *Hadleigh Castle* as his first major work after his election is a complicated

177. *Hadleigh Castle.* 1814. Pencil, 8.1 × 11.1 cm. London, Victoria and Albert Museum

Salisbury Cathedral, or *The Chain Pier, Brighton*, there was an underlying reason, because either of a commission from a third party, or he was deliberately courting popularity. Hadleigh Castle, on the north bank of the Thames estuary, was certainly not in 'Constable country'. The two towers were all that remained of a castle, built by Edward III in the 1360s on an earlier site, after a landslide in the sixteenth century had tipped most of the building into the sea. It had no obvious connections with Constable's life, other than that he had visited it in 1814 (see p. 86), when he had been impressed by its melancholy setting. In 1828 the largest of the two towers, which occupies the prominent position in his 1814 drawing, may have provided a parallel to his own circumstances. In a later comment to Lucas he mentions adding a 'Ruin' to his *Glebe Farm* 'for not to have a symbol in the book of myself would be missing the opportunity', but this may not refer to ruins other than Hadleigh Castle. The solitariness of the Gothic tower may have impressed him, but equally he would have remembered his friendship with W.W. Driffield who had baptized him, and made him a Christian when near death, and he could not fail to remember the particularly difficult period of his courtship of Maria during 1814. These factors may also have aroused strong memories.

question, which is not easily answered. For all his previous major works, he had chosen scenes that drove his own nail home, as regards his countryside and his original method of painting it. The *Dedham Vale* of 1828 can be seen as a mature summation of all his previous imagery. Even when he was painting large pictures of scenes away from home, such as

The 1814 drawing concentrated on one of the towers to the exclusion of everything else. From its brief notations came other works that show Constable moving away from its

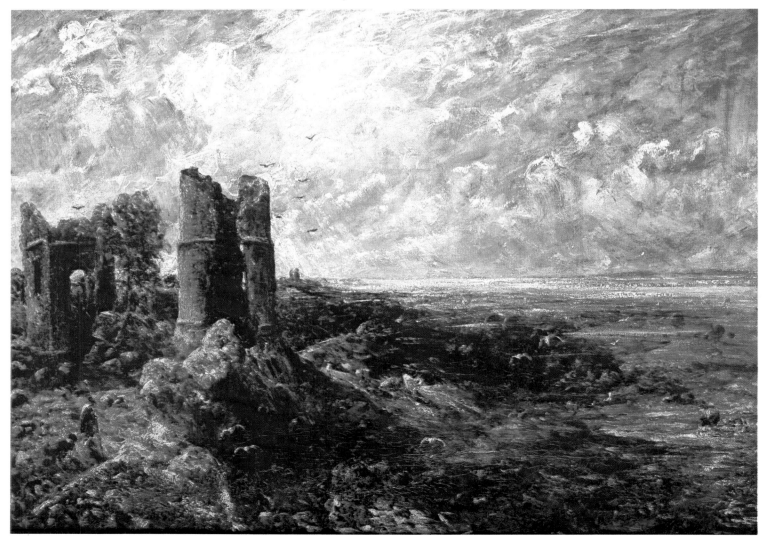

178. *Study for Hadleigh Castle.* 1828–9. Oil on canvas, 123.2 × 167 cm. London, Tate Gallery

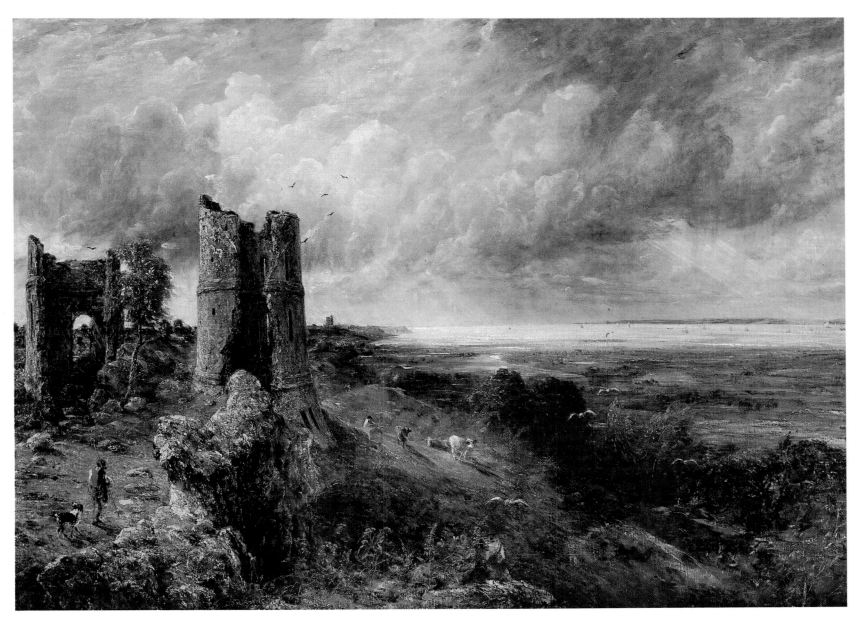

179. *Hadleigh Castle, The Mouth of the Thames — Morning after a Stormy Night.* 1829. Oil on canvas, 122 × 164.5 cm. New Haven, Yale Center for British Art, Paul Mellon Collection

solitary appearance to the rich imagery of the finished picture. Louis Hawes has shown that in this sequence an oil sketch belonging to Paul Mellon should also be included. It must have been painted some time during 1828–9, and was largely based on the 1814 drawing for the main elements of its design: for the fall of land to the water's edge, the rocky outcrop in front of the tower, the distant promontory of Shoeburyness, and the distant tower of St Clement's, Leigh-on-Sea, echoing that of Hadleigh.[14] The attribution to Constable of this small oil sketch has been doubted, probably because of its violent and hasty handling, but it fits in well with Constable's technique for his small initial compositional sketches. It includes extra details of a shepherd, obvious changes to the arrangement of the whirling birds, and, most important of all, an extension of the scene to the right. None of these creative alterations could be expected of a copyist, or a forger. Also they would not casually use something on which he had

already painted cattle on the back. The next stage seems to have been a pen drawing (ex. coll. A.M. Austin), which also further expands the composition to the right, and has additional details of the shepherd's dog, the tree growing between the two towers, and the rays of light from the sky, which is such a dramatic feature of the finished picture. He has moved, then, from a solitary ruin to a broader view of the landscape he had last seen fifteen years before. It now includes much more of the opposite shore looking towards Sheerness.

His large-scale sketch (Plate 178), at the Tate Gallery, takes the development a stage further. The composition is now much more open at the right. He has introduced some incidental detail in the middle ground, of cattle and figures, and a formation of gulls now soar out to sea. These additions all add to an increasingly complex sense of space, but the main axis of the design is still lopsided to the left, from bottom right in a diagonal to the towers. In its violent, monochromatic

handling the sketch follows on from his previous large-scale sketches, except that it is not quite a 'six-footer'. Before the finished picture was discovered, it was seen to embody all his so-called 'impressionistic' tendencies, but it now takes its place in the rhythm of his work as an exciting first rehearsal of the visual elements and is better described as 'expressionistic', rather than impressionistic. Its restless surface is full of the strokes and thrusts of his palette knife, with dabs of yellow ochre and red. Skeins of paint are drawn this way and that over a dark ground, especially where he suggests the fall of the land to the sea. The sky is a veritable battleground, as he converts into agitated impasto the source of light flooding down to the brightness of the horizon. The whole sketch is divided into an extreme contrast of light and dark.

In the finished picture (Plate 179) these experiments are made more coherent, and the overall effect is richer and warmer, but, as we shall see, his loose technique was once more an obstacle to its acceptance. The major difference, however, concerns the layers of personal emotion that the finished picture contains. When it was sent to the Academy, he gave it a more descriptive title than any of his previous works, with the exception of *The Summerland* (Plate 75) of 1814, where the quotation from Robert Bloomfield gave added point to a particular detail in the picture. What had previously been implicit was now made explicit. Constable called his 'Nore' *Hadleigh Castle, The Mouth of the Thames — Morning after a Stormy Night*, that is, he described the place, and time of day, but he also implied to his peers something about his personal survival after his own stormy night. To the lengthy title he also added a slightly misremembered quotation from his favourite poem, Thomson's *Seasons*, in this case *Summer*:

> The desert joys
> Wildly, through all his melancholy bounds
> Rude ruins glitter; and the briny deep,
> Seen from some pointed promontory's top,
> Far to the dim horizon's utmost verge,
> Restless, reflects a floating gleam.

This is obviously intended to set the atmospheric mood for the picture by lending it a respectable literary emotion, as Turner had done so often before. The quotation actually comes from a section in Thomson praising the sun, whose power and light are responsible for all earthly beauty and joy. Here his interest in the 'bolder phenomena of nature' cannot have been more clearly emphasized, with key words such as 'melancholy', 'glitter', 'restless', and 'reflects', adding to the effect.

But he was nervous at its reception. He wrote to Leslie on the 5 April 1829, from Well Walk:

> Since I saw you I have been quite shut up here. I have persevered on my picture of the Castle which I shall bring to Charlotte [Street] early tomorrow morning — Can you oblige me with a call to tell me whether I can or ought to send it to the [Pandemonium deleted] Exhibition — I am grievously nervous about it — as I am still smarting under my election. I have little enough of either self-knowledge or prudence — (as you know) and I am pretty willing to submit to what you shall decide — with others whom I

value . . . I am in the height of agony about my crazy old walls of the castle.

This is a sad letter for a fifty-three year old artist to write, who had just been elected to the Academy. His nervousness about his picture's reception may be the reason for the inclusion of elements of the 'historical sublime'. Perhaps he hoped that its ruin subject, and the added literary quotation, would enable it to be considered under the same aegis as the historical landscapes of Turner. It also has references to other ruin landscapes, which could be recognized by a common culture. Turner's diploma picture of *Dolbadern Castle* would have been known. But equally, in the context of historical justification, there would be the example of J.R. Cozens's *Ruin in the Campagna* (now at Bloomington, Indiana), and, more immediately, Sir George Beaumont's *Peel Castle in a Storm* of c. 1805 (Leicester Museum and Art Gallery), which had inspired those lines of Wordsworth about the death of his brother that Constable knew so well. He would have been further pleased if echoes of Wilson, Claude, and Ruisdael had been heard.

His picture, however, is not an antiquarian topographical work, neither is it 'all poetry', as he described Cozens. For the first time in his work he had included conventional elements of the sublime, perhaps partly to justify his new academic status. He achieved his sublime effects, however, by his own deeply personal technique. In spite of the layers of personal emotion, and the references to other art, his principal interest remained the natural effects and light and shade, emphasized as they are in the title and to which his expressive handling of paint contributed a major part. The structure follows to a certain extent his normal method for composition, with a high viewpoint and a diagonal that follows the line of the beach from bottom right to the left. There are, however, further complications to this basic plan. Each half, left to right, has two further diagonals, which give the effect of a perspective with three vanishing points. That at the right follows the line of the gulls out to sea and meets the horizon with the light accent of a sail. The line at the left follows the diagonal of the shepherd and his dog. This is confirmed by a diagram in a letter to Lucas of 26 December 1831 (Plate 180). *Hadleigh Castle*, in its breadth of scope and multiple viewpoints, looks back to his *Stour Valley and Dedham Church* (Plate 84) of 1814, but whereas that work was sunlit and peaceful, the effects of the stormy night are still obvious in *Hadleigh Castle* with its sharp accent of light and dark, and suggestion of a bird's eye view.[15]

The detail (Plate 181) reveals clearly enough his range of tones and variety of effect. The buff ground, in places, shows through the darker transparent glazes to give a rich, warm effect of space and depth. These transparent areas are contrasted with rougher impasto by which the distant cow, in its own area of light, the foliage near at hand, and the gulls are suggested. The tonal contrast is nicely adjusted according to the spatial effect required. This is what he was later to call 'chiaroscuro'. His variety of touch not only expresses the movement of light over the objects but also their relation in space. Furthermore, the myriad accents of pure primary colours, blue, yellow, pink, red and green, give luminosity and

said to me 'there goes all my dew'. He held in great respect Chantrey's judgement in most matters, but this did not prevent his carefully taking from the picture all that the great sculptor had done for it.

Leslie is more than kind to Chantrey, but Constable realized that his technique could become distracting and admitted to Fisher in May of the following year:

> I have filled my head with certain notions of *freshness* — *sparkle* — brightness — till it has influenced my practice in no small degree, & is in fact taking the place of truth so invidious is manner in all things — it is a species of self worship — which should always be combated — & we have nature (another word for moral feeling) always in our reach to do it with — if we have the resolution to look at her.

Notwithstanding this pious and optimistic reiteration of his basic tenets, there is an increasing use of a nervous surface flicker of white, often set against dark, even black accents, which some still find distracting in his late work. It is a problem with later ramifications, which will be considered in the next chapter. Nevertheless, in its spaciousness and its mastery of 'evanescent' effects, in its sense of the 'chiaroscuro of nature', as he was to call it, and deeply affecting personal subject matter, *Hadleigh Castle* was his most romantic work to date. It transcends the Sublime, and becomes Romantic, because not only are we impressed by the timelessness of these Gothic ruins rising dramatically above a restless sea, but also we are meant to feel a personal emotion, through his atmospheric exactitude, and thus are involved in his recent tragic loss. In the last resort the message we feel is optimistic and life enhancing; Nature provides renewed hope, and melancholy is cast away, with the rising sun in the east and its light bursting through the clouds to silhouette his 'crazy old walls' and to illuminate the ships on the distant sea. In its atmospheric expression of personal emotion, it is in strong contrast to the earnest literalism of J.C.C. Dahl's contemporary *Morning after a Stormy Night* at Munich.

As with so many of his major works, *Hadleigh Castle* remained unsold, despite favourable notices in the press. He had, meanwhile, become involved in further ventures, which were partly the result of his new status. The most immediate was the necessity of presenting a Diploma work to the Academy, without which he could not receive his Diploma. This, in turn, involved him in complicated dealings with a patron, of the sort that had soured his relationship with Tinney.

Following the success of his upright version of *The Lock* (Plate 154, pp. 156–7), he seems to have developed, during 1825, a large horizontal version (Plate 183), which he eventually signed and dated 1826, and sold to his friend, James Carpenter, the bookseller. Constable's letter to Carpenter, probably of 1826, mentions that he had 'been at the picture ever since I saw you & it is now all over wet — I was at work on it at 7 o clock this morning. I should have been at it still. . . . I wish your picture was as good as Claude Lorrain — for I beg

180. Detail of diagram in letter to Lucas of 26 December 1831. Cambridge, Fitzwilliam Museum

depth in the estuary and on the horizon. His knowledge of George Field's colour theories are here put into practical effect, and mark a considerable advance in his technique since, say, the 1814 work to which it has just been compared. He has also used the detail of the shepherd's red waistcoat against a complementary green, which is a colouristic device he had used since his revolutionary oil sketches of 1808 onwards. His most considerable and imaginative achievement is in the turbulent grandeur of the sky, which reveals how far by 1829 it had become the 'key note' 'the *standard of scale*', and the 'chief *Organ of Sentiment*', as he had intended in 1821. It also reflects his growing interest in the 'bolder phenomena of nature'. His search for atmospheric truth also achieves in this one work the contrasts of 'calm and exhilaration', liveliness and peace, 'fresh and blowing', which he had sought in the *Leaping Horse* (Plate 165).

To this end, he made increasing use of flecks of white to enhance his 'dewy freshness', particularly noticeable in the trees at the left. Critics joked that his picture had been splashed by whitewash from his ceiling. Others spoke of his 'snow'. Leslie

witnessed an amusing scene before this picture at the Academy on one of the varnishing days. Chantrey told Constable its foreground was too cold, and taking his palette from him, he passed a strong glazing of asphaltum all over that part of the picture, and while this was going on, Constable who stood behind him in some degree of alarm,

181. Detail of Plate 179

182. *The Lock. c.* 1826. Reed pen, and brown wash, with pencil and traces of white heightening. Overall, 28.7 × 36.4 cm. Cambridge, Fitzwilliam Museum

to assure you that your conduct to me about it, has been most liberal and kind.' On 23 July 1828, he wrote to Carpenter again: 'I hope you will like the "new edition of your picture" and that you do not think it the worse for the retouch.' According to this letter, Carpenter must have wanted it to be a companion to Constable's early *Lock* (*Landscape: Boys Fishing*) of 1814, or some other painting in his extensive collection. The following January of 1829, Constable had it back again for exhibition at the British Institution. (Constable's few collectors had to be long suffering.) When he was elected to the Royal Academy in February he knew he had to submit a picture but why, exactly, he should have chosen this example, which was already sold, is not clear. An agreement exists, by which Constable could have the picture back on a deposit of 100 guineas, till he had painted a picture of the same size by June 1830. He also by this same agreement committed himself to paint a Hampstead Heath scene of the same size as that which Chantrey had, apparently, bought (see Plate 166). Constable still had a number of major works in his hands, such as *The Leaping Horse* (Plate 165), *The Cornfield* (Plate 169), and *Dedham Vale* (Plate 176). They all commemorated his native scenes, and any one of them would, presumably, have been equally acceptable. Indeed the 'eye salve' of *The Cornfield*, and the Academic pretensions of *Dedham Vale* should have made them eminently suitable. Perhaps he perceived *The Lock* to have been popular, and thought it would be less controversial. Paradoxically, none of these pictures appeared in his *English Landscape*, though in the course of that publication some were proposed but abandoned, although the Morrison Lock and *The Cornfield* were engraved by Lucas separately and published by Moon in 1834.[16] He may have been too nervous, by the way, to submit his most recent work, *Hadleigh Castle*.

His upright *Lock* was transformed into a horizontal version by means of a drawing *c.* 1825–6 (Plate 182). He enlarged his original drawing by the addition of a larger piece of paper to extend the design at the left and at the top. The drawing has been described as 'curious', because of the apparent incorrect perspective on the lintel of the lock, but this lintel is a detail of construction that we have seen came and went in his various representations of Flatford Lock, and in every respect, the drawing has the morphology of his 'Claudian' style of drawing, which became noticeable after his trip to Coleorton. The feathery trees are a typical example of this technique. It shows, furthermore, an intermediate stage in the design, between the upright picture, which has a barge waiting to move downstream, and the Carpenter picture, which has a barge waiting to enter the lock to make its passage upstream. In the drawing this barge has not yet appeared, but there is a hint of one, further upstream, which is much clearer in the finished picture. Its sky and overall effect show Constable in the full flood of creativity as a draughtsman.

The finished work not only makes this detail of the barge more definite, but includes Flatford Old Bridge at the extreme right. As one would expect the whole picture is highly refined, but the expressive, changeable sky may have been the result of the alterations he undertook in 1826, 1828 and, possibly, in 1829. It also has hints of his 'whitewash' in the trees and foreground detail. Its structure has the same low viewpoint as the original painting of 1824, and the diagonal underpinning of the composition to the left and right under the horizon line is much firmer than in the Cambridge drawing. These compositional elements, which occur so obviously again and again in his finished pictures may have been emphasized when he, or Dunthorne, came to square off, and transfer his designs to the

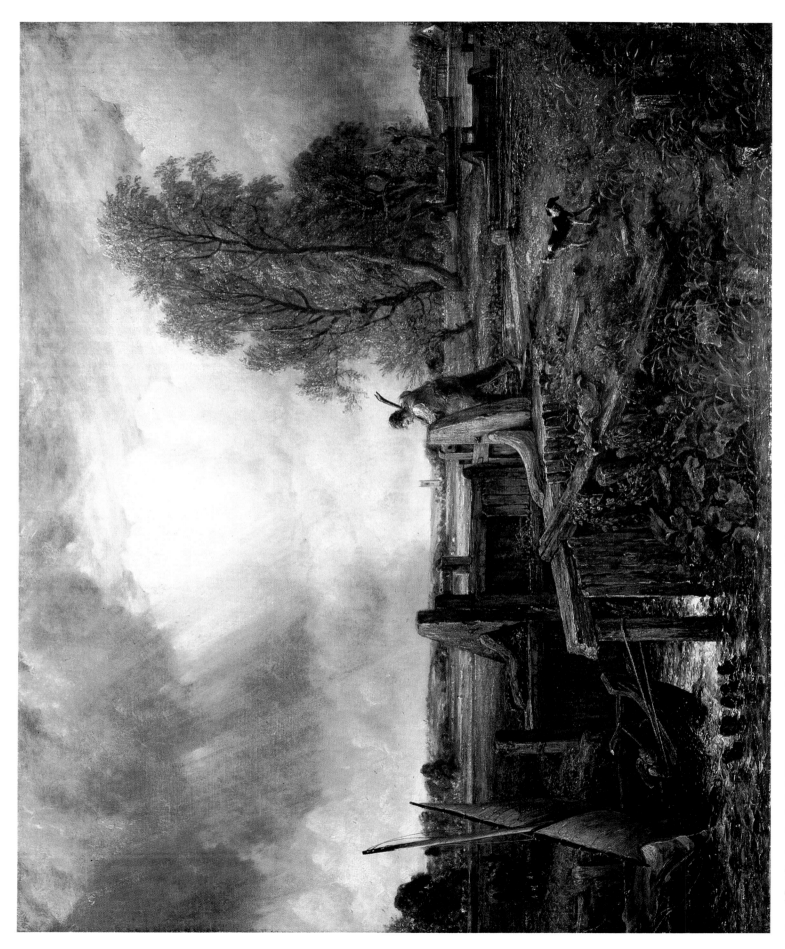

183. *A Boat Passing a Lock*. 1826. Oil on canvas, 101.6 × 127 cm. London, Royal Academy of Arts

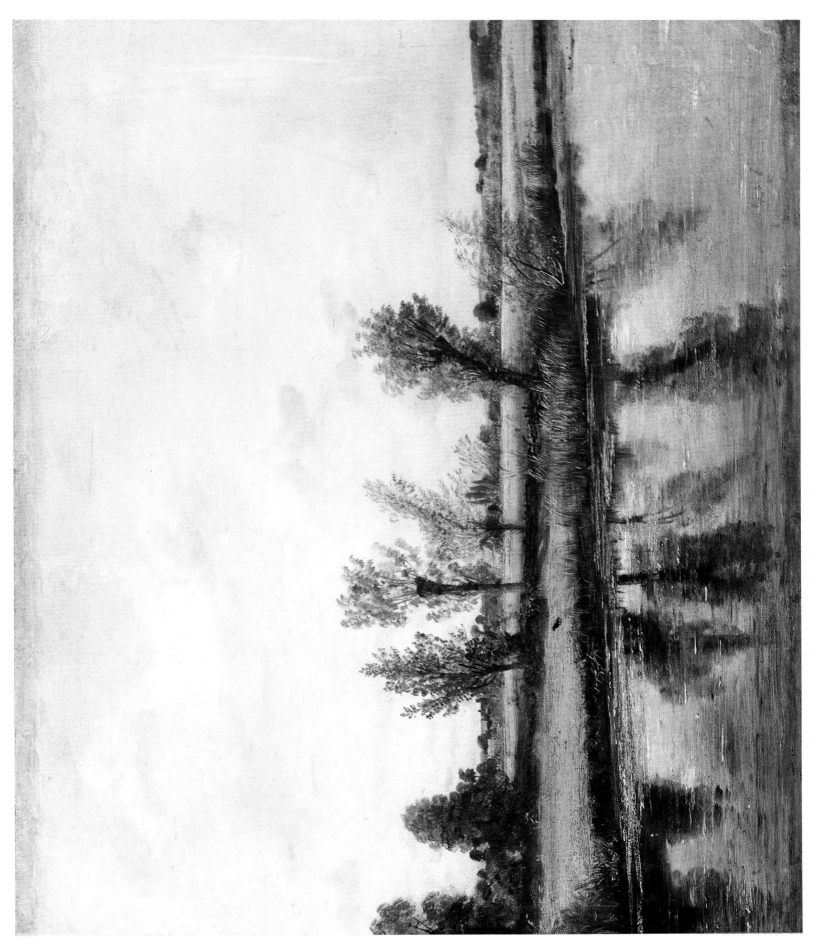

184. *Water Meadows near Salisbury*. 1829. Oil on canvas, 45.7 × 55.3 cm. London, Victoria and Albert Museum

final canvases. In some unfinished, preparatory sketches traces of ruled lines can actually often be seen. In the horizontal *Lock*, we find Dedham Church tower is again at dead centre. The *Lock* is not the most spectacular of his works, but its soothing spaciousness, helped by its horizontal format, and the rich texture of his atmospheric effects must have been what he wanted to be remembered by, in competition with all the other Diploma works in the Academy. He received his Diploma from the grudging and indifferent President, Sir Thomas Lawrence, on 10 December 1829, ironically shortly before Lawrence's death.

Constable's difficulties did not end there. He had been working on a version of *Helmingham Dell* (Plate 196) for Carpenter, to replace his *Lock* but as he was about to send it to the Academy, he decided to ask Carpenter if he could forfeit the 100 guineas, and send his new work 'independently of all other considerations', although he still promised to paint the Hampstead Heath scene. Carpenter reluctantly agreed but, to Constable's annoyance, demanded the frame, within an hour of the picture going to the Exhibition. Constable was further incensed that Carpenter had offered old books and second-hand furniture instead of the actual 100 guineas. Thus ended another relationship with a patron, although Constable remained on good terms with the son, W.H. Carpenter, who was also a bookseller and print dealer.[17]

Another important venture of 1829, with ramifications for the rest of his career, which also partly arose out of his new status as an Academician, was his relationship with David Lucas (1802–81), the engraver. They had probably first met in 1824, when Lucas was an assistant to S.W. Reynolds, who had been then so keen to engrave Constable's *Lock*. The first mention of Lucas, however, in the correspondence is a letter to Leslie of May 1829, which implies that Lucas was already working for Constable. As a newly appointed, but insecure Academician he probably doubly felt the need to justify himself and promulgate his real intentions, and by what better

medium than that of engraving? The developing relationship between Lucas and Constable and their joint project to engrave a careful selection of Constable's work in mezzotint is so important for what it tells us of Constable's view of his art that it deserves a special section.

A pleasant interlude in 1829 from the hurt of his election and grief of his loss was an invitation to visit Salisbury. He took his two eldest children, John Charles and Minna, to stay with the Fishers in July. Fisher had been in London during June and wrote: 'I leave town for Salisbury tomorrow morning, where I shall be happy to see you, but shall not see you. You know Dr Sam Johnson's sentiment: make new friendships continually & do not let your old ones die a protracted death.' Fisher was justified in being cynical. Constable had not been able to visit him since 1823, but a plea from Mrs Fisher may have persuaded him and he arrived on 7 July. He had a peaceful and restorative time, sketching out of doors, and using Fisher's oil paints for a number of fresh oil sketches. His drawings can be as calm as the wonderfully still view of *Old Sarum* of 20 July, now in the Victoria Art Gallery, Bath, or as agitated as a view of *Cottages and trees near Salisbury* drawn on 28 July 1829, now in the Victoria and Albert Museum (R. 315), which reveals that Fisher's influence was not universally calming.[18] Constable's oil sketches are as naturalistic and sunny as anything he did in 1820, such as *The View from Archdeacon Fisher's house (Leydenhall)* also in the Victoria and Albert.[19] From this refreshing visit came one minor masterpiece, *Watermeadows near Salisbury* (Plate 184) Victoria and Albert Museum, which was to cause an upset at the Academy the following year, and one major work, which is the masterpiece of his later years, *Salisbury Cathedral from the Meadows* (Plate 188; Marjorie, Lady Ashton of Hyde). As this embodies many of his dearly won tenets, which mark the climax of his career, it, too, is best discussed, with his mezzotints, in the last chapter, which will enable us to reach some conclusions about the ultimate direction of Constable's art.

Chapter 8

'I may yet make some impression with my "light" – my "dews" – my "breezes" – my "bloom" and my "freshness" – no one of which qualities has yet been perfected on the canvas of any painter in the world'

Constable's late works have been perceived as somewhat apart from his previous activity, even more at odds with contemporary notions of what was fit for academic consumption. They have also been given political meanings, as if they were part of his own conservative reaction to radical developments in society of which he disapproved.[1] Yet it could be equally argued that they were political *only* in the sense that they make a point about his own radical artistic position, rather than influencing the society in which he lived. He was, it is true, against an extension of the franchise that the Reform Bill would bring, he hated Dissenters, and feared Catholic emancipation. He and Fisher worried about attacks on the Established Church, but he stubbornly held to his individual artistic views, which had few contemporary parallels, and which brought him into conflict with the art establishment of his day.

A particularly harsh example of the incomprehension that greeted his works was the rejection of his *Water Meadows near Salisbury* (Plate 184), Victoria and Albert Museum, by the selecting council of the Royal Academy, of which Constable himself was a newly-joined member in 1830. Academicians had an automatic right to show their works, but by some amazing oversight, Constable's painting was included in work submitted by outsiders. It was promptly rejected as a 'nasty green thing'. Constable refused to allow it to be hung when the mistake was discovered on the grounds that he could not 'think of its being hung after it (had) been fairly turned out'. There is some suspicion that he had set up the whole episode to confirm to himself that the Royal Academy did not appreciate his work.[2] The painting is one of the most placid of the sketches from his Salisbury visits of 1829, and looks back in its naturalism to his calmer days by the Stour. It may even have been painted on the spot from behind Fisher's house, Leydenhall.

It is not surprising, therefore, that when the opportunity arose he seized the chance of bringing his message to the public through the medium of engravings and public lectures. There is a great temptation to see Constable's attempt, during his last years, to organize his thoughts and justify his art as the last logical act in a career that had been meticulously planned from the very beginning. Though his will was strong to follow the

path that he had 'very distinctly marked out' for himself, his self-knowledge was not always certain. He could be deflected from his aims by not knowing which leg of his breeches he should put on first, as Fisher had chided him in July 1823. He casually took advice from Farington, Stothard, Sir George Beaumont, and Leslie about the progress of his pictures, changing major works and proposing new ones on a whim, or in a vain attempt to come into line with academic requirements. His progress on the engravings, although neurotic, the frequently revised lectures, which he was both pleased and nervous to deliver, culminating in the prestigious series at the Royal Institution in May 1836, and the creation of a number of major masterpieces all ought to have brought about a satisfyingly coherent end to his career; but it is expecting too much of Constable's temperament to assume that this was, in fact, the case. There remain certain unanswered questions at the periphery of his thought, as we will see. In the main, however, his last years were not a morose and negative coda to the death of Maria, and the overwhelming impression is one of positive creativity, not always understood, then or now, which enlarged upon his earlier visual aims in the distinctive late style of a great master.

The first mention that Constable was engaged with engraving is in a note of May 1829 to Leslie which was carried to him by way of Lucas.[3] The first extant letter to Lucas is of 28 August 1829. Constable must have begun his scheme for engravings after his works, then, sometime in the first half of 1829. He had, presumably, already met David Lucas in the studio of S.W. Reynolds in 1824. Lucas, an unknown engraver, by 1827 was working on his own. The note of May 1829 may have been prompted by Constable asking Lucas to produce two small mezzotints (*The Approaching Storm* and *The Departing Storm*) by way of a trial run. He could have chosen mezzotint engraving for its fitness for reproducing oil impasto in a wide range of textures and tonal contrasts, while Lucas, as a young engraver, would have had the advantage of being inexpensive. He quickly became bound to Constable as a protégé, and in spite of Constable's detailed and sometimes harsh supervision, remained totally loyal. Some small indication of their close relationship, apart from their extensive correspondence, is a diagrammatic drawing of *The Stour Valley*

(Plate 4) in the Fitzwilliam Museum, Cambridge, which shows Constable giving an illustration to his new disciple of the character of the Stour Valley, so that Lucas could understand the lie of the land.[4] Lucas's small prints must have been satisfactory for, by the end of the year, Constable's new project was underway. When his prints eventually were published with an introduction, he stated that the project was begun, not from any mercenary motive, 'but merely as a pleasing professional occupation, and was pursued with the hope of imparting pleasure and instruction to others. He had imagined to himself certain objects in art, and has always pursued them.'

His last sentence gives the most convincing reason. Constable clearly had a didactic aim to represent the best of his art, and from the very beginning (September 1829), he constantly changed his mind about what should be engraved to express his 'certain objects in art'. In fact, he not only constantly altered the subjects, but obsessively tinkered with the proofs, and inundated Lucas with instructions, suggestions, criticisms and, occasionally, praise. Even after two years of working together closely when Constable received a proof of *Hadleigh Castle*, he could still write to Lucas in the following terms, on 5 May 1832:

> I am so sadly greived at the proof you now send me of the Castle that I am most anxious to see you. Your art may have resources of which I know nothing — but so deplorably deficient in all feeling is the present state of the plate that I can suggest nothing at all — to me it is *utterly utterly hopeless*. . . .

Part of Constable's anxiety was, no doubt, brought about by his illnesses, but he was also probably concerned that his attempt to justify the uniqueness of his own art, by publishing plates after his works, would inevitably be compared with Turner's *Liber Studiorum*, and its predecessor Claude's *Liber Veritatis*. Turner's publication had appeared in fourteen parts between 1807 and 1819, and it covered a much wider range of landscape, classified by Turner as 'historical', 'marine', 'mountainous', 'architectural', and 'pastoral'. Constable, by his constant reshuffling of subjects, and the addition of the initial letters, 'P', 'L', 'F', and 'G', on his plates, signifying, perhaps, 'pastoral', 'lyrical', 'fancy', and 'grand' was equally engaged in the same self-justifying activity. In a fit about the cost of his project he actually referred to Turner's 'Liber stupidorum'.[5]

His scheme did not progress, however, with the certainty of Turner's ambitious publication. Proof copies of the engravings, as they were produced by Lucas from 1829 onwards, were shown around and Lawrence, before his death in January 1830, seems to have admired a proof of *Old Sarum*, probably based on Constable's small oil sketch of the same year, now in the Victoria and Albert Museum. They were not engraved in the order in which they were eventually published, and the indecision that marked the progress of his finished paintings seems to have accompanied his engravings. His ideas for subjects wavered, his need to retouch was so overpowering, and his overall aims were in such a state of flux, that had he ended the 'book', as he called it, with the eight prints that he envisaged in February 1830, his finances and his state of mind

would have been much sounder. If Michelangelo's long, drawn-out work on the monument to Julius II could be called 'The Tragedy of the Tomb', then Constable's efforts for 'English Landscape Scenery' could be entitled 'The Misery of the Mezzotints'.

Eventually, as the project took shape, he decided that Parts, or 'Numbers', from I to IV would have four plates each, but that Part V would have six, making twenty-two plates in all. The contents of the first set was determined by May 1830 and, out of at least ten subjects that he had in hand, he chose: *A Dell (Helmingham Park)*, *Weymouth Bay*, *A Mill (Dedham)*, and *Spring*. The most expensive were printed on India paper, published in dark pink wrappers, and sold at two guineas; a set on French paper, wrapped in purple, was $1\frac{1}{2}$ guineas, and ordinary prints, in blue, would cost one guinea. He had paid Lucas fifteen guineas for the first two plates, and thereafter seventeen guineas, and the total cost, with something for proofs and a gratuity for Lucas, came to somewhere between sixty and seventy guineas each issue of four plates. They were published from Constable's own house in Charlotte St, and Dominic Colnaghi also had sets for sale. In a letter to Lucas of 30 April 1830, Constable said that he was 'now fairly sick of the concerne and as they have been the first, I devoutly hope they will be the last, plates I shall ever see done from my own works under my own eye'. But by 24 May, he could write to Fisher that 'my little book promises well ... Should it pay I shall continue'. It was a financial disaster, but he was still revising further new editions at his death in 1837. From the published plates of *English Landscape Scenery* it will be seen that Constable used mainly small sketches which he had by him, or which were done specially for Lucas. Views of the Stour Valley predominate, with Hampstead, and Brighton next in favour. His range of seasons covers spring, summer, and autumn, with the emphasis on summer, and his times of day range from morning, noon, evening, and sunset, but noon is the most popular. Winter is not included. A number of plates have direct personal connections, such as the frontispiece of the family home, Part V, and the first number consisted entirely of places which the family owned or of which, like Helmingham and Weymouth, he had deep personal memories. Nevertheless, he does seem to have tried to achieve a balance, and his most important interest seems to have been in dramatic atmospheric effects.

Peter De Wint, the water-colourist, received the first complete set on 23 July 1830, and John Britton, a topographical draughtsman received another copy which he thought 'too black'. In so saying, Britton had made a justifiable criticism of Lucas's engravings. A comparison with one of the plates from the first part, *Spring*, with the earlier oil sketch from which it was made, *Spring Ploughing* (Plates 185, and 186), reveals the severity of the prints. What began as one of Constable's most atmospheric and light-keyed oil sketches of c. 1821, has developed in the engraving into a dark, grandiose study, with heavy rain clouds, and an impressive multiplicity of light and dark accents. It has become a finished work in its own right, but without the spontaneity of the original. The other three prints in the first part, *Dedham Mill*, *A Dell*, *Helmingham Park*, and *Weymouth Bay* are even darker. Fisher's forebodings of

185. *Spring Ploughing. c.* 1821. Oil on panel, 19 × 36.2 cm. London, Victoria and Albert Museum

186. *Spring.* 1830. Mezzotint by David Lucas after Constable. 15.6 × 25.6 cm. New Haven, Yale Center for British Art, Paul Mellon Collection

1824 seem to have come true, and it remains a fascinating conjecture what the result would have been if Constable had followed Fisher's suggestion to use the new technique of lithography. Fisher had foreseen that the 'burr' of mezzotint could not touch Constable's colour and the 'cool tint of English daylight'. The method of working from the dark velvet texture of the burred plate to the lighter tones by scraping away may have been attractive to Constable for reproducing the density of oil paint, but it also produced a predominant darkness. Moreover, it pandered to Constable's inability to leave anything alone in his quest for perfection of light and dark. On the other hand, Constable's atmospheric pencil drawings would have translated well into lithographs, as his contemporary, Bonington, had found for the reproduction of his own drawings.

Constable, however, had larger aims, which were intimately bound up with his progress as a painter. The key to an understanding of what these were is his fascination with light and dark, and this became the justification for the appearance of the plates. When Britton complained that they were 'too black', Constable argued that he was 'knocking [S.W.] Reynold's black fog out of him as fast as I can', but he went on: 'Still you must do us the justice to recollect, that "chiaroscuro" is the sole object (almost) of these things — & of my poor style of landscape in general.' His interest in 'chiaroscuro' has already been noted, but in his last years it became an obsession as the series progressed. When he began the scheme in 1829, it might have been true to say that the prints were meant to show off his paintings, but the depth of his involvement with the prints, and their black and white tonality, in turn influenced his painting, and became part of his total aesthetic. In spite of poor sales, he pressed forward with the five parts between 1830 and 1832, and even contemplated a second edition in 1833. He felt it necessary to provide an introduction, and a text to accompany each plate. His friend, Henry Phillips, provided a draft address in March 1832 when his twenty-two plates were finally issued, but this was too short, and in no way encompassed Constable's large aims, and he decided to write his own.[6] The agony of putting into words what his art was about went through at least three drafts between March and May 1832, and there were further changes in the printed introduction between January 1833 and May 1833, for which Leslie had given advice.[7] Of the texts to accompany the individual plates, only four were completed, though there were proofs for two and fragments for one more.[8]

His principal point of justification, however, was the 'CHIAR'OSCURO OF NATURE' which appears on the title page of 'English Landscape'. Landscape was his subject, and various classical texts, from Virgil, Horace, and Ovid, and modern poets such as Thomson and Wordsworth were quoted to give credence to his work, but his immediate aim was to promote the study of 'the Rural Scenery of England'. This had been his abiding interest, since he had never been abroad, and he emphasized this point by making his introductory plate the view of his old home at East Bergholt, the importance of which to the whole development of his art has already been stated (Plate 1). His visual aims were equally important:

to mark the influence of light and shadow upon Landscape, not only in its general effect on the whole, and as a means of rendering a proper emphasis on the 'parts', in Painting, but also to show its use and power as a medium of expression, so as to note 'the day, the hour, the sunshine, and the shade'. In some of these subjects of Landscape an attempt has been made to arrest the more abrupt and transient appearances of the CHIAR'OSCURO IN NATURE; to shew its effect in the most striking manner, to give 'to one brief moment caught from fleeting time', a lasting and sober existence, and to render permanent many of those splendid but evanescent Exhibitions, which are ever occuring in the changes of external Nature.

These are very important principles which go a long way to explain the development of his art from the moment he began to paint large-scale works in his studio away from the actuality of the subject in front of him. His interest in transient effects had become more and more complex.

From his constant alteration of the proofs, often in pencil, heightened with white, he undoubtedly developed a particular feel for light and shade as expressed in black and white, and this he saw was particularly relevant to his interests in 'chiar'oscuro'. From a lifetime's interest in atmospheric effects he now used the word to describe everything to do with the three-dimensional representation of the visible world: light and shade, as tone; reflection and refraction, which created these variations; the ambient atmosphere, and skies and their changeability; sudden phenomena, such as rainbows, even the variation of colour could be considered as part of 'chiar'oscuro'. The opposition, furthermore, of warm and cool colours could give emphasis, to make objects recede or advance. The tactile sense of paint itself, as we have also seen, could be used to denote near and far. He was to develop these ideas extensively in his lectures, as he had been prompted to do by a letter from Fisher on 27 September 1826, but there is no doubt that his work from 1829 onwards cannot be properly understood without an appreciation of this overall definition.

The engravings of *Spring* (Plate 186) and *Stoke by Nayland* (Plate 187) both had written texts completed, which emphasize this general point. *Spring*, he hoped, would

give some idea of one of those bright and animated days of the early year, when all nature bears so exhilarating an aspect . . . causing that playful change so much desired by the painter of

Light and shade alternate, warmth and cold,
And bright and dewy clouds, and vernal show'rs,
And all the fine variety of things . . .

He went on to explain the 'natural history' of the clouds, learned from his beginnings as a miller in the family's windmill, which we can see in the background, in just the same way that he had explained to Lucas the effects of water and wind on the trees in his *Stratford Mill* (Plate 111, see p. 114). Similar comments about atmospheric change, which Constable attempted to explain scientifically, are also introduced into the text for *Stoke by Nayland* (Plate 187). Its origin was in a series of sketches done out of doors, dating from *c.* 1810 (see p.

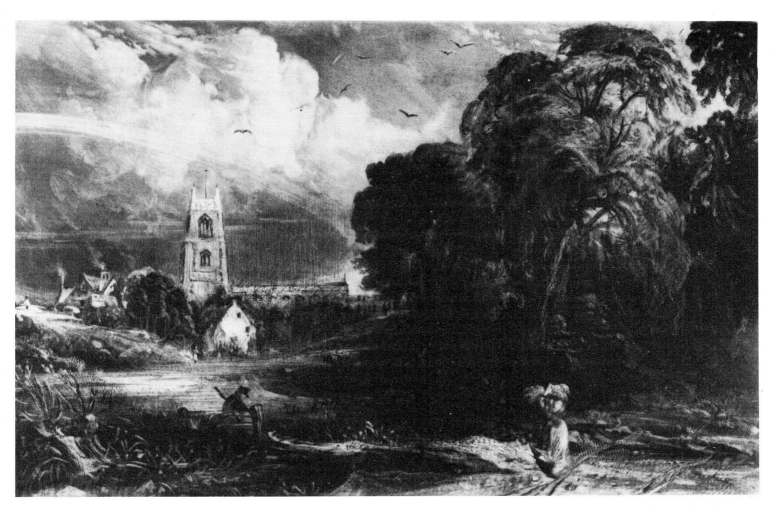

187. *Stoke-by-Nayland, Suffolk.* 1830. Mezzotint by David Lucas after Constable. 17.9 × 25.1 cm. New Haven, Yale Center for British Art, Paul Mellon Collection

68 and Plate 62). To their impressionistic effect and loose immediacy, he has added a wider viewpoint, and increased the importance of the church. He has also included in the engraving the picturesque detail of the figure carrying faggots, and the dramatic, unifying bow of the rainbow.

The printed text confirms what we see in the plate. It begins with a quotation:

> Through the lighten'd air
> A higher lustre and a clearer calm
> Diffusive tremble.

The solemn stillness of Nature in a Summer's Noon, when attended by thunder clouds, is the sentiment attempted in this print; at the same time an endeavour has been made to give additional interest to this Landscape by the introduction of the Rainbow, and other attending circumstances that might occur at such an hour. The effect of light and shadow on the sky and landscape are such as would be observed when looking to the northward at noon; that time of the day being decidedly marked by the direction of the shadows and the sun shining full on the south side of the Church

He went on to make observations about the Rainbow, and how it is seen, never foreshortened 'or seen obliquely, as it must be parallel with the plane of the picture, though a part of

it only may be introduced'. This is generally consistent with his practice. 'Nature, in all the varied aspects of her beauty, exhibits no feature more lively nor any that awaken a more soothing reflection than the Rainbow, "Mild arch of promise".' There are further observations on the rainbow, which quote what he called 'recent experiments', and from these we can assume he had become involved, as we know from other notes, with optical experiments about the creation of rainbows.

His interest in the appearance of the rainbow, and the 'fine variety' of natural effects is typical of the whole series of *English Landscape Scenery*. His emphasis on a turbulent, changeable scene at noon on a summer's day provides the most obvious difference between the engravings and his earlier work. Whereas, say, the overall effect of *The Hay Wain* is the still, bright calm of a summer's day at noon, his twenty-two plates stress stormy, rainy, or blustery summer noons, with dramatic gleams of light, rolling clouds, and thunderstorms. In 1834, when he had worked himself into a state about the independent publication by Moon of *The Lock* and *The Cornfield* which, apparently, were selling better than his own prints, he complained irritably to Leslie on 15 December, 'but every gleam of sunshine is blighted to me in the art at least. Can it therefore be wondered at that I paint continual storms? "Tempest o'er tempest rolled" — still the "darkness" is

201

188. *Salisbury Cathedral from the Meadows*. 1831. Oil on canvas, 151.8 × 189.9 cm. London, the property of Marjorie, Lady Ashton of Hyde, on loan to the National Gallery

189. *Salisbury Cathedral from Long Bridge, near Fisherton Mill.* 1829. Oil on paper laid on card, 18 × 27.9 cm. Private collection

majestic, and I have not to accuse myself of ever having prostituted the moral feeling of art, but have always done my best.'

Allowing for some exaggeration, the tendencies of his prints ran parallel with the concerns of his paintings from 1829 onwards. His head was full of the effects of 'chiar'oscuro' from his printmaking scheme. *The Water Meadows near Salisbury* (Plate 184) is an exception because of its fresh naturalistic appearance, as is the drawing he did on the spot of *Old Sarum*, but the oil sketch he painted in 1829 is monochromatic and dramatic (Victoria and Albert Museum). From this sketch he had Lucas engrave a plate, which he replaced in 1831 with another attempt. When Constable wrote the accompanying text, he took pains to emphasize the importance of 'General Effect' in setting the mood of a landscape.[9] The subject of the mound of this ancient and abandoned city, the forerunner of 'New Sarum', or Salisbury is, as he stated,

> Grand in itself and interesting in its associations, so that no kind of effect could be introduced too striking, or too impressive to portray it; and among the various appearances of the elements, we naturally look to the grander phenomena of Nature, as according best with the character of such a scene. Sudden and abrupt appearances of light, thunder clouds, wild autumnal evenings, solemn and shadowy twilights 'flinging half an image on the straining sight', with transitory gleams of light; even conflicts of the elements, to heighten, if possible, the sentiment which belongs to a subject so awful and impressive.

In his last years, it is as if Constable were searching for suitable subjects, as his text implies, that would match his restless involvement with the more extreme phenomena of nature. Subjects such as *Old Sarum*, with its rich associations of the past and *Stonehenge* (Plate 226), would not have been chosen by him when he had first 'very distinctly marked out a path for' himself in 1812. Also, he was not then painting in extremes of 'cold and grey' or 'ruddy and bright', even in the freest of his sketches. His description of the weather, which would accord best with such a scene, sounds like the 'Sublime' setting of a Gothic horror novel. His change can be felt not only in the new 'powerful organs of expression' now at his command, but also by the introduction of an obviously emotional subject-matter with philosophic overtones, that could be compared with Turner's pictures which make comments about the past or the present.[10] There is a sense of loss, and dissatisfaction with the times both artists lived through. When the plate was engraved Constable showed a proof to Lawrence, who liked it, perhaps because it was more in the vein of historical landscape, and said it should be dedicated to the House of Commons.[11] Old Sarum was the last of the 'rotten boroughs', returning two members to Parliament with no inhabitants. It was abolished in the Reform Bill of 1832, but Constable wrote at great length in his letterpress, emphasizing its former glories and its role in the establishment of the feudal system. He, like Turner, seems to regret the passing of the old and its replacement by newer forces.

Some such political comment may have been part of his conception of the great masterpiece of his late years, which he

seems to have begun in 1829 during his visits to Salisbury either in July, or in November when he went there again to collect his daughter Minna. Fisher wrote to him on 9 August 1829: 'I am quite sure the "Church under a cloud" is the best subject you can take. It will be an amazing advantage to go every day and look afresh at your material drawn from nature herself.' This is probably a reference to the beginnings of *Salisbury Cathedral from the Meadows* (Plate 188), collection Marjorie, Lady Ashton of Hyde, and 'the Church under a cloud' was also a private joke between Fisher and Constable about his previous view of Salisbury done for Fisher's late uncle, the Bishop, in 1823. The Bishop had complained: 'If Constable would but leave out his black clouds' (see p. 124). It had also come to mean to Fisher and his friend the beleaguered state of the Anglican Church with threats of its tithes being taken away, and even its disestablishment. For such old Anglican Tories as Fisher and Constable these radical ideas clearly originated with the devil's party and its representatives, Lord Brougham and 'Old Hume — The Devil's vice-regents on earth', as Constable had called them in his famous outburst against 'mechanicks' in 1825.[12]

Constable needed some encouragement from Fisher, who wrote on 3 September

> I yearn to see you tranquilly and collectedly at work on your next great picture: undisturbed by gossips good and ill natured; at a season of the year, when the glands of the body are unobstructed by cold, and the nerves in a state of quiescence. ... I long to see you do what you are fully capable of, 'touch the top of English Art'. To put forth your *power* in a *finished polished* picture which shall be the wonder and the imitation — struggle of this and future ages — But any freak of imagination or anxiety distracts you. Now come and work and don't *talk* about it.

Constable certainly had enough material in the way of drawings and sketches done on the spot which he could use. There is a drawing in the Yale Center for British Art, New Haven, showing Salisbury Cathedral from the northwest, but with the cathedral more distant than in the finished picture. An oil sketch, which recently appeared at Christie's in 1982, also shows the cathedral farther off and may have been his working up of the initial idea which Fisher wanted to encourage.[13] The drawing, however, includes a suggestion of the waggon and horses which appear in the finished picture. Another pencil sketch (Plate 190), now in the Fitzwilliam Museum, Cambridge, is drawn from the same northwest viewpoint, but nearer to the cathedral. The waggon is not present in the Cambridge drawing, but an angler is suggested in the centre foreground who, although he does not appear in the finished picture, does occur in another oil sketch (Plate 189) from the Fenwick Collection, which also recently came to light. This oil sketch also has the stormy sky, which is such a feature of the finished picture. It was the basis of a small mezzotint engraved by Lucas and published by Moon in 1838. Another drawing in the Lady Lever Art Gallery, Port Sunlight, has the waggon and horses reintroduced. It is also squared, with Constable's inimitable method of diagonal squaring. Its enlargement of the scene at the right, the introduction of a figure

on the bridge, and a dog, all bring it closer to a small oil sketch in the Tate (P. 36), which also has traces of squaring, and which follows the major part of its composition. The Fenwick and the Tate Gallery sketches were probably executed away from the motif, in the course of preparation for the finished painting, sometime in 1830.

In a letter to Lucas of October 1830, Constable asked him for his *Flatford Mill*, — 'it will help me in my sketch of Salisbury'. Constable may well have been referring to a full-scale sketch (Plate 191), in the Guildhall Art Gallery, London. Some doubt has been placed on this typical large-scale sketch by Leslie Parris in his catalogue of the Tate Gallery's collection, but it is freely, even violently, painted in the manner of his preliminary 'exercises', and contains details that occur nowhere else and could not have been invented by an imitator. Its obvious difference from the other preliminary work is its format, which is squarer than the long rectangles of the other sketches. The angler on the bridge, with his creel and dog, who may have been a punning reference to Fisher, has been eliminated to open up the foreground at the right, to give greater importance to the waggon and horses. The dog has been moved to the left. Constable may well have wanted his 'Flatford Mill' for details of the principal group of trees at the left.

He was apparently working on his finished picture in the winter of 1831, as a letter of 2 February to Lucas stated that because of a cold he is 'making sad work' on his canvas. When completed (Plate 188), it was exhibited at the Royal Academy of 1831, with a long, slightly misremembered quotation from Thomson's *Seasons*:

> As from the face of Heaven the scatter'd clouds
> Tumultuous rove, th' interminable sky
> Sublimer swells, and o'er the world expands
> A purer azure. . . . Through the lighten'd air
> A higher lustre and a clearer calm,
> Diffusive tremble; while, as if in sign
> Of danger past, a glittering robe of joy,
> Set off abundant by the yellow ray,
> Invests the fields, and nature smiles reviv'd.

This draws attention to the rainbow which appears in the exhibited painting and binds the whole composition together. His interest in rainbows and the scattered and tumultuous effects of weather are here given free rein. From his comments on *Old Sarum*, which had not yet been written, we can imagine that the dramatic weather had been chosen as an appropriate 'General Effect'; but it is not completely clear what the actual subject was. He later suggested in his lectures that in one instance of telling a story, Ruisdael failed,

> because he attempted to tell that which is outside the reach of art. In a picture which was known, while he was living, to be called 'An Allegory of the Life of Man' (and it may therefore be supposed he so intended it) [*The Jewish Cemetery*], there are ruins to indicate old age, a stream to signify the course of life, and rocks and precipices to shadow forth its danger. But how are we to discover all this,

Constable asked.[14]

190. *Salisbury Cathedral from the North West.* 1829. Pencil, 23.4 × 32.7 cm. Cambridge, Fitzwilliam Museum

His common-sense approach remains as a warning not to over-interpret Constable's own painting, and it may, therefore, be inappropriate to read any more into the painting than is suggested by his quotation from Thomson about natural change. The painting could be construed as an allegory of Constable's own life, as the passage he quoted from Thomson refers to nature's rejuvenation after the death of Celadon's lover, Amelia. But his picture is, nevertheless, restless and worrying for other reasons. Some general political reference to the passage of the Reform Bill that had particularly upset Fisher and Constable in March 1831 has already been mentioned, and the lightning flashes around the tower could be taken as attacks on the body of the church. The rainbow, the quotation, and the image of the spire thrusting through the dark clouds to the pure 'azure', suggest the stability of the church and happier times to come.

It appears equally likely that the subject had as much emotion in it about details of his own life, rather than expressing irate comments on the political upheavals of the day. Salisbury had been the see of the Bishop who had been his 'kind mentor', and at Salisbury he had first met his closest friend, Archdeacon John Fisher, who had given him solace after the death of Maria. The cathedral floats above the landscape just as Constable has described St Paul's floating above London, when seen from Hampstead, and its permanence amidst the buffetings of nature and the happiness he had experienced there may be part of his act of homage to Salisbury and the Fishers. The end of the rainbow falling on Fisher's house, Leydenhall, is, perhaps, a symbol of their past times together, but Fisher himself no longer appears on the bridge. In these personal references, *Salisbury Cathedral from the Meadows* could take its place with other late reminiscences of important people in his life: *Helmingham Dell* for Pulham, *The Glebe Farm* for the Bishop, *Dedham Vale*, and later *The Cenotaph*, for Sir George Beaumont.

It also contains elements from his own earlier works as a re-

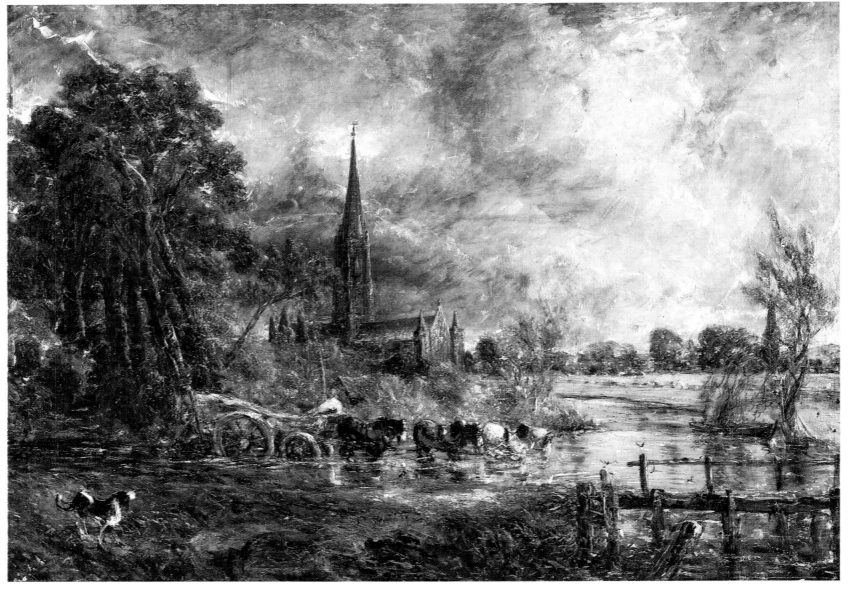

191. *Study for Salisbury Cathedral from the Meadows*. 1829–31. Oil on canvas, 135.9 × 188 cm. London, Guildhall Art Library

creation of his Stour Valley Canal scenes. The waggon in the water looks back to *The Haywain*; the leading white horse echoes *The White Horse*; the black and white dog is a bit player from *The Cornfield*; the man with a pole in the rowing boat reappears from *The Haywain*; the willow tree from *The Leaping Horse*; the large tree at the left is a much dramatized, and Salvator Rosa-like re-creation of the elms in his *Flatford Mill*, and *The Leaping Horse*. The stumps, sedges, and footbridge in the foreground are the latest examples of his love of 'willows, Old Rotten Banks, slimy posts'. The extensive open meadows at the right are also a favourite motif from the past.

The agitation, however, of this deeply nostalgic painting is very different from the serenity of his earlier masterpieces. Everything is exaggerated, such as the height of the spire, and either larger than life, as is the waggon, or strangely smaller, as are the red-roofed houses behind it, or not visible from this viewpoint, as is the tower of St Thomas's Church at the left. The atmospheric effects are equally pushed to their limit. *The Haywain* is light and sunny beside the sublime effects of

Salisbury Cathedral from the Meadows. Its lightest area and darkest tone are actually placed adjacently, absolutely in the centre under the northwest tower, to give a maximum contrast of black and white. This is emphasized by his composition of criss-cross diagonals under the horizon line, which project from the right from the diagonal of the plank and meet at another of these elemental black and white juxtapositions. But although much of the flickering surface has this clash of dark and light, accented by skeins of white paint, and slashes of the palette knife, and, doubtless, increased by his endless re-workings of the picture, there is much of pure colour in it. He has dabs and spots of primary colours in, for example, the red of the woman's cloak, the red of the horse's collars, pink and white in swirls around the spire, touches of red against the green and blues against pink at the left.[15] There is also, of course, the important transient symbol of the rainbow with its primary colours.

Paul Schweizer has shown that Constable's knowledge of the rainbow was not accurate according to modern scientific

192. Sir Peter Paul Rubens (1577–1640). Detail from *Rainbow Landscape*. After 1635. Oil on panel, 135.2 × 233.7 cm. London, Wallace Collection

knowledge partly because of his acceptance of the tri-chromatic tradition, but he was as up-to-date as he could have managed with the scientific evidence of the time.[16] He made diagrams where he attempted to work out the angles of re-fraction from water droplets in the air — another example of his quest for scientific accuracy where natural phenomena were concerned — and his letterpress for the print of *Stoke by Nayland* shows that he already knew much about the rainbow's formation. Yet he must have known by 1831 that a rainbow would not have been visible from the spectator's position in *Salisbury Cathedral from the Meadows*, where the light clearly falls at a summer's height at the right. In this instance he has balanced his pragmatic attempt to render the primary colours of the rainbow against its bold and imaginative effect. There were, in fact, artistic precedents, of which the most famous, Rubens's *Rainbow Landscape* (Plate 192), in the Wallace Collec-tion, he knew as a pair to *The Chateau de Steen*.[17] It is yet another reminder of the influence of Rubens on his work.[18] Even his assistant, John Dunthorne, was influenced by Constable's interests, with his own modest attempt at a rainbow landscape (Plate 194), in the Yale Center for British Art, New Haven

painted in 1829.

Shortly after the exhibition of *Salisbury Cathedral from the Meadows*, one evening of June 1831, Constable painted a dramatic water-colour at Hampstead of a shaft of light, called a 'sun pillar' which was refracted into the primary and secondary arcs of a rainbow (Plate 197). As Schweizer has pointed out, Constable 'has clearly and correctly differentiated between the lower and the narrower primary band of the rainbow and the upper arc, which is always several degrees wider on account of the greater dispersion of prismatic light that takes place in the secondary bow. He was also careful to record a fact known since the time of Aristotle's *Meteorologica*, that the colour sequence of the secondary arc, with purple at the top and red on the bottom of the band, is always the reverse of the colour sequence that appears in the primary arc.' Schweizer argues that Constable may have learned this from Luke Howard's *Climate of London*. It is another telling instance of Constable's attempts to come to grips with scientific fact, as an essential part of his expressive repertoire, and shows the advance in his knowledge since his sketch of 1812 (Plate 70). He produced other atmospheric views from Hampstead in the 1830s as part

193. John Dunthorne (1798–1832). *A Landscape near Salisbury with a Rainbow*. 1829. Oil on canvas, 25.5 × 36 cm. New Haven, Yale Center for British Art, Paul Mellon Collection

194. *A Cottage and Lane at Langham ('The Glebe Farm')*. c. 1810. Oil on canvas, 19.7 × 28 cm. London, Victoria and Albert Museum

of his research into the 'bolder phenomena' of nature (Plates 198 and 199).

While he was beginning the great *Salisbury*, Fisher had an embarrassing letter to write. Because of the complete failure of his rents, he was forced to ask Constable to buy back his *White Horse*, and his *Salisbury*, the version that Fisher had acquired after it was rejected by the Bishop. He hoped, forlornly, that he would eventually be in a position to buy them again. Perhaps the rainbow is 'an arc of promise' that presages better times for Fisher, too. Although Constable had to sell out from his funds, held in trust as he saw it for his children, he paid Fisher £200 for the two, a sad outcome for Fisher's original courageous act of patronage.

Meanwhile, although Constable was busy with his prints, and duties at the Academy, and there was hardly a time in the

1830s when he was not, he had been working on his exhibits for the Academy of 1830, where he was to suffer the slight of having his *Water Meadows from Salisbury* (Plate 184) rejected. Sometime during 1830, and again in 1831 and 1832, he was engaged in another nostalgic exercise, that of painting further versions of *The Glebe Farm*, at Langham, a site that was intimately bound up with memories of Bishop Fisher, who had been its Rector. The basis of Constable's picture had been an oil sketch of c. 1810 (Plate 194), in the Victoria and Albert Museum. He had developed this into a painting he had exhibited at the British Institution in 1827 (see p. 179), but he turned to the design again in about 1830, with a larger version (Plate 202) in the Tate Gallery. This does not show the heavy reworking of his other contemporary works because Leslie, who admired it, was given it before Constable could bring it to his normally high degree of finish.[19] Constable painted another version for Lucas to engrave between December 1831 and January 1832.[20] This is also in the Tate Gallery (P. 37) and differs from Plate 202, not only in its higher degree of finish, but also in the deletion of the wispy tree from the foreground, and the addition of a seated girl. 'The Lane', as Constable called it, gives his composition a strong diagonal emphasis, and it is by no means an objective record of Langham as it was. When Leslie finally visited the scene in the company of Constable's friend William Purton in 1840, he noted that 'All is so much changed excepting the Church, that we could scarcely recognise it as the scene of "The Glebe Farm" ', and elsewhere he remarked that 'the rising ground and trees on the right hand are imaginary, as the ground, in reality, descends rather steeply on that side of the Church'.[21] The church cannot, in fact, be seen from Constable's point of view, and what he has done, again, is to re-create a *capriccio* of all the elements that made this for him a hallowed spot. He is not only re-creating from personal associations. There are echoes of other art, too, which we know Constable admired, and which are more obvious in the unfinished version. Its quiet rustic air, and delicate touches of dark and light, look back to the imaginary Suffolk villages of Gainsborough, and to the beginnings of his own art when he fancied he saw a Gainsborough in every hedge and hollow tree and Dr Fisher had 'entirely influenced his own life'. Its extended composition also has elements of those Netherlandish artists, such as Wijnants and Rubens, who had inspired both Suffolk artists.

During 1830, he was also at work on the reworking of a theme that went back to his earliest drawings from nature in Helmingham Park. When he had asked Carpenter to sell back his *Boat Passing a Lock* (Plate 183) he had agreed to paint another picture in its place and he had chosen a replica of the painting he had painted c. 1825–6 for James Pulham, the Woodbridge solicitor (Plate 195), in the Philadelphia Museum of Art, John G. Johnson collection. He decided not to go through with his agreement after all (see above pp. 258, 260), and he sent the replica (Plate 196), now at Kansas City, Nelson Gallery-Atkins Museum, to the Royal Academy of 1830. When James Pulham died in May 1830, Constable rushed to Woodbridge and bought back from the widow his earlier version of *Helmingham Dell* (Philadelphia), with another picture, presumably so they would not be knocked down at a

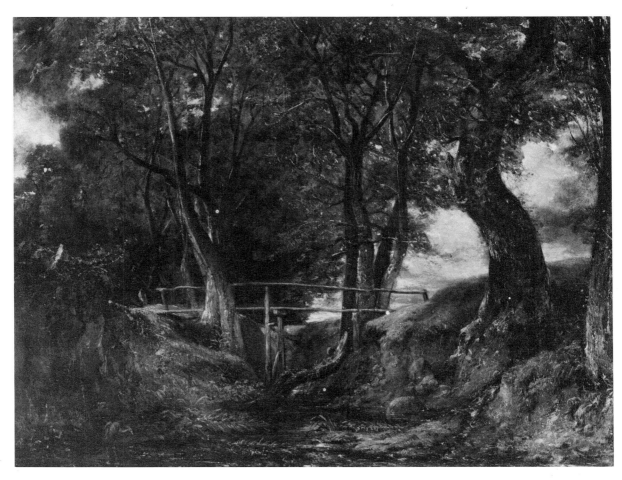

195. *Helmingham Dell*. 1825/6–33. Oil on canvas, 70.8 × 91.4 cm. Philadelphia Museum of Art, The John G. Johnson Collection

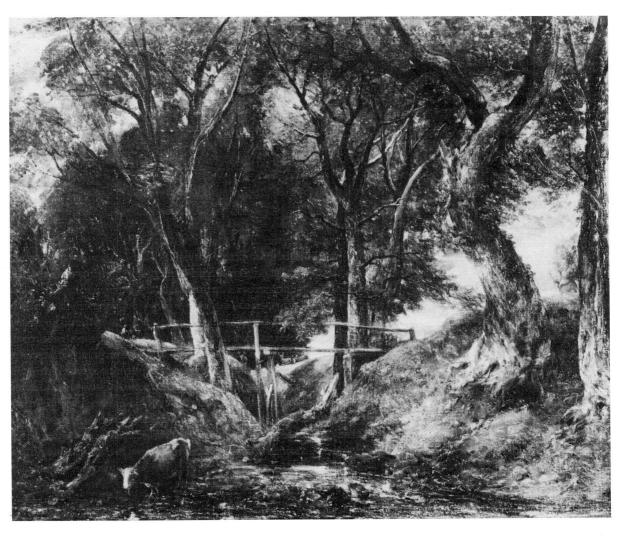

196. *Helmingham Dell*. 1830. Oil on canvas, 113.3 × 130.8 cm. Kansas City, the Nelson-Atkins Museum of Art (Nelson Fund)

197. *Hampstead Heath in a Storm.* 1831. Water-colour, 19.7 × 32.4 cm. London, British Museum

country sale. As he then worked further on this version, it has the appearance of a picture of the 1830s, and the two are best considered together. Both were based on his drawing of 1800 (Plate 19, see p. 28) but both paintings have been finished by the addition of a large impressive tree at the left. The Philadelphia painting has a heron, which has been replaced by a typical drinking cow from Constable's stock in the Kansas picture. This also has stags in the centre and at the right.

It is difficult to see any traces of his early attitudes in either picture. Both are enclosed woodland scenes, unusual in Constable's art, and there is none of his freshness and variety of greens. The Philadelphia picture is the slightly darker of the two paintings, with darkened and cracked bitumastic areas visible throughout, and only the touch of red in the woman's cloak to spark it into colourful life. They are both melancholy autumnal works, with no traces of human activity, or presence, save the 'wood[en] bridge', as a Constable pun to remind us of their association with Pulham. Perhaps their solitary appearance may be connected with his attempt at Shakespearian illustration, with his subject of *Jacques and the Wounded Stag*, which he was contemplating at this time, and which occupied him throughout the 1830s.[22] A drawing of 1828 exists and the subject was included in his original plans for *English Landscape Scenery* in 1830 and 1831. In their rich, dark impasto and enclosed scene, the two paintings also look forward to his *Cenotaph* of 1836 (Plate 223), another memorial to an old friend. Nevertheless, in their subtlety of tonal relationships, even if subdued, these two views of the Hel-

mingham reveal the strides his art had made since he first worked out of doors in Helmingham Park in 1800, and was full of his new-found friend, Ramsay Richard Reinagle. A comparison with a *Wooded Landscape* (Plate 200) by Reinagle of 1833, now in the Yale Center for British Art, emphasizes Constable's mature vision. Reinagle's art had clearly stagnated and its artificiality is clear when put alongside Constable's lively sense of chiaroscuro. The Philadelphia version was exhibited at the British Institution in 1833, after Constable's reworkings, and given by him to Robert Ludgate, who died the same year. When it was hastily included in an auction of Ludgate's effects, its authenticity was doubted and it was knocked down for the derisory price of £2. 15s. Constable had to write in November 1833 confirming that it was by him, in the face of a sarcastic attack by *The Morning Chronicle*.[23] It was a sad outcome for his years of perseverance and reveals the general misapprehension that greeted his work. The Landscape Lectures, which he began that year, were meant undoubtedly to correct that sorry state of affairs, together with the publication of his engravings. It is a moot point whether he succeeded.

During 1830 and 1831, he was much involved with his engravings and the painting of *Salisbury Cathedral from the Meadows*. A new duty, which he took equally seriously, was that of Visitor in the Life Class at the Royal Academy who had to set the model and advise the students. He seems to have been well-liked and his comments highly thought of. His first pose in January 1831 was that of Eve from Raphael, academic

198. *Cloud Study*. 1830. Pencil and water-colour, 22.8 × 19 cm. London, Victoria and Albert Museum

199. *View at Hampstead towards the City of London and St. Paul's*. 1833. Water-colour, 11 × 19 cm. London, Victoria and Albert Museum

200. Ramsay Richard Reinagle (1763–1804). *Wooded Landscape*. 1833. Oil on paper on panel, 84 × 109 cm. New Haven, Yale Center for British Art, Paul Mellon Collection

enough, but his idea of setting the model against a bower of laurels, with oranges tied on, so that the figure could be seen against a landscape background was unique. It looks forward to life drawing practice at the end of the century in France, when the model was seen no longer in isolation, but in relation to its surroundings. Constable, according to Leslie, 'could never look at any object unconnected with a background or other objects', a tradition which Sickert perpetuated into the twentieth century. Constable's plan, however, did not go smoothly, as his servants were arrested by the new 'Peelers' on suspicion that the greenery had been stolen. His letter to Leslie of 4 January 1831 amusingly recounts his difficulties:

I sett my 'maiden' figure yesterday and it is exceedingly liked — old Etty congratulated me *upon it*. Do come and see

it — it is the same girl I had with me when you called. She makes a most delightfull Eve, and I have put her in Paradise (leaving out Adam). I have dressed up a bower of laurels and have put in *her hand* the *forbidden fruit*. In my address to the students, I said that probably they expected a landscape background from me. *Prithee come and see her*, for I am quite popular in the *Life*. At all events I spare neither pains nor expense to become a good Academician *for your sake* — perhaps more than my own. It cost me ten shillings for my 'Garden of Eden' beside my man being twice stopped on Sunday evening by the police — with the green boughs, coming from Hampstead — thinking (as was the case) they had robbed some gentleman's garden.

My second number is much liked. We have stuck up the *new law*, but I am painting my own 'Eve' in spite of it. The

fun of it is that my own Garden of Eden was taken for 'Christmas' *holly* and *mistletoe*. The chimney to the gas lamps succeeds entirely — but we find it difficult to keep the room warm — poor Eve, shivered sadly, and became like a 'goose' all over. I got her warm & told her not to be such a goose as to tell her 'Aunt', who was very loath to let her come — to the Academy.

A drawing of him in the Life Class, probably done at the time by Daniel Maclise (1806–70), presumably shows him painting his *Eve* (Plate 201).

His Academy exhibits of 1831 were the *Salisbury Cathedral from the Meadows*, and a version of *Yarmouth Pier*. Both his hanging of the exhibition and his own works, particularly *Salisbury*, were viciously attacked. *The Morning Chronicle* called it a 'coarse vulgar imitation of Turner's freaks and follies', and Constable said to Leslie (2 June 1831) that his work had been described as 'Chaos'. He was saddened, too, by the death of his friend John Jackson on 1 June, but he did manage to get away to Suffolk, so that his three girls could stay with his sister, Martha Whalley, who now lived at Dedham. His brief visit caused his normal sad reflections, as he wrote to Leslie on 5 July 'Nothing can exceed the beauty of the country — it makes pictures seem sad trumpery, even those that possess most of nature — what must be those that have it not.'

One unusual event in the entire history of his art was the commissioning of a copy after Greuze for Lady Jackson to commemorate a daughter who had been taken from her on her separation from her husband.[24] He began the copy reluctantly in November 1831. More amenable was a dinner with the President of the Royal Academy (Shee), Leslie, Howard, and Jack Bannister, among others, to dine off half a buck sent by Lady Dysart. He was also pleased to attend the coronation of 'that good man', William IV, at Westminster Abbey on 8 September 1831. The rest of the year he alternated between bouts of illness, rheumatism, fretting over his children, and the seemingly never-ending project of his *English Landscape Scenery*.

His illness prevented him from using his right hand, and he was unable to act as Visitor to the Life Academy during the winter of 1832. His place was taken by Etty who outdid Constable in setting *Venus Sacrificing to the Graces*, amidst a 'voluptuous tableau', 'loaded with fruit the most recherché', as the *Morning Herald* described it. While Constable was ill he dictated a letter to Leslie, from his bed, of 14 January 1832, where he made a comment about the late work of Claude that he should, perhaps, have borne in mind about his own late work: 'Claude's exhilaration and light, in which he was the first to delight the world, he departed from at the age of between 50 and 60, and he then became a professor of the *higher walks of art*, and he [fell] in a great degree, into the manner of the painters around him, so difficult it is to be natural, and so easy to be superior in our own opinion.' His major exhibit for the Academy of 1832, which he somehow managed, finally, to finish, *The Opening of Waterloo Bridge Seen from Whitehall Stairs, June 18th 1817* (Plate 203), now in a private collection, cannot in any way be deemed 'natural'. He also prepared an unprecedented number of other works for exhibition, including two

201. Daniel Maclise, RA (1806–70). *Constable Late in Life. c.* 1831. Pencil, 14 × 10.8 cm. London, National Portrait Gallery

Hampstead Heath views, a 'Moonlight', and four drawings.

He seems to have been engaged on the *Waterloo Bridge* immediately after his illness, because he had asked Lucas on 21 February 1832, to send over 'all the *sketches* and drawings &c &c &c which related to the *Waterloo*, which I am now about'. We know there would have been a great number of his previous sketches, as he had been engaged upon it, intermittently, since he had seen the opening of the bridge in 1817. Lucas would have been working on the mezzotint which had been proposed since the beginning of the scheme, in a letter of 15 September 1829. By 28 February 1832, Constable was 'dashing away at the great London', as he wrote to Lucas, 'And why not? I may as well produce this abortion as another — for who cares for landscape. . ?'

After advice from Leslie, he widened the composition, and put the canvas on a new stretcher.[25] In a letter to Leslie of 4 March 1832, he called it his 'Harlequin's Jacket', and when it was sent to the Academy it caused much comment by its brightness of colour. Constable was restless about it, and 'it has not my redeeming voice ("the rural")'. This may have been the reason for its long period of gestation. In 1825, Stothard, his old friend, had made a suggestion for 'a very capital alteration', but now Stothard thought it 'very unfinished, Sir — much to do — figures not made out Sir,' which Constable reported to Leslie in a letter of 24 April 1832. Constable was

202. *The Glebe Farm*. 1830. Oil on canvas, 65.1 × 95.6 cm. London, Tate Gallery

also unhappy about its position on the walls of the Academy, and so, as it turned out, was Turner. Leslie in his *Autobiographical Recollections* tells what happened:

> A sea-piece, by Turner was next to it, a grey picture, beautiful and true, but with no positive colour in any part of it. Constable's 'Waterloo' seemed as if painted with liquid gold and silver, and Turner came several times into the room while he was heightening with vermilion and lake the decorations and flags of the city barges. Turner stood behind, looking from the 'Waterloo' to his own picture, and at last brought his palette from the great room where he was touching another picture, and putting a round daub of red lead, somewhat bigger than a shilling, on his grey sea, went away without saying a word.

> The intensity of the red lead, made more vivid by the coolness of his picture, caused even the vermilion and lake of Constable to look weak. I came into the room just as Turner left it. 'He has been here', said Constable, 'and fired a gun.' On the opposite wall was a picture by Jones, of Shadrach, Meshach and Abednego in the furnace. 'A coal', said Cooper, 'has bounced across the room from Jones's picture, and set fire to Turner's Sea.' The great man did not come into the room for a day and a half; and then, in the last moments that were allowed for painting, he glazed the scarlet seal he had put on his picture, and shaped it into a buoy.[26]

Turner's picture, the *Helvoetsluys* previously in the Indiana University Art Museum, Bloomington, Indiana, and now with Colnaghi, no longer has the striking contrast which Leslie described, whereas Constable's great picture remains a riot of red.

Constable had made a flamboyant painting of an event that had taken place some fifteen years before, when G.R. Rennie's new bridge over the Thames was opened by the Prince Regent on 18 June 1817, the second anniversary of Waterloo. There was a great concourse of people, and much festivity to mark

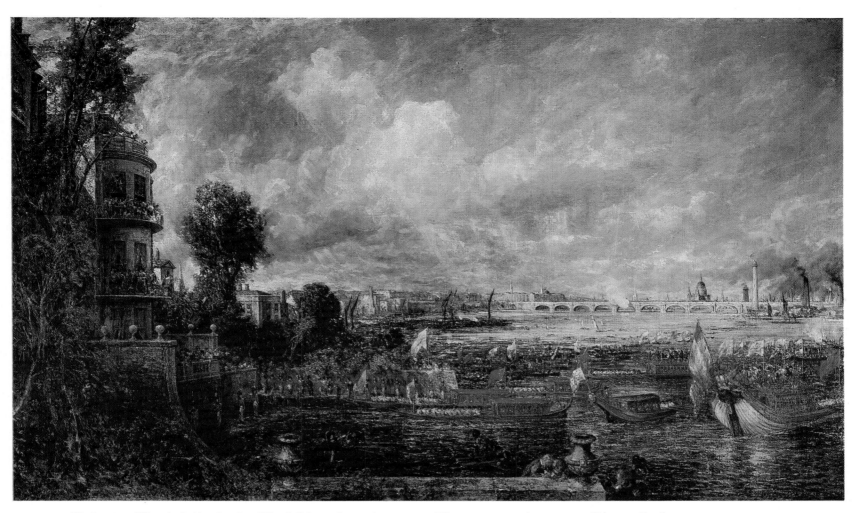

203. *The Opening of Waterloo Bridge, Seen from Whitehall Stairs, June 18th 1817*. 1832. Oil on canvas, 134.6 × 219.7 cm. Private collection

the occasion. Constable must have been in a balcony over-looking the garden of Fife House, and Whitehall Stairs, from which the Prince Regent embarked to sail the short distance downstream to the bridge, accompanied by the Lord Mayor of London's barge. Prominent at the left end of the bridge is Somerset House, then the home of the Royal Academy. It is so far from Constable's normal subject matter that the interesting question remains as to why he began it, and then came back to it again and again. He was undoubtedly impressed by the patriotic fervour that attended the scene, and, royalist that he was, he may have thought that a picture commemorating such an historic scene would bring him academic success. The representation of Somerset House may have been an attempt to win official recognition in 1819, when he began his lengthy scheme. It would also have brought home to the public that he was capable of a greater variety of subjects than his habitual Suffolk scenes. He may too have been impressed by the success of Augustus Wall Callcott's *The Entrance to the Pool of London*, exhibited at the Royal Academy in 1816, and Turner's famous rival view of *The Dort*, 1818. He now lived in London, why shouldn't he translate his Suffolk river scenes, into a view of the Thames, the greatest river of them all? He may have thought so in 1819, but his progress on this new subject was difficult, with many false starts and changes of mind.

The pencil drawing of *c.* 1819 (Plate 204), now in the

Victoria and Albert Museum, seems to have been drawn on the spot from a balcony overlooking the garden of Fife House. There is no suggestion of the festivities that surrounded the event, and it may well have been drawn solely for purposes of topographical accuracy. An oil sketch in a private collection also has a higher viewpoint, but another oil in the Royal Academy, and a drawing in a private collection, may be connected with a finished painting of *c.* 1820–4, in Cincinnati, which has a low viewpoint, and is a straightforward topo-graphical view of the River Thames and the new Bridge. There is a suggestion in the Cincinnati picture of Mrs Constable and young John Charles in the foreground talking to a Thames waterman. It is in the tradition of Samuel Scott, which Farington would have appreciated, as he had warned Con-stable about making a bird's-eye view, that in his experience as a topographer would detract from the buildings.

A freely drawn pen and ink sketch, and an oil sketch, both in the Victoria and Albert Museum (R. 175 and R. 174), are closer to the finished picture with a colourful display of soldiers at the left and the derricks, the chimney and smoke at the right. In November 1820, however, he showed Farington a large picture begun on canvas; by 1824 'a small baloon' had been finished; and then he lost inclination to pursue his project. Yet by October 1825, a new large canvas was begun and in December, Johnny Dunthorne was engaged on transferring

204. *Waterloo Bridge from the West. c.* 1819. Pencil, 30.6 × 41 cm. London, Victoria and Albert Museum

an intricate outline. This may have incorporated the 'capital alteration' which Stothard had suggested, possibly the introduction of the bow-fronted house at the left. In July 1826 he had access to Lord Pembroke's Terrace, which appears in the foreground, and what we see now in the finished picture is essentially what was in hand by 1826 with a further two feet added. What the earlier stages were, or what the Bishop of Salisbury crawled on his knees to admire in 1822 is not sure. It is certain, however, that a mezzotint was in hand by 1829, with which the unfinished sketch (Plate 205) in the Yale Center for British Art, New Haven, is connected. It bears traces of the squaring that Lucas found useful and gives a good idea of what little information he often had to go on. Although, in the main, the plate was taken from the Yale sketch, it contains elements from the finished picture. There is also a large-scale 'sketch' (Plate 206) in the collection of the National Trust, Anglesey Abbey, which may date from somewhere between 1829 and 1832. It is unusual in that it is bigger than the finished painting. At this date, apart from the subject matter being again on his mind, he may also have consciously sought to emulate Canaletto, as Leslie thought, and Turner, whose colourful Italian scenes had made their appearance in the Academy during the 1820s.[27] Mrs Pulham, the French wife of James Brook Pulham, said to her husband on 8 April 1832: 'Pulham

come here. I am quite in love with the Lord Mayor's bottom — the boat sits very beautifully on the water.'[28]

The picture, however, was not favourably received. *The Morning Chronicle* had its normal diatribe: 'It is impossible to describe this picture, figures painting and all; but as Turner is not so funny this year as usual, it is among so much dullness, a relaxation to the muscles.' Even Leslie could only justify it by defending Constable's technique of carrying on the whole together, rather than finishing as he went, which had the disadvantage

> of tempting the artist at times to sacrifice parts to the general effect. With Constable chiaroscuro was the one thing to be obtained at whatever cost. 'I was always determined', he said, 'that my pictures should have chiaroscuro, if they had nothing else.' In pursuit of this indispensable quality, and of that brightness in nature ... he was led by degrees into a peculiar mode of execution. ... In the Waterloo Bridge he had indulged in the vagaries of the palette knife ... to an excess ... It was a glorious failure,

so Leslie thought.[29] Constable was to indulge in even greater extravagances of his technique in the years to come, which are among the most difficult of his late works to appreciate.

The remainder of 1832, however, was taken up with

205. *The Opening of Waterloo Bridge. c.* 1829. Oil on canvas, 62 × 99 cm. New Haven, Yale Center for British Art, Paul Mellon Collection

206. *The Opening of Waterloo Bridge. c.* 1829–32. Oil on canvas, 148 × 200 cm. Anglesey Abbey, Cambridgeshire, National Trust

207. *The Thames and Waterloo Bridge. c.* 1820–4. Oil on millboard, 29 × 48 cm. London, Victoria and Albert Museum

208. *On the Stour with a Farmhouse in the Background. c. 1834. Oil on canvas, 25.4 × 34.9 cm. London, Victoria and Albert Museum*

personal matters and a commission of a less adventurous nature. The sudden illness of his daughter, Minna, with scarlet fever gave him great concern during June 1832, but when she was better she was sent to stay with her Aunt Martha at Dedham, accompanied by her father, who stayed at Flatford with Abram. The illnesses of his children were a constant worry, in addition to the agony of *English Landscape*. A scandal affecting Westall, and Reinagle whom he disliked, concerning their speculative dealings in pictures did nothing to cheer his spirits. He was worried, too, about the sudden decline of 'poor dear John Dunthorne', who from June seemed to be suffering from a heart disease. Constable wrote to Leslie on 22 June: 'He cannot long remain to me. I do not contemplate a happy old age even if I should attain it.' These were to be prophetic words. On 6 July, Dunthorne was much worse. 'It makes me sadly melancholy,' Constable wrote again to Leslie, 'I shall lose a sincere friend, whose attachment to me has been like a sons from his infancy. He is without fault and so much the fitter for heaven. I woke in the night about him.' Dunthorne, however, who was still manfully attempting to carry on his successful restorer's business, appeared to rally, and Constable was active again in the affairs of the Academy.

He was pleased to hear of the prospects for a new National Gallery to be built in Trafalgar Square from designs by Wilkins in which the Royal Academy would have space. He seemed to have forgotten his initial dislike of such an institution. He was busy, too, with a commission for a house portrait of Englefield House in Berkshire, where he went in August to make sketches. This did not turn out satisfactorily, partly through the behaviour of the haughty owner, Richard Benyon de Beauvoir, and partly through Constable's innate dislike for such work. On Constable's return, he was to receive further bad news, as he related to Leslie on 4 September:

> You will be grieved to hear that I have lost my dear friend Archdeacon Fisher. . . .
> I cannot say but this sudden and awfull event has strongly affected me. The closest intimacy had subsisted for many years between us — we loved each other and confided in each other entirely — and this makes a sad gap in my life and worldly prospects. He would have helped my children, for he was a good adviser though impetuous — and a truly religious man.
> God bless him till we meet again — I cannot tell how singularly his death has affected me.
> I shall pass this week at Hampstead, to copy the winter piece — for which indeed my mind seems in a fit state.

Fisher, who had been ailing, had gone to Boulogne to improve his health, but, unfortunately, as was later learnt, caught cholera. He was forty-five. The *English Landscape Scenery* was to have been dedicated to him; he appeared briefly in the early stages of *Salisbury Cathedral from the Meadows*; but his monument remains in the letters between him and Constable, the most moving correspondence in the history of art between an artist and a sympathetic listener. The vivacious portrait of 1816 (Plate 93), presents his appearance at a happier time, when he and his portraitist seemed to have all before them.

Constable in bleak mood was copying a Ruisdael *Winter Landscape* from Sir Robert Peel's collection.[30] Typical of his state of mind was the letter of 2 October to Lucas, in which he talks of adding 'a Ruin' to the little *Glebe Farm*: 'For *not* to have a symbol in the book of myself, and of the "work" which I have projected, would be missing the opportunity'. His grief was increased by hearing 'sad, sad accounts indeed of poor John Dunthorne — he will never see London again'. Dunthorne had returned to East Bergholt, where Constable visited his bedside, and he died on 2 November. Constable wrote to Leslie that 'His loss makes a gap that cannot be filled up with me in this world. So with poor Fisher. I am unfortunate in my friendships.' Constable attended the funeral on 9 November and was further upset by the state of his very first fellow artist, John Dunthorne, Senior, the 'Don Quixote', who was now 'entirely broken hearted'. The following April, 1833, Dunthorne lost his final child, and Constable little thought he would 'live to lament the death of every one'.[31] Small wonder, then, that his late work sometimes had the air of fatal frenzy.

He could still confide, however, in Leslie about artistic matters; he was able to harangue Lucas about the progress of the prints; and there were a number of friends in Hampstead, such as Jack Bannister, the actor, and Herbert Evans, and Mr Haines, his doctors, with all of whom he could share a convivial dinner. Charles Holford's garden provided laurels for his life class, and trees to draw, as accurately as ever, and he it was who encouraged Constable to give his first lecture on landscape at the Hampstead Literary and Scientific Society. Constable had long treated his house at Well Walk as his 'home' and his house in Charlotte St as his 'office'. Another friend, William Purton, helped with his drafts for the letter-press of *English Landscape Scenery*. A new member of the household, Charles Boner (1815–70), an earnest youth of German extraction, had been hired as a tutor to his children in 1831, and then, eventually, became Constable's amanuensis, often dealing with Lucas. Constable made a new friend after the tragedies of 1832, when, on 13 December, George Constable (1792–1878), a brewer and maltster of Arundel in Sussex, but no relation, wrote enthusiastically out of the blue:

> I have looked over your beautiful work on English Landscape with more than common delight. I am charmed with it! the perfectly natural yet masterly manner with which you have treated the light and shade is to me quite astonishing. I must say that it is the most perfect and interesting work on landscape that I have ever seen . . . I must endeavour to possess it to take it home with me.

Constable could not resist such praise from a stranger, and he lost no time in taking round and selling him the most expensive set at 10 guineas. There quickly developed a close friendship. George Constable sent Constable's son, John Charles, fossils and invited them to stay with them, which Constable managed to do finally in July 1834. He found a new scenery which captivated him and which was to provide the subject of his last great work, *Arundel Mill and Castle* (Plate 227).

During the winter of 1832/3, however, he was engaged on his view of *Englefield House*, which was not well received, by either the owner, or the Academy. He had begun the

commission, very reluctantly, because of a promise he had made as long ago as 1824, and, finally, he had made his careful drawings of the architecture during August 1832.[32] He mentioned painting cows in the foreground in a letter to Leslie of 17 December 1832, but by early spring 1833 he wrote again to Leslie: 'My house tires me very much. The windows & window frames & chimneys and chimney pots are endless — but I shall fill the canvas beyond repentance.' He had trouble with the hanging of his picture in the Academy. As he wrote to Lane on 14 May: 'Shee told me it was "only a picture of a house", and ought to have been put into the Architectural Room. I told him that it was a "picture of a summer morning, including a house".'

For once *The Morning Post* praised it for his freshness and truth, and hoped, incidentally, that he had permanently lost his whitewash brush, but the patron was extremely dissatisfied. According to Lane, who wrote the following year, when the dispute was still going on (21 March 1834):

> Mr Benyon de Beauvoir's principal objection seemed to be the specky or spotty appearance of your touch and the quantity of sheep oxen &c which are in the foreground, and which he said looked as if he had his farm yard before his Drawing Room windows.
>
> Eventually, deer were substituted for the cows and Richard Benyon de Beauvoir reluctantly paid the 100 guineas due, only to banish the picture to a distant relative's house.

For once, the press and a visitor, Lady Morley, who exclaimed on seeing the picture, 'how fresh — how dewy — how exhilarating', were on Constable's side, but his fellow Academicians and patrons were united in mutual incomprehension. He had experienced, yet again, a miserable winter. He was plagued further by a cold. He had sent his reworked *Salisbury Cathedral from the Meadows* to the British Institution with no result, and also the Philadelphia version of *Helmingham Dell*, then the property of Robert Ludgate, and as yet unpaid for. One of his earliest teachers, J.T. Smith, had died, as a warning to the newly-fledged museum profession, 'in great debt and poverty', while, with great misgivings, Constable had sent his son, Charles Golding, away to a boarding school in Folkestone. A large picture, which was to be *The Cenotaph* (Plate 223), he had temporarily abandoned, and, finally, he had been extremely annoyed at a condescending visit from the wealthy collector, William Wells of Redleaf. He wrote to Leslie before the opening of the Academy, summing up his position:

> I have laid by the Cenotaph *for the present*. I am determined not to harass *my mind* and HEALTH by scrambling over my canvas — as I hitherto have too often done. Why should I — I have little to lose and *nothing* to gain. I ought to respect myself — for my friends' sake, who love me — and my children. It is time at '56' to begin at least to '*know one's self*' — and I do know what *I am not*, and your regard for me has at least awakened me to believe in the possibility that I may yet make some impression with my 'light' — my 'dews' — my 'breezes' — my *bloom* and my *freshness* — no one of which

qualities has yet been perfected on the canvas of any painter in this world.[33]

He sounds desperate, but resolved to go on with what he perceived to be his real aims. The lack of support at the Academy must have been galling, and his other works, *A Hampstead Heath, showery noon*; *A Cottage in a Cornfield* (Victoria and Albert Museum, R. 352), a version of an earlier work 'licked up . . . into a pretty look'; a *Landscape, sunset*; and three drawings were not sold. Abram sent him a quote from his favourite conservative journal, John Bull: 'Mr. Constable is either laughing at the public, or wishes to be laughed at himself', which cannot have helped his peace of mind.[34] He was also apprehensive at the prospect of losing Leslie who had been offered a post at West Point Military Academy in the United States.

Leslie in fact, departed in September 1833, but his situation did not live up to the promises he had received from his fellow Americans, and he was back by May of the following year. He had been present at the first of Constable's lectures on landscape in Hampstead on 17 June 1833. Constable had begun the second of his two-pronged assault against the general ignorance about landscape, from which he seemed perpetually to suffer. His first attack had been through the medium of his mezzotints and their descriptions. He revealed to Wilkie at about this time: 'Of a sad freak with which I have been long "*possessed*" of feeling a *duty — on my part —* to *tell* the world that there is such a thing as Landscape existing with "Art" — as I have in so great measure failed to "*show*" the world that it is possible to accomplish it.'[35] He was asked to lecture at Worcester in 1834, at the newly built Athenaeum for the Worcester Literary and Scientific Institution but he postponed it, and gave his second lecture at Hampstead on 22 June 1835. He eventually gave three lectures at Worcester on 6, 8, and 9 October 1835, and so involved with this alternative pulpit did he become that he offered and delivered what became four lectures at the Royal Institution in Albemarle St, in London in 1836 (26 May, 2, 9 and 16 June). Because the final lectures are an amplification and consolidation of what he gave originally in 1833, they are best considered later, but it is important to remember that his didactic aims were very much part of his painted work throughout this period. He did receive some encouragement from his fellow painters. Sir William Beechey, the portrait painter, he was glad to point out 'knows a good deal of landscape, and loves it, and, in short, like all real painters, his heart is in it'.

Constable's own painterly activities for the rest of 1833 were somewhat inhibited, as if his own heart were not in it, after the rebuffs of the first half of the year. His *Helmingham Dell* was bought at Ludgate's sale for the derisory sum of £2. 15s, a fact that was seized on by *The Morning Chronicle*. In August he went to Suffolk, but, apparently, did nothing, and then sent both of his sons, Charles Golding, and the eldest, John Charles, to Dr Pearce's school at Folkestone. He sent a version of his *Lock* to Brussels, but that rest home for J.L. David accorded him no honours. He began designing illustrations for Gray's *Elegy*, some of which were sent to the Academy the following year, but these seem to have been pot-boilers in a 'Keepsake' mode.

209. *Folkestone: Ford Road and the Ropewalk*. 1833. Water-colour, pencil and traces of sepia and black ink, 12.7 × 21 cm. Cambridge, Fitzwilliam Museum

210. *Landscape Composition. c.* 1833. Indian ink, water-colour, pencil and grey wash with scraping, 10.6 × 14.2 cm. Cambridge, Fitzwilliam Museum

211. *On the Stour with a Farmhouse in the Background. c.* 1834. Water-colour, 14.3 × 19.5 cm. London, British Museum

211. *On the Stour with a Farmhouse in the Background. c.* 1834. Water-colour, 14.3 × 19.5 cm. London, British Museum

In October, he had to rush to Folkestone, where his eldest son had been injured in a fall, sleep-walking. He there produced a number of fresh, charming water-colours, which are at variance with his ravaged mood.

A comparison of one of them, *Folkestone, Ford Road and the Ropewalk* (Plate 209), now in the Fitzwilliam Museum, Cambridge, with an imaginary *Landscape Composition* (Plate 210), also in the Fitzwilliam Museum, shows the range of his art and the state of his mind at this time. The *Ford Road* is the most atmospheric and least topographical of his Folkestone water-colours, all of which are clear and bright. There is some hint that he might have been showing off to his sons' schoolfellows. It is full of feathery, calligraphic touches, which are noticeable in his drawings since at least 1823, and has the feeling, as it were, of 'a healthful breeze at noon'. A rainbow has been included. It is a consummate, even jaunty, finished water-colour of easy distinction. With the other drawing, however, we are in the realm of Constable's own imagination, and it is not unique. It was given to Lucas, possibly to make some point about the chiaroscuro of landscape, and Lucas's inscription tells us that it was 'drawn in the Harrow Paddington with his finger and the revers [*sic*] end of a pen'. 'The Old Harrow' was the inn where Lucas and Constable met to discuss the progress of the prints. The drawing is the embodiment of all that was in Constable's head. Both drawings have chiaroscuro, but whereas the Folkestone view has a careful disposition of light and shade, is colourful, and re-creates an actual scene, with exquisite touches of water-colour, pen and ink, the Paddington drawing is monochromatic, drawn with his finger and anything that came to hand. Forms are indistinguishable, and it is of nowhere identifiable, although it suggests Hampstead, with the family windmill from Suffolk superimposed. Trees, clouds, rain and space are interchangeable in an impassioned evocation of his life's work. It is all dewy moisture and exhilaration. This contrast of two small works is a microcosm of his last years, which he hoped his lectures would explain.

There is no doubt, however, that his private sketches enter a completely private world of ever-increasing complexity, which has no parallel in European art until the twentieth century. It is, as if, as an old man, he is conducting a dialogue with himself about his life's work. There are a number of oil sketches and water-colours, dating from *c.* 1834 onwards, which are totally imaginary sketches towards a finished picture that never came to fruition. Through their dense and agitated surfaces can be seen glimmerings of Suffolk scenes that depend on earlier memories of his Stour Valley subjects. They are, it must be remembered, unfinished studies, not finished works, and there had always been, since at least 1810, a disparity between his sketches and those pictures intended for public exhibition. But whereas his early free sketching from nature could be called impressionistic in its feeling for sunshine and shadow, the broadening of his artistic aims and his concentration on almost irreconcilable opposites of light and dark, serene harmony, and bold phenomena, breezy exhilaration, and still summer days, all made these late studies expressionistic and almost impenetrable. No doubt, the succession of tragic events in his private life, and his frustration with the established art world did not help in the creation of a lucid style.

An outline pen and ink drawing in the British Museum, dated 1829, may have been the first idea for this series of free studies.[36] A water-colour (Plate 211), also in the British Museum, then densely reworks this older theme. It represents, evidently, Willy Lott's House (see Plates 90, 128 and 131), but drawn from memory, and, unusually, from downstream and

212. *On the Stour. c.* 1834. Oil on canvas, 62 × 79 cm. Washington, D.C., The Phillips Collection

on the same bank of the River Stour. It is as if the White Horse had crossed the river. The ferry that plied from near this position is placed centrally, while behind is a turbulent reminiscence of the trees at Flatford Lock. It is remarkable for the same scratchings and flecks that were already noticeable in his drawings for *The Leaping Horse* (Plates 161, 162). An oil sketch (Plate 208) in the Victoria and Albert Museum is seen from a slightly different viewpoint, and it opens out the composition to the right, as do so many of his major works. A dramatic oil (Plate 212), in the Phillips Collection, Washington, D.C., is a variant of these studies. The view is closed in at the right by the cottage, which has been enlarged. The ferry has been replaced by an angler. An oil in the Lady Lever Art Gallery, Port Sunlight, moves the cottage even further to the left, and it is no longer Willy Lott's House, as we know it.[37] The space at the right has been filled by a rainbow. A further sketch, in the possession of University College, Los Angeles, is a combination of these images in a larger format.

No finished picture seems to have emerged from this

frenzied activity of *c.* 1834. The studies were apparently directed towards an image of 'On the Stour' that would combine elements of *The White Horse*, and what came to be *The Valley Farm* (Plate 217). Willy Lott's House, is so important in all these studies, that, perhaps, Constable was attempting to create a symbol of Suffolk longevity to be compared with his own career. According to Leslie, Willy Lott only left his house for four days out of the over eighty years of his life. The strength of Constable's personal involvement has brought with it, obviously, a vehemence of style. These 'On the Stour' studies have been described as 'balanced and mature', but although they express everything of his mature art, their balance is uncertain — space is indefinable, and his quest for 'dews', has given them a nervous flicker of white opaque paint, over a warm, translucent, brown ground, which disguises all forms. His attempt to grasp the very moisture of the atmosphere, can be likened to the late work of Titan, which displays a gestural way of painting that abandons all conventions, in an attempt to come to terms with light, which, to a landscape painter, is life itself. They are further ramifications of Con-

213. *Stoke-by-Nayland*. *c*. 1835. Oil on canvas, 126 × 168.8 cm. Chicago, The Art Institute of Chicago

stable quoting a passage from Thomson for his *Hadleigh Castle*, in which the sun is the origin of life. These 'On the Stour' sketches are at the extremity of realism, and border on the abstract, with wedges and skeins of white set against blocks of dark. They are not smoothed out exercises in 'white lead and oil', which he had loathed, but studies in marks of impasto. The sky is no longer the '*chief* organ of sentiment', but the *only* instrument, in that it invades everywhere, and it is his paint, with flecks of pure reds, greens, and blues, almost independent of form and shadow, which orchestrates his theme. Such 'bravura', however, is not the slick manner that he had criticized in 1802. His manner is a genuine and abstract late style, concerned solely with air and paint.

There are other studies, too, that work out different themes from his heart, that illuminate his past life. Two drawings (Plates 214 and 215), in the Victoria and Albert Museum, are equally difficult to date. The only certain fact about them is that they were drawn sometime after 1831. They have been compared to the blot drawings of Alexander Cozens, or to Leonardo da Vinci's advice about looking at old stained walls

to provide imagery, of which Constable was well aware, but he needed no aid to composition. The image of Dedham Church and Dedham Lock had been engraved on his memory since childhood, and both drawings pick up again the unrealized painting of the early 1820s (Plates 100, 101, 102–4 and see p. 110) which was concerned with a design of Dedham Lock. They are also remarkable studies in sepia, as if he were thinking in terms of mezzotint, of the fall of light, the flicker of reflections from the water by a mill stream, and the density of trees, and how light comes through them, that his art had always described. Their spontaneity and abstract expressive qualities, however, look forward, again, to the twentieth century.

There is only one large-scale finished work of his last years, in which he has allowed this freedom of handling full expression. If the studies for the unresolved 'On the Stour' date from *c*. 1834, then his *Stoke-by-Nayland* (Plate 213) may date from *c*. 1835, when his creative urge had, perhaps, been stirred by a visit to Sussex. He had also been encouraged by his amateur artist friend, William Purton, who liked his work, and

214. *View on the Stour: Dedham Church in the Distance. c.* 1831–6. Pencil and sepia wash, 20.5 × 16.9 cm. London, Victoria and Albert Museum

215. *Trees and a Stretch of Water on the Stour. c.* 1831–6. Pencil and sepia wash, 20 × 16 cm. London, Victoria and Albert Museum

had helped him with the text for *English Landscape Scenery*. He wrote to Purton, sometime in 1835:

> I am glad you encourage me with 'Stoke'. What say you to a summer morning? July or August, at eight or nine o' clock, after a slight shower during the night, to enchance the dews in the shadowed part of the picture under
> 'Hedge row elms and hillocks green'
> Then the plough, cart, horse, gate, cows, donkey &c are all good paintable material for the foreground, and the size of the canvas sufficient to try one's strength, and keep one at full collar.

His spirit sounds sprightly, but his direction is diffused, and his letter is actually strange for a mature artist to write. As had happened before, he changed his picture on the passing comment of an amateur artist. But the letter also reveals what he thought about his work at the time. The painting he is talking about, certainly the late view of *Stoke-by-Nayland*, now at Chicago, is a further variation of his view of the village, which had been engraved by Lucas (Plate 187), and which, in turn, had evolved from his early sketches of *c.* 1810 (Plate 62). His engraving had embodied 'the sentiment of the solemn Stillness of Nature in a Summer's Noon', but now he is asking Purton what would he like. How about a summer morning? What permutation of staffage would suit? So there is a Suffolk plough, and a Suffolk waggon, dimly reminiscent of the dung cart in the *Stour Valley and Dedham Church* (Plate 84), at Boston, drawn up in the lane, while two Suffolk lads pass the time of day overlooked by a giant donkey. The whole has no regard for perspective, space, or the proportion of the houses in the background, the size of the cows in the foreground, or the Ely Cathedral-like dominance of what is a small village church. These niceties no longer bother him. Not because it has been painted by an imitator, as has been suggested, but because the cascading tumble of trees, the darks and lights of the lane, and his love of the place and its atmosphere, permeated with its 'dews', are the sole purpose of its expression. It is an image from the heart, which, as with the late work of all great artists, had become obsessive. The handwriting of the clouds, the trees, and the 'chiaroscuro', which his lectures attempted to define, are all inimitably Constable's. It is a long way in technique from the 'eye-salve' of *The Cornfield* (Plate 169), also a lane scene, or the tentative elegance of his first early morning picture, the Proby *Morning in Dedham Vale* (Plate 58).

It is tempting, but not entirely reasonable to attribute the very agitated manner of these late sketches and paintings solely to personal distress. He had, it is true, further setbacks between 1833 and 1834. He had been ill and depressed at the beginning of 1834 with rheumatism, and had written, sadly, to Leslie, now in the United States, on 20 January 1834, missing him: 'I know not how to write to you. I have been sadly ill since you left England and my mind so depressed that I have scarcely been able to do any one thing', which suggests that he was unable to concentrate or complete anything. To bring his thoughts to coherence for the letterpress of *English Landscape Scenery*, and, then, compose his lectures had also occasioned much anxiety. He had been working again on his *Salisbury*

Cathedral from the Meadows, which was to be sent to Birmingham, but he had been busy on a large landscape.

> I find it of use to myself, though little noticed by others. I find it hard to touch a pencil now that you are not here to see — even when you did not like what I was about. It was a delight to have your (voice) addressed to my canvas — I am now alone — still the trees and the clouds all seem to ask me to do something like them — and that is no small reward for a life of labour.

His illness had prevented the completion of as many finished works in 1834 as he had sent to the Academy in 1832 and 1833. He could only manage a finished water-colour of *Old Sarum* (V&A, R. 359), a detailed study of trees, from Mr Holford's garden at Hampstead, and two further illustrations of Gray's *Elegy*, which were bought by Samuel Rogers.[38] Also in April 1834, he had sent four representative and fairly recent works to the Royal Hibernian Academy, in Dublin, and his *Salisbury* and the *Lock* were sent to Worcester in June. These were conscientious efforts to spread his art on new ground. Nevertheless, he did stir himself by the call of the trees and clouds, and his spirits were raised by a visit to Sussex in July 1834, to see George Constable, at last, in Arundel. This was new territory and he seems to have been surprised by its beauty. He may also have been glad that Leslie had returned from America, and thinking of him continually, he could write immediately on 16 July 1834, with his new impressions. The fact that his son, John Charles, was equally happy collecting fossils with him at Arundel, and had been given an 'electrifying machine' by George Constable obviously gave pleasure to the proud parent:

> The Castle is the cheif ornament of this place — but all here sinks to insignificance in comparison with the woods, and hills. The woods hang from excessive steeps, and precipices, and the trees are beyond everything beautiful: I never saw such beauty in *natural landscape* before. I wish it may influence what I may do in future, for I have too much preferred the picturesque to the beautifull — which will I hope account for the *broken ruggedness of my style*.

Constable seems to have undergone a change of heart, but, almost immediately, in the same letter, he is describing the meadows, the river, old houses and a picturesque old barn, as beautiful. How he actually distinguished between the 'Picturesque' and the 'Beautiful' is not at all clear, or how much he realized that his 'broken ruggedness of style' fitted Payne Knight's description of The Picturesque, but at the very beginnings of his art he had offended the rules of the 'Beautiful', and the 'Picturesque' by his choice of a particularly low-class, rural subject. He was to draw tumble-down 'picturesque' cottages throughout his career, since he had first 'pick'd up' cottages for J.T. Smith, and on his current trip to Sussex. From the moment of his creation of large-scale works in a finished manner, he had been involved with the 'Picturesque' in some way, even if by then it meant for him only the creation of 'painterly' paintings. Payne Knight, again, had praised rich impasto. Constable's stay at Coleorton with Sir George Beaumont had futher modified his outlook. What his stay at

Arundel may have done was to remind him that an individual, or, in his case, 'rugged', or 'ferocious' style, could be acceptable if the subject matter itself was by common consent 'beautiful'. He had already flirted with the 'Sublime' in *Hadleigh Castle* and *Old Sarum*. Perhaps now his last hope for popular success was to avoid criticism by choosing landscape subjects that did not offend immediately, as his Stour Valley scenes had done. To some extent, his remaining works were a last attempt to outwit the arbiters of taste, which Turner had learned so long ago. Turner's style was generally beyond comprehension, and even Constable was to describe Turner's work, two year later, as 'tinted steam', but Turner's subjects, Venice, Ancient and Modern Rome, the Alps, Staffa, could be appreciated as beautiful and grand in themselves. Constable's *Stonehenge, The Cenotaph*, possibly *The Valley Farm*, and his final *Arundel Mill and Castle* were not full so much of 'eye-salve' on their surface, as a sort of 'mind salve', which he hoped would prove popular. His pious hopes of 'making something of nothing' would no longer do.

His own integrity did not allow him to descend to the sentimentality of Collins, or smooth his technique, so that he would be as suave as J.B. Pyne, or F.R. Lee. His lectures, furthermore, composed during this anxious period, are very severe on those Italianate Dutch artists, such as Berchem or Both, and those French artists, such as Boucher, who he thought had lost touch with reality through their artificial manner. Constable's last years, then, can be seen as a hesitant step in a new direction, that is, coming to terms with the taste of his time, which may have, ironically, already moved into a more sentimental Victorian era. At Arundel he did, in fact, produce placid drawings of the sort he had drawn in Suffolk and at Salisbury, when his mind was at ease. A large pencil drawing of *North Stoke* in the British Museum has all his subtlety of tone, which defined space and atmosphere, with telling touches of closely observed detail, which his 1813 and 1814 sketchbooks had revealed so long ago.[39] Another drawing on the same day, 12 July 1834, of a picturesque 'Farmhouse at Houghton', showed that he could be as agitated, with a 'broken ruggedness of style', as he had in Salisbury in 1829.

His pleasant trip had, however, soothed him somewhat. He had visited Petworth and had an agreeable renewal of acquaintanceship with Lord Egremont, who had invited him to stay. He took up the invitation, after much dithering about reminding Lord Egremont to ask him again, in September, when the Leslies were there. It had taken him some time, eleven years earlier, to learn to relax with Sir George Beaumont. With Lady Dysart he was more at ease, and he visited her twice in August at Ham Hall to talk about the woods at Bentley. This, after all, concerned family and local loyalties. On 16 October 1834, he took his boys to see the burning of the Houses of Parliament, as did practically every Londoner, but, unlike Turner, was not moved to paint a picture of it. In December he even sat to Wilkie for a head in his *Columbus*.

In spite of his apparent peace of mind about the publication of his own works, the arguments with Lucas still continued. He had borrowed his *Stratford Mill* from Tinney's widow for Lucas to engrave, and he felt particularly guilty, in view of his

own dilatoriness in the past, that Lucas had kept it so long. When Lucas published prints of *The Lock* and *The Cornfield* commercially, he was beside himself and he was unconstrained in haranguing poor Lucas: 'We all have our foibles and our failings. A love of money has seemed always to me to be yours ... every bit of sunshine [is] clouded over in me.' Luckily, Constable realised he had gone too far and their friendship was resumed and henceforth remained unbroken. In his letter of apology to Lucas, Constable was pleased to announce that he had sold his *Glebe Farm* to George Constable: 'The picturesque is a favourite, but it chose its possessor.' It is not clear if he did, in fact, sell a version to George Constable.[40]

He was now involved in his next major work, which was also a Stour Valley scene, and, as it turned out, his last. His new inspiration and the high ideals of the previous summer in Sussex took a year or more to gestate, and he turned instead to a subject that occurred in one of his earliest oils of *c.* 1802, *Willy Lott's House*. His painting came to be called *The Valley Farm* (Plate 217). He already had it in hand in 1833, and certainly by 1834, when on 17 December he wrote to Purton that he was 'foolishly bent on a large canvas'. His violent sketches of 1834 may also have been part of its genesis, as it features Willy Lott's House so prominently, seen, though, from across the river. He had, in fact, paid a brief visit in January 1835 to Suffolk to vote and his true Blue party was successful, but his visit also stirred memories. The material he assembled for this picture ranged over his entire career, from his early sketch of *c.* 1802, to studies of trees. He even wrote to John Dunthorne Senior on 14 February 1835 for 'poor John's studies of the ashes in the town meadow, and a study of plants that grew in the lane below, Mr. Coleman's, near the spouts which ran into the pond ... I am about an ash or two now', as well as sending him prints of *The Lock* and *The Cornfield* that he had been so annoyed about initially. Constable was thus following his normal procedure for a finished work but on this occasion there was no large-scale sketch, as there was not to be for his next major work. Perhaps he felt his pictures were so much from memory that he needed no trial run. There are, however, detailed drawings of individual items, not from his albums, but drawn specially for the occasion.

To the 1802 oil, he used two pages (31, 70) from the 1813 sketchbook in the Victoria and Albert Museum (R. 121, see Plates 73, 78 for other pages from this sketchbook). Two paintings of *c.* 1814, one (H. 192) and another, previously in the collection of James Lenox and the New York Public Library, were also sketches that he could use. Two further roughly blocked-in oil sketches (see Plate 216), also in the Victoria and Albert Museum, may date from this early period rather than the date of the finished picture, although they have the appearance of compositional studies and may not have been done on the spot. They both have the motif of the ferry and the boatman that he had also used in his 'On the Stour' group. The boatman also appeared in the Ipswich *Mill Stream* of 1814 (Plate 77). A wild small drawing at the Fitzwilliam Museum, Cambridge, is a hasty compositional sketch done close in date to the finished picture. He has, however, also used a drawing from the 1820s of an *Ash Tree* (Plate 218), in the Victoria and Albert Museum, which was later reworked and

216. *Sketch of Willy Lott's House Used for 'The Valley Farm'. c.* 1814. Oil on canvas, 34 × 28 cm. London, Victoria and Albert Museum

217. *The Valley Farm*. 1835. Oil on canvas, 148.6 × 125.7 cm. London, Tate Gallery

219. *Drawing of an Ash Tree. c.* 1835. Pencil and water-colour squared for enlargement, 99 × 68 cm. London, Victoria and Albert Museum

218. *Drawing of an Ash Tree.* 1820s. Pencil, 33 × 23.8 cm. London, Victoria and Albert Museum

enlarged and then transferred by squaring for the picture (Plate 219). Mr Holford's garden proved useful again. A similar companion drawing in the Victoria and Albert Museum may not have been used in the painting, but was a tree, which was mentioned in his lectures, with a vagrant at its foot and a notice board nailed warning of their punishment by 'LAW.' There is also the most charming water-colour of a seated Suffolk girl and her basket (Plate 220), in the Victoria and Albert Museum, who eventually appears reversed and, unfortunately, turned into a witch in the boat. These careful studies show no sign of nervous agitation, and reveal that his ability to sit down and draw carefully had not deserted him.

By March he thought his picture 'must go' to the Academy but, as always, he was not satisfied that it was finished. He complained to Leslie, 'It is woefully deficient in paint in places.' Boner was leaving him for Germany, and Wells had seen it and was grudging about its qualities. To Constable's great delight, however, Mr Vernon came, 'saw it free from the mustiness of old pictures — he saw the daylight purely and bought it — it is his,' as it turned out for £300, the most he had ever received and the first time in his life he had sold an Academy exhibit straight off his easel. Even then, he could not resist a sharp punning remark to a prospective purchaser. Vernon had asked if it was painted for any particular person, to which Constable replied, 'Yes Sir, it was painted for a very *particular person* for whom I have all my life painted.' He wrote to George Constable on 8 April 1835: 'I have got my picture in a very beautifull state, I have kept my brightness without my spottiness, and I have preserved God Almighty's daylight which is enjoyed by all mankind, excepting only the lovers of old dirty canvas, perished pictures at a thousand guineas each, cart grease, tarr and snuff of candles.'

One sometimes wonders whether Constable is talking about the same picture. *The Valley Farm* is one of his darkest works and the press were unduly virulent about its 'spottiness'. *The Literary Gazette* had 'heard of dust being thrown in people's

eyes to prevent their seeing defects. Mr Constable seems to be in the habit, when he has completed a picture, and while it is yet wet, of sprinkling flake white over its surface, from a dredging box, for the purpose of concealing its beauties.' The Revd John Eagles in *Blackwood's Magazine* also had difficulty with Constable's 'dews', and thought his 'conceited imbecility' distressing, and that his picture was 'magnified folly'. After its return from the Academy as Constable's only exhibit, he could not resist working on it further, 'oiling out', 'making out', 'polishing', 'scraping', so that he hoped the 'sleet and snow' had disappeared, leaving in places 'silver, ivory and a little gold'. These techniques of his were all designed to enrich the surface and avoid a flat, dead look. Certainly, the rich, warm textured surfaces of his late works no longer have the fresh natural colours of his earlier paintings, but to compare it with jewellery shows how his attitudes had changed. If the colours he described were far away from nature, and, it would seem,

contradicted his 'God Almighty's daylight', then equally artificial were his methods of construction, and his feeling for space and proportion.

It is again carefully constructed with the double grid of his *Hadleigh Castle*. The central point of his main diagonal is the chimney of the house, and the line of its roof follows this main diagonal to the corner. Another line, below the horizon line, points in the direction of the stumps at the left. The ferry and cows trace the course of the opposite diagonal. These composition lines not only define the picture plane, but are also, as they have been in his previous pictures, his principal lines receding into the depth of space. The tree at the left, and the dark tree at the right are exactly on the line of the vertical division of the picture plane into quarters, and mark the half-centre.

But even with this very carefully worked out construction, his perspective and space are arbitrary. As with his *Stoke-by-*

221. *Littlehampton*. 1835. Water-colour and scraping-out, 16.8 × 25.4 cm. London, British Museum

222. *Old Sarum*. 1834. Water-colour and scraping-out, 30.2 × 48.3 cm. London, Victoria and Albert Museum

223. *Cenotaph to the Memory of Sir Joshua Reynolds, Erected in the Grounds of Coleorton Hall, Leicestershire, by the Late Sir George Beaumont.* 1836. Oil on canvas, 132.1 × 108 cm. London, National Gallery

Nayland, elements are introduced without regard for their overall size. At the left, most noticeably, a giant seems to be leaning on the fence looking down on the woman at the water's edge. He is out of scale, too, with the ploughing scene behind, another episode from Constable's past. It is in this light that we must appreciate *The Valley Farm*, the last of his Stour Valley subjects. It is an artificial construction of the scenes that had made him a painter, and, in spite of his protestations to the contrary, naturalism has been replaced by the act of painting for its own sake: from an ever-more elaborate geometrical construction of its surface, to an ever-more impenetrability. It is a harmony in silver and gold, as Whistler might have called it, and in this looks forward to the symbolists, and the art of the late nineteenth century.

Vernon had still not received his picture by 9 December. Constable admitted to Leslie, he 'had been fidgetting about it — but it never was half so good before, and I will do as I like with it, for I have a greater interest in it than anybody else'.

Constable had taken up his landscape lectures again, speaking at the Hampstead Assembly Rooms on 22 June, which apparently, as he reported to Boner, 'went off extremely well. I was never flurried — only occasionally referring to notes.' Constable in July of 1835 then paid another visit to Arundel with his two eldest children. A sketchbook that survives (Victoria and Albert Museum, R. 382) shows that he made visits to Littlehampton (see Plate 221), and Fittleworth, as well as drawing old cottages, ruins, and Sussex antiquities. In it are two studies, which together with a larger finished drawing of *Arundel Mill and Castle*, he used in 1836 and 1837 for his last major work.

In August, his son, Charles Golding, aged fourteen, about to enter a life in the East Indian Merchant Marine, joined his first ship, *The Buckinghamshire*, and set sail for Bombay, much to his father's distress. Constable gave three further lectures at Worcester on 6, 8 and 9 October, where he had also sent five pictures for exhibition. In a show of misplaced loyalty to his protégé, he tried unsuccessfully to have David Lucas elected as an ARA. At the beginning of 1836, after his success in Worcester, he offered his services as a lecturer to the Royal Institution in Albemarle St, in London, and Michael Faraday was pleased to accept him. His son, John Charles, had been attending scientific lectures, and part of Constable's aims were not only to justify landscape as a legitimate branch of art but to persuade a sympathetic audience that it could be compared with science: 'Painting is a science, and should be pursued as an inquiry into the laws of nature. Why, then, may not landscape be considered as a branch of natural philosophy, of which pictures are but the experiments' he asked in his last lecture.[41] From a note found by Leslie, it is clear that he hoped his researches into meteorology, colour, the laws of optics, the effects of a rainbow, geology, and plant life, all of which had occupied him during his latter years, would be combined: 'In such an age as this, painting should be *understood*, not looked on with blind wonder, nor considered only a poetic aspiration, but as a pursuit, *legitimate, scientific, and mechanical*.[42] His lectures, which were well attended, with an average audience of about two hundred people, were given at the end of May and beginning of June, after the Royal Academy had opened

with two of his works. His lectures gave a considered view of the history of landscape, but he was also clearly justifying his own approach, and what he said could be applied to his exhibited works.

Of all his late paintings, perhaps the two most satisfactory are the two he showed in 1836, his *The Cenotaph* (Plate 223), now in the National Gallery, London, and his water-colour of *Stonehenge* (Plate 226), in the Victoria and Albert Museum. They combine all the complexities of his late style, and his new-found grandeur of landscape without the dense impenetrability of his late manner, which is so often disturbing. These two works are romantic images, which stand outside their time, and yet are part of its taste so successfully because they combine his knowledge of old master painting, and his own individual style, with subjects that could be seen to be respectable. The full title of the *Cenotaph* (Plate 223) as it was exhibited at the Academy, was *Cenotaph to the Memory of Sir Joshua Reynolds, erected in the grounds of Coleorton Hall, Leicestershire, by the late Sir George Beaumont*, and also included part of Wordsworth's lines that were written on the plinth and which he had transcribed on his visit to Coleorton in 1823, when he had made his initial drawing:

Ye lime trees ranged before this hallowed urn. .
. . . . Where REYNOLDS' mid our country's noblest dead,
In the last sanctity of fame is laid;

He had first considered finishing his *Arundel Mill and Castle*, already begun, in time for the Academy, but, as he wrote to George Constable on 12 May 1836, he found he could not do both, 'and so I preferred to see Sir Joshua Reynolds' name and Sir George Beaumont's once more in the catalogue, for the last time in the old house'. The Academy was about to move from Somerset House to the new National Gallery buildings in Trafalgar Square. After the opening of the Exhibition, Constable had, revealingly, refused to let the newspapers into his house for fear of adverse criticism about his *Cenotaph*. He need not have worried. No academician could complain. His painting was an act of homage to the Royal Academy's first President, Reynolds, and an honorary exhibitor, Beaumont, who had done so much for both the Academy and the foundation of the National Gallery. To them he has added the busts of Michelangelo and Raphael, which were not actually on the site. Rather like Sir Joshua's last Discourse, Constable finished at Somerset House with the names of Michelangelo, and Raphael, for good measure. The painting is dense and enclosed and is comparable to his studies of Helmingham, that is, it re-created a special hallowed spot. He thus brought the acceptability of history painting to his landscape.

If we had no other water-colour from Constable's hand, then *Stonehenge* (Plate 226), would rank with any of his oils as a masterpiece in a medium that he rarely resorted to for his finished statements. If it is compared with other of his late water-colours such as the British Museum's *On the Stour* (Plate 211), or a loosely painted oil, such as *A Cottage among Trees with a Sandbank* (Plate 224), in the Victoria and Albert Museum, then the strength and subtlety of *Stonehenge* is immediately obvious. It was based on a careful pencil drawing made on his visit to Salisbury in 1820 (Plate 225), but this patient study has

224. *A Cottage among Trees with a Sandbank. c.* 1835–6. Oil on paper laid on canvas, 17.8 × 21.9 cm. London, Victoria and Albert Museum

225. *Stonehenge.* 1820. Pencil, 11.5 × 18.7 cm. London, Victoria and Albert Museum

226. *Stonehenge*. 1836. Water-colour, 38.7 × 59.1 cm. London, Victoria and Albert Museum

been transformed into a dramatic and timeless image, which, for once in his late work, reconciles his highest aims with complete clarity. As in the best of his work, it is both timeless and immediate, and its presence as an image, based on observed fact, is helped by his choice of subject matter. With this one work he has finally equalled Turner's difficult but successful role as a history painter disguised as a practitioner in landscape. As Turner had done before him, he disarmed academic criticism by accompanying his water-colour in the exhibition with a suitable quotation: 'The mysterious monument of Stonehenge, standing remote on a bare and boundless heath, as much unconnected with the events of past ages as it is with the uses of the present, carries you back beyond all historical records into the obscurity of a totally unknown period.' He had painted the 'Sublime' before, notably with *Hadleigh Castle*, but in this large water-colour all the evanescent effects of nature together with the 'grander phenomena' of a double rainbow falling on the exact centre of this solid ruin touches that general spirit which he had so often missed. There is even a hare, running out of the picture to point up the contrast between fleeting effects and timeless solidity. Even if we did not know all this, as Constable had asked about

Ruisdael, its mastery of touch with the translucent medium of water-colour in the sky, and his skill at rendering the structure of the stones, its control of 'chiaroscuro' are cause for admiration. Again, his geometric structure of diagonals on the picture plane helps also to define space: such as the line of stones and the hare which are on one line from left to far right. Key points in its composition have their decisive effect because of his vertical division into four, so that the standing stones with a lintel at the left, and the waggon train at the right are precisely placed at the half-centre. He had already been working on it in September 1835, when he wrote to Leslie on the fourteenth: 'I have made a beautiful drawing of Stone Henge. I venture to use such an expression to you', and in this instance his own judgement was correct. His use of the term 'beautiful', seems to have been a conscious effort to come to terms with the climate of criticism which so often found fault with his works. In the past, he had held stubbornly to the view that his own scenery and interests would provide beauty enough. It may have been the preparation of his lectures, as well as his discovery of the beauty of Sussex, which caused him to modify his attitudes, but his process of change and development had already been in train since his visit to Coleorton in 1823.

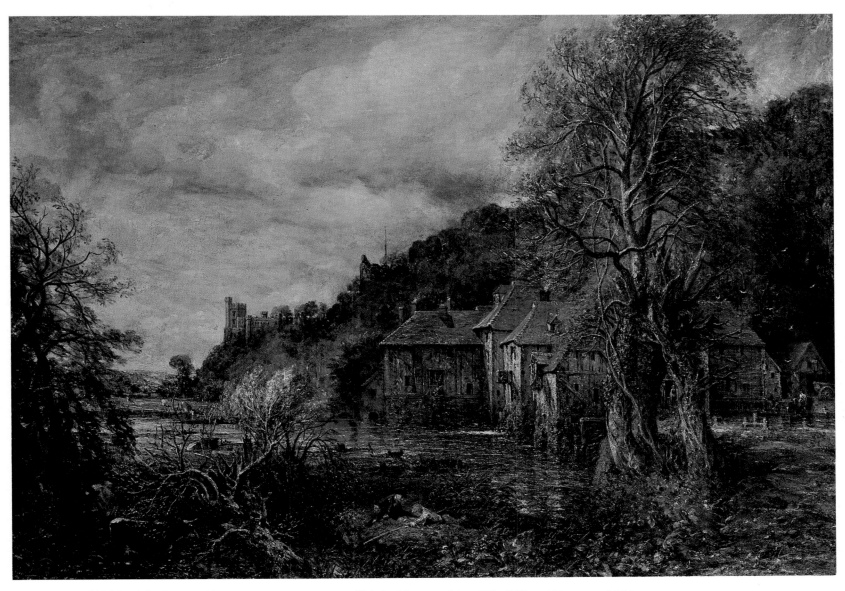

227. *Arundel Mill and Castle*. 1837. Oil on canvas, 72.4 × 100.3 cm. Toledo, Museum of Art, Gift of Edward Drummond Libbey

The lectures on landscape, however, to which he had devoted as much research and thought as he had on clouds, rainbows, and the growth of trees, finally brought him to the point of making a concise explanation of his art. It is unfortunate that his complete texts do not survive, and we know that much of what he said was impromptu, in the same way as was the execution of his paintings. Nevertheless, enough underlying structure survives from scraps of his own notes, and Leslie's recollections and notes, to reveal him as a serious art historian, when the subject hardly existed in England.[43] He was, for example, in the vanguard of taste for his appreciation and hard-won knowledge of the early Italian painters, and early German and Netherlandish masters. He had visited Mrs Aders' collection of German painting in London, and wrote to her in gratitude: 'how very superior, how affecting is The Art in its purity, so totally free from vulgarity so spiritual'.[44] It was not until the Victorian age that similar sentiments could be expressed freely, apart from such pioneers in taste as Flaxman, Blake, Roscoe, Charles Eastlake, and Ottley, whom he knew. And Constable, it must be remembered, had never been abroad. Tuscan hill towns and Gothic Germany were unknown to him, except through the medium

of prints, as they had been earlier to Blake, and from his extensive library.[45]

It is, however, with the great masters of landscape that we feel his wisdom. He had begun his first lecture at Hampstead with some trepidation; by 1836 at the Royal Institution, between 26 May, 2, 9 and 16 June, his knowledge and confidence had increased. He was particularly pleased to see Wordsworth in his audience, and on 15 June he sent him a copy of his *English Landscape Scenery*, and hoped Wordsworth would be at his last lecture. This letter is of interest, too, because it reveals it was through their mutual patron, Sir George Beaumont, that Constable first saw a volume of Wordsworth's *Lyrical Ballads*. probably in 1801 or 1802. This contact with the great naturalistic poet of Romanticism at this time was until recently unknown, and may have been the reason that in his last lecture at Hampstead, he quoted Wordsworth.[46]

Constable's comments on the whole development of landscape from its earliest beginnings can still be read with profit by present-day students of art history, who have all the benefits of a vast literature, the availability of images, and blockbuster exhibitions, even if we allow his occasional artistic prejudice

239

and misconceptions. We must not forget that Constable was talking without the benefit of the magic lantern, so that his illustrations were tables and charts, prints and copies, pinned up for his audience to see. He was, apparently, quite good at lecturing, unlike Turner, whose lectures were incoherent, and inaudible. Constable was also speaking with passion, after a lifetime's experience, about what he had won with great difficulty, and not just gathered together casually for a one-night appearance. Those aspects of his lectures that tell us most about his own art laid down precepts, to which he hoped to adhere and from which we can also learn. His course had not always been as straight as he had hoped, but, like the River Stour, broadened at the end.

Apart from his deep feeling for Claude, and sensitive appreciation of Gainsborough, which have been quoted earlier (see pp. 27–8, and pp. 23–26), what he had to say about the Dutch and Flemish schools seems most pertinent to his own art:

> In no other branch of the art is Rubens greater than in landscape; the freshness and dewy light, the joyous and animated character which he has imparted to it, impressing on the level and monotonous scenery of Flanders all the richness which belongs to its noblest features.
>
> Rubens delighted in phenomena; rainbows upon a stormy sky — bursts of sunshine — moonlight — meteors — and impetuous torrents mingling their sound with wind and waves. Among his finest works are a pair of landscapes, which came to England from Genoa, one of which is now in the National Gallery [*Chateau de Steen*].
>
> By the rainbow of Rubens, I do not allude to a particular picture, for Rubens often introduced it; I mean, indeed, more than the rainbow itself, I mean dewy light and freshness, the departing shower, with the exhilaration of the returning sun, effects which Rubens, more than any other painter has perfected on canvas . . .

Constable could have been describing the almost irreconcilable aims of his last works. Similarly, when he attempted to describe the chiaroscuro of Rembrandt, he undoubtedly had his own art in mind:

> Rembrandt's *Mill* is a picture wholly made by chiaroscuro; the last ray of light just gleams on the upper sail of the mill, and all other details are lost in large and simple masses of shade. . . .
>
> Chiaroscuro is by no means confined to dark pictures; the works of Cuyp, though generally light, are full of it. It may be defined as that power which creates space; we find it everywhere and at all times in nature; opposition, union, light, shade, reflection, and refraction, all contribute to it. . . .
>
> In Claude's pictures, with scarcely an exception, the sun ever shines. Ruysdael, on the contrary, delighted in, and has made delightful to our eyes, those solemn days, peculiar to his country and ours, when without storm, large rolling clouds scarcely permit a ray of sunlight to break the shades of the forest. By these effects he enveloped the most ordinary scenes in grandeur.

With comments such as these, we are better able to understand Constable's *Cenotaph* (Plate 223), *The Valley Farm*, or his views of *Helmingham Dell* (Plates 195 and 196). An interesting test case as to whether his hopes were achieved, is provided by his last Hampstead Heath view, *Hampstead Heath with a Rainbow* (Plate 228), now in the Tate Gallery, which was delivered to its owner in September 1836. Its possessor, W. George Jennings, was an amateur artist and admirer of Constable's work. He had paid £50, which he admitted were generous terms, and wrote enthusiastically: 'it is most admirable. As for the Sky and distance nothing finer was, or ever will be put upon canvass — to use the words of An: Carracci you have ground, not colour, but pure air, they are absolutely aetherial — To the extraordinary power of Art you have added all the *Truth* of nature & what more can painting accomplish?' He went on to praise 'the dewy freshness of the Summer Shower', and his letter uses all Constable's own particular terms. The painting is the last dramatic development of the Hampstead Heath series begun in 1819 (see Plate 108), but in its agitated handling and sheer invention — the double rainbow falls on a windmill that never existed, it presents a very different mood from his calm views of the Heath as it was (see Plates 121, 124). Yet its owner spoke of it, as if everything Constable intended in his last works had been achieved. He himself, doubtless pleased to receive such a sympathetic letter from Jennings, wrote to George Constable on 16 September: 'I have lately turned out one of my best bits of Heath so fresh — so bright, dewy & sunshiney, — that I preferred [it] to any former effort . . . painted for a very old friend — an amateur who well knows how to appreciate it for I now see that I shall never be able to paint down to Ignorance, almost all the world is . . . ignorant and Vulgar.' Could we now look at it in the same way? Or does his obsessive working of the surface and its drama of the storm interfere with our appreciation of it?

During the autumn of 1836, he was saddened by the departure of Charley for the Far East, again, in November, but during the winter of 1836/7, he was much engaged working with Lucas on further proofs of his engravings, particularly a large plate of his *Salisbury Cathedral from the Meadows*. For once, he was fairly satisfied with its progress: 'The print is a noble and beautifull thing . . . the bow is noble.' He decided to call it *The Rainbow, Salisbury*, after going the rounds of friendly Academicians to ask about a suitable title. He had hoped, the previous February of 1835, that its sentiment would be 'that of solemnity, not gaiety . . . yet it must be bright, clear, alive, fresh'.

Similar sentiments occupied him with his painting of *Arundel Mill and Castle* (Plate 227), which he had again taken up. His son, John Charles, had been the first to encourage him to paint this subject from the drawings he had made in 1835, and he, not George Constable, bought it at the artist's posthumous sale. By May 1836, it had been 'prettily laid in as far as chiaroscuro', as he wrote to George Constable, and on 17 February 1837, he wrote again to him, that he was 'at work on a beautifull subject, Arundel Mill, for which I am indebted to your friendship. It is, and shall be, my best picture — the size, three or four feet. It is safe for the Exhibition, as we have as much as six weeks good.' These six weeks were all he was to be allowed.

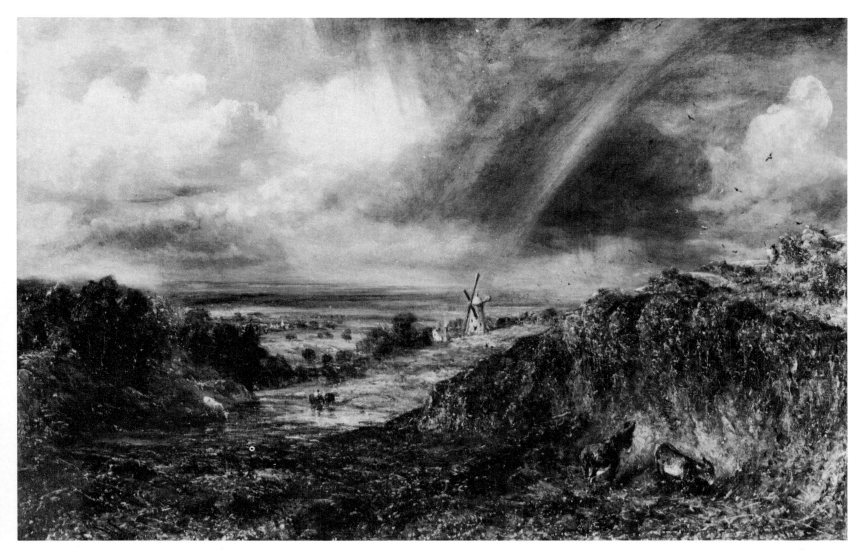

228. *Hampstead Heath with a Rainbow*. 1836. Oil on canvas, 50.8 × 76.2 cm. London, Tate Gallery

He had been reappointed as Visitor, taking the place of Turner, in the Life Class held for the last time in Somerset House. He had set the male model as the assassin in Titian's *St. Peter Martyr*, one of his favourite pictures, which he had seen only in the form of prints, and on 25 March, he gave a short concluding speech to the students, reminding them of the values of British art, for which he was cheered. On 28 March, he was visited by Alfred Tidey (1808–92), the miniaturist, who saw him at work on his *Arundel Mill*. According to Tidey's recollections in 1888, Constable 'seemed well satisfied with the result of his labours. He said while giving a touch here and there with his palette knife, and retiring to see the effect, "it is neither too warm, nor too cold, too light nor too dark and this constitutes everything in a Picture".'

Leslie saw him for the last time on the evening of 30 March while walking home from a general assembly of the Academy. Constable complained of being taken advantage of financially, but during their walk he went out of his way to give a shilling to a distressed beggar child. The two friends parted laughing. According to Leslie, on the evening of 31 March, Constable went out on one of his many charitable errands, connected

with the Artist's Benevolent Fund. 'He returned about nine o'clock, ate a hearty supper, and feeling chilly, had his bed warmed, a luxury he rarely indulged in. It was his custom to read; between ten and eleven he had read himself to sleep.' He awoke in pain, called his son, John Charles, who had just returned from the theatre, and within half an hour, in his attic room at Charlotte St, was dead, it is thought from a heart attack, at the age of 61. Leslie identified his bedside book as Southey's *Life of Cowper*, so dear to him during his courtship of Maria, and he was buried by her in the vault at Hampstead.

According to a rule of the Academy, a deceased artist's work could appear at the Exhibition following his death, and *Arundel Mill and Castle* (Plate 227), now in the Toledo Museum of Art, was thought to be sufficiently finished to be shown. It was his only work in the new rooms of the National Gallery in 1837. A small sketch (Plate 229), in the Fine Arts Museum of San Francisco, has been thought to have been done on the spot, and it belonged to George Constable. It is now so rubbed and bleached, that it is difficult to be sure of its exact status, but it may have been his only preliminary compositional sketch for the large painting, done away from the motif. It contains some

241

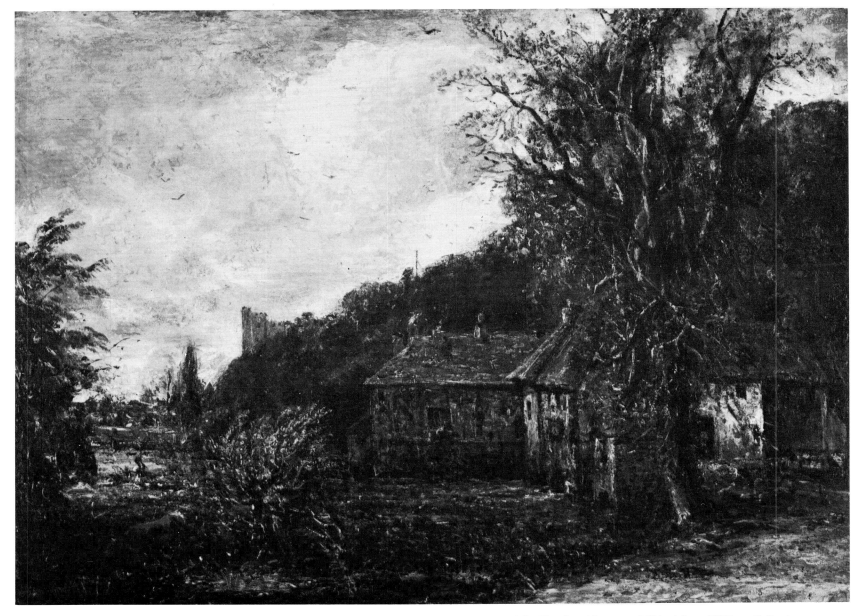

229. *Sketch for Arundel Mill and Castle*. 1835–6. Oil on board, 29.5 × 40.6 cm. San Francisco, The Fine Arts Museums, Mildred Anna Williams Collection.

of the underlying geometry, which occurs, in a more rigorous manner, in the finished work, but with only one cow at the left, and without the fisherboys in the foreground of the exhibited picture, who first appeared as early as 1813. His son, John Charles, had enjoyed fishing in Sussex and looked forward to going there again in the summer of 1837. Amazingly, however, given George Constable's relation with his namesake, he was later accused by Leslie of perpetrating forgeries, so that some caution should be exercised about the San Francisco sketch. Nevertheless, in spite of its present over-cleaned state, it must be considered as genuine.

The Toledo painting has that looseness of manner, and vibrancy of 'dew', which are to be found in all Constable's late works, and which are more restrained in the finished picture. His attempts to reconcile light and dark, warm and cold, are clear from his description to Tidey, and in it he has made

much use of bitumen to enrich his darks, such as the rump of the cow at the left, which opposes black and white. There are other flecks of light and dark on the water, and at the right, to give a kaleidoscope of his chiaroscuro. Yet, as he had told Tidey, it has that overall warmth of tone of his late works, balanced by the cool light of the sky. It also had the severe geometry, which held his late works together. The central point is the large square loading hatch of the mill, to which his perspective lines from left and right converge, on the horizon line. The vertical accents, at the half centres, are emphasized by the tower of the castle, and the large tree at the right. A further construction line leads from the flagpole in the centre of the picture down the lines of the gables to the right hand corner. By his immensely rich and detailed foreground, however, these guide lines are disguised, and the picture remains, as he had hoped, a triumph of his last days.

Conclusion

We do not know how Constable's art would have developed. To his original feeling that 'there was room enough for a natural peinture', he had tried to remain faithful, until the provision of large-scale works for exhibition, executed away from the motif had taken his art a stage further, so that his pictures became not so much transcripts of the visible world, but reminiscences of the places to which he was emotionally attached, painted in a style that came increasingly out of himself, with a 'bravura' that he had originally frowned upon. His method of working in oil, with combinations of glazes and thick impasto, gave his works a richness of texture that took on a life of its own, and in this way his marks no longer described objects, as they had done during his early career, but attempted to grasp the surrounding atmosphere. He had imagined himself driving a nail to secure realism, but in the end he found himself constructing a 'noble' art, concerned with the 'beautifull', and 'grandeur', in abstract terms. That he had done it at all, against the taste for his 'rural' picturesque, was part of his achievement as a Romantic artist, to be ranked with Wordsworth and Turner amongst the heroes of the Romantic movement. It is not surprising, therefore, that at the end of his life, he could appreciate Turner's 'tinted steam', because he, too, had finally come to terms with the ineffableness of light and colour. Constable's range of subject matter was, however, always more restricted than Turner's. Only at the end of his life did he emulate Turner's pathos, and, then, he applied his feeling for 'grandeur', and 'solemnity' strictly to his own closely observed subjects. He may have worked, and lectured impromptu, but his laborious and painstaking art is in strong contrast to Turner's rapid and confident technique, based as it was on his earliest beginnings as a water-colourist and a warier view of the world. Equally different are Constable's lack of self-confidence, in the face of 'ignorance'.

The glib way of lesser contemporaries such as Collins, J.B. Pyne, or F.R. Lee, was not for him.

Constable had no followers of any magnitude. Paintings by F.W. Watts (1800–62), or Constable's son, Lionel, once they are identified, seem either too generalized, or small-minded. Even at the end of the nineteenth century, or the beginning of the twentieth century, when forgers were copying his mezzotints, the works of Wilson Steer, a genuine imitator, move only by their surface. The Impressionists, in some sense, through the influence of the Barbizon School, could be said to be his logical heirs, but his feeling for the timelessness of landscape, its 'moral feel', and his emotional involvement with it, stand apart from their immediacy. Only, perhaps, in their different ways, can the late work of Monet, and that of Cézanne, be seen to exhibit the same obsession with place and paint. In Constable's Romantic art were the seeds of, on the one hand, the logical developments of Neo-Impressionism, and, on the other, the personal extremities of Van Gogh. If anything, his work looks forward to the inventions of the twentieth century, when, as the other side of the classical coin, paint and gesture could rank equally with subject and space. As with many works of the twentieth century, because of the force of his personal artistic revolution, there is, equally, little regard for social comment in his paintings.

Among papers that Leslie found after Constable's death was, perhaps, Constable's own best obituary, to stand with *The White Horse, The Haywain,* and *Cornfield,* and his *Stonehenge,* for his sturdy Suffolk art:

> My art flatters nobody by imitation, it courts nobody
> by *smoothness,* it tickles nobody by *petiteness,* it is
> without either *fal de lal,* or *fiddle de dee,* how then
> can I hope to be popular.

He would have been surprised at how much his art is now so universally loved.

Notes

Chapter 1

1. Wilton 1, Shirley 27. The inscription reads:

 > Hic locus aetatis nostrae primordia novit
 > Annos Felices Lactitiaeque dies:
 > Hic locus ingenuis pueriles imbuit annos
 > Artibus, et nostrae laudis origo fuit.

 The quotation has not been identified but a translation appears in John Fisher's hand on a loose sheet in a sketchbook in the Louvre R.F. 08700 (see JCC, VI, p. 54). A further translation by Christopher Cookson, the eldest of Mrs Fisher's three brothers is transcribed from the same sheet in JCFDC, pp. 116–17. It may have been written by Fisher himself.

2. JCC, VI, p. 78.
3. JCC, IV, p. 387.
4. *Life*, p. 1.
5. Fitzwilliam Museum, Cambridge, no. 3314b, Gadney 30.
6. *Diary*, p. 233, 15 September 1794.
7. A Frenchman, François de la Rochefoucauld had toured Suffolk in 1774, and saw that 'the land is better cultivated than Essex. . . . All the fields are small and enclosed; houses and farms abound and all bear the mark of tidiness and prosperity.' Quoted by Rosenthal, 1983, p. 11, from S. C. Roberts, *A Frenchman in England*, Cambridge, 1933, pp. 172–3.

 Cobbett remarked that 'you can, in no direction go . . . a quarter of a mile without finding views a painter might crave, and then the country round about it so well cultivated; the land in such a beautiful state'. Quoted by Rosenthal, p. 11, from W. Cobbett, *Rural Rides*, London, 1853, II, p. 225.

8. Robert Southey in his *Letters from England*, 1807, poked fun at the mania for the Picturesque: 'Within the last thirty years a taste for the picturesque has sprung up; and a course of summer travelling is now looked upon to be as essential as ever a course of spring physic was in old times.' For more recent surveys of this phenomenon see:— C. Hussey, *The Picturesque*, London, 1927; W. Hipple, *The Beautiful, the Sublime and the Picturesque*, New York, 1957; M. Clarke, *The Tempting Prospect*, London, 1981.
9. The celebrated print by H. Merke after Rowlandson's design, *An Artist Travelling in Wales*, 1799, aquatint.
10. Gilpin, 1809.
11. *Life*, p. 25.
12. JCC, VI, p. 185.
13. *Life*, p. 4.
14. JCC, II, p. 127, and JCC, I, pp. 104–5. Constable's use of the word 'cottage' suggests that his family had not yet moved to East Bergholt House, although the date generally given is 1774. He can hardly have been farmed out to a wet nurse immediately on birth. The house does not occur in the rate lists until 1779 but his inscription on p. 34 of the 1813 sketchbook describes it as the 'House in which I was born.'
15. *Life*, p. 2 and JCC, I, pp. 307–10. Beckett shows the fallacy of this tradition of the Constables coming from Yorkshire, which was largely invented by Mary Constable.
16. JCC, I, pp. 3–8.
17. Quoted from the diary of John Crozier, a miller of Maldon, Essex, now in Essex Records Office, in A. Smart and A. Brooks, 1976, p. 17.
18. From *Ipswich Journal*, 19 August 1797, quoted in Rosenthal, 1983, p. 8.
19. See A. Smart and A. Brooks, p. 17. For other references to the servants and gardeners, Prestney and Peck, see JCC, I, pp. 83–4. James Revans constantly occurs in the family correspondence from JCC, I, p. 6 onwards. John's father writes in 1811 with some anxiety about the taking of his mate Zachariah Savell by the Press Gang and relates that the Master, William Frances, had run away. JCC, I, p. 62.
20. See JCC, I, pp. 135–6.
21. See JCC, I, pp. 316–21, for family trees.
22. JCFDC, pp. 114–16.
23. JCC, VI, p. 88.
24. For Constable's conservatism, see, for example, his outburst against the Reform Bill of 1832: 'It goes to give the government into the hands of the rabble and dregs of the people, and the devil's agents on earth — the agitators. . . . No Wigg government ever did or can do good to *this* peculiar country — they are always the blocks as well as the wiggs — and always when in power, are our worst stumbling blocks.' JCC, III, p. 49. For the loyalty of their servants, see JCC, I, p. 6.
25. JCC, I, p. 6 and JCFCD, p. 56.
26. JCC, I, p. 286.
27. JCC, I, p. 6.
28. JCC, I, p. 68.
29. Hoskins, p. 141.
30. For Clare's preference for the wild state of the heathland over enclosed land see *The Village Minstrel and Other Poems*, 1821, for example: 'Ye Commons left free in the rude rags of nature' and 'Ye injured fields ye once were gay/When Nature's hand displayed.' Clare was born in 1793 at Helpston, Hunts., which was finally enclosed in 1809. For further information see J. W. and Anne Tibble, *John Clare*, 1933, and *idem, Prose of John Clare*, 1951. Clare reveals a happier view of nature in *The Shepherd's Calendar* of 1827, perhaps closer to Constable's.
31. Hoskins, p. 142.
32. Ian Fleming-Williams, 'A Runover Dungle and a Possible Date for "Spring"', *Burlington Magazine*, CXIV, June 1972, p. 390 and Rosenthal, 1983, p. 206, p. 246 n. 70 for the dating of the sketch to 1821.
33. Reynolds, 1965, p. 16.
34. For a detailed description and account of the arson and riots see Rosenthal, 1983, p. 207 ff.
35. For statistics of the Lexden Hundred, Colchester Division in which Dedham lay and the Samford Hundred, in which East Bergholt lay, including acreage — that of East Bergholt declined in the twentieth century; population, 970 in 1801 and 1360 in 1831; average weekly wages 10s. 10¾d. in 1800, 12s. 0d. in 1830; and the price of wheat, bread and meat, and rents, see *The Victoria History of the Country of England: Essex*, ed. William Page and J. H. Round, London, 1907, vol. II, p. 342 and *The Victoria History of England; Suffolk*, I, London, 1911, p. 690.

36. JCC, I, pp. 190–1.
37. G. E. Mingay, *English Landed Society in the Eighteenth Century*, London, 1963, p. 185, quoted by J. Hayes, *The Landscape Paintings of Gainsborough*, 1982, p. 27, no. 40.
38. JCC, I, pp. 295–300.
39. For John Stollery see JCC, I, pp. 68–70; for the theft of the watch see JCC, I, p. 204.
40. JCC, VI, p. 108, 1 February 1823.

Chapter 2

1. *Life*, p. 3.
2. For Gainsborough's remark, see Hayes, pp. 40–1. For Constable's, JCC, VI, p. 78.
3. *Life*, p. 3.
4. JCFDC, p. 54.
5. For Beaumont, see Herrmann and Owen; and for Beaumont and Girtin, Sotheby's Sale, 16 March 1978, lots 91–5.
6. *Diary*, 5 June 1815.
7. *Life*, p. 5.
8. Turner's admiration for Claude, and his sense of rivalry with the art of the past, is shown by his bequest to the nation of his own *Dido Building Carthage* and *The Sun Rising Through Vapour*, on condition that they hung between two Claudes, *The Marriage of Isaac and Rebecca('The Mill')*, and *Seaport: The Embarkation of the Queen of Sheba*.
9. *Discourses*, pp. 52–3.
10. For John Thomas Smith, known as 'Antiquity', after his book *The Antiquities of London and its Environs*, 1800, or 'Nollekens', after *Nollekens and his Times*, 2 vols., 1828, see *A Book for a Rainy Day*, 1845 (1905 ed.). See also JCC, II, pp. 3 ff.
11. Smith, 1905, p. 136.
12. JCC, II, p. 5.
13. JCFCD, p. 54.
14. For Gilpin and The Picturesque, see C. P. Barbier. The passage quoted here is from a MS essay in the Fitzwilliam Museum, Cambridge, entitled 'Introduction for Examining Landscape' (where the drawings he refers to are to be found), some of which is quoted by Barbier. Constable owned four of Gilpin's published works, as well as the principal published sources for The Picturesque, e.g.: Burke, Uvedale Price and Payne Knight (see JCFDC, pp. 25–52 and the present Bibliography). For more recent discussions see also the Bibliography, under: Bicknell, Hipple, Hussey and Watkin. It has been argued by Rosenthal, 1983, that Constable's work fits a normal definition of the Picturesque, but it does not fit Gilpin's.
15. *Life*, p. 7.
16. *Diary*, IV, 1425, 1 August 1800.
17. JCC, V, p. 27.
18. For Constable, JCC, III, p. 19; and for Gainsborough, Woodall, p. 99.
19. *Discourses*, p. 59.
20. Smith, 1905, p. 160.
21. JCC, II, p. 16.
22. Woodall, p. 91, 22 May 1788.
23. JCC, III, p. 16.
24. JCFCD, p. 199 ff.
25. Tate 1976 (7) and (8).
26. JCC, II, p. 14.
27. *Diary*, IV, p. 1164, 26 February 1799.
28. *Diary*, p. 1166, 2 March 1799.
29. *Diary*, p. 1202.
30. JCC, II, p. 17.
31. For Reinagle, see Ellis Waterhouse, *The Dictionary of British 18th Century Painters*, Woodbridge, 1981, p. 300 and for his relations with Constable see JCC, IV, pp. 214–22. For examples of drawings by Constable which are close to Reinagle's, see Tate 1976, pp. 11–14, of *c.* 1797–9.
32. *Diary*, p. 1223.
33. *Diary*, VIII, pp. 3080–1, 6 July 1807.
34. *Diary*, p. 1516, 9 March 1801.
35. JCC, II, p. 24.
36. JCC, II, p. 26.
37. *The Prelude*, 1805 ed., III, 511–16.
38. *Diary*, p. 1399, 29 May 1800.

39. *Diary*, p. 1518, 13 March 1801.
40. *Diary*, p. 1219, 8 May 1799.
41. *Diary*, p. 1527, 25 March 1801.
42. Henry Monro's Diary for 1808, JCC, IV, p. 236.
43. *Life*, p. 6.
44. JCC, II, p. 25.
45. Examples of early drawings in the manner of Frost and Gainsborough are at the Fitzwilliam Museum, Cambridge; Oldham; Huntington Library, San Marino, California; and a private collection. For drawings by Frost and the relationship between Frost and Constable, see Frank Brown, *George Frost Drawings of Ipswich and Sketches of Suffolk*, Ipswich, 1895; *idem*, November 1966, pp. 163–8; John Hayes, 1970, pp. 71–6; M. Rosenthal, 1974; *idem*, November 1974, pp. 41–2; *idem*, 1976; Fleming-Williams, 1976, pp. 8, 24–5; Gadney, 1976, pp. 12, 40 (2).
46. JCC, II, p. 25.
47. JCC, II, p. 19.
48. JCC, II, p. 344.
49. JCC, II, pp. 17–21, and JCC, VI, p. 5.
50. Reynolds, 16A and 16B; Tate Gallery, 1976 (22).
51. The Panorama was a painted landscape or townscape, either arranged on the inside of cylinder with the spectator in the centre (a *cyclorama*) or a scene that was unrolled or unfolded successively in front of the spectator. A patent for such a device was granted to Robert Ker Porter in 1787, although Robert Barker, the Scottish inventor, is generally credited with first showing the Panorama in London in 1789, and he became the proprietor of the Leicester Square Panorama. Reinagle engaged in an unsuccessful speculation with one of Barker's sons, Thomas Edward Barker. Constable wrote to Dunthorne in 1803: 'Panorama painting seems all the rage. There are four or five now exhibiting, and Mr. Reinagle is coming out with another, a view of Rome' (JCC, II, p. 34).

Girtin produced a large panorama of London called the *Eidometropolis*, which was exhibited at Spring Gardens in 1802, although it may have been produced a few years earlier (Girtin and Loshak, pp. 33–6, 45). It apparently covered as much as 1944 sq. ft. of canvas and may have measured 9 feet by 216 feet. In 1805 Robert Ker Porter, a friend of Girtin's and, previously, a member of his sketching club (with Sir George Beaumont) displayed a painting of *The Battle of Agincourt*, which covered 2800 square feet.

An earlier spectacle, which deeply impressed Reynolds and Gainsborough, was P. J. De Loutherbourg's *Eidophusikon* of 1781. This used moving pictures, lights, and coloured sheets, to the accompaniment of music, 'the picturesque of sound'. (See Ephraim Hardcastle, *Wine and Walnuts*, 1823; Rüdiger Joppien, *Die Szenenbilder, Philippe Jacques de Loutherbourg, Eine Untersuchung zu ihrer Stellung Zwischen Malerei and Theater*, Cologne, 1972, pp. 342–66; S. Rosenfeld, 'The Eidophusikon Illustrated,' *Theatre Notebook*, XVIII, 1963, (2), pp. 52–4; *P. J. De Loutherbourg R.A.*, Kenwood The Iveagh Bequest, 1973, introduction and under (87).)

Another, later, public spectacle was *The Diorama* invented in 1822 by L. J. M. Daguerre which was described by Constable to Fisher as 'part transparency'; 'the spectator is in a dark chamber', the light was thrown upon the picture from the roof, 'and has great illusion. — It is without the pale of the art because its object is deception.' ('The art' (i.e. *real* art), 'pleases by *reminding, not by deceiving*', added by Leslie) JCC, VI, p. 134, 20 September 1823. By 1823 Constable saw his art as a more complicated affair than straightforward naturalism.
52. JCC, II, p. 34.
53. *Diary*, IV, p. 1576, 13 July 1801.
54. *Diary*, IV, p. 1568, 27 June 1801.
55. Christie's Sale, 29 March 1983, lot 126, repr.
56. *Diary*, IV, p. 1129, 6 January 1799.
57. *Diary*, VIII, p. 3142, 16 November 1807, and JCFDC, p. 314.
58. *Life*, p. 13.
59. *Life*, pp. 17–18.
60. JCC, II, p. 28.
61. JCC, II, p. 189.
62. *Diary*, VI, 1 June 1804.
63. *Diary*, II, p. 286, 2 January 1795; and *Diary*, I, p. 93, 13 November 1793.
64. *Diary*, VIII, 1923, pp. 208–9.
65. *Diary*, p. 3142, 16 November 1807; and JCFDC, pp. 114–16.
66. From time to time during his career Constable would condescend to

work at portraiture. Such 'jobs', as he called those painting tasks that were not generated by him, and which also included copies after other people's portraits, occurred as the result of family relationships, the pressure of friends, or when he felt hard up, that is particularly around *c.* 1808 and 1818. At least sixty-eight portraits are extant, and he worked at them throughout his career, even as late as the 1830s. They are mostly of the '¾' size, or smaller, and prices remained low, as far as we know. He received only £25 as late as 1830 (Mr Lea). There is, significantly, an absence of the 'farmers', to which Farington refers, and it is a possibility that Constable was deliberately disparaging his own efforts at painting the bourgeosie. He was particularly rude about the 'squire' Lambert whose ' "study" contains pictures of racers & hunters, guns, gaiters, gloves, half pence, turnscrews, gunflints &c &c.' (JCC, VI, p. 192).

67. JCC, II, p. 87.
68. See Tate 1976 (122).
69. *Diary*, V, p. 1591, 19 August 1801.
70. See Reynolds, nos. 21–32a; and *Life*, p. 16.
71. JCC, II, p. 351.
72. JCC, VI, p. 197.
73. *Diary*, VIII, p. 3138, 10 November 1807.
74. *Diary*, p. 1729, 20 May 1802.
75. JCC, II, pp. 31–2.
76. *Diary*, VIII, p. 3088, 15 July 1807.
77. *Letters*, ed. N. Carrington, 1965, p. 47, 24 September 1912.

Chapter 3

1. For the paintings originally attributed to Gaspard Poussin, see Kenwood, The Iveagh Bequest, *Gaspard Poussin*, 1980 (30) and (31); and Cambridge, Fitzwilliam Museum, London, RA, *Painting from Nature*, 1980–1 (3) and (4), repr., as anon, northern artist, *c.* 1700.
2. JCFDC, p. 200.
3. For a drawing by Constable that shows his studio, now in the Victoria and Albert Museum (R. 14), identified in Smart and Brooks, pl. 10.
4. JCC, II, p. 87.
5. JCC, II, p. 34.
6. For these two drawings, see Tate 1976 (38) in the Victoria and Albert Museum (R. 52) and (39), in the collection of Stanhope Shelton.
7. *Diary*, VI, p. 2239.
8. *Diary*, VI, p. 2238.
9. *Diary*, VI, p. 2288.
10. Footnote 1, FW, pp. 26 and 27, and Tate (53) and (54).
11. JCC, IV, pp. 12–13.
12. JCC, IV, pp. 20–3, 24 November 1810.
13. JCC, III, pp. 94–5.
14. For a transcript of Mrs Harden's diary see: D. Foskett, *John Harden of Brathay Hall*, 1974, pp. 29–31.
15. Tate (10).
16. For Constable's relationship with Wordsworth see: J. R. Watson, 1962, pp. 361–7, and Reed, September 1982, pp. 481–3.
17. *Diary*, VIII, p. 3164, 12 December 1807.
18. *Life*.
19. IFW, pp. 32–5.
20. Girtin and Loshak 487, fig. 97.
21. JCC, II, p. 127.
22. *Diary*, IX, p. 3432.
23. JCC, I, pp. 24–5.
24. JCC, I, p. 26.
25. JCC, I, p. 29.
26. Pope, I, pp. 3–4, 1808.
27. *Diary*, VIII, 13 March 1807.
28. Parris 7.
29. *Diary*, p. 3666, 8 June 1810.
30. Parris 8.
31. Parris 10.
32. Parris 6.
33. Tate, p. 11. Victoria and Albert Museum, R. 330.
34. JCC, IV, p. 26.
35. JCC, VI, p. 13.
36. JCC, I, p. 69.
37. JCC, II, p. 63.

Chapter 4

1. For 'that it is our duty' see JCC, II, p. 55; for his letter of 22 September 1812 see JCC, II, p. 85, where the 'feild' is the London art world.
2. JCC, II, 30 June 1813.
 Cowper had written:
 . . dear companion of my walks,
 Whose arm this twentieth winter I perceive
 Fast locked in mine, with pleasure such as love (*The Task*, I, pp. 144–6).
 Constable's habitual slight mis-remembering of the lines shows how much he had to heart the poems he read. Cowper goes on to say: 'Thou knowest my praise of nature most sincere' (I, p. 150). Constable's attitude to nature can be compared to Cowper's in the same section of *The Task* (I, pp. 150–66 and 177–9). Constable would have sympathized with Cowper's 'God made the country, and man made the town.' (I, p. 749.) For another interpretation of Cowper's influence on Constable see Rosenthal, pp. 76–8.
3. JCC, VI, p. 21.
4. For a description of the 1813 and 1814 sketchbooks see Reynolds, 121 & 132, who has also published them in facsimile, London, HMSO, 1973.
5. It says much for Constable's complicated local relationships that in 1814, against family disapproval (JCC, I, p. 103), he encouraged Dunthorne's son to become his assistant when he could hardly afford it, and then broke completely with Dunthorne, senior, for what may have been local snobbish reasons. To be associated with Dunthorne, the local, badly behaved, atheist and artisan, when he was hoping to marry the Rector's daughter would not do. For Dunthorne, jr. see under Tate 1976 (340). His assistance in the execution of replicas in Constable's studio is undoubted, but difficult to ascertain. His own work, Tate (340) and a small oil in the Yale Center for British Art, *A Rainbow near Salisbury*, B1981.25.246, come very close to Constable's style.
6. Artists were in the habit of exhibiting their unsold works from the RA at the following winter exhibition of the British Institution, which was devoted to contemporary works. The summer exhibition of the British Institution showed Old Masters.
7. The original of *A Summerland* was exhibited at the Tate, 1976 (123) and subsequently sold at Christie's, July 1982. For the identification of the artist who altered the original's sky as Linnell, we are indebted to David Lucas's annotations to Leslie's *Life* (see JCFDC, p. 62). Constable remained on fairly good terms with Linnell, even after this event (see JCC, IV, pp. 287–95), apart from minor arguments caused by Constable's gossip. The painting by Callcott was identified by David Brown as the *Open Landscape Sheep Grazing*, exhibited at the BI, 1812, now in the York City Art Gallery (see David Brown, 1981 (13)). For further information on Allnutt see JCC, IV, pp. 82–5. His dashing portrait by Thomas Lawrence was recently with Noortman and Brod, New York and London, *18th and 19th Century British Paintings*, 1983 (9), repr. in colour.
8. For further arguments over the identity of *The Ferry* see Tate 1976 (129), Parris 9, and Rosenthal, pp. 69, 243, no. 67.
9. For Turner's perspective drawings and his notes to Opie and Shee, see *Turner Studies*, vol. 2, 2, cf. also Malton.
10. See I. Fleming-Williams, 1972.
11. Possibly the third edition, 1812, of *Principles of Taste*. See also Rosenthal, pp. 74–8.
12. *Prelude*, VI, pp. 10, 30 and XI, pp. 223–4.
13. JCC, II, p. 134.
14. By Charles Rhyne, in a lecture delivered at the College Art Association: 'The Substance of Constable's Art', San Francisco, 1981, quoted by Rosenthal, pp. 89, 243, n. 50.
15. Rosenthal, *Connoisseur*, 1974, pp. 88–91.
16. For a description of the Constable estate and the sale of the family house see Chapter One, and Tate 1976, p. 34 (VII).
17. Victoria and Albert Museum Sketchbook, R. 121, p. 10, R. 132, pp. 61, 63. For a complete history and further discussion of the painting see Parris 14.

Chapter 5

1. JCC, VI, p. 142.
2. For a full description of the versions of *Dedham Lock and Mill*, see under Tate 1976 (166) and also under Parris (17) and New York, 1983 (17).

3. Letter to Maria, JCC, II, p. 329.

4. For the Huntingdon Library drawing, see under Parris (17), fig. 2 and Rosenthal, fig. 146. Its size does not fit known sketchbooks. For the finished versions, see letter of 1841, Parris, p. 84, n. 8.

5. See under Tate 1976 (165).

6. Although Constable several times described himself as having no fixed method of painting, unusual first-hand evidence, apart from the paintings themselves, was provided by, ironically, Turner's friend, the Revd H. S. Trimmer, quoted in Walter Thornbury's *The Life of J. M. W. Turner, R.A.*, 1862, who had it from George Field: 'Yet certainly a method he had, and very unlike that of other people, which inclined to dead colour in white and black, or vermilion and Prussian blue. He used the spatula freely, and the vehicle he employed enabled him to plaster. This was copal varnish and linseed oil diluted in turpentine.'

7. JCFDC, pp. 56–7.

8. Abram in 1821 believed Fisher to be 'sincerely attach'd to you & has a high opinion of you as a Man & an Artist, & I like him for liking you' (JCC, I, p. 191).

9. He was to say to Fisher in 1823, that 'A man sees nothing in nature but what he knows' (JCC, VI, p. 113), and his desire to investigate what he was looking at led to his cloud studies and to the point of view he held at the time of his lectures. See also p. 322.

10. See Tate 1976 (179) and Parris (18) for further examples: 'I am without one, they are much liked' (JCC, VI, p. 128).

11. JCC, VI, p. 76.

12. For other views of the Cathedral, from the South-West, also in the Victoria and Albert Museum see R. 197, based on a drawing from a similar viewpoint, R. 187. Underneath a poor sketch, called *Hampstead Heath*, in the Yale Center for British Art (B1976.7.17), x-rays have revealed another sketch of the *Cathedral from the Close*, identical to Plate 136. The sketch must, presumably, be by Constable himself, rather than a copy after him.

13. For Dorothea, see under Mrs John Pike (JCC, VI, p. 36).

14. Henry Greswolde Lewis's sister, Magdalene, was the second wife of Lionel, 5th Earl of Dysart. Lewis had, essentially, been putting back what Sir John Soane had removed in his remodelling of 1783. See New York, 183, under (28).

15. For the dated oil sketches of October 1820, see under Tate (185) and JCC, II, p. 264.

16. For reproductions of this small sketchbook ($2\frac{5}{8} \times 3\frac{5}{8}$ ins.) in the British Museum, no. 1972-6-17-15, see Tate 1976 (168) and Fleming-Williams, 1976, pl. 25a, b, c, d.

17. Constable's finished works could, as an extension of this analogy, be considered in the mode of *The Idyllium*, or 'loco-descriptive' poetry, as Wordsworth called it in his Preface to his *Poems* of 1815.

18. The blossoming tree with its white flowers seems to be an elder. Constable was particularly fond of this tree. An oil sketch of it was exhibited at the Tate 1976 (189), now in Dublin, and he spoke to Leslie about them in 1835. He thought their beauty was tinged with melancholy (JCC, III, p. 126).

19. Apart from his constant worry over the financial situation of his family, two further points emerge from his letter: his constant love of trees, 'natural' but also elegant, which he could foresee might prove of use, not only as studies to draw upon, but in his conceit of drawing upon them as capital for the future, as finished works to be sold, and, therefore, as good as owning land. He could no longer visit East Bergholt so regularly, and we have seen how he had to make use of Johnny Dunthorne's drawing of the 'scrave' for his *Haywain*. For another study of trees at Hampstead, see Victoria and Albert Museum, R. 223 (1822?). See also Hoozee, 20, 79, 392, 393, 394, 395 (R. 235), *Trunk of an Elm*, H 396 (R. 234), the last can be compared to a post-impressionist painting by Van Gogh.

20. JCFDC, pp. 44–5.

21. For further full commentary on these cloud studies see, essentially, Louis Hawes, 1969, and John E. Thornes, 1978, and 1979. For the study of cirrus clouds in the Victoria and Albert Museum which appears to be so inscribed see R. 250, pl. 189. One (see p. 144) has been described as 'altocumulus', but Dr Thornes has pointed out, 1978, p. 28, that it was not defined until 1855 by Renou. Howard would probably have called it 'cirrostratus'.

22. Ruysdael had been cited as the model for his *Haywain* in a favourable review in *The Observer* of 25 June 1821 (JCC, I, p. 201, quoted by Abram), but the influence of Ruysdael can be shown on his nearly contemporary *View of Hampstead Heath with the House called 'The Salt Box'*. The composition and general structure is very close to a Ruysdael *Landscape with Figures and Cattle*, which was lent by the Earl of Musgrave to the BI of 1819, and copied by Constable in a drawing identified by Robert Hoozee (see Tate 1976 (167)). There is a copy by Constable after an etching by Ruysdael, the *Wheatfield* in the Victoria and Albert Museum (R. 169). His admiring comments on Ruysdael can be found in a letter to Fisher, 28 November 1826: 'I have seen an affecting picture this morning by Ruysdael. It haunts my mind and clings to my heart . . . the whole so true, clear and fresh & as brisk as champagne — a shower has not long passed' (JCC, VI, p. 229). Constable was to devote further praise to Ruysdael's 'compass of mind' in his landscape lectures (*Discourses*, 63), and the sentiment of his landscapes did not go unnoticed.

23. An oil sketch in the Victoria and Albert Museum, R. 252, shows the end of Lower Terrace, nos. 3 and 4. No. 2, where the Constable family stayed is off the picture to the left.

24. 1812; JCC, II, p. 78.

25. Abram's letter of 1821 first tells him of the prospective commission (JCC, I, p. 200–1). For further details of its history and a reproduction, see under Tate 1976 (212).

26. See his journal to Maria of 16 September 1825. JCC, II, p. 394, for the changes he made to the house, including the painting room made habitable — 'to produce better pictures than he could make'.

27. Adapted from Wordsworth's *The Thanksgiving Ode on the General Peace*.

Chapter 6

1. JCC, VI, p. 122.

2. 30 September 1823, JCC, VI, p. 133.

3. The Fonthill sale was organized by Phillips of London, with pictures added to it supplied by the Reinagles. Fisher reported on 2 October 1823 (JCC, VI, p. 135) that he had bought 'three lots of old china. One of them I bought on the speculation of *swapping* it with you for one of your little sea pieces.' Constable replied on 19 October that 'I like old china myself but I have a sister who is rather cracked who doats on it' (JCC, VI, p. 140). His sister Mary made a collection of china.

4. JCC, VI, pp. 173 and 212.

5. See Tate 1976, under 224.

6. *Life*, p. 155.

7. For further information about Payne Knight see M. Clarke, N. Penny, and P. Funnell, 1982. Fisher replied, unjustly, 'Priapus Knight (how punishment visits a man in *kind*) bought these drawings for the sake of seeing a set of prints, underwritten "in the possession of R. P. Knight Esqr."' (JCC, VI, p. 151)

8. JCC, II, p. 349.

9. JCC, II, p. 415. This version was in the collection of Maj. Gen. E. H. Goulbourn (see Tate 1976 (312), repr.). It was not, apparently, painted on commission as it remained in his studio until his death.

10. See Reynolds, Victoria and Albert Museum cat., p. 170 n. and R. 279–284 and Fleming-Williams, 1976, pl. 34 for the British Museum drawing, and figs. 57 and 58, for two others of Worthing and Brighton. Fig. 57 was recently sold at Sotheby's 15 March 1984, lot 92.

11. For typical beach scenes by F. L. T. Francia, see *Calais Beach*, 1823, repr. A. Wilton, 1977, pl. 128; by Bonington, apart from innumerable oils, see *Coast Scene with Shipping*, 1828, Aberdeen Art Gallery, exhibited, Nottingham etc., *R. P. Bonington*, 1965 (230), repr. pl. 16; by Eugène Isabey, see *A Beach Scene in Normandy*, Cambridge, Fitzwilliam Museum (PD17.1970). Other water-colourists whose beach scenes were popular during the Romantic period, and were also reproduced as prints included Prout, Callow, T. S. Boys, A. V. Copley Fielding, J. D. Harding, Clarkson Stanfield, J. S. Cotman and David Cox. Bonington's *A Fish Market, Boulogne*, now in the Yale Center for British Art, may well be the picture he exhibited at the Paris Salon of 1824.

12. For Constable's influence on Delacroix's painting see Lee Johnson, *Delacroix*, New York, 1963 (and 1966), pp. 20–7, and also his detailed catalogue entry for *Scenes from the Chios Massacres*, in L. Johnson, *The Paintings of Eugène Delacroix 1816–1831*, vol. 1, 1981, under (105).

13. Although Constable nowhere mentions his meeting with Delacroix, the fact that the letter was received, and survives, shows that Delacroix

delivered it. See JCC, IV, pp. 199–200, for Schroth's letter. There is no evidence that Constable was away from London during the latter half of May 1825. A sketchbook of Constable's, with Brighton drawings passed into Delacroix's hands and may well have been given to him by Constable on this occasion. See *Burlington Magazine*, March 1966, pp. 138–41.

14. Delacroix, *Journal*, 3 vols., ed. André Joubin, 1950.

15. JCC, II, p. 386.

16. See Lee Johnson, ibid., 1981, (105).

17. John Brealey who cleaned Renoir's *Coup de Vent*, Fitzwilliam Museum, Cambridge, pointed out, in a communication to the author, that Renoir has used glazes in the foreground of this quintessentially Impressionist picture.

18. Hugh Honour, 1979, p. 102 and n. 91, p. 338, suggests that Constable's appeal to French artists lay mainly in his technique, and his elevation of a simple subject-matter, and rightly draws attention to such works as Paul Huet's *Guardian's House in the Forest of Compiègne*, 1826 (Coll. Michel Legrand), fig. 57, as being influenced by Constable. Honour quotes from P-A Coupin and from *Le Figaro*, where there is mention of 'true and simple' landscapes which opened French artists' eyes used to 'une nature de convention'. Honour uses Pontus Grate, *Deux Critiques d'art de l'epoque romantique*, Stockholm, pp. 36–8. Honour further points out that there were 'true and simple' landscapes in France predating the arrival of Constable's works, such as David's *Vue de Jardin du Luxembourg* (Louvre) and paintings by Louis Gauffier (c. 1796), Turpin de Crissé (1806) and J-L Demarne (1814), but in no way can these isolated small scale works, or the sketches of P. H. Valenciennes or even Corot's work of the 1820s, be compared with Constable's revolutionary large-scale examples. Their technique and use of colour is much more conservative than Constable's finished works and his sketches were much more radical. Honour makes a distinction, made in the Romantic period, and by Constable himself, it must be emphasized, between a *plein-air* sketch and a finished work of art painted in the studio, quoting Paul Huet (Honour, n. 96, pp. 338–9) and Thomas Cole about the difficulties of working entirely in front of nature, but no one before Constable had given the *appearance* of works done in the open air so clearly. (See William Brockenden's letter (JCC, IV, p. 264, 13 December 1824) for the immediate effect of Constable's pictures: 'The School of Nature *versus* the School of Birmingham.') There does seem to be a direct influence on certain works by Rousseau and Daubigny, but their knowledge of Constable may have been from reputation alone. The dramatic preliminary sketch of *Dedham Lock* (Plate 104), probably not a *plein-air* sketch, was, as an echo of this interest, owned by M. Albert Hecht, Director of the Paris Opera and friend of Manet and Degas.

19. The Constable family possessed most of Constable's *plein-air* sketches, not revealed until 1887–8, when with the increasing interest in 'impressionist' painting they were a revelation, but it must be remembered that his 1826 version of *The Lock* had been given to the Royal Academy in 1829 as his Diploma work, to be seen with other Diploma works, and his *Cornfield* was in the National Gallery from 1838. The Sheepshanks, Vernon and Vaughan collection pictures were also available at South Kensington from the 1860s onwards (see Reynolds, Victoria and Albert Museum cat., pp. 137, 184, 254, 301, 321 and 323).

20. JCC, VI, p. 180.

21. JCC, VI, p. 181.

22. S. W. Reynolds did not, in fact, finish his engraving but he got as far as proof copies, and a letter (c. 1826) from Reynolds asks after a companion to *The Lock* (see JCC, IV, pp. 266–7). Arrowsmith's proposal for twelve beach scenes came to nothing. Apart from a print after his portrait of Dr Wingfield, headmaster of Westminster School, and a Canon of Winchester Cathedral, by Ward, which did not sell — 'no one will buy a *schoolmaster* — nor is it likely. Who would buy the Keeper of the tread mill, or a turn key of Newgate, who has been in either place' (JCC, VI, p. 231) — the first completed print after his large finished works was that by Frederick Smith after *The Chain Pier, Brighton*, in 1829 (see Tate Gallery, 1976, p. 248). His association with Lucas, Reynolds' pupil, is a complete saga. See Chapter 8.

23. For the preliminary work on *The Leaping Horse* Leslie confused the issue by implying in his first edition of *The Life*, that there were two sketches, but Graham Reynolds remarked that as this reference is deleted from the second edition (Victoria and Albert Museum cat.) Leslie must have realized that he was wrong. Ian Fleming-Williams has subsequently

suggested that Leslie may have been referring to the two preliminary drawings in the British Museum.

24. See J. Hayes *The Drawings of Thomas Gainsborough*, 1970, 2 vols., nos. 284, 311, and 811 for particularly free examples with similar slashings of white chalk.

25. See A. Smart and C. A. Brooks, 1976, pp. 104–5, figs. 60–3, p. 139.

26. Henry Phillips, the botanist, tried to get Constable to put his ideas in written form for an article for a journal he was proposing: *The Sussex Courier of Literature and Athenaeum of Arts and Sciences*, but he was not successful. He helped draft the introduction for *English Landscape Scenery* and may have been helpful for remarks on Brighton scenery Constable incorporated in his plate *A Sea-Beach* (see JCC, V, p. 80).

27. JCC, II, p. 344.

28. JCC, V, p. 52.

29. JCC, II, p. 424.

30. The use of the tree may be proof that the picture is by Constable, as well as its apparently impeccable provenance from the Revd J. H. Smith, who bought it from the artist's sale. (See David G. Taylor, 1980, pp. 567–8.) Its handling of the foreground detail, the clouds, and the introduction of the figure in a red cloak and tricorn hat at the left remain as very strange details in Constable's early work.

31. JCC, VI, p. 181.

32. Constable's state of mind in 1826 was not 'serene.' He admitted on 8 April that he was 'much worn, having worked very hard & have now the consolation of knowing I must work a great deal harder, or go to the workhouse.' He was sad that his eldest boy, John Charles, partly for health reasons, had been sent off to school in Brighton with Henry Phillips. He allowed himself to describe a bawdy caricature he had seen of Mrs Elizabeth Fry, the Quaker philanthropist (JCC, VI, p. 217) and Fisher sympathized with his melancholy, to which Constable answered, 'When my mind is disturbed — it stirs up the mud' (JCC, VI, p. 220). He was still vexed at Tinney. At the Academy, however, he was able to praise Callcott, Lawrence and 'Turner never gave me so much pleasure [with his *Forum Romanum* and three others] — and so much pain before.' He thought one of Callcott's works was as Turner's, 'too yellow, but every man who distinguishes himself in a great way, is on a precipice' (JCC, VI, p. 220).

Chapter 7

1. JCC, VI, p. 204.

2. Parris, figs. 3, 4, 5.

3. JCC, IV, p. 155.

4. For Constable's gossiping in 1823, see JCC, IV, pp. 287–91.

5. For the Collins-Constable relation, see JCC, IV, pp. 285–96, and VI, p. 232, — 'this unpleasant fellow', as Constable described him. For a partial account of Collins and his *Frost Scene*, see Wilkie Collins, *Memoirs of the Life of William Collins, Esq., R.A.*, 2 vols., 1848, reprint 1978, I, pp. 270, 272–3, 279–84. For his patrons and prices see II, p. 346. Constable's sharp remarks about Collins are just the sort of acerbic comments that Leslie deletes from his *Life*, and which Wilkie Collins also removes from the memoirs of his father. His description of the picture praises the 'true finish and nature which attest the severe study bestowed upon the landscape, as well as the figures in this fine picture'. Collins's description suggests that *A Frost Scene* may have once included more detail at the left, as Constable's had, and, although the Yale picture is certainly from the Peel Collection, the faint suspicion remains that the present version may be reduced, as Wilkie Collins speaks of a picture of 'large dimensions', and 500 guineas seems excessive for a picture of 33 × 44 ins., even accounting for Sir Robert Peel's generosity.

6. See Victoria and Albert Museum (R. 290–300) and Fleming-Williams, 1976, pl. 39, and fig. 66.

7. His outburst against 'mechanicks' to Maria on Saturday 22 October 1825 is typical of his ultra-conservative views: 'almost every mechanick — whether master or man — is a rebel and blackguard — dissatisfied . . . he is only made respectable by being kept in solitude and worked for himself or by one master — whom he has always served but directly he is *congregated* with his brethren his evil dispositions are fanned and ready to burst into flame . . . remember I know these people well — having seen so many of them at my father's.' For the personal interpretation of the relationship of his art to his political views, see Rosenthal, 1983, pp. 191–213.

8. Danby's picture was *The Opening of the Sixth Seal*, a subject in the style of Martin that Constable loathed. He had to admit, however, that Turner's *Dido Directing the Equipment of the Fleet*, which probably best fits his description of 'golden visions' was admirable. Constable genuinely admired Turner's art, but it is not clear what Turner thought of Constable. Constable's comments on Etty are typical and it is clear from this and other opinions expressed elsewhere that Constable thought his principal rival of 1828 was not to be taken too seriously.

9. Constable's touching letter to his simple brother, Golding, written, one supposes, in Suffolk vernacular, had made over on 19 December 1828, a gift of furniture for Golding's new home, but he added: 'but poor dear Bergholt will fill me full of sad sad associations — especially the sight of the Rectory — & its dark trees — but a few year will set all these sorrows at rest — but I cannot recover my last happiness — the loss grows upon me — but I must turn to my dear infants.' (JCFDC, p. 81.) Constable erected the following inscription on Maria's tomb in Hampstead Church:

> Eheu! quam tenui e filo pendet
> Quid quid in vita maxime arridet
> [Alas, by such a slender thread hangs whatever is
> greatly pleasing in life.]

10. JCC, III, p. 19.
11. The sentimental pictures of William Redmore Bigg, RA (1755–1828) were not to Constable's taste and they had gradually fallen out of favour. Of later years Bigg had been one of Constable's 'lame ducks, born without the gift of flight, along their pedestrian passage through life' (JCC, IV, p. 244). He had been forced to earn his living by picture restoring and a little dealing. Constable's letters are full of descriptions of his impoverished household. It is ironic that Constable succeeded to his place, as Bigg had also had a long wait, in his case twenty-seven years from 1787 to 1812, to be elected as a full Academician (see JCC, IV, pp. 244–6).
12. *Life*, pp. 238–9.
13. JCC, VI, p. 214.
14. See Louis Hawes, 1982, III, p. 31 and *idem*, 1983, pp. 455–69.
15. JCC, IV, p. 363. An interesting comparison can be made with J.C.C. Dahl's (1788–1857) contemporary *Morning After a Stormy Night* (Munich, Neue Pinakothek). Dahl's work is, however, much more literal than Constable's expressive and multi-layered work.
16. Shirley 35 & 36, pp. 198–9.
17. For Constable, and James and W. H. Carpenter, see JCC, IV, pp. 135–52.
18. The Bath drawing is reproduced in Ian Fleming-Williams, 1976, pl. 41. The Victoria and Albert drawing is also reproduced in Tate 1976, (265).
19. See Victoria and Albert Museum (R. 320), Tate (267), and New York, 1983 (35).

Chapter 8

1. For a discussion, for example, of *Salisbury Cathedral from the Meadows*, see Reynolds, 1966, p. 118; Tate Gallery, 1976 (282); Parris, 1981 (36); Paulson, p. 124; and Rosenthal, pp. 227–36. See also Paul D. Schweizer, *Artibus et historiae*, 1982, pp. 125–39.
2. For a discussion of the episode and a list of the various sources of the story, see Tate Gallery, 1976 (269).
3. JCC, III, p. 22.
4. For a detailed discussion of the relationship between Lucas and Constable see, principally, JCC, IV, pp. 314–463, but also Shirley, 1930; Reynolds, 1965, pp. 111–18; Tate Gallery, 1976, pp. 273–81, and Wilton, 1979.
5. 12 March 1831, JCC, IV, p. 344.
6. JCD, p. 82.
7. JCD, pp. 82–5.
8. Those subjects with texts were: *East Bergholt*; *Spring*; *Summer Morning*; *A Sea Beach, Brighton*; *Stoke by Nayland*; *Old Sarum*; *Dedham Mill* (fragment).
9. JCD, pp. 24–6.
10. See for example, *The Burning of the Houses of Parliament*, R.A., 1835, Butlin and Joll, 364; *Ancient Rome*, R.A. 1839, Butlin and Joll, 378; *Modern Rome*, R.A. 1839, Butlin and Joll, 379; *Slavers throwing overboard the Dead and Dying*, R.A. 1840, Butlin and Joll, 385.

11. *Life*, p. 267.
12. See JCC, II, p. 403.
13. See Christie's, 19 November 1982, the Property of the D. A. Maffett Will Trust, lot 44, *Salisbury Cathedral from the Meadows*, repr., and lot 45, in which the Cathedral is near at hand, but with other differences. It is from this sketch that the small mezzotint (Shirley 30) was made. For further comment and the provenance of these sketches, see Parris, 1983, p. 223.
14. See JCD, p. 64.
15. These touches of primary colours seem to suggest a knowledge of Titian's colouring, as well as Rubens, and the same technique can be seen in *Hadleigh Castle*. Maria had seen Lord Fitzwilliam's collection at Richmond in 1813 (see JCC, II, p. 111), that is Viscount Fitzwilliam of Merrion, whose collection is now in the Fitzwilliam Museum, Cambridge, and which includes a notable Titian from the Orleans Collection. Constable must also have had access to the celebrated Bridgewater Collection, as a letter from the President of the Royal Academy, Martin Archer Shee, of 21 June 1830, enclosed a ticket for a friend of Constable's, a Mr Town (JCFDC, p. 286).
16. See Schweizer, *Art Bulletin*, 1982.
17. He mentions it in his Lectures, JCD, p. 61, and doubtless saw it when it was in the Watson Taylor Sale of 15 June 1823, lot 60, at Christie's, even if he had not seen it earlier when Buchanan was selling both Rubens in London, from the Balbi Collection, Genoa. The pair was split, which Constable bemoaned, when the *Chateau de Steen* was sold to Sir George Beaumont in 1803.
18. Rubens was also influential on Constable's drawing technique, see for example, Constable's drawing of a root of a tree, drawn at Hampstead, 22 September 1831 (Victoria and Albert Museum, R. 335) which could be compared to a drawing by Rubens in the Fitzwilliam Museum, Cambridge, once owned by Kerrich, whom Farington knew: *A Path bordered by trees* (2178) (see *European Drawings from the Fitzwilliam*, 1976–7 (88)).
19. The circumstances are mentioned in the catalogue of Leslie's sale, Foster, 25 April 1860, lot 97.
20. See JCC, IV, p. 361.
21. *Life*, p. 215.
22. See Tate 1976 (327), engraved by Lucas (S. 15), published 1845.
23. See JCC, IV, pp. 104–5.
24. See Tom Boyd, 'English Girl: French Style. A Constable copy explained', *Country Life*, 8 June 1978, p. 1660.
25. JCC, III, p. 62.
26. Leslie, *Autobiographical Recollections*, pp. 202–3.
27. For further details of the picture's history see Tate 1976 (174–6) and (286). For typical colourful works by Turner, see Butlin and Joll, nos. 330, 337 and 342.
28. JCC, III, p. 66.
29. *Life*, p. 283.
30. See Tate 1976 (292).
31. JCC, I, p. 274.
32. See Tate 1976 (289), (290), (291), (296).
33. JCC, III, p. 96.
34. JCC, I, p. 275.
35. JCFDC, p. 5.
36. Reynolds, 1970, pl. 536.
37. Tate 1976, p. 329.
38. Tate 1976, pp. 298–302 and 306.
39. IFW, 1976, pl. 48.
40. See Parris, Tate Gallery Catalogue (41).
41. JCD, p. 69.
42. JCD, p. 69.
43. For detailed description and comment on Constable's lectures, see JCD, pp. 28–77; JCFDC, pp. 5–24; and Tate 1976 (307–10).
44. JCD, p. 98.
45. See JCFDC, pp. 25–52.
46. See Mark L. Reed, 'Constable, Wordsworth, and Beaumont: A New Constable letter in Evidence', *Art Bulletin*, September 1982, LXIV, No. 3, pp. 481–3; and JCFDC, p. 24, for the apt quotation from Wordsworth's sonnet, 'Upon the sight of a beautiful picture by Sir G. H. Beaumont, Bt.', the last six lines of which were quoted at Hampstead on 25 July 1836.

Abbreviations & Bibliography

Gadney Gadney, Reg, *John Constable R.A., A Catalogue of Drawings and Watercolours, with a selection of mezzotints by David Lucas, after Constable for English Landscape Scenery in the Fitzwilliam Museum, Cambridge*, The Arts Council of Great Britain, 1976.

H. Hoozee, Robert, *L'Opera Completa di Constable*, Milan, 1979.

IFW Fleming-Williams, Ian, *Constable Landscape Drawings*, London, 1976.

JCC I Beckett, R. B., ed., *John Constable's Correspondence I: The Family at East Bergholt*, Ipswich, 1962, revised and reprinted 1976.

JCC II Beckett, R. B., ed., *John Constable's Correspondence II: Early Friends and Maria Bicknell (Mrs. Constable)*, Suffolk Records Society, Ipswich, 1964.

JCC III Beckett, R. B., ed., *John Constable's Correspondence III: The Correspondence with C. R. Leslie*, Suffolk Records Society, Ipswich, 1965.

JCC IV Beckett, R. B., ed., *John Constable's Correspondence IV: Patrons Dealers and Fellow Artists*, Suffolk Records Society, Ipswich, 1966.

JCC V Beckett, R. B., ed., *John Constable's Correspondence V: Various Friends, with Charles Boner and the Artist's Children*, Suffolk Records Society, Ipswich, 1967.

JCC VI Beckett, R. B., ed., *John Constable's Correspondence VI: The Fishers*, Suffolk Records Society, Ipswich, 1968.

JCD Beckett, R. B., ed., *John Constable's Discourses*, Suffolk Records Society, Ipswich, 1970.

JCFDC Parris, Leslie; Shields, Conal; Fleming-Williams, Ian, eds., *John Constable: Further Documents and Correspondence*, Tate Gallery and Suffolk Records Society, London and Ipswich, 1975.

Life, See under Leslie, C. R., *Memoirs* . . .

P. Parris, Leslie, *The Tate Gallery Constable Collection*, London, 1981.

R. Reynolds, Graham, *Victoria and Albert Museum, Catalogue of the Constable Collection*, 2nd revised edition, London, 1973.

RA Royal Academy or Royal Academician.

Tate 1976 Leslie Parris, Ian Fleming-Williams, Conal Shields, *Constable Paintings, Watercolours, and Drawings*, Exhibition Catalogue, Tate Gallery, London, 1976.

ADAMS, E., *Francis Danby, Varieties of Poetic Landscape*, New Haven and London, 1975

AIKIN, J., *The Calendar of Nature*, 2nd ed., London, 1792

—— *An Essay on . . . Thomson's Seasons*, London, 1788

ALISON, A., *An Essay on the Nature and Principles of Taste*, Edinburgh, 1790

Arts Council, *The Shock of Recognition* (Exhibition Catalogue), London, 1972

ASHTON, T. S., *An Economic History of England: the Eighteenth Century*, London, 1972

BADT, K., *John Constable's Clouds*, London, 1950

BARBIER, C. W., *William Gilpin*, Oxford, 1963

BARRELL, J., *The Idea of Landscape and the Sense of Place*, Cambridge, 1972

—— *The Dark Side of Landscape*, Cambridge, 1980

BARRELL, J. and BULL, J., *The Penguin Book of English Pastoral Verse*, London, 1974

BARRY, J., *Lectures on Painting by . . . Barry, Opie, and Fuseli*, London, 1848

BASKETT, J., *Constable Oil Sketches*, London, 1966

BAYARD, J., *The Exhibition Watercolor 1770–1870* (Exhibition Catalogue), New Haven, 1981

BECKETT, R. B., 'Constable's *Helmingham Dell*', *Art Quarterly* XXIV (1961), pp. 2–14

—— *John Constable's Correspondence*, Vols. I–VI, Ipswich, 1962–8

—— *John Constable's Discourses*, Ipswich, 1970

—— 'Constable and France', *Connoisseur*, CXXXVII (May 1956)

BICKNELL, P., *Beauty, Horror and Immensity* (Exhibition Catalogue), Cambridge, 1981

BINYON, LAURENCE, *Catalogue of Drawings by British Artists . . . in the British Museum*, 4 vols, London, 1898–1907

BLOOMFIELD, R., *The Farmer's Boy*, London, 1800

—— *Rural Tales, Ballads, and Songs*, 4th ed., London, 1805

—— *Wild Flowers*, London, 1809

—— *Remains*, London, 1824

Board of Agriculture, *The Agricultural State of the Kingdom*, London, 1816

BOHLER, J. G., *Constable und Rubens*, Munich, 1955

BOVILL, E. W., *English Country Life 1780–1830*, London, 1962

BROWN, A. F. J., *Essex at Work 1700–1815*, Chelmsford, 1969

—— *Essex People 1750–1900*, Chelmsford, 1972

BROWN, D. B., *Augustus Wall Callcott* (Exhibition Catalogue), London, 1981

BROWN, F., *George Frost of Ipswich*, Ipswich, 1899

BRYSON, N., *Word and Image*, Cambridge, 1981

BULL, D., *Classic Ground* (Exhibition Catalogue), New Haven, 1981

BURKE, E., *Works*, 16 vols, London, 1827

BURKE, J., *English Art 1714–1800*, Oxford, 1976

BUTLIN, M. and JOLL, E., *The Paintings of J. M. W. Turner*, New Haven and London, 1977

CAREY, W., *Some Memoirs of the Patronage and Progress of the Fine Arts in England*, London, 1826

CHAMBERS, J. D. and MINGAY, G. E., *The Agricultural Revolution 1750–1880*, London, 1966

CLARE, J., *Poems descriptive of Rural Life and Scenery*, London, 1820

—— *The Village Minstrel and other Poems*, London, 1821

—— *The Shepherd's Calendar*, London, 1827

CLARK, K., *John Constable. The Hay Wain in the National Gallery*, London, 1944

CLARKE, M., *The Tempting Prospect*, London, 1981.

CLARKE, M. and PENNY, N., *The Arrogant Connoisseur* (Exhibition Catalogue), Whitworth Art Gallery, Manchester, 1982

CLARKE, P., ed., *Country Towns in pre-industrial England*, Leicester, 1981

COBBETT, W., *Rural Rides*, London, 1830

COLNAGHI, P. D. & CO., *John Linnell and his Circle* (Exhibition Catalogue), London, 1973

COMPTON, M. E. and FUSSELL, G. E., 'Agricultural Adjustments after the Napoleonic Wars', *Economic History 4* (14) (February 1939)

CONISBEE, P., *Painting from Nature* (Exhibition Catalogue), London, 1980

CONSTABLE, W. G., ' "The Lock" as a Theme in the work of John Constable', in *In Honour of Daryl Lindsay: Essays and Studies*, ed. Franz Philipp and June Stewart, Melbourne, 1964

COOK, O., *Constable's Hampstead*, London, 1976

COOPER, J. G., *Letters concerning Taste*, London, 1755

CORMACK, M., 'Constable's *Hadleigh Castle', Portfolio* (Summer 1980), pp. 36–41

COWPER, W., *Poems*, 2 vols, London, 1813

—— *Letters*, ed. W. Hayley, London, 1812

COXE, P., *The Social Day*, London, 1823

CRABBE, G., *The Village*, London, 1783

—— *Poems*, London, 1807

—— *The Borough*, London, 1810

—— *Tales*, London, 1812

DAY, H., *Constable Drawings*, Eastbourne, 1975

DAYES, E., *Works*, London, 1805

EDWARDS, E., *Anecdotes of Painters*, London, 1808

EDWARDS, R., *Thomas Jones* (Exhibition Catalogue), Marble Hill, 1970

FARINGTON, J., *Diary* (in course of publication), 6 vols, New Haven and London, 1978, et seq.

FAWCETT, T., *The Rise of English Provincial Art*, Oxford, 1974

FLEMING-WILLIAMS, I., 'A Runnover Dungle and a possible date for "Spring"', *Burlington Magazine* CXIV (1972)

—— *Constable Landscape Watercolours & Drawings*, London, 1976

—— 'A rediscovered Constable: the Venables *Cottage in a Cornfield', Connoisseur* CXCVIII (June 1978)

—— 'John Constable at Brightwell: a newly discovered Painting,' *Connoisseur* CCIV (July 1980)

FLEMING-WILLIAMS, I. and PARRIS, L., 'Which Constable?', *Burlington Magazine* CXX, 906 (September 1978), pp. 566–79

—— and —— *Lionel Constable* (Exhibition Catalogue), London, 1982

—— and —— *The Discovery of Constable*, London, 1984

——, —— and Shields, C., *Constable Paintings Watercolours & Drawings* (Exhibition Catalogue), London, 1976

——, —— and —— (eds.), *John Constable. Further Documents and Correspondence*, Ipswich, 1976

DU FRESNOY, C. A., *De Arte Graphica*, trans. W. Mason, London, 1783

GADNEY, R., *Constable and his World*, London, 1976

—— *John Constable R.A. 1776–1837. A Catalogue of Drawings . . . in the Fitzwilliam Museum, Cambridge*, Cambridge, 1976

GAGE, J., *Colour in Turner, Poetry and Truth*, London, 1976

—— *A Decade of English Naturalism 1810–1820* (Exhibition Catalogue), Norwich and London, 1969

GESSNER, S., *Works*, London, 1797

—— *Letters*, London, 1804

GILPIN, W., *Observations . . . on . . . Cambridge, Norfolk, Suffolk and London*, London, 1809

GOLDSMITH, O., *The Deserted Village*, London, 1770

GOMBRICH, E. H., *Art and Illusion*, various eds.

GONNER, E. C. K., *Common Land and Enclosure*, London, 1912

GOWING, L., *Constable 1776–1837*, London, 1960

GRAHAM, M., *Memoirs of the Life of Nicholas Poussin*, London, 1820

GRAY, T., *Complete Poems*, eds. Starr and Hendrickson, Oxford, 1964

GREENACRE, F., *The Bristol School of Artists* (Exhibition Catalogue), Bristol, 1973

HAMMELMANN, H. and BOASE, T., *Book Illustration in eighteenth-century England*, New Haven and London, 1975

HAMMOND, J. L. and B., *The Village Labourer*, 2 vols., London, 1948

HARDIE, M., *Watercolour Painting in Britain*, 4 vols., London, 1966–68

HASSELL, J., *Memoirs of the Late George Morland*, London, 1806

HAWES, L., 'Constable's Sky Sketches', *Journal of the Warburg and Courtauld Institutes* XXXII (1969)

—— *Constable's Stonehenge*, London, 1975

—— *Presences of Nature. British Landscape 1780–1830* (Exhibition Catalogue), New Haven, 1982

—— 'Constable's *Hadleigh Castle* and British Romantic Ruin Painting', *Art Bulletin*, LXV, no. 3 (September 1983) pp. 455–69

—— 'Constable's *Distant View of Hadleigh Castle', idem*, pp. 469–70

HAY, D. (et al.), *Albion's Fatal Tree*, London, 1975

HAYES, J., 'The Drawings of George Frost (1745–1821)', *Master Drawings* (November 1966), pp. 163–8

—— *The Drawings of Thomas Gainsborough*, 2 vols., London, 1970

—— *Gainsborough's Prints*, London, 1971

—— *Gainsborough*, London, 1975

—— *Thomas Gainsborough* (Exhibition Catalogue), London, 1980

—— *The Landscape Paintings of Thomas Gainsborough*, 2 vols, London, 1982

HERMANN, L., *British Landscape Painting of the Eighteenth Century*, London, 1973

—— and OWEN, F., *Sir George Beaumont of Coleorton, Leicestershire*, Leicester, n.d.

HIPPLE, W. J., *The Beautiful, the Sublime, and the Picturesque*, Carbondale, 1957

HOLLIS, P. (ed.), *Class and Conflict in nineteenth-century England 1815–1850*, London, 1973

HOLMES, C. J., *Constable*, London, 1901

—— *Constable and his influence on Landscape Painting*, London, 1902

—— *Constable, Gainsborough and Lucas*, London, 1921

HONOUR, H., *Romanticism*, New York and London, 1979

HORN, P., *The Rural World 1750–1850*, London, 1980

HOSKINS, W. G., *The Making of the English Landscape*, London, 1955

HOWARD, D., 'Some eighteenth-century Followers of Claude', *Burlington Magazine* CXI (1969)

HOOZEE, R., *L'Opera completa di John Constable*, Milan, 1979

HUSSEY, C., *The Picturesque*, London, 1927

JENNINGS, C., *John Constable in Constable's Country*, East Bergholt, 1976

JONES, T., Memoirs', ed. A. P. Oppé, *Walpole Society* XXXII (1946–8)

KAUFFMAN, C. M., *Sketches by John Constable in the Victoria and Albert Museum*, London, 1981

KAY, H. I., 'The Haywain', *Burlington Magazine* LXII (1933), pp. 281–9

KITSON, M., 'John Constable 1810–16, a chronological Study', *Journal of the Warburg and Courtauld Institutes* XX (July-December 1957)

—— *Turner*, London, 1964

—— *The Art of Claude Lorrain* (Exhibition Catalogue), London, 1969

—— 'The Inspiration of John Constable', *RSA Journal*, CXXIV, 1976, pp. 238–51

—— 'John Constable at the Tate', *Burlington Magazine*, CXVIII, 1976, pp. 248–52

KNIGHT, R. P., *The Landscape*, 2nd ed., London, 1795

—— *An Analytical Inquiry into the Principles of Taste*, London, 1805

KROEBER, K., *Romantic Landscape Vision Constable and Wordsworth*, Madison and London, 1975

LANGHORNE, J., *Poetical Works*, London, 1804

LESLIE, C. R., *Memoirs of the Life of John Constable, Esq. R.A.*, 1843, 2nd ed. (rev.) 1845, 3rd ed. 1896, London, 1937, (ed. A. Shirley)

—— *Autobiographical Recollections*, London, 1860

LINDSAY, J., *J. M. W. Turner*, London, 1973

—— *Thomas Gainsborough. His Life and Art*, London, 1981

LIPKING, L., *The Ordering of the Arts in eighteenth-century England*, Princeton, 1970

MACK, M., *The Garden and the City*, London and Toronto, 1969

MALINS, E., *English Landscaping and Literature*, London, 1966

MALTHUS, T. R., *Observations on the Effects of the Corn Laws*, London, 1815

—— *The Rural Economy of Norfolk*, 2 vols, 2nd ed., London, 1795

—— *On the Appropriation and Inclosure of Commonable Lands*, London, 1801

MASON, W., *The English Garden*, London, 1772

MINGAY, G. E., *English Landed Society in the Eighteenth Century*, London, 1963

MITCHELL, B. C. and DEANE, P., *Abstract of British Historical Statistics*, Cambridge, 1969

MITCHISON, R., 'The Old Board of Agriculture (1793–1822)', *English Historical Review* 74 (1959)

MOIR, E., *The Discovery of Britain*, London, 1964

MORSE, D., *Perspectives on Romanticism*, London, 1981

NICHOLSON, B., *Joseph Wright of Derby*, 2 vols, London and New York, 1968

Nottingham, University of, *John Constable and the Suffolk Landscape*

(Exhibition); *Souvenir of the model of the Flatford area* (Exhibition Catalogue), Nottingham, 1976

OGDEN, H. V. S. and M. S., *English Taste in Landscape in the Seventeenth Century*, Ann Arbor, 1955

OPIE, J., *Lectures on Painting*, London, 1809

OWEN, F., *Sir George Beaumont, Artist and Patron* (Exhibition Catalogue), London, 1969

—— 'Sir George Beaumont and the Contemporary Artist', *Apollo* LXXXIX (1969)

PARRIS, L., *Landscape in Britain c. 1750–1850* (Exhibition Catalogue), London, 1973

—— *The Tate Constable Collection*, London, 1981

—— 'Some recently discovered oil sketches by John Constable'. *Burlington Magazine*, CXXV, 961, (April 1983), pp. 220–23

—— and SHIELDS, C., *John Constable*, London, 1969

PARRIS, L. and SHIELDS, C., *Constable, the Art of Nature* (Exhibition Catalogue), London, 1971

PAULSON, R., *Literary Landscape. Turner and Constable*, New Haven and London, 1982

PEACOCK, A. J., *Bread or Blood*, London, 1965

PEACOCK, C., *John Constable, The Man and his Work*, London, 1965

PECKHAM, M., *The Triumph of Romanticism*, Columbia, S. Carolina, 1971

POOL, P., *John Constable*, London, 1964

POPE, A., *Poetical Works*, ed. H. Davis, London, 1967

POTT, J. H., *An Essay on Landscape Painting*, London, 1782

PRICE, U., *An Essay on the Picturesque*, London, 1794

—— *Thoughts on the Defence of Property*, Hereford and London, 1797

—— *A Dialogue on . . . the Picturesque and the Beautiful*, London, 1801

PYNE, W. H., *Etchings of Rustic Figures*, London, 1815

REITLINGER, G., *The Economics of Taste*, London, 1961

REYNOLDS, G., *Constable the Natural Painter*, London, 1966

—— *Catalogue of the Constable Collection in the Victoria and Albert Museum*, 2nd ed., London, 1973

—— *John Constable's Sketchbooks of 1813 and 1814*, London, 1973

—— 'John Constable: Struggle and Success', *Apollo*, CIII, April 1976, pp. 322–4

—— *Salisbury Cathedral from the Bishop's Grounds*, Ottawa, 1977

—— *Constable with his friend in 1806*, 5 vols, Paris, 1981

—— *Constable's England* (Exhibition Catalogue), New York, 1983

—— *The Later Paintings and Drawings of John Constable*, New Haven and London, 2 vols., 1984

REYNOLDS, J., *Works*, ed. Malone, 2 vols, London, 1797

—— *Discourses on Art*, ed. R. Wark, New Haven and London, 1975

RHYNE, C., 'Fresh Light on John Constable', *Apollo* LXXXVII 73, (March 1968), pp. 227 ff.

—— 'Lionel Constable's East Berlin Sketchbook,' *ARTnews* 77/9 (1978)

—— 'Constable Drawings and Watercolors in the Collection of Mr and Mrs Paul Mellon', I & II, *Master Drawings* XIX 2 & 4 (1981)

RICHARDSON, J., *Works*, London, 1773

RICKARD, G. O., *Constable's Country. A Guide to the Vale of Dedham*, Colchester, 1948

DE LA ROCHEFOUCAULD, F., *Melanges sur L'Angleterre*, trans. S. C. Roberts, Cambridge, 1933

ROSE, M., *The English Poor Law 1780–1930*, Newton Abbot, 1971

ROSENTHAL, M., *George Frost 1745–1821* (Exhibition Catalogue), Sudbury, 1974

—— 'On the Waterfront. Ipswich Docks in 1803', *Antique Collector* (November 1974)

—— 'Golding Constable's Gardens', *Connoisseur*, (October 1974), pp. 88–91

—— *Constable, The Painter and his Landscape*, New Haven and London, 1983

RUDDICK, W., *Joseph Farington. Watercolours and Drawings* (Exhibition Catalogue), Bolton, 1977

RUSKIN, J., *Works*, eds. Cook and Wedderburn

SCHWEIZER, P. D., 'John Constable, Rainbow Science, and English Colour Theory', *Art Bulletin*, LXIV, (September 1982), pp. 424–45

—— 'John Constable and the Anglican Church Establishment,' *Artibus et historiae*, Venice-Vienna, no. 5 CIII, 1982, pp. 125–139

SHENSTONE, W., *Poetical Works*, London, 1795

SHIRLEY, A., *The Published Mezzotints of D. Lucas after John Constable R.A.*, Oxford, 1930

—— *John Constable R.A.*, London, 1948

—— *The Rainbow, a Portrait of John Constable*, London, n.d.

SIMPSON, FRANK, 'Constable's Lock: A Postscript', *Connoisseur*, LXXIX, (March 1952)

SMART, A. and BROOKS, C. A., *Constable and his Country*, London, 1976

SMITH, J. T., *Remarks on Rural Scenery*, London, 1797

—— *Nollekens and his times*, 2 vols., London, 1828

—— *A Book for a Rainy Day*, London, 1845 (1905 ed.)

SOLKIN, D. H., *Richard Wilson* (Exhibition Catalogue), London, 1982

SOUTHEY, R., *Letters from England*, (By Don Manuel Alvarez Espriella (Pseud.)), London, 1807

SUNDERLAND, J., *Constable*, 2nd ed., Oxford, 1980

SUTTON, D., 'Constable's *Whitehall Stairs*', *Connoisseur* 136 CXXVI, (1955), pp. 249–55

TAYLOR, D. G., 'New light on an early Painting by John Constable', *Burlington Magazine* CXXII, (August 1980)

THICKNESSE, P., *A Sketch of the Life and Paintings of Thomas Gainsborough Esq.*, London, 1788

THIRSK, J. and IMRAY, J., *Suffolk Farming in the Nineteenth Century*, Ipswich, 1968

THOMPSON, E. P., *The Making of the English Working Class*, London, 1963

THOMPSON, F. M. L., *English Landed Society in the Nineteenth Century*, London, 1963

THOMSON, J., *The Seasons*, London, 1730, revised ed. 1744

THORNES, J. E., 'The Accurate Dating of certain of John Constable's Cloud Studies 1821–2 using historical weather records', *Occasional Papers, Department of Geography University of College London*, (August 1978)

—— 'Constable's Clouds', *Burlington Magazine*, CXXI, (1979), pp. 697–704

TURNER, J., *The Politics of Landscape*, Oxford, 1979

TYLER, R. E. G., 'Rubens and "The Hay Wain"', *Connoisseur*, Vol. 189, No. 762, (August 1975), pp. 270–75

VIRGIL, *Works*, 4 vols, trans J. Dryden, London, 1782

WALKER, J., *John Constable*, London, 1979

WALLER, A., *The Suffolk Stour*, Ipswich, 1957

WATERHOUSE, E. K., *Reynolds*, London, 1941

—— *Gainsborough*, London, 1958

—— *Painting in Britain 1530–1790*, London, 1962

—— *Reynolds*, London, 1973

WATSON, J. R., 'Wordsworth and Constable', *Review of English Studies* 13, (1962)

—— *Picturesque Landscape and English Romantic Poetry*, London, 1970

WHITE, C., *English Landscape 1630–1850* (Exhibition Catalogue), New Haven, 1977

WHITE, G., *The Natural History and Antiquities of Selborne*, ed. J. W. White, London, 1813

WHITLEY, W. T., *Art in England 1800–37*, 2 vols, London, 1930–2

WHITTINGHAM, S., *Constable and Turner at Salisbury*, London, 1972

WILTON, A., *British Watercolours 1750–1850*, Oxford, 1977

—— *Constable's English Landscape Scenery*, London, 1979

WOODALL, M., *Gainsborough's Letters*, London, 1963

WORDSWORTH, W., *Poetical Works*, ed. de Selincourt and Darbishire, Oxford, 1940–54

WRIGHT, T., *Some Account of the Life of Richard Wilson*, London, 1824

YOUNG, A., *The Farmer's Tour through the East of England*, 4 vols, London, 1771

—— (ed.), *Annals of Agriculture and other useful Arts*, 45 vols, London and Bury St. Edmunds, 1784–1808

—— *General View of the Agriculture of the County of Suffolk*, London, 1797, revised ed. 1813

—— *The Farmer's Kalendar*, London, 1805

—— *General View of the Agriculture of the County of Essex*, London, 1807

—— *Autobiography*, ed., M. Betham-Edwards, London, 1898

Index